M. Ellen Stammer, Ed.D.

Women

and

lcohol

THE JOURNEY BACK

GARDNER PRESS, INC.
New York Sydney London

GARDNER PRESS, INC.
19 Union Square West
New York, New York 10003

Library of Congress Cataloguing in Publication Data

Stammer, M. Ellen.
 Women in alcohol : the journey back / by M. Ellen Stammer.
 p. cm.
 Includes bibliographical references.
 ISBN 0-89876-173-5 : $14.95
 1. Women—Alcohol use. 2. Alcoholics—Rehabilitation. I. Title.
HV5137.S73 1990
362.29'2'082—dc20 90-3129
 CIP

Cover illustration: *A Corner of the Moulin de la Galette;*
Henri de TOULOUSE-LAUTREC;
National Gallery of Art, Washington;
Chester Dale Collection.

Cover Design: Deborah Daley

Book Design:
Publishers Creative Services, Inc.

PRINTED IN THE UNITED STATES OF AMERICA

10 9 8 7 6 5 4 3 2 1

Dedication

To the women who enriched my life by participating in the study and to Sister Pat for being my mentor. Her guidance, encouragement, and intellectual challenge made the original study possible. A special prayer goes to Dr. David Logsdon who encouraged me to begin this project and who was so abruptly called to be with the angels. A special thank you to "Nancy Nurse" and to my family for giving me the encouragement not only to begin this project but to continue. My love to a very special Al-Anon group whose exceptional warmth, sensitivity, and ability to share supported me in my own search for acceptance.

The women represented in this book have chosen aliases by which to be identified. Any resemblance to people having the same names is purely coincidental.

. . . And there is darkness before light . . .

Preface

lcoholism is an insidious disease, the effects of which are passed from generation to generation frequently without awareness. This book is about the cultural path or life-ways of women who found themselves in the depths of despair and addicted to alcohol and in some cases other drugs as well. It traces the life of each woman and illustrates what it was like to grow up in her particular family, the meaning of alcohol in her life, and how she used it and other drugs as a way to cope with her feelings of deprivation. Each woman's voice is unique yet universal and through actual conversation, the reader gains first-hand insight into the feelings and perceptions each woman had about her life—what happened to propel her into treatment and what it means to accept the identity of being alcoholic.

Women and Alcohol is a true account and because of that the names of the women interviewed and their descriptions have been altered to protect their anonymity. Jennifer, Lucy, Beryl, Carnelian, Natasha, and Lynne are between 25 and 35 years old, whereas Mary Helen, Catherine, Linda, Julie, and Zelda are of another generation. From Beryl's heart rendering account of her physical abuse and incest to Mary Helen's warm rememberances of growing up in a nurturing family, all the

women had similar perceptions about themselves—they had failed somehow to become people having worth and value. In each case accepting herself as she is with all her imperfections is the key to turning the woman's life around. Acceptance is a life-long process deepening with the experience of living without the use of mind altering chemicals. This is the story told by those who are living it. It is shared in the hope that each woman may somehow reach out and touch the life of another to say that there is hope and there is joy in living.

Contents

Part 1

GROWING UP

1

Introduction

This book is about the cultural paths—or life-ways—of women who are recovering alcoholics. It is an ethnography. An ethnography examines and describes a culture from the point of view of the people living in it. It is a process of learning what it is like to walk in another's footsteps and a way for us to begin to understand various phenonema when standard measures fail. This ethnography was initially written as an Ed.D. dissertation. The book focuses on the first of the four questions in the original study to reveal and examine the cultural path or sequence of events that lead women to alcoholism—and ultimately to recovery.

It is now recognized that alcoholism tends to occur in families. Why this happens is not known. It seemed reasonable, then, to begin one's cultural path at the earliest point of remembering. Two assumptions formed the foundation of the study and this book: (1) alcoholism is a chronic, progressive, and potentially fatal disease from which recovery is possible, and (2) women in recovery are able to reflect on their experience of alcoholism and getting sober and relate that experience to others. I am deeply indebted to the 34 women who participated in my study and freely shared with me their par-

ticular life-ways. The understanding that emerged from the many months of close association with these women provided insight into the series of events that led them to destructive drinking and the challenge each faced in recovery. This book is an attempt to share this understanding with others.

Life-ways can be compared with a river: at times it meanders in calm tributaries stopping occasionally in silent deep pools of thought; at other points it is a deluge flowing over obstacles in its path—pounding, twisting, turning, and plummeting aggressively to reach somewhere beyond. Each path beckons. Sometimes there seems to be no choice. This journey into alcoholism may begin as subtle as a quiet peaceful tributary or as sudden surging torrent. To understand how such a journey may begin, visualize with me a warm summer's day in a quiet cove. A young woman is reclining on an inflatable raft, one hand lies emersed in the water as the other shades the noon sun from her face. The sun's warmth feels luxurious. Soon time is suspended. All of life's concerns have evaporated. It is quiet, pleasurable, and only occasionally does the hand in the water feel a gentle pull. "Not me, not me! Alcohol is my friend, it won't turn on me!" "I know too much about these pills, I'll be careful, it won't touch me." Time passes unobserved. The woman does not notice how far from the shore she has drifted or the small fingers from the depths below reaching out to gently coax her craft on a swifter course. The family, dozing on the river bank has yet to show concern as it, too, is lulled by the apparent peacefulness of the scene. But the river named alcohol is insistent. Soon the small craft begins to twist and turn in response to an unseen force. It accelerates, struggling against, yet complying with, the fluctuating commands. Gradually alcohol assumes control. The family begins to stir and once alert finds itself powerless to act. It, too, begins to respond to alcohol's commands. What is this force that has assumed control both of those adrift and those ashore? What happened? How did it start?

Mary Helen

As I walk toward one end of the rambling two story apartment building, a well dressed woman bearing a radiant smile emerges from a hidden recess. "Ellen?" Yes, I reply. "Come," she says. "I'm Mary Helen and we have much to talk about today." Grasping my hand in a firm embrace I feel her inner strength. Her deep brown eyes framed by brown hair, now gracefully softened by silver threads, magestically crown her trim five-foot-six frame. Her vibrance eminates warmth and sincerity and make me feel welcome. "I am the student," I say. "Yes, and I will be your teacher," she acknowledges. We settle in the living room and while I prepare my tape recorder, she pours coffee. Morning sunbeams dance across the balcony of her apartment. "Where shall I begin?" she asks. "At the beginning," I reply.

I think that I had a very stable normal healthy childhood. In retrospect, I must say that my sisters and I were privileged in many ways in that we were treasured. Even in those terrible years when no one had much money. Mom and dad might only have thirty cents between them some weeks but we managed to have food on the table, a roof over our heads, and adequate clothing to wear. My parents showed affection for each other and for us. They were careful not to play favorites, but I did manage to get more than my share of attention from dad. Daddy was my prince, my king, and the most handsome man around, so I thought! My parents valued education and helped us with our studies. We were active in the church as we got older and we did many things together as a family. There were four girls in our family and I was the second child. Growing up all of us had responsibilities to help mother with work around the house. Mother was kind and considerate and she guided all of us in the things we had to know and do to make a home run smoothly. I didn't mind doing inside chores, they were expected of me and they were something I anticipated I would be doing when I grew up. I can remember

when I learned to iron—my youngest sister had those dresses with all the little frills and lace, and I just loved ironing them for her. Everything had to be starched, even the pillow cases, because they stayed smoother longer. My sisters and I were all different in temperment but I was the sunny one, the cheerful one, the peace maker, and I had a lot of energy. We lived in the country and the nearest neighbors were some distance away so we learned how to play together and amuse ourselves. Who would have thought it would turn out this way! Alcoholic—all of us! Two of my sisters died from it. I have another who is recovering as I am. Today, my goal is to make the days I have left good, primarily for me, and then automatically for anybody who is around me. To be needed is a precious gift, not an obligation.

Jennifer

A soft rap on the door at the appointed time sends me scurrying to open it. "Jennifer?" I ask. "Yes," she replies. "Come in, I'm Ellen and I'm looking forward to our talk." "It's a good thing for me to do periodically—share my story," she calmly says. "It helps me to remember what it was like then and how it is now. I don't ever want to forget what it was like. I don't want to go back to that." As we settle ourselves around the small desk in the motel room, I notice how her long natural blonde hair that falls gently passed her shoulders frames her face and accents brilliant blue eyes and creamy skin. Radiating the vitality of her mid-20s, she reaches for the diet coke I have poured, takes a hefty swallow and asks, "Where shall I begin?" And I reply, "At the beginning."

Both my parents were alcoholic. My mother was a low bottom in that she almost died from it but my father was a high bottom. He felt that having four drinks a night was not a good practice even though he had done it for many, many years so he decided to make some changes in his life. Both of them are in A.A. today. I have two sisters and a brother. We all

6

turned out to be alcoholic and today all of us are in A.A. but there were many years of pain and struggle as we were growing up. I don't know if I had a normal childhood, 'cause I don't know what a normal childhood is. I'm the youngest and when I was coming along my brother and sisters were pealing off and leaving to go to collee. Today I am close to one of my sisters. I always felt close to my mother and I spent a lot of time waiting around for her to finish a drinking episode so we could have some time together. My father had a job that required a lot of traveling and I remember we used to call him the "white knight." He'd sort of charge in every so often, make pronouncements, and then leave again. My brother and sisters were afraid of him, but for some reason I felt that he was very important to me and I wanted to get to know him. So I would go up to him and say, "Well, why do you always leave us?" and "When are you going to come back and stay with us for a while?" I always sensed that I needed a father and I needed to feel close to him so I would kind of get angry and say, "I don't care if you won't talk to me, I'm going to make you talk to me." And I think in a way we became as close as we could be.

Catherine

I walked through the busy office complex and found the appointed spot. A demure woman with greying hair seated behind a desk rises to greet me. Her warm brown eyes compliment the tranquility I feel in her presence. She extends her hand to me and her grasp is firm and vibrant. "Ellen?" she said. "Yes," said I. Come with me, we will find a quiet, private spot where we can talk. I follow her to a small conference room nearby. As we begin to get comfortable, another person quietly appears, leaves coffee, and closes the door as she softly retreats. We chat for a few minutes while I settle myself. Highly observant, she notes when I placed my small tape recorder unobtrusively on one end of the table. Soon she asks me where she should begin and I reply, "At the beginning."

7

My mother and father weren't alcoholics and it never oc-
curred to any of us that I would turn out to be the alcoholic
in the family. I had to lose it all and almost die before my wall
of denial crumbled. Growing up . . . I suppose in some way
I felt a part of things. I was always very independent and my
father encouraged that in me. I loved school and I did well
in it. In summer classes I learned about architecture, music,
painting, and sketching. To me that was the fun stuff. I liked
being with other children my own age and I loved sports, I
still do. I played baseball and football with the boys and
climbed trees. I wasn't interested in playing with dolls—that
didn't impress me. Although I have a brother and two sisters,
we are all four years apart and I am the oldest. It was expected
that I help with the younger ones.

Suddenly she hesitates. I can see painful memories flooding
to the present. Her composure falters slightly as she lets out
a deep sigh. I notice the warmth of her brown eyes fading
behind a mist that threatens to envelope her entire being. The
gaiety evident in her voice when we first met is now filled with
resignation. Quietly she begins to share her painful thoughts
and feelings with me.

My mother constantly reminded me that one of my respon-
sibilities was to help take care of my brother and sisters because
I was the oldest. I was the one who was supposed to set the
example, the good example, and I was prompted about that
constantly. My parents didn't go away too often, but when
they did I would be the one to stay home and take care of the
younger children who were not allowed to go. I wanted love
from my parents and I think they truly believed they gave it.
Now I realize that what I got was their *approval* for taking care
of the younger children, but at the time I thought approval
was love and I wanted to be loved.

Lucy

Stepping into the library's marble foyer I feel the welcome
coolness of the air conditioning. A tall slender woman in her

early 30s glides toward me. Her cropped light brown hair frames her face highlighting large soulful hazel eyes. Briefly hesitating she softly says, "Ellen?" "Yes," I answer. "Good, come with me, there is a conference room on the second floor we can use." Abruptly she turns, her colorful skirt swaying gently to her cadence as she sweeps ahead of me. . . . Again, she asks . . . and I reply.

I came from a very large family—there were 12 of us and today I feel that all of us are strangers. I was second from the top. My sister was four years older than me and she was the one that I really became close to. She sort of mothered me and she would call me "little one." When I was just starting my teens she went into the convent and I still miss her. It was traumatic for me. I cried and cried when she left. Now I was the oldest one at home and I felt like the weight of the world was on my shoulders. I became the major caretaker of my brothers and sisters—that was what my mother expected me to do. I got approval from her by being a second mother to the rest of the children in the family and doing chores around the house. My father was very strict and it seemed like I could never do anything to please him. He always found fault with everything I did. He demanded perfection but I never really knew what he wanted. None of us could do anything to satisfy him. My father was always working. He had two jobs to support us, but even when he was home he was not there—he had his beer to keep him company. Although my father never drank to the point that he couldn't function, when he drank, his mood and his behavior changed. He became verbally abusive and mean. When he wasn't drinking, he was irritable and I learned very early to keep out of his way. Today I realize that he was an alcoholic. But he was a professional and no one thought of him as being alcoholic. I wanted his approval, but I felt like I never got it. I wanted my mother to love me, but I never had the sense that she thought I was important in my own right. It was the work I did that counted and even then she never let me know that I had done something well. I never had a best friend. I didn't have any friends. There were always so many chores to do that I had to hurry home from school and get to work. Today I'm trying to learn how to make friends and know what it's like to have fun. That sounds like

it would be easy to do, but it's very difficult for me. I'm finding that I have to give myself permission to have fun and then let myself feel what it is like. I never thought I'd have to work at learning how to enjoy myself.

More than any other chronic illness, alcoholism and addiction to other drugs forces us to examine our own feelings, attitudes, and beliefs. And it is painful. Many of us have learned to feel comfortable with the pain of denial—there is no addiction here we say. A number of noted researchers have found over the years that alcoholism does tend to cluster in families. The presence of one or more parents who are alcoholic in the family structure make it more likely that children will develop alcohol problems later in life. The knowledge that this disease affects not only the individual but also family, friends, and co-workers is undisputed. Yet the social stigma connecting alcoholism still exists. Until recently, families refused to recognize that alcoholism had invaded their family life. Instead it became "the situation"—to be hidden, ignored, and denied. Denial is so strong that relatives may cease to talk about or make any references to the "missing relative" at family gatherings. Over time newer generations may honestly not know about close relatives who are alcoholic and thus be unaware of their own potential to develop the disease.

Although first thought to be a disease of men, it is now evident that women are not immune from alcoholism or dependency on other drugs. Nonetheless, factors leading women to alcoholism are still not well understood though many explanations have been offered. Case histories of alcoholic women suggest that the environment in which a woman is raised, what she learns about her worth and value as a person, and her genetic predisposition are all among the myriad factors activating this disease. On one hand, a woman's family constellation may consist of a domineering mother or father who rigidly controls family behavior and activities. On the other hand, an atmosphere of ambivalence, inconsistency, and fluctuating family standards is the norm. In either situation the skills necessary for future successful social integration are either deficient or absent.

For better or worse, mothers are the dominant force and role model in the life of most young women. As frustration mounts from trying to attain unreasonable, impossible, or ambiguous expections, this smouldering force turns into anger, which grows into rage as the young woman's perceptions of failure and inadequacy are confirmed. Alcohol, the family medicinal agent, provides relief and is used to escape from these perceptions of ineptness.

Investigators assessing self concept in women alcoholics and addicts repeatedly find that they suffer from a diminished sense of personal worth and adequacy. They feel less adequate, worthwhile, and valued as family members in comparison with their siblings and they are less able to cope with sources of stress. Women alcoholics frequently mention a sense of rejection by one or both parents suggesting that prolonged deprivation of dependency or closeness needs (mothering, love, affection, acceptance, security, food, warmth, protection) also contributes to the development of alcoholism. The significance of meeting human needs has recently been observed in women undergoing treatment for cancer. Perceiving acceptance by others, love, belonging and autonomy are important human needs to enable cancer patients to continue to feel worthwhile as persons.

Meeting human needs can be best explained by using a straight line having a fulcrum or balancing point in the middle. One end illustrates deprivation, the other abundance. In the middle, human needs can be characterized as either partially or fully met. When the line remains in balance, human needs are being reasonably satisfied. Meeting human closeness needs is one function of family life. If the family is in balance, human closeness needs of its members are being fulfilled. In a smoothly working family, balance is reflected through clearly defined roles, stable, predictable family rules and an emotional climate that is tolerant of others. Balance is manifested in the caring, sharing, and concern for the well-being of each person within the family's immediate circle. One *feels* a flow of energy that is warm and nurturing among family members. One senses the encouragement their children receive to

develop independence. Attention, acceptance, appreciation, approval, love, and belonging are human closeness needs that keep the balance in a person's life.

A woman's first contact with life is in the family. It is here that she learns from others who she is. Her sense of belonging is dependent upon her perceptions of acceptance, approval, and love from the family. Each of us has a human need to feel close to others. Belonging to our primary group promotes well-being, happiness, joy, affection, roots, and esteem. It advances one's confidence and a belief in the self as one who has worth and value. It facilitates trust in others. When human closeness needs are perceived as either lacking or excessive, life is out of balance. If alcohol assumes control in family life, a once smoothly working family becomes imbalanced. On one hand, inconsistency, ambiguous roles, fluctuating family standards, and chaos may characterize family life. On the other, a restricted, over-protected family life is sufficient to extinguish the lamp of self-confidence before it is fully lit.

2

Looking
For Love

Love is a concept: a word we use to describe our feelings about ourselves and others. Love conveys warmth, compassion, caring, and much more. It brings us close to others. Each of us has a human need to feel close and connected to our immediate family and perhaps to an extended family as well. Feeling close means being accepted as one is. We sense approval of ourselves as a person and perceive that we have worth and value. We feel good about ourselves. When we feel good about ourselves, we are able to share a part of us and nurture others. We are able to give and to receive love.

All of us have different experiences: feeling treasured, getting attention, receiving affection, feeling alone, wanting love, looking for approval, waiting for Mom to sober up, and wanting to be with Dad are some of them. In retrospect, Jennifer wonders what a normal childhood is whereas Mary Helen acknowledges that she had one. She felt loved and connected to her family. Participating in household tasks and helping to take care of her youngest sister was perceived as a natural part of her life. In contrast Lucy detected a lack of concern for

her as a person and she felt burdened with the responsibility of a large family. A shy child, she struggled to meet vague and unrealistic expectations in the hope of winning Father's approval and receiving Mother's love. Although Catherine's father encouraged her to seek the company of her peers in the things she liked to do, mother provided constant reminders about her household and care-taking responsibilities dampening the pleasure of self exploration.

A young girl's first experience with giving and receiving love is in the family. It is here that she senses approval for her actions and begins to perceive her worth and value. In the effort to win approval and be accepted, she learns that being responsible is a highly valued expectation. One earns approval and is rewarded with love by taking care of others and doing chores. Most young girls are expected to do chores inside the home by helping Mother with housework and in the care of younger brothers and sisters. Doing chores and taking care of others earns respect. In most families it is Mother who communicates what it is that daughters do to earn respect and love. Although doing what father says is important, doing what mother says is paramount. Mother is the ''chief of family operations.'' Her orders are law. For many this communication is one way—down.

In spite of the fact that Mary Helen, Catherine, and Lucy did chores and took care of younger brothers and sisters, their perceptions of their parents' regard for them differed. Mary Helen felt treasured. Her mother, kind and considerate, recognized her individuality. Along with the guidance and direction to learn home management, Mary Helen's personal human needs for closeness (attention, appreciation, approval, acceptance) were considered. She perceived herself to be a person. Catherine, on the other hand, sensed that her mother was not concerned about her as a person and Lucy perceived that she was no one's little girl. Approval for the things they did, respect for themselves as persons, and love freely given remained illusive.

Sensing unconcern about one as a person is seen as rejection and is stressful. Reiminiscing about earlier times, Catherine continued to share her perceptions and feelings of rejection

14

with me. "I think," she said, "that I really felt that I had to learn those skills when I didn't want to—like ironing those damned starched shirts. I did get angry because I felt like my mother wasn't there for me when I needed her. Not so much for doing things or giving me things, but just being there when I needed her. I couldn't talk to her about the things I wanted to know about so I never felt close to her. Somehow I always had the feeling that she didn't care for me. It was my younger brother who got all the attention. She never fussed at him even when he invaded the privacy of my room and messed up everything. And it seemed to me that I always got blamed for all the things that he did. We had a woman who would come in to help with the housework because I did have a younger sister who was born with a handicap and she required a lot of our attention, but one day my mother decided I was going to do the work and she let the woman go. I can remember ironing Dad's shirts and they had to be starched. It seemed like I always had a huge pile every wash day and they were so big. I had to stand on a small box to reach the ironing board and it seemed like it took me forever to do all those damned shirts and I wanted to be out playing or doing something that I wanted to do. It seemed as though I was angry all the time, but I stuffed it 'cause girls were supposed to be sweet and nice and not get mad and do everything for everybody else."

Doing everything for everybody else. Whereas Catherine begrudgingly learned to do for others, Lucy readily absorbed the overwhelming responsibility for a large family seeking her father's approval and mother's love. No matter how hard she tried, her human need to be close and feel connected was denied. Lucy thoughts about her mother reflect those of many women: "Mother ran the household and I just did what she said to do. My mother was a very stoic, strong, controlling woman. She never showed her feelings. She was definitely an authority figure. I was in awe of her power but at the same time I wanted to please her. I wanted her to love me, but I never had a sense that she really cared about me. My mother's generation finds it hard to be friends with their kids. I couldn't sit down and talk to my mother about the things that I wanted to know about. That was taboo."

Measuring up is another valued expectation of homelife. One measures up by getting along with Mother. Getting along with Mother means following the rules. Being nice and being good are ways to get along. Being nice means not speaking out, asking questions, having opinions, getting mad, or showing anger. Carnelian's penetrating amber eyes look directly into mine and we both smile as I, too, remember similar messages being directed to me in my own life-way. "It was subtle," remarked Carnelian, "but I learned that being nice was a way to have people like you . . . and I wanted to be liked. To me, then, it meant that I couldn't be angry with another person if they did something that displeased me or if I found their behavior toward me to be unacceptable. That's been the hardest thing for me to do in recovery, to express my anger. Instead, I learned to put on my mask—the happy face that had the pleasant expression and conveyed an "everything is just fine" attitude even though inside I felt like hell. I didn't know what to do with my anger so I just stuffed it. I *had* to be accepted and I truly believed that as a woman being angry was not a lady-like thing to do."

Being good meant not doing "bad things" like having sex or getting pregnant before marriage. Whereas Mary Helen and Catherine incorporated these family rules as a natural part of their bonding process, Jennifer, Lucy, and Carnelian had more direct "don't" messages. Jennifer expressed it this way: "I was a pretty good kid in terms of not breaking the rules. I was terrified of what would happen if I did something really, really bad. The messages were don't get pregnant, don't get arrested —and everything will be fine.

Children are well aware when they do not measure up to mother's expectations. Fear of not measuring up and guilt from perceived infractions of family rules may become the norm. In homes having an authoritarian, controlling mother, fear, intimidation and guilt were the methods used to maintain order and control behavior. Love, the reward for being good, was bestowed at random, if at all. "You were loved if you were good." "There wasn't a lot of closeness in my family." "We were just there and said yes ma'am and no ma'am and did

what we were supposed to do'' were common themes among these women.

Mary turns and briefly gazes out the large window at the vast array of humanity streaming past en route to a thousand different places. Shadows from the setting sun accent her drooping shoulders and pallid blue eyes. Finally she turns to me. ''I got a double dose of guilt if I didn't follow all the rules of my family. I was often made to feel guilty if I didn't obey my parents. That was kind of the accepted way of delivering discipline in my family. I was raised with a lot of guilt, I never felt like I was ever good enough. I have such a poor image of myself. I never felt like I was worthwhile. I was always told don't embarrass the family, look at what you are doing to the family. I lived in constant fear of my mother. She totally controlled me with approval. I was always afraid of what she would do to me. You see I come from a family where the females are the controllers. I was pushed. I had to move faster, further, I had to excell. But the purpose was to take care of the men. As a woman my sole purpose for existing was to take care of the men. My needs didn't count. I didn't have any sense that my mother thought I was a person. When my first husband walked out on me and the kids and didn't support us, she let me know it was my fault. I didn't measure up.''

The human need to be loved and to belong to a group is undisputed. Each of us needs to feel that a special ''other'' is attentive to our needs. Approval for what one does and acceptance by those closest to us are also human needs. They convey worth, value, and love. Daughters look to their mothers for a sense of who they are as persons. They look for attention, appreciation, approval, acceptance, and love. Receiving individual attention from Mother generates feelings of closeness and confirms that one is a viable entity in the family.

Lucille raises her downcast eyes and directs them to me. I can see lingering traces of pain and hear the wanting as she speaks. ''Basically I was a good girl growing up,'' she quietly states. ''I didn't give my parents any trouble. But I had a real need for love and affection and I don't think that I got as much as I thought I should have. I was overweight as a child and

I got a lot of messages that I wasn't quite right. Mom was always trying to get me to lose weight and I felt physically unattractive and unlovable because of that. Somehow I didn't measure up. I always felt that my mother had difficulty in talking with me about matters that made her uncomfortable and growing up I never felt like I could go and talk to her about my feelings and other concerns. Even today our relationship is pretty superficial.''

As she speaks, her misty brown eyes convey poignant yearning. ''I couldn't talk to my mother about sex. I couldn't ask her what it was like to be a woman and I really wanted her to share that with me. I wanted to feel like I really knew her and she knew me. I wanted her to be my friend. Instead, I got the message that it wasn't cool to talk about my problems and if I had any, I should handle them on my own. And I learned very early that it was very important to protect the family integrity. I was the oldest child and I just seemed to be the one to take on all this responsibility and I didn't like it. I felt like I was carrying the weight of the world on my shoulders and I wanted my burden lifted. I wanted to be free but I was afraid. From as early as I can remember up until I was about ten years old, I seemed to be filled with fear. Somehow I wasn't good enough. The fear and the loneliness were just overwhelming. But I could never talk to anybody about it. I just kept it all inside. I felt like my mother wouldn't understand. I was also fearful of being physically hurt. I got a lot of 'watch out for strangers' type of thing and stuff like ''don't go to sleep with gum in your mouth ' and ' don't climb that high in a tree you will fall and break something or hurt something.'' I had a lot of fear about being trapped, about being in closed places and I think basically I learned to be untrusting and a wary kind of person.''

Being afraid, being wary of others, being untrusting, not being able to talk to mother, and feeling unloveable are the memories Lucille has about growing up. Mary, on the other hand, vividly remembers the fear and guilt instilled in her by mother and the uphill battle she has had to wage with herself to acknowledge her value. She finds her infrequent visits to her mother emotionally draining and still grieves for the

warmth she felt she never had. Mother still measures her worth totally by performance and tries to control her actions though intimidation, fear, and guilt. No matter how hard she tries, Mary still feels that she never measures up. As a child, failure to measure up and gain approval produced perceptions of in adequacy still evident today. This imperfection meant one had less value as a person. As these feelings of failure and her perceptions of inadequacy were reinforced, she began to view herself as utterly worthless.

Receiving attention and love from mother is sought in a variety of ways. Zelda's vivacity permeates the dining room where we are seated. As she talks I notice that she occasionally strokes several philodendron leaves and the plant seems to reflect the energy of her gaiety. ''I couldn't keep my mouth shut in school. I was the class clown. The nuns used to call me devilish and they put the fear in me, but good, but I could just walk that line. I lived in fear that they would tell my mother that I was not going to be perfect and I wanted to be a perfect little girl and please my mother. I'm a people pleaser, I really am. And that's been difficult for me today. I don't think at the time I felt that acting out would give me the attention that I wanted 'cause I was always a very outgoing person, but today I realize that I wanted more love and attention from her than I got. But in spite of that, I felt close to my family. If anything happened, my aunts, uncles, and cousins would converge to help. We closed the family circle in time of trouble and nurtured each other.''

Receiving individual attention, sensing acceptance, and perceiving that one is loved are vital human needs. In spite of the fact that both Mary Helen and Zelda acknowledge feeling connected to their families, both continue, each in her own way, to seek more attention and love from the one they perceive holds the power over their lives—Mary Helen through achievement and Zelda by using humor. Seeking human need fulfillment occurs in a variety of ways. Carnelian, believing that women should not be angry, suppressed her growing rage under a mask of pleasant servitude; Jennifer, who periodically received attention between drinking bouts, waited patiently for mother's attention; Lucy, suffering the loss of her older

sister in silence, sought recognition from her parents by excelling in caretaking responsibilities; Catherine looked to her father for relief from the drudgery of daily living, whereas Lucille and Mary both wondered what it would be like to be loved by anyone. Instead, being intimidated, feeling guilty and feeling like a failure became natural events in their life-ways. Ultimately, it is the failure to measure up that is perceived as the reason love is withheld. Somehow each woman had failed to become a person worthy of receiving attention, affection, acceptance, and therefore, love.

"I had an insatiable need for love" and "I wanted to be the one who was the most loved in my family" were common statements among many of the women. Acting out was one way to obtain love. "I acted out. I would do anything to get the attention I felt I needed," were characteristic utterances. For some, acting out was more subtle.

Julie looks at me with infinite patience as she begins to communicate her concept of love and how she went about satisfying her human need for attention and love. "As a young woman I found that if I got all dressed up I got a lot of attention. You see, I thought love and receiving attention were synonymous. Where I grew up, it was fashionable when people visited others to wear hats and skins and I noticed that when women did this they got a lot of attention. So as soon as I could, that's what I did! I was always parading around as if I were on stage and I got a lot of attention that way. I remember my fantasy very vividly. I was going to be driven around in a chauffeured driven car, I was going to have a fur coat, lots of money, and be very sophisticated. I don't have any recollection of wanting to be who I was."

Daughters want and expect to learn from mothers what it is like to be a woman. This expectation may not be fulfilled. When asked, Lucy leans forward in the chair, her body quivers slightly and for a few moments she stares wistfully to some point beyond the two of us. Finally, she directs her pain filled eyes to me and with a mixture of sadness, hurt, and lingering bitterness in her voice says: "I was never friends with my mother and my father is an alcoholic. I always felt like I loved my parents but I never felt like I really knew them and I never

felt like they took time to really know me. I felt that I could never go to my mother and talk to her about anything. I never got any instruction on becoming a woman. The only thing I got was a pamphlet laid on my bed one day.''

Young women also look to their fathers for attention, reassurance, and the warmth that comes from knowing a tender hug will soothe away the hurts of growing. They seek approval and acceptance for who they are. They look for love. Catherine and Mary Helen spoke softly and with tenderness when they said: ''I was Daddy's little girl. I won his approval and rewards from him by helping Mother take care of the rest of the children in the family. I was like a second mother.'' And Catherine added: ''My Dad was the one I went to for love. He was the one I sat with while we watched the Yankees or the Dodgers play. He was the one I would go to and he would calmly talk to me and tell me that everything was going to be all right.''

Kelli's tall slender frame suddenly leans forward, her out-stretched arms reaching out to me across the small table send my tape recorder crashing to the floor. Her intense, deep brown eyes penetrate to the center of my being and I feel a shiver begin somewhere in the depths of my own soul. What feeling has she awakened in me? Her hands pressing on my arms feel like the first breath of fall and I tremble slightly. Would she really share with me? What is she thinking? How will I react? Except for the color of her hair, she could be my step-daughter. This interview is hitting home and I know she senses my discomfort. Our eyes meet and just as suddenly hers softens and she relaxes her grip. ''When I was growing up, it was my dad who gave me the attention I so desperately wanted. I always had the strong feeling he wanted a boy to be first in our family but he did spend a lot of time with me and I learned how to correctly pitch a baseball and we went camping and things like that. I really like sports and I just loved being with him. Mom, well we got along. When my brother got old enough to take my place with Dad I began to be more aware of her. Then I realized I was more comfortable with my aunt's family because there was more openness and more physical affection given. And when she was angry, she'd say

she was angry and then get over it and then things would get back to normal, you know, doing things for us. If she was angry, she let me know about it but it didn't affect the ways she felt about me. When my mother was angry with me, it was both my behavior and me that were bad. And she would hold onto her anger for a long time and pout and pretend that nothing was wrong."

Not all fathers expect their daughters to do housework. Doreene, a vivacious, natural strawberry blonde in her mid 20s, smiles quietly as she thinks about her dad. When she speaks, her voice has a tender quality and her mischievous blue eyes dance while she describes her life on the farm where she did "men's work." I was dad's favorite. I was supposed to be his boy and I didn't come out as one but he didn't care. I was special to him and we did a lot of things together and my brother just kinda got lost in the shuffle. My dad raised me as a boy. I was literally raised as a boy. I was *his* boy. I chewed tobacco and wore overalls, spit and hammered and sawed and baled hay. I worked with the men folks. I never learned how to cook and clean. I picked that up 20 years later. And I was a hellion. I was into everything. I mean I got into trouble for breaking and entering, I set the school on fire, I hit a teacher. My dad laughs now, he said he spent more time in school than I did. But somewhere around the ninth grade, I decided it was easier to play the game and do what everyone wanted me to do and be the little sweetheart than to be the bad kid. I finally figured out that I was petite and pretty and if I became a little darling and did what young women were supposed to do, I could get a lot of attention from everyone."

The overwhelming human need to receive attention, be accepted and perceive approval prompted Doreen to reevaluate her actions. "Playing the game," achieves personal rewards. It now becomes beneficial to follow rules and fulfill expectations of others. When rules are known, attainable, and have benefits perceived as having value to the self, daughters will strive to follow them. The realization that attention, approval, and acceptance could be attained simply by conforming to cultural expectations for women and following rules became Doreen's catalyst for outward change. Her mask in place, her

fermenting inner turmoil hidden, she basked, for a time, in the rewards of being what others wanted her to be.

When expectations are ambiguous and unrealistic, young women still try to meet them in the hope of receiving approval and love. It was a late warm spring afternoon. Lucy hurried home from school to finish her household chores before dad arrived to begin his daily inspection of the house. Throwing off her sweater, she began a fervent assault on the small bathroom adjacent to the front hall foyer. As she worked she began to hum her favorite melody. An hour later the tiny bathroom sparkled as a result of her efforts and a sunbeam from the fading light danced expectantly on a faucet. She learned back from her kneeling position, surveyed the room and with a quiet smile began to collect the tools of her efforts. "Maybe this time," she thought, "maybe this time he'll at least say it looks good." The sound of heavy feet climbing the stairs and walking toward the front door made her heart pound. She knew the weight of that step and today the sound was heavier than usual. The door flew open and the tall man walked toward her as she scurried on her hands and knees to get out of his way. Without a word he removed a worn handkerchief from his faded trouser pocket, bent down and wiped it along the baseboard. Finding nothing, he knelt and with his piercing eyes closely examined the room. "Ah, there's one!" He reached out, picked up the strand of hair from the floor, turned and held it in front of her nose. She could hardly breathe, it was if her heart had stopped. With a shove he sent her sprawling. "Next time you clean the bathroom, I want it clean," he screamed. "Look at this filth!" "I will talk to your mother about withholding your supper!" She could hear the receding footsteps as he made his way to the kitchen, then the door to the refrigerator opening, and, the clink of glass as he removed a bottle of beer. As she sat on the floor in the approaching twilight, she didn't even feel the moisture as silent tears cascaded down pale cheeks and splashed on rough red hands.

Alcohol, as a periodic household commodity, is used in conjunction with family and cultural expectations. When alcohol becomes enmeshed in family life, it subtly begins to usurp con-

trol and manage it. Alcohol then achieves the central focus of power within the family. Family energies are mobilized to meet alcohol's demands and taking care of the alcoholic becomes the primary focus.

"All during my mother's drinking years we were close to each other and we're still close," says Jennifer. It was really hard for me when she hit her bottom 'cause I had years when I was really angry with her. I kept trying to understand. I kept thinking well, O.K., she has these problems and if we can solve these problems, then she will be happy and she'll quit drinking. We spent years discussing her problems, while she was drinking, of course. But there came a time when I had to get out and I moved from home. I was so angry that I had to get away from the whole situation. She's in recovery now and when we do talk we are still close. It's different now, but it's hard. I have to keep reminding myself that I'm primarily responsible for taking care of me and doing things for my own recovery. I have to be careful not to fall back into the old way of doing things and become totally involved in her life and forget that I have one of my own."

Family turbulence, a condition that develops when alcohol becomes the central controlling force, affects every family member. In a 1989 report published by the Al-Anon World Service Office, 72 percent of its adult members report at least one alcoholic in their lives and 86 percent of those in Alateen reported they have an alcoholic parent. Family turbulence is characterized by inconsistent behavior, fluctuating family standards, ambiguous role expectations, and denial of the alcoholic drinking. When this occurs family life becomes unbalanced. Children learn that inconsistency and uncertainty are normal. A permission granted by the alcoholic parent one day may be violently rescinded on the next. Not knowing what to expect—well, maybe it will be different this time.

Barbara's slim, four-foot body begins to radiate her excitement in anticipation of spending the night with her friend. She quickly combs her short dark curly hair and pushes stubborn strands into place. Her black skin radiates warmth and her wide brown eyes dance in anticipation. She knows she looks good and for the first time in a long while she feels good.

Looking at the bed where her small red overnight bag lays open, she smiles, picks up the last garment, places it carefully inside and zips it shut. She is looking forward to visiting her friend on the other side of the city. Her father has promised her that she can go. He has even given her the money for the bus fare. Sometimes when he drinks it is O.K. He is kind and he will give her things, like the money for the bus. But lately he is changing. "I never knew what he would be like after he had a few drinks. He was like a different person. And Mom, well Mom usually got 'tired' and passed out on the couch. Sometimes she never made it to the couch. She would be on the floor." Barbara picks up her bag and looks around the room to see if she has forgotten anything. Satisfied, she walks to the staircase. She hears familiar sounds coming from the lower floor of the tri-level frame home. Her mother and father must be sitting at the bar. They always start there. It is cocktail time. Today, though, the voices sound louder than usual. A slight tremble suddenly permeates her body and she feels her stomach tighten as fear enters her life again. She'd have to go right by them on her way out the door. If they have had too much to drink, she knows she won't make it. She hesitates, braces herself for the worst, then quietly descends. Her hand is on the doorknob when she feels herself being spun around and the bag being yanked from her hand. "What's in that bag, you little bitch? Where do you think you're goin'? Who gave you permission to go anywhere? You aren't going anywhere! You're staying right her tonight!" She doesn't feel the blow that lands across her face. She has become numb to the beatings. The force sends her body reeling across the foyer crashing into the wall before coming to rest on the hardwood floor.

This event illustrates one behavioral response when a permission is arbitrarily rescinded. This turbulence, then, succeeds in keeping the family continually out of balance. Over time the prospect of similar responses produce tension. Tension builds and subsides with each event producing stress. One begins to feel powerless against the actions of the alcoholic. The family begins to anticipate and prepare for negative actions. Family members become preoccupied with the alco-

holic's mood and continually assess the emotional milieu. How the alcoholic feels will determine how they feel. They become adept at interpreting tone of voice and other body language signals.

Barbara's intense brown eyes briefly scan my body then lock into my questioning eyes. Her penetrating look searches my body language for understanding and acceptance. I reach out to hold hands. Her eyes soften as the tension fades. ''I always knew that I was very much atuned to Dad's moods and how he would come home from work,'' she continued. ''We all were. When Dad came home from work and you heard his whistle, him whistling coming up the walk, everybody sat down and braced. When he walked in, we were all sitting on the sofa and if he laughed and joked it was like—phew! But if he didn't, we just sat there the rest of the evening looking at TV and not looking at him.''

Although family tension subsides during periods when the alcoholic is not present, how family members interact with each other continues to be affected by the alcoholic.

Barbara reflects on the tension existing in her home even when her father was away for short periods. ''In a way,'' she said, ''I think my mom set us up. There was a period of time when my father traveled and when he wasn't there I would have kind of a normal life and have some fun. I could do my ironing, talk to my brothers, watch TV, and even laugh a little bit. But it was kinda like she was setting us up because she'd say, ''Oh, things will be different'' and then he'd come back from out of town and we'd be right back in it again. I think I spent half of my growing up life in my room, alone, being punished for something and I didn't have the foggiest idea what it was that I was supposed to have done. So it was this constant never knowing what was going to happen—the inconsistency that really kept me on edge.''

Tension also occurs if mother is the alcoholic. Nicky's reserved countenance permeates the tiny room where we meet to talk. She slides deftly into a chair sitting erect, hands clasped, forearms resting gently on the table. Her wide amber eyes look expectantly at me and in a soft voice she calmly relates: ''I was

just about finished with my junior year in high school when I began to fall apart. My mother's drinking had really progressed and my father just wouldn't listen to any of us in the family. My brother and my sister and I went to my father and told him that we were very concerned about mom's drinking. We told him that she spent all her time drinking while he was away at work. But he didn't want to believe us. He kept making excuses for her drinking and told us that we just didn't undertand all the stresses in her life. But we knew, we knew that alcohol was the problem. We even went to see our family physician and asked him for some help but he told us we had a fantastic imagination. Many years later I found out he died of alcoholism too, but at the time we just felt so frustrated—nobody would listen to us, nobody would believe us, nobody would help us. I felt like I was sinking in quicksand and I started to become angry. Big time angry. I felt like I didn't have any parents. And my mood was heavily influenced by what was going on at home. I couldn't keep my mind on my work at school and I began to drink myself. My own life-style started to revolve around alcohol. I could see it happening and I just couldn't do anything to stop it. I didn't know what to do to stop it. By the time I was supposed to be a senior in high school, I had flunked out of school."

Nicky's plea for help disregarded by her father and summarily dismissed by the one professional she felt could offer support, led her to become even more preoccupied with conditions at home. Feeling ignored, her opinions rejected, her frustration smouldered and exploded as intense anger. Unaware of her own growing involvement with alcohol, she continued on her path of self-destruction.

When parents who have had problems with alcohol in the past abstain without participating in a twelve-step recovery program, a condition known as "being dry" exists. Being dry means abstinence without change. Behaviors of the alcoholic and spouse remain unchanged perpetuating the same emotional and physical climate that existed during the drinking. Negative thoughts, feelings, and attitudes family members have about themselves continue to be perpetuated and at-

tributes of self-care activities are not communicated. Human needs of family members continue to be ignored and child abuse may be intensified.

Beryl captures the essence of human misery inflicted upon another. Today she is still an exceptionally attractive, five-foot-two inch young woman. Her light brown hair cascades softly around her face barely caressing her shoulders and accenting the trimness of her petite 110 pound frame. Her rich, deep blue-green eyes, like pools in tropical lagoons, are watchful and she regards me somewhat warily. Will I still accept her after she tells me about herself? I can see her pain, feel her anger, and yet, sense her defeat. She is in her early 30s now. I reach out and we hold hands.

Beryl begins by telling me that the picture of the smiling child on the piano was taken when she was five. I see a beautiful child and I marvel at the ability of the photographer to capture one second of happiness in her life. As quickly as clouds cover the sunlight, a shadow suddenly extends itself across her face, her body tenses, and she leans toward me as if preparing to run or shield herself from a forthcoming undefendable assault. Painfully, through clenched teeth, she begins to tell me what it was like for her growing up. "My folks never drank. My dad told me he was an alcoholic when he was young and I heard a lot of horror stories about his drinking when I was growing up. I remember he had a jug of bourbon in the cabinet under the kitchen sink and no one was allowed to touch it. Every once in a while he would open the door, look at the booze, and I'd hear him say "I'm not going to drink you, you bastard," then he'd close the door and walk away. I never saw my mother take a drink, but I learned many years later that she too was an alcoholic. I guess you could say that I probably had my first drink before I was born. Neither one of my parents went to A.A."

"I was frequently beaten and I never knew why. My mother would go into a frenzy and out would come the heavy cast iron skillet. When that happened I knew I was really in for it. One time she hit me on the head and I woke up later on the floor, alone. The side of my head was bloody and I was

scared but I couldn't say anything. I remember another time seeing f-u-c-k written on the sidewalk and I asked my mother what that meant. I was standing outside of her bedroom when I asked her that and she flew into a rage and threw me down the stairs. I got a broken leg out of that one and I didn't find out what the word meant until many years later. Another time she twisted my arm until it broke. But I was taught never to cry during these beatings. When she was beating me, she would say "I'll give you something to really cry for," but the other side of that was don't you dare cry. My bones were broken a number of times and our family doctor would never believe me each time I had to go to have stitches or a cast put on."

"When I was 12, my father raped and beat me and I have incest issues that I'm only just starting to deal with today. It's very painful. Feelings weren't allowed in my house. Laughing and crying weren't O.K. things to do. You didn't hug my mother, touching wasn't O.K., but it was O.K. for my father to rape me. Talking to my mother about sex was forbidden, you never mentioned sex, but she knew every time my father went after me. It was O.K. to get angry and hit someone else or throw something threw a window—the anger part was all right. The only thing I can say about my homelife was that I was kept warm and fed. I remember later when I was grown and ready to leave home, she beat me one last time and I just stood there and took it. Through my young years I've had cracked ribs, a broken jaw, two broken legs, one broken arm, several concussions, and numerous lacerations requiring suturing."

One way to attain respite from the whims and fluctuating mood of the alcoholic is by getting away and staying away. Becoming involved in school activities is one way of staying away. Beryl continues by saying: "I was involved in anything and everything at school to keep from going home. I didn't like to be at home. I was in the marching band, the glee club, the orchestra, the latin club, the spanish club, future teachers of America, future nurses, just anything to keep from going home. I also had a paper route and worked as a candy striper

on weekends in our local hospital. I don't know why, but I was able to do pretty well in school and get some good grades. I really liked some of my teachers, they were nice to me."

"I started having my periods when I was 9-years-old. I was scared to death when that happened. Fortunately I was at school and I had a great teacher who spent some time with me and told me about menstruation. My mother certainly never mentioned it. My teacher helped me clean up and put on a pad and when I did tell my mother about it, she didn't say a word, she just gave me a belt and a box of Kotex. But my periods were never regular, and sometimes it would be months before I had one so the doctor put me on some medication for the pain and told me I would grow out of it. I guess I was about ten or eleven at the time."

"When I finished high school my mother decided I would be a nurse and she sent me to the local hospital for training. That was heaven. I was away from home and even though the nuns kept an eye on all of us, I was free from so much. Though I really didn't realize that then. I still expected that somehow I'd be penalized and beaten for something. I remember the time I had my first drink. We had some time off and I went to my girlfriend's house. She had a party and I got totally wiped out. I had a blackout that night too and my classmates told me later that I ended up swimming nude in the nearby pond. But my mother kept track of me. She would call the hospital periodically to make sure I was doing what I was supposed to be doing and when I graduated she made me come back home to live at first. I didn't want to go back into that environment again, but I felt I had no choice. I went to a doctor and told him that I was very nervous all the time because I had to move back in with my folks and I was afraid the abuse would begin again. He gave me a prescription for a sleeping pill, a tranquilizer for the tightness in my stomach, and continued giving me the pain medication for my periods. I started taking seconal for sleep, valium and librax for the tightness in my stomach, and percodan around the time of my period. I would be in excruciating pain each month even though I might not have a period. I was an emotional and physical disaster going somewhere to happen."

"The abuse did start again and I never cried during any of the beatings that my mother gave me. I couldn't hit back or defend myself either. Finally I got up the courage to move out because I was getting afraid that I was going to hit her back. And that would mean I was a very bad person and I was afraid that if I hit her, I'd kill her. Finally I was free, and I started running. Before I found treatment for my alcoholism, drug addiction, and the twelve-step recovery program, I had several admissions to a psychiatric hospital and ended up in jail."

"When I did get involved in A.A. and N.A., I felt like I had found people who understood me. I felt loved and accepted for who I was. I remember one meeting in particular. I hadn't been in the program too long but I felt free enough to begin sharing some things. It felt good. But after the meeting someone came up to me and gave me a great big hug. I went into a panic attack. I remember crawling into a corner and screaming. I don't remember too much about it except that there were a lot of people standing around trying to comfort me. I don't remember how long it lasted or what happened. It's like I blacked out. I woke up the next day in my own bedroom with my sponsor sitting in a chair by my bed reading."

In homes where incest and beatings occur, children are powerless to protect themselves. When fighting between parents is the norm and physical violence may take place, getting away from home before the verbal abuse begins may offer relief. If one wants to get away, timing is essential.

"I was in my room curled up on the floor of the tiny closet where I usually went to feel safe and I left the door ajar," remembers Barbara. "It looked more natural that way. I heard my brother come into the room and he whispered to me through the crack in the door saying, 'It's time, we can get away before they start fighting again!' I knew he was right because Dad was drinking and he didn't pay much attention to what we did when he was drinking and mom didn't either because she was busy stewing over the fact that he was drunk. I could hear the voices from the kitchen getting louder and I, too, knew that the fighting was about to start. If we wanted to leave, we had only a few minutes left before our chance

evaporated. Our sneakers muffled our footsteps as we quick-
ly moved along the hall to be back of the house. I could feel
the pain in my stomach starting. It was always the same—
they'd start fighting then they'd turn on us and somehow we
would be to blame for the whole mess. When the fighting
started, my stomach would start to churn and it felt like I had
a great big hard rock sitting in the pit of my stomach. It seemed
like an eternity until we got to the back door but its well oiled
hinges responded noiselessly to my touch. In an instant we
were out closing the door quietly behind us and then racing
to the shed to get our bikes. Phew, we just made it! She's start-
ing to really get on him now about the drinking. Tomorrow
he'll try and sober up and then we'll be in for it again and
back on restriction. I can hear him now—'you start with no
privileges and you earn them' and then he'll ask us where
we think we're going and we'll have to remind him it's a school
day and then he'll tell us we're late when we're really on time.
He'll be ready for us when we come home and tell us we're
late and ask where the hell we've been. Sometimes I think
I'm going crazy.''

Inconsistency and irratic behavior on the part of the alco-
holic keep the family out of balance. The spouse slides into
the chaos created by the alcoholic attempting unsuccessfully
to control and manage the drinking. Responsibility to self and
other family members become secondary and finally become
totally neglected. Instead, energy is spent anticipating what
the alcoholic will do next. Keeping secrets becomes the norm
and the family rule survives intact—what is seen does not
exist, there are no problems here. In such an unhealthy fam-
ily atmosphere, anger, fear, loneliness, anxiety, tension, and
stress are constant companions. Tension builds and subsides
with each drinking episode. The anticipation of another drink-
ing bout is stressful. Ultimately this unrelenting stress is ex-
pressed as anger. Family members become defensive with each
other, each feeling as though she is sitting on a powder keg—
one spark will be sufficient to ignite the fermenting chaos. In
this climate, children continue to obey the family rule and do
not talk to each other about the crazy things that are happen-
ing to them. Instead, they may try to hide or get away from

family arguments as best they can. Their human needs denied, feelings suppressed until they are no longer capable of being felt, they begin to perceive that they are responsible for the family situation. As their fear of being criticized, reprimanded, embarassed, and possibly beaten grows, their ultimate fear, that of being abandoned, may be realized.

Tears well up in Sarita's eyes, forming pools in unseen caverns behind small lids, and finally seeping gently out and down pale cheeks. As she starts to talk, I reach out to put my arm around her. With head bowed, her fingers continually twisting and unfolding a frayed handkerchief, she explains what it was like to be young in her family. "My parents were missionaries and I grew up in another country. I got the message that when I grew up I was to be a mother, marry somebody, have lots of children, and that my life would be centered around my children and home. That my whole purpose in life would be to fulfill my family's needs. I didn't receive anything about what it would be like to be a woman and about a women being somebody that was fulfilled. Dad told me stories about what it was like for him before he became a pastor and it sounded like he had a lot of fun. Today I realize that he was an alcoholic. I never saw either of my parents take a drink and alcohol was never kept in the home. There were seven of us in my family and I was next to the youngest. Normally you'd think I would have received a lot of nurturing, but unfortunately it didn't turn out that way. None of us got to be very close to each other and even today we are almost like strangers. I don't think any of us ever felt that we had the chance to really get to know each other and feel connected and I still feel that loss. I don't feel close to either of my parents either. I could talk to them about some things, but there were a lot of things in my family that you didn't mention, like what is it like to be a woman, and what is sex all about? I didn't have anyone to talk to about how I felt when I reached puberty and started having all these changes in my body. It was almost as if I wasn't supposed to have feelings. We lived out in the wilds of nowhere and my mother was our teacher for a while, but when each of us got to be seven-years-old, we were sent to a city where there was a boarding school so that we could

33

receive an education. And once you were in boarding school, mom and dad would visit you for a short time every five or six months. But once you left home, you never returned. When it was time for me to go to high school, I was sent back to the States to live with a relative. When it came to be my turn to leave home, I cried. I felt lost, abandoned, alone, and isolated. The loneliness I felt was so painful. The pain was constantly with me. My stomach had this big hard knot in it all the time. I was very shy and it was hard for me to make friends. I lived in a house on the school grounds that housed 25 to 30 other children and we had a house mother, but she didn't have much time to spend with any of us. I was so scared most of the time that I couldn't relax enough to make friends. And a lot of this stuff comes back today whenever I go through a change, whether it's moving to a new city or getting a different job."

Feeling close or connected to one's family generates feelings of belonging and being loved. We tend to assume that all family members develop intimate or close relationships and feel connected to each other. This is not always true. Next to the youngest in her family, Sarita endured the pain of family separation as each of her five brothers and sisters preceded her to some unknown place. With each departure, stress mounted reinforcing her feeling of isolation. Unable to talk to her parents about her fears, she suffered her pain alone. When her turn came to leave, the pain of rejection, abandonment, and isolation became unbearable. Somehow, she reasoned, she was responsible for being sent into "exile." Later experiencing the physical and hormonal changes of puberty added more fear reinforcing her perceptions of abnormality and worthlessness.

For other women feeling distant and disconnected reflects their perceptions of a lack of appreciation and attention for their contributions within the family structure.

Barbara describes it best by saying: "When I was growing up I was no one's little girl. I have two brothers close to me in age but we are not close to each other. There was no sharing in my family. I had no sense of closeness, it just wasn't there. I'm an adult child of an alcoholic and those issues are very strong in our family—the 'Don't feel,' the 'Don't talk,'

the 'Don't make waves.' I don't even want to say we were a loving family. I'd come home from school and my mother would be sick and my father would be passed out on the floor. Mother would deny her illness and when my daddy came to he would tell us that he hadn't been drinking. It was just a part of my life and I assumed all families were like ours. Today I'm trying to learn what it is like to be close to someone but it's hard. I don't know what to expect and I'm afraid to take the risk.''

Barbara's comment illustrates more than a lack of bonding to her family. She begins to provide insight into the process of invalidating reality. She learns not to see her father when he passes out on the floor and to suppress her feelings about what she does see. She also learns not to distinguish between her mother's verbal response and behavior. What her mother says and what she does are not two different things. She learns the family rules: First, there is no drinking here, and second, do not question your father about it. Passing out on the floor is a normal event. Before she was four-years-old she had learned not to ask her father about his drinking or to discuss any of the bizzare events occurring in her homelife with any other family member. What she saw did not exist.

Beryl staring wistfully ahead, unmindful of traffic darting past an open window, dispassionately relates: ''My mother always said 'eat, you'll feel better.' By the time I was four I could probably eat you out of house and home. It wasn't just one oreo cookie, it was a box of oreo cookies. When I graduated from school, I weighed 290 pounds. And to this day the only way my mother knows how to show me love is by feeding me or handing me money. That's great if you need the money, but I wanted love. I didn't realize that growing up. Growing up it was O.K., give me the money. You know, that was the only love I got. But there came a time when I was in school and not living at home and my mother would call periodically to check up on me. I would hear her voice on the phone and throw up. I lost over a hundred pounds before that year was finished.''

Adaption to alcoholic drinking takes many forms. Among older women, Father was the predominant person who drank.

Although his drinking was initially "hidden" from the children by Mother, a family atmosphere of shame and fear existed. Sitting at the desk in my hotel room, Linda's almost magical radiance emphasizes the intensity of her commitment. I can feel her urgency and recognize her need to communicate with me. Perhaps I, who sought to find commonalities in the cultural path and who would later write, could convey to others the enormous power of the alcoholic to envelope and affect the lives of others. I notice her blouse of earth colors complement her deep brown suit. Together they bring life to her soft facial features, highlighting intense blue eyes and red hair now softening with touches of grey. A woman of obvious maturity she is articulate in discussing concepts associated with codependency. "My father was an alcoholic," she quietly begins, "but when I was growing up I think his drinking was just hidden from me. I remember that he would come home from work staggering and he and my mother would have words. What bothered my mother was that the neighbors would see him staggering home. And there was fear of not having enough money as a result of drinking. I knew that she constantly worried about our family's ability to survive those depressed times. Her energy was consumed by fretting over having enough money to buy the things we needed to live. Although my father always provided what he could, there was never any left over to fall back on. I knew she was constantly worried that the money my father spent for alcohol would leave us short. But my father always managed to get extra jobs to support his habit. We were never hungry or without, but I could always feel the tension within our household. It was normal to be tense and worried all the time. Although they tried to hide their conflict from me, I overheard their arguments. It was always the same. I would be in bed when my father came home from his second job, but I clearly remember the arguments. He and my mother would argue about his drinking and finances and I'd hear him say 'I might as well go out and kill myself.' He would leave the house and go to the garage and stay there and I had visions of him hanging from the rafters. I would wonder if in the morning I would find out that my father had hung himself. And that happened a lot." Again, the family rule

held—do not discuss the drinking. Linda continues, "I could talk to my mother about some things, but we never discussed my father's drinking problem. She was aware that I was aware, but it was a "no-no" to talk about it."

If mother was the alcoholic, her drinking was not "hidden" from the family but it still became the "family secret." "My mother drank," says Nicky. "She drank all her life, but I couldn't talk to anyone about that. She's an alcoholic." When mother is the alcoholic, siblings frequently gather close to protect each other from harm. "I remember my brother protecting me when my mother was drinking," Nicky added. She was not violent, but she was just kind of nasty. Her facial expression would change and her behavior changed and I was frightened by that. My brother was my protector. When no one would listen and help us, eventually we just stopped talking about it. After a while no one was communicating to anyone. We became strangers living in the same household. But I worried. I worried all the time. I didn't have a mother and my father sort of faded to the background of my life. He enabled my mother to continue her drinking until she died. I felt absolutely powerless. Just powerless!"

Although siblings gathered close when mother was drinking, the women, for the most part, were not afraid of being around home. Home was a known entity. They knew what to expect. If they were not beaten or molested, they had some positive thoughts to express about their experience. Carnelian's vibrant energy and genuine sincere warmth in concert with the summer's heat fades and I can see it quietly retreating behind repression and submission as she ponders earlier experiences: "I got the message that my role in life was primarily to take care of other people and that my needs were secondary. I was supposed to help take care of my younger brother and sister and the family pets and then I could take care of me if there was any time left. But there never seemed to be any time for me. I was comfortable being around home and felt secure even though my mother continued to drink. In fact, home was the only place I could be sure of because we moved so much. We moved about every year and a half. So, schools would change, cities would change, friends would change,

but home was always home. It was the familiar things, the familiar furniture and grandmother because she lived with us too. Grandmother gave me love.''

In contrast to Nicky who remained in one community while growing up, Carnelian's family moved frequently. Although her mother continued to drink, Carnelian found stability in her immediate surroundings. Grandmother became the focal point to soothe the pain of change and encourage the wonder of growing up. Grandmother met Carnelian's human need for attention and freely gave her love.

When the child did not have a sibling and was alone, home was still a known entity. Again, unless the woman had been physically abused or molested by her father, she was not afraid of him. Most of the women readily admitted that they did not feel comfortable talking to Father about the things that bothered them. Father, for the most part, was considered to be a kind person who remained in the background of their lives. For most, it was Mother who held the power to bestow approval and love.

When mother drank, "taking care of others" included protecting and taking care of Mother. Sitting pertly behind the desk in her office, I notice that Lynne's four-foot-eleven inches are diminished even more by the massive oak desk. At the time I don't think it strange that she has distanced herself from me by putting such an obstacle between us. It is only much later that I remember the wariness of her constantly darting blue eyes, her insistance upon leaving the door to the office open "in case I'm needed," and the tenseness in her body. She remains constantly alert, no vigilant, the whole time we are together. There are three of us at the interview. Fear is also present. Lynne begins by proudly relating her alcoholic lineage. "My grandmother is an active alcoholic," she says. "My father died from alcoholism when he was in his early 40s and my younger brother is now an active alcoholic and a drug addict. When I was very young, I didn't notice my mother drinking a lot but as the years went by she started to drink much more. I was away at summer camp when my father committed suicide and I wasn't told about it until several weeks after I came home. It was at that point that I decided that since

I was the oldest, I had to take care of her. My mother eventually remarried and my stepfather traveled a lot and I did my best to hide the drinking. My stepfather didn't drink and I wanted him to like us so I tried to make sure that the house was clean when he came home so he would not know what was going on. I helped by hiding the bottles and my mother was not aware that I was doing that. I would find them in the cupboards or the clothes hamper. But I did my best to cover everything up. I wanted to make sure he stayed with us. I wanted him to love me. I had my hands full going to school and trying to do well plus keeping things running at home. You see, if I was perfect in everything I did, then I felt I would get my stepfather's approval and love. He was always kind to me and I appreciated that. But he fell into the trap too and became an A-1 enabler along with everyone else in the family. But my stepfather was no dummy. He knew my mother was drinking and I overheard the arguments, and they were frequent, but my mother continued to drink.''

Deprived of the opportunity to meet her own human needs and mourn her father's death, Lynne immediately assumed the awesome responsibility of taking care of home, mother, and younger brother. Gradually mother became the child and Lynne the mother. Although she was able to keep up with her school work, Lynne's emotional involvement with mother's drinking prevented her from making friends and having experiences with other children of her own age. When her mother remarried, Lynne, hoping for love, tried to cover up the fact that Mother was drinking too much and she attempted to protect her from her new husband's disapproval. Although her stepfather treated her kindly, he, too, became involved in the fermenting chaos and contributed to the tension and ambiguity of the household.

Protecting the drinking person from the reality of unacceptable behavior is called enabling. Enabling allows the alcoholic to continue to drink without experiencing the consequences of drinking. ''I became an A-1 enabler,'' acknowledged Lynne. I knew mother was drinking too much and I had to protect her.'' Although both Lynne and Lucy absorbed the responsibility for family life, a difference can be discerned. In Lucy's

life-way, assumption of household responsibility was an endeavor to receive attention from mother and earn her father's love. In contrast, after Lynne's father committed suicide, she became very protective of her mother. She protected mother by covering up her drinking. When her mother remarried, Lynne exerted even more energy to protect and prevent mother's drinking from being revealed. It was only after making this comparison that I realized Lynne's vigilance still continued and I began to wonder how this would affect her sobriety over time.

As drinking behaviors subtly evolve, family life is quietly rearranged to accommodate the addiction. Ultimately, the child becomes the parent and the parent becomes the child. Jennifer clearly communicates her feelings of frustration and resentment when she realized her parents were depending on her to meet their human needs. "When my father and mother both began to drink heavily, I was just entering my teens," she says. "My brothers and sisters were grown and gone by that time and I found myself starting to do the grocery shopping and housekeeping. I started making sure the house was cleaned up when I got home from school and before I went out. But it wasn't too long before that became my job. And after a while it was like nothin' got done unless I did it. The house was a wreck. The kitchen table was always covered with shit—months of bills, old bills, newly paid bills, and it was always like that. I'd cook dinner but now we ate it in front of the TV set and that was totally opposite of what we had done up until that time. There weren't any family projects any more. It was like the whole family structure that we had had disappeared. And I lost the feeling that I could depend on my family for anything."

The nature of family turbulence may be more subtle in its form but the effect on the young woman is just as severe as its more overt forms. An autocratic, controlling, overprotected homelife void of physical violence is also stressful. Being overprotected means not being allowed to attend school activities or play with other children outside of the immediate family because mother fears for the young woman's safety. If she is

allowed to attend events, older brothers or a parent usually attend the function with the child.

Linda wistfully gazes somewhere beyond the two of us as she speaks: "My mother was very protective of me. We didn't have a car and there wasn't any transportation in my home town so I didn't get to very many basketball games with the rest of the kids in class and things like that. In high school I didn't date or do any of the stuff that the others did because there wasn't any way to get there unless I walked and my mother wouldn't allow me to walk. She was convinced I would be raped on the way home." And Julie adds: "My brothers were always around to take care of me. Especially when we went out to parties. And my brothers did not marry until I finished high school. That was the subtle agreement after my father died." Such excessive protection creates a form of isolation preventing practice in social conversation, the ability to make rational choices and to assume the responsibility for those choices.

For women reaching maturity in the 50s and 60s, being a wife, having children and being a mother superceded professional attainment. Catherine speaks to me about this in a matter of fact way. "In my family, a woman was a mother, a homemaker who stayed home, took care of the house and raised the children. And when I married and had children of my own, I could no more think of leaving them at home when they were little to go out to work. Although I wanted to continue working in my profession, I thought it was wrong to think of myself and my needs. I don't know where I got this notion but I suspect that it had a lot to do with how I was brought up. My mother didn't work and none of my friend's mothers worked. It was Father who provided for our economic needs."

Nonetheless, families anticipated and expected to educate daughters. However, if money was tight, investment was made in favor of boys in the family. Cecelia's pale blue eyes glisten with moisture as she remembers her earlier beginnings. "I was in my first year of college when my mother told me I wasn't going back the next year. She said my grades weren't high enough. I had a brother who was a year ahead of me.

Now, I think they probably couldn't afford to have us both there, but she didn't tell me that. It probably would have been easier had she done so. I was so angry with my parents. They made me feel like I was stupid. I went to work and eventually saved enough money to pay for my own education. But that sense of not being smart enough has followed me all of my life. I really have to give myself a 'can do' pep talk before I have the courage to attempt something new.''

On the other hand, cultural expectations for women from a previous generation did not include education as a prerequisite for adult responsibilities. Linda smiles as she reflects on an earlier time. ''Ever since I can remember, I had always wanted to be a nurse,'' she said. ''I knew that the financial situation in our home was such that there was nothing left over to put aside for my future education and I also knew that my father was against my going into nursing. I think he felt it would be too strenuous for me. But that also fit with the times. When I was coming along, women were discouraged from getting an education. My sister was working in a shoe factory and when she realized I wanted to become a nurse, she helped me. When I got to be a senior, I could sense that my folks were proud of me but I never got any encouragement from them. I don't think they really knew how to communicate their feelings, but they came to my graduation and my father was sober that day. That meant a lot to me. I think the fact that they didn't show anger when I went into nursing gave me the sense that it was O.K. to do that. I didn't get any encouragement along the way, but they didn't prevent me from going. But underneath it all, I thought that was the way all parents communicated their feelings about their children's choices and accomplishments.''

In contrast, women reaching maturity in the 70s and 80s received the message that getting an education and having an income to support one's self were primary. Marriage, if it occurred at all, would happen after college. As with older women, daughters were expected to be intelligent, get straight A's in school and to go on for further education. Now families provided money for the woman's education. Kelli remarks: ''I never got the impression that as a female I could only fulfill

certain roles in life. One of the most important things to my parents was that I not feel restricted because I was a girl. My mom has two sisters who at a very early age got married and had kids, real minimal educational level, and no skills to survive on their own. And so, its been real important, especially to my mom, that people have survival skills to be able to support themselves. And when we started talking about what was I gonna do with my life, there was a lot of emphasis on not feeling like I needed to go into a traditional female role. It was that I should feel free to go to college, to get an education, to have a career. And, not a career in a necessarily female type thing.''

Possessing emotional strength is a family expectation for women. Being strong means being assertive, decisive, outgoing, independent, responsible, doing things for one's self, and not asking for any help. Zelda pushes stubborn strands of her thick auburn hair bent on mischief away from her face and gazes intently at me while she speaks: "I was taught strength,'' she said. "Above all else don't be weak. Crying is bad. As a child when my dad died I learned to be strong for my mother. And to be strong meant no crying. Be strong, keep my problems to myself, be independent, responsible, and above all, dependable.''

Although emphasis was placed on possessing emotional strength, the other side of the message emphasized being dependent upon a husband. Picking a man of ''good status'' who had the potential for earning a good income was a way to please parents. "I met this guy whom I didn't like. He was a kid with all sorts of problems. But I think I was quite impressed with him and I figured daddy would really like him. He was quite well traveled, his family was rich, and he was studying to be a doctor.'' This type of perspective was held by several of the women.

Throughout the woman's life, tension—the underlying variable in her cultural path—builds and subsides creating stress. Stress becomes the dominant theme in her life-way leading her to alcoholism. On one hand family rules enforced by a controlling authoritarian mother, using love as a technique to maintain control, dominated homelife enhancing

frustration and tension to become stress. Cultural expectations required the subordinating of one's own needs without recriprocity. Thus the women learned to meet human needs of others by suppressing and denying existence of her own personal needs for closeness; specifically, the human needs for appreciation, attention, approval, acceptance, love, and belonging. This protected, rigidly controlled environment prevented development of trust, intimacy, and communication. Over time the women began to perceive that love was denied to them.

On the other hand, in families where one or both parents were alcoholic, inconsistency, ambiguous role expectations, and fluctuating family standards created an atmosphere of unrelenting chaos creating stress. These women learned to deny the alcoholic drinking—what they saw did not exist. They were required to suppress their own personal human needs and give undivided attention to the ever-increasing demands of the alcoholic in the family. Ultimately, they too, perceived that love was denied to them.

3

Getting Alcohol Messages

Messages about alcohol are communicated in a variety of ways. Albert Bandura, a highly regarded investigator, has long advocated that most human behavior is learned through observing others. We store our observations in the brain and later this information serves as a guide for action. Extensive research has expanded our knowledge about the communication process. We now know that it is not only what we do, our actions, but also the words we use and how we use them. Words are a potent means of transmitting messages. But words alone only carry part of it. It has been found that a very high percentage of verbal communication is received through body language and voice quality. Fifty-five percent of the messages we receive and interpret is through facial expression and physical posture; 38 percent is from vocal intonation and inflection and only seven percent is perceived from the words we speak. In other words, in most cases, what we do, the words we choose, how we say

them along with our body language are vitally important and may have a profound impact on the person decoding our transmission. It is through a combination of our smiles or frowns, raised eyebrows, tense or relaxed facial muscles, intonation and inflection of our voice along with the words we choose that we get a point across even though it may not be the one we intended.

How alcohol is used or not used in the context of family life, the individual's perception about her worth and value as a person in the family unit, and cultural sanctions making it more permissible for women to drink, are conditions influencing each woman's attitude toward the use of alcohol in her own life. One condition stimulating her perceptions has to do with human need fulfillment. The human need to feel connected, to belong, to receive approval, and to be accepted by others motivates her to seek ways to fulfill these needs. How she receives and decodes family messages about drinking ultimately depends on the degree to which her human needs for closeness are met. Appreciation, attention, approval, and acceptance are vital closeness needs. When they are reasonably satisfied, messages about alcohol may go unnoticed. Although I met with each woman individually in the place she selected, messages given and actually received about the use and purpose of alcohol may be best illustrated through group interaction.

"I can't remember any messages one way or another about alcohol when I was growing up," comments Mary Helen. We didn't have it in the house and at that time it wasn't even considered as something to be offered to company. I was about 12 or 13 when Dad started going up the corporate ladder and we began to move, but even then alcohol was not a part of the social scene. It wasn't until the second world war when I began to notice that drinks were being served at social gatherings. Even then it didn't occur to me or to anyone else in my family to have an alcoholic drink when we went out or had people in. But that changed."

Mary Helen's kind brown eyes suddenly sparkle and a wide smile conveys the wisdom of experience. "My first episode with alcohol was not by my choice! I went to a dinner dance

with my husband and ordered a coke to drink. "I was too busy dancing and having a fine time to realize that my husband's friends were adding a healthy amount of bourbon to my coke while we were dancing and making sure my glass never got empty. I ended up getting drunk and having a blackout. I became so ill that I ended up in the hospital. Ten years passed before I picked up a drink again and initially it was to be a part of things. When my husband came home from the war, he had started smoking and he liked to have a drink once in a while and I wanted to share in that too. I wanted to be a part of things. I remember getting sick trying to learn how to smoke, but I was determined to conquer it, and of course once I learned how, I was hooked. I remember buying wine to serve when we had friends in for dinner and right from the beginning I decided that, for me, one glass was not enough. But it was not until my mother-in-law came to live with us that I began to feel the stress of trying to manage my home and raise three young boys. What I didn't realize at the time was that I looked at my mother-in-law as competition and I didn't know how to handle that. It was at that point that I discovered alcohol to be an excellent anodyne for the constant irritations in my homelife. It just helped me smooth out. I didn't have to worry about my mother-in-law reprimanding the boys about their table manners or the boys getting into it with each other, things just went smoother for me. And that was the beginning. That was when I started to have a couple glasses of wine every day while I was getting supper."

Although Mary Helen does not remember receiving any special messages about drinking, she did in fact receive the cultural message that drinking alcohol in a social context was an acceptable thing to do. Attending a dance with her husband where drinking is now fashionable and permissible for women to do, she is unaware of the propensity for those who drink alcoholically to subtly sabotage the health of neophytes. In spite of the dramatic sequellae, she remains unaware of alcohol's devastating potential. As the use of alcohol becomes more widespread and socially acceptable, she begins offering wine when she has company. "It is fashionable;" "it is social;" "it is relaxing;" "it enhances the evening;" "it makes the even-

47

ing pleasant'' is the way she describes her developing attitude toward drinking. From the beginning, though, one glass of wine is never enough. Gradually, alcohol is incorporated into her social life. As perceptions of disharmony in Mary Helen's homelife grow, alcohol assumes a more important role and its purpose changes. It is now a ''medicine'' to calm disturbing fears of encroachment upon her homelife. Alcohol, she decides, is an effective agent to ease the stress in her life.

Messages that alcohol is used for medicinal purposes were common. ''My dad made wine during prohibition,'' Catherine muses. ''Although we had it for friends and Mother used it as brandy for peaches and fruitcakes and stuff like that, I learned that alcohol was used when one got sick. Brandy was used as the cold remedy in our family and I hated it. It was a shot of brandy and a tablespoon of honey in lemonade. Then I had to take a hot bath and go to bed with vicks and flannel. Yuk!''

''I really didn't start drinking until I was in college and it was a social type of thing. Occasionally a group of us would go out for pizza and beer, but drinking was not important to any of us at that time. Studying, getting good grades, and being able to get a job to support one's self when one's education was finished was the goal. We were just coming out of the depression and even though the war had started and drinking was more socially acceptable when I went out on a date, having money and not being dirt poor were more important to me. In looking back, though, I can see that when I did drink I drank differently from my friends. I always wanted more than one drink. One was never enough. When we went out for pizza and beer I managed to consume most of it. There would never be any left if I was around. I looked forward to my glass being full. I remember the time that a group of us deliberately set out to get drunk so that we could see what it was like. It seemed to take me longer than the others to get there. I had a high tolerance right from the beginning. But when I did get too much, oh, I was so sick! I didn't drink for quite a while after that, but I went back to it and when I did I began to pick the people to be around who liked to drink like I did.''

The depression of the 30s left an indelible mark on many who felt its effects. "Not being dirt poor" was a common statement among women reaching maturity in the mid-40s and 50s. Although Catherine experimented with alcohol in college, getting an education to enable her to get a good job became her first priority. It was when she began to work that she began to socialize with her peers. Drinking was now an accepted part of the social scene. It is only in reflection that she is able to realize it was how she drank that made her different from her friends. Gradually she gravitated toward a social scene where drinking was the focus of the social activity. Heavy drinking was an accepted and expected way of socialization.

Cecelia's entire six-foot frame radiates fitness, adding power and vitality to her countenance. I have the impression that a person of shorter stature with a different point of view would be reticent in her presence. Leaning forward she jostles me on the shoulder. The ensuing vibration flashes through my body attacking every strand of wood in the seat of my chair. With a wide grin and a hearty chuckle she leans back stomping her feet on the floor as she does so. "I remember being allowed to have egg nog at home during the Christmas season," she said. "It had a little alcohol in it but apparently not very much. When I was in my mid teens I was allowed to go to a Christmas ball and my date and I had egg nog. I thought it would be like the egg nog we had at home and I was too busy dancing and having a good time to realize that it had a lot more alcohol in it. I ended up getting drunk and the next day I was so embarrassed. I did get the message, loud and clear when I was growing up, that getting drunk was not a lady-like thing to do. You'd think I'd learn with that experience. But I didn't. I went to a New Year's party that next week and ended up getting smashed again! I didn't plan it. It just happened. And once again, I was so humiliated the next day because apparently I said a lot of things and did a lot of things that to this day I don't remember. That was my first blackout. I didn't drink for many years after that but when I married I found my husband had a lot of social events to attend. He was a business man on the way up and so there

were a lot of cocktail parties. I've always been a shy person. I do just fine in a small group but throw me in the midst of a large group of people who chit chat about things that don't mean a hill of beans and I go crazy. I get anxious. I get tense. My throat feels parched and I can't think of a thing to say to anyone. But I found that if I took that drink, it helped to smooth things out. I could talk to people and survive the evening. So that was the beginning.''

Many of the women from a previous generation innocently drank without caution and experienced drunkenness during their first drinking occasion. They were dancing, they were socializing with others, they were thirsty, and they drank in the same manner as they would nonalcoholic drinks. Their initial episode could be labeled ''the age of innocence.'' It was their unknowing that made them vulnerable. Unaware of their family history of alcoholism, lacking knowledge about the toxic properties of alcohol and continued exposure to a social group where heavy drinking was expected, are factors that increased their vulnerability. Feeling embarrassed, ashamed, and guilty are the feelings when initial consequences specifically relating to alcohol misuse are known and felt. Each vowed to exercise more ''self control'' the next time they drank, and for a while their self policing worked.

Using wine to complement or enhance the taste of food and hard liquor as a medicine to cure common ailments were ways many families used alcohol. Brandied fruit desserts brought a nice closure to one's meal; serving wine with meals added to the social mileau. Brandy or hard liquor became the cure for colds, flu, and other upper respiratory ailments. All the women, however, had at least one thing in common—they wanted more than one glass of wine or one beer or one mixed drink. One was never enough. ''Somehow I knew that when others had one it was O.K. for me to have two'' or ''I learned that some people giggle with one but it always took two or three for me to giggle'' were common remarks. Wanting more than one glass, picking friends who liked to drink, taking longer than others to get drunk, getting violently ill with the first drinking episode, drinking more than friends and having blackouts were initial experiences many of the women had.

Most agreed that when they drank they reacted differently to alcohol. It relaxed them or it made them feel energetic. They liked the feeling alcohol provided. "Everything on the inside worked right when I drank" was a common statement. Although all agreed that one drink was never enough, there was another underlying purpose. Alcohol was immediately viewed as a way to relieve the concerns and feelings the women had about themselves as persons. It became their "wonder drug." It promised them popularity, security, confidence, and social acceptance. It met their human need to feel close and connected—to belong and to be accepted by a social group at face value.

Geri's soft voice complements her aura of calmness as she begins to relate her experiences. "My mother didn't drink. She had a sister who couldn't control her drinking and she often remarked that she would never drink but I never really understood why she said that. I thought it was because my father drank. My father started drinking later in life and I think he was a periodic alcoholic. Even before I was old enough to drive I would be the one to go and get my father out of the bar in town. Pausing for a moment, a quiet smile creeps softly across her face. I can remember thinking that I was not going to drink like my dad. I would never get sloppy drunk like he did. I just couldn't understand why he couldn't stop once he started to drink. He could keep away from it for long periods, but once he started to drink, it just continued for quite a while."

Geri now speaks with tenderness denoting a special memory. "My grandmother made wine from berries and we had it with our meal when we visited her. She also made the best fruit deserts and I remember how good her brandied peaches tasted. So, I had alcohol from the beginning—not every day, but usually we would visit grandmother on Sunday after church and have our big meal together. I used to look forward to that. It was not so much the wine at that time as it was the fact that Sunday was a special day when all of us were together and I felt close to my family. I guess I started when I was a freshman in high school. I seemed to gravitate toward the kids who drank and I guess you could say I hung

out with the rough crowd. We always drank on weekends and we knew the places where we could get it. I don't remember how long it was between the time I started to drink and when I had my first blackout, but I do remember how it happened. I think I must have been a senior because my boyfriend told me that he had taken a job in another state and I became incensed to think that he didn't even discuss it with me. I felt rejected and I drank over that. I got good and drunk and that's when I had a blackout. I didn't remember a thing that happened but my girlfriend told me later how angry I had become and what a scene I had created at the party.''

Getting together, feeling close to others, and feeling a part of the family fulfills our human need to be close and to belong. Family time was special for Geri and she told us that she looked forward to Sunday dinner at grandmother's where she enjoyed being with her family. Alcohol was a part of the festivities but not the most important part. The focus was on the gathering and the meal. Alcohol as a home remedy to relieve upper respiratory problems, although of questionable value, was yet another use in family life as Geri illustrated. However, if alcohol is used as an anodyne to relieve emotional pain, its purpose takes an entirely different focus. It now becomes the drug one chooses to make one feel better, and as such, the risk of dependence upon it grows. Although Geri had experienced both the social and "medicinal" effects of alcohol, she knew from watching her father drink that alcohol could be used to obliterate brutally strong feelings. When her boyfriend announced that he was moving to another state to take a job, feelings of rejection and being abandoned arose. Hurt, angry, and frustrated, she reacted in the only way she knew to cope with her tremendous pain—she drank to the point of blacking out.

In some families, rituals evolve around the use of alcohol. "I was just trying to remember when I had my first taste of alcohol," mused Linda. I was probably six or seven and it was a little shot glass of my father's home brew. In the winter time he would bring up a bottle of beer from the basement, then he would heat the poker in the coals until it was red hot and plunge it into the beer to warm it. This was usually around

Christmas time and the occasion seemed very special to me because you could smell the burning and the steam. I didn't especially care for the taste of it but I felt like I was an adult when I was allowed to have a taste like everybody else. But I can remember the sensation of it going down and how warm and comfortable it made me feel. That's what I liked about it. I felt warm and comfortable. My mother made wine but I never saw her drink very much of it. She used it more for medicinal purposes, when she didn't feel good."

"I remember the first time that I drank what I consider to be a drink," she continues. "I was in college and out on a date. I really didn't know anything about ordering drinks and my date thought that I might like apricot brandy and soda. And I remember having six of those and enjoying every one. I enjoyed the feeling that I got from it. It was warm. Warm is probably the best word to use to describe it. It made me feel warm and comfortable. I felt like I was wrapped in a warm, loving cocoon. I felt safe. The tension was gone. I felt just the way I did when my family allowed me to have beer on special occasions. But my date got sloppy drunk. I mean he was slurring his words and weaving when he tried to walk. I can remember saying to myself 'gracious, he doesn't even know how to drink!' It wasn't until some time after that that I remember I had been drinking drink for drink with him but it never entered my mind that I was any different from him. I just thought he couldn't handle his drinks."

Although not all women reported having an initial high tolerance for alcohol, many noted that they were able to drink much more than others. "Having a high tolerance from the beginning," "drinking more than others," "knowing I could handle a lot," "drinking differently," and "wanting more" were frequent statements made by the women. With each drinking occasion, the drive to continue to drink long after others had stopped increased. "I couldn't seem to get enough" was repeatedly expressed.

Among families of younger women, negative attitudes about alcohol coexisted with permission to drink. "My father made home brew periodically, too," Lucille added. "When I was growing up he used to let me taste it when he made

some and occasionally I'd have sips of his homemade wine. My mother doesn't drink but she takes tranquilizers. There is alcoholism on her side of the family. My grandfather and several uncles are alcoholic although it's not referred to as an illness. My uncles who are alcoholic are considered by the rest of the family to be "hopeless cases" and of course the feeling is that they could do something about it if they wanted to. My grandfather's alcoholism was never discussed. The message I got was that drinking was O.K., but getting drunk was definitely not O.K. I was taken to church and my church didn't prohibit drinking but, again, getting drunk was certainly not O.K. If one drank, one was supposed to control how much one drank and not get drunk. That message came through loud and clear."

Leaning forward, Julie pours each of us a glass of ice tea. As she settles back, glass in hand, a broad grin creeps across her face from a hidden recess and complements her mischievous amber eyes. "Not exactly like bourbon, but much better for us," she said. "Pass the lemon," said I. Settling back, Julie looks briefly at me and then lets her gaze rest upon Jennifer. When she speaks, her compassionate voice reflects the special understanding from having walked the path. "I had an aunt and uncle who were very special people and they came to our house occasionally. They enjoyed playing cards and sometimes they would play at our house. I remember they smoked and they always had a cocktail in a big glass. They always laughed, joked, and looked happy. It looked very sophisticated to me and I wanted to be like that when I grew up." Jennifer's deep blue eyes widen, "You too?" "I was around five years old and I remember a lot of parties at our house. My father had a job overseas and at that time there were always lots of parties going on. I thought it was very exciting and sophisticated. I also thought that's what one did to have a good time and to relax, and in my mind I just couldn't wait to be old enough to do that too. To have that much fun would be just wonderful! I was the kind of kid who would always stick around the adults so I could watch them. I didn't want to go play somewhere else, I always wanted to sit around and watch the adults—they just fascinated me! I wanted to

be associated with them and I aspired to be like them. And I began to learn that to have a good time was to have a little too much. I guess my first real experience with alcohol was when my dad had a promotion party. I was probably about 12 and my folks let me have a Tom Collins. Well it tasted so good I had four and just got wasted! I was a wreck. I remember walking around in a fog and ended up sitting on the stairs watching this big party going on and then the next morning I woke up in my own bed. That's all I remember, but I thought it was great that I could party like everybody else!" Hearty laughter at their innocence fills the room. In the quiet that follows, each of us become pensive—each alone with her private thoughts. Julie breaks the silence first.

"My mother told me years later, after I got sober, that when I was little I was always finishing the wine glasses at holiday time or if we had company and wine was served." Doreene chuckles and then becomes extremely serious. "My dad told me that when I was in diapers and just toddling around that I went after the beer they were drinking. I was into cleaning out what was left in the bottles! At first my folks thought that was funny and cute but then they began to think that perhaps it wasn't a good idea for me to be doing that. They started dumping their cigarette ashes and butts in the bottles and made sure they went into the trash, but I still went after it anyway. They would find me rummaging through the trash for those bottles! When I think about it now it seems as though I was strange with alcohol right from the beginning." Nodding, Julie conveys her understanding when she says, "I remember that at some point I began to think that wine was very special. I knew there was something about it and I remembered that I always wanted more than one glass of wine. It was warm, it made me feel very warm. I think that's the best way for me to describe how it made me feel."

Having the notion that alcohol is special and feeling warm were comments made by several of the women. "I felt that way too," says Audrey. "I was brought up with alcohol. Wine was considered part of the meal and it was special to me. I remember that before I was ten I had a tiny mug and my folks gave me beer. I don't remember how often I had it, but I do

remember that mug. But when I was around ten, I remember coming home from school every day at lunch time and I'd have my little glass of wine. And I looked forward to that. I liked the taste of it. It was warm and I enjoyed it. Yes, I think warm is the best word to describe it. And it also made me feel very grown up and sophisticated. But the other side of that is that my folks wanted to teach me how to drink in a responsible way. The message was that I was still responsible for myself if I drank and of course as a woman getting drunk was not an acceptable thing to do.''

I can see tears beginning to silently roll down Audrey's pale cheeks but she continues to hold eye contact with me. "I didn't connect that my parents were alcoholic until after I had been in therapy for several years and even now it's hard for me to accept that reality,'' she quietly says. After a brief pause, she begins to share her observations with me. "When I was about nine or ten, I began to realize their moods changed when they drank. I didn't notice it when we had wine with meals, but if we had company, and we frequently did, they would drink and become argumentative. I dreaded any holiday because that's when they drank more. By the time I was 12 I had an ulcer and I took all kinds of odd jobs to be away from home when they were drinking. My father's dead now but my mother still drinks. It took me a long time to realize that I've probably never seen my parents sober. I never really knew who they were and that's what hurts.'' I reach out and we hold hands. I can feel my own throat tighten and a heaviness in my chest from my own unresolved grief. I am surprised to find tears suddenly cascading down my own cheeks. Audrey has hit home.

"I think the main message I received about alcohol was that it was something one drank after a hard day's work,'' said Doreene. "It was not a reward type of thing, it was more the getting together to celebrate what we had accomplished. And farmers are hard workers! When I got old enough to work with my dad in the fields, he let me have beer. And we drank together. It was our special time. I can still remember having cold beer on a hot summer's day after the hay was in. I worked with the men folks. As I said before, I was my dad's boy and

I loved being with him. I drank and smoked like he did. I really don't remember too much about my mother in those early years. I mean she was there. I have pictures of all of us. But it was my dad who was important to me. So I don't remember getting any of those girls shouldn't be drunk messages until I went to work. And then I couldn't understand what everyone was talking about. I got drunk whenever and wherever I pleased! Course that didn't make me too popular with other women but I wasn't worried about that. I know I told you before that in school I figured out that it was easier to play the 'little darling' and get attention, but when it came time to drink and get drunk, it didn't make any difference where I was. Today I know that's called addiction. At the time, though, I thought I was just being independent and doing my own thing!''

"The first time I remember being drunk I was eight years old," Doreene continues. "It was New Year's Eve and my family got together. It was a small gathering—my brother, my grandparents, ma and dad. My folks let my brother and me have a little champagne with a lot of 7-Up in it. What they didn't know was that I replaced the 7-Up with the champagne and had a fine time. I remember getting really silly. I was on the landing going upstairs pretending that I was Snoopy on his doghouse and they thought that was funny. And it wasn't too long after that that I remember drinking before I went to school. We lived out in farm country and it was kinda an accepted thing for kids to steal their parents beer and have one on the way to school. And I did that. And as I got older I drank at home. I could drink at home and I drank with my dad after the day's work was done."

"I remember one time coming home very late so I went down to the basement. I knew I was in trouble—the room was just spinning and I ended up setting the couch on fire with one of my cigarettes. That didn't go over to well with my mother! To me that was heavy drinking then. I was out of control and off and running with my addiction, but I didn't know it and neither did my folks. They didn't like me to drink and drive and my dad told me that if I was going to get drunk that I needed to stay home. Well, of course I didn't. And things

57

got a lot worse before it was all over. When the time came and I had to tell my dad that I was in treatment, he couldn't believe it. He thought that my craziness was just a part of my adolescence because he did some of the stuff that I was doing when he was growing up. He just thought that when I got older and had more responsibility that I'd grow out of it. And you see, I got straight A's in school. I was the teen of the week, I had the lead in all the plays, I was in the National Honor Society, I was president of the Latin Club, I was working full time during the summer and weekends and I worked some afternoons, I had been an exchange student, so by every measure of success I was doing O.K.'' Leaning back, nestling herself in the cushions of the large couch, Doreene's dancing blue eyes turn mischievous. "And I lied to them, that's the other part of it, I lied to them. I told them I was going to a football game or whatever but instead I was going out with a drinking crowd. I had my first blackout when I was 16.''

Drinking alcohol and smoking are modeled by many parents as sophisticated things to do. Julie and Jennifer wanted to emulate the behaviors of their family. Drinking was viewed as a way to have a good time. Drinking meant having fun. On special occasions, such as a promotion party, having a little too much was sanctioned for Dad and viewed as a reward for achievement. Including children in drinking activities sanctions the use of alcohol. As a child, Audrey was included by her family in their social activities and allowed to have a small mug of beer. Drinking responsibly was the message that was sent. Instead, she received: Wine was special; drinking was a normal thing that everyone did; adults got into arguments when they drank. It's best to be out of the way when that happens. Doreene received a slightly different transmission: Drink like a man. Drinking with the men folks is the reward after a hard day's work in the fields. It celebrates accomplishment. It is O.K. to have a little too much. Raised by the man's standards, she didn't encounter, or perhaps hear, the cultural message that a woman should not be drunk.

Mary pauses and turns to look out of the window again. When she turns back to me I can see a faint glimmer of light in her palid blue eyes. "When I first started to drink it was

to impress others. I felt that I had to be able to do something to impress you. And that goes back a long way for me. Growing up I felt that I was never loved. My parents are Irish Catholic and I always felt that they had my brother and me because it was expected that they have children. They were so strict with both of us that there were times when I felt like I was suffocating. Some people don't remember what it was like to have their first drink, but I do. I remember exactly when and what it was like. I was around eight years old. We were visiting my grandparents and I was sitting in my granddaddy's rocking chair, just slowly rocking back and forth. My granddaddy kept a bottle of port wine for special occasions and I don't remember why he brought it out at this time, but he did. It was their custom to have wine at special times. He poured wine for my parents and he gave me a small glass of it. I loved it. It went straight to my head and I *loved* what it did to me. And right there and then I swore that I would get that feeling back again someday. Oh, I can still remember it! It made me high. It made me float. It gave me a feeling of well-being. I was worth something. It gave me a feeling of being somebody. And I wanted that. Oh yes, I wanted that. I wanted to be somebody. And in later years when I drank, I felt like I was somebody. I had worth.''

In contrast, Barbara, felt guilty when she drank. ''I don't think I ever felt acceptance or self confident when I drank with others. I think I felt guilty. And that goes back a long way for me. Guilty is how I've felt all my life. I felt guilty for being born. I always felt I needed to apologize for being around. No matter how hard I tried I just couldn't get it right. And I acted out a lot. I remember my dad used to say 'Barbara, if you were only like your brothers.' But I didn't know how to be like them. I was too busy trying to figure out how to be what he wanted me to be. And I never did find out, at least not when I was growing up. So I don't particularly remember any messages about alcohol one way or the other. If there were any, I didn't hear them. You see, even though my parents drank, I did not connect the fact that I was a child of alcoholics until I had been sober and in therapy myself for over 15 months. And it was a shock to make that connection. Growing up my life was fill-

ed with fear. I never knew when I was going to be beaten or sent to my room for something that I was supposed to have done. I was about seven years old when I discovered those big felt tipped ink pens the teacher had and I would take a whiff off of those as often as I could. It gave me a light headed feeling and I could just sort of drift off for a little bit. I guess you could say it gave me a real cheap high. But there was something about the smell of it for me. It had to be a petroleum based product. It wasn't just anything that would do it. it had to be a gasoline type smell, diesel fumes, or cleaning fluid. Even "white-out" was O.K. There is just something about the smell that draws me to it. It's the same way that some people like the smell of a new book. Somehow I knew I had to keep my little pleasure a secret. Nobody told me this, but I knew down deep that it was something that I couldn't let other people see me do. And I sniffed every chance I got."

The human need for safety and protection is undisputed. Being beaten, being sent to her room, feeling guilty, being afraid, feeling rejected, and being isolated are feelings and experiences Barbara had early in life. Earlier she shared with us how she felt when she could not talk to her parents about matters that were important to her. Frequently sent to her room as punishment, feelings of isolation deepened until the pain and stress became unbearable. Already programmed not to discuss the brutal things that were happening to her at home and to believe that what she saw and experienced did not exist, messages about alcohol, if any, were unheard. Her human need to be protected from excessive fear, anxiety, and chaos, her only goal became survival. Sooner or later stress requires relief. Sniffing glue provided brief episodes of relief until she was introduced to alcohol.

With a mischievous sparkle in her deep brown eyes complementing a subtle grin, Barbara continues. "I think I must be addicted to excitement, she said. I remember how thrilling it was to attend my first football game. I just cheered and cheered. That was the day I got to attend my first party after the game and I was having a fine time, or so I thought. My boyfriend told me the next day that after two beers I just sort of went wild. It took him plus two others to get me out of there

once I started to dance on the table tops. Needless to say I was more than a little indignant about having to leave the party so early! But it was the first time I felt I could really let go and have fun. Although I didn't care much for the taste of the beer, I knew I had found *the* answer. I wasn't old enough to drink but it didn't take me long to read labels and find my father's Nyquil!''

A brief silence permeates the spacious, airy town home. Jennifer reaches over and helps herself to another glass of iced tea. Breaking the silence she continues: ''The next time I remember getting gut wretchingly drunk was when I was 13. I was with some friends and we were on the way to the teen center to a dance. We each had a bottle of Boone's Farm Wine and it was like we had to hurry up and drink it before we got to the teen center. So, we all finished our bottle in about a half hour and I just got totally blitzed and sick. I've never been so sick in all my life. I was sick the whole night with dry heaves and spent my time hanging out the car window. It was really awful. After that I didn't have a whole lot of exposure to alcohol until I was about 15 or 16 but at that point I was just really eager and willing, obviously. I wanted to experience everything and to experiment with everything. My aunt and uncle were part of the 60s smoke pot, go to Woodstock generation, and I thought that was really great. I wanted to be like that too. So when I was 13 I started smoking hash. I don't think I got off on it, but I thought it was really neat to smoke hash. My father's company transferred him to another area and so we moved. Then I got into smoking pot and taking speed. It wasn't on a regular basis but it was often as I could do it. I was still interested in being on the swim team and playing hockey so I had to juggle the times when I could smoke, but I knew I wanted to get loaded and be wild. That was the year I tried LSD and I really enjoyed the feeling it gave me. It changed my perception of everything and for me it was positive. I felt like I could take on anything, I could solve any problem. All these thoughts were just flying through my mind. It was, ''I'm going to figure out how I can get myself to the west coast in three days hitch-hiking'' or if I looked at a painting it was, ''Well, it is obvious that the artist intended to make

a statement about such and such." And all this was coming from the mind of a 13 year old! But I felt great. I wasn't depressed. I didn't have any feelings of low self worth. I didn't have any "I can'ts." I didn't have any fears about anything. I just felt great. You see I liked feeling up. I never liked downers so I never did any of the tranquilizers. Taking a downer was my idea of ruining my evening. I didn't want to be all bumbed out."

Carnelian chuckles as she brings a tray of sandwiches from the kitchen and proceeds to offer some to each of us. "I liked the downers. They took away all the pain. I felt a tremendous sense of relaxation. It took over my entire being—physical, mental and emotional. I felt relaxed but not tired and I could do a lot without having things bug me. House cleaning used to drive me crazy but if I were loaded I could do the whole house, no big deal, get it done, and that was it. There was no anxiety, no stress. I think in the beginning when I started experimenting with alcohol, and later, too, when I started using other drugs, they just helped me to cope with my pain of every day living. I tried grass and the first couple of times it didn't do anything for me, but that third time I really caught a buzz. It was *wonderful*. I really liked it because there wasn't that full feeling I'd get from drinking beer or the mugginess that I got from drinking other drinks. I found that it put me into a trance-like state. It's a sinking back feeling, being almost asleep but still awake. It was a very hypnotic feeling and I just *loved* that feeling. I dropped acid a couple of time, but I never really cared for that. It made me be more active. I was at the beach when I took it and I just started running up and down the beach screaming and everything was just so distorted. I didn't like that. I was afraid too. I had no idea what was going to happen next. At least with the booze and the freeze-dry I had some idea, at least in the beginning, of where I was gonna be and what was gonna happen. With the acid I didn't have any idea and it was frightening to me. And I found I liked quaaludes. Now, those were ideal. I got all the benefits of a drunk without wasting time drinking!" Genuine laughter echoes throughout the room!

A moment later I notice Carnelian's shoulders drooping, her head bows to hide tears gently spilling down pale cheeks. "My father had a job that involved moving every few years and we lived all over the world. Wine was served with meals ever since I can remember and when I was old enough, I guess about ten, I had a tiny glass that was mine. Wine was considered to be a food, part of the meal. Drugs were different. Nice people didn't do drugs. It was the junkies on the street, the ones who mug little old ladies who did drugs. We never had any drugs in the house. My parents didn't use sleeping pills, tranquilizers, or anything like that. I think the hardest thing for me to do when I was in treatment was to tell my folks that I was a drug addict. It's still painful for me to remember that. Somehow it's still more acceptable to me to be an alcoholic—that I could more easily accept." I reach out and put my arm around her.

Audrey and Carnelian were brought up with the notion that wine was a normal part of the noon and evening meals. Family time was special and alcohol, initially, was part of the closeness of it all. In contrast, Julie and Jennifer learned that alcohol was used specifically for enjoyment. Having a good time meant drinking a little too much. Other women received the message that getting drunk was not sanctioned. Despite the incongruity between consuming a depressant while maintaining emotional and mental control, the woman was expected to demonstrate that she could "hold her liquor." For some this meant an added stipulation of only consuming one or two drinks during the entire evening's activities while others were allowed free reign to drink as much as they pleased as long as they maintained control of themselves. Messages that one does not "do drugs," meaning ilicit drugs, was heard by all. Carnelian put it best when she said ". . . nice people don't do drugs—only junkies do drugs, the ones that mug little old ladies . . ." This reflection provides insight into her value orientation—that people who "do drugs" are without worth and value.

"I think I mentioned earlier that I was an A-1 enabler and perhaps in many ways I still am" interjects Lynne. "That has

been the hardest thing for me to break. My mother and I were extremely close when I was growing up. I don't remember a time when my mother and father didn't drink but in the early years they both spent time with me and drinking didn't seem to interfere with that. Alcohol was just a normal part of our family. I knew that when I grew up I would drink. It just seemed like a normal thing to do. But when I got to be about 12, things started to change. Dad went to Viet Nam and Mom spent more time with the bottle than me. My father died and Mom eventually remarried. I wanted my stepfather to like us so I did everything I could to hide the fact that my mother was drinking so much. I would hurry home from school to see if she was all right and then I would pick up the house as best I could before my stepfather got home from work. I kept up with it all the way through high school and through most of college but then it got to be a bit much. I was taking care of my little brother, keeping the house clean, going to school and trying to make straight A's. And somewhere in there mother let me know that I was old enough to drink. I didn't drink very often but when I did it would be a fifth of whatever was around. I could never seem to stop with one drink, I had to finish the whole bottle! I was just about to graduate from college when I started having trouble getting to sleep. I tried alcohol but it just didn't seem to help with that. I had to drink too much to get to sleep and the next day I wasn't as alert as I felt I should be. I learned later that was called passing out! Finally I went to see my mother's doctor and he gave me a prescription for valium. And for quite a while I took them like they were supposed to be taken and I cut way back on my drinking. I didn't think that I could get hooked if they were prescribed by a physician, and since by this time I was a nurse, I felt I knew too much about these kinds of drugs to get addicted. But the time came when I started to abuse them.''

American women live in a society in which drinking is an accepted part of the culture. Sooner or later all young women will be faced with making a choice to drink or not to drink. Very early in life, Lynne received the message that drinking was a normal thing to do. She, too, watched as her parents

participated in parties where alcohol was the focus of the social gathering. Very early on she also made the decision to drink when her parents gave their permission. Drinking, she perceived, was a way of socializing and having fun. When she realized that her mother was beginning to spend more time with the bottle than with her, she began a process known as "covering up." Covering up is the method family members of an alcoholic use to keep up appearances by attempting, unsuccessfully, to hide the drinking from others. It may be those outside of the immediate family circle or members of one's own family. Lynne wanted to hide her mother's excessive drinking from her stepfather. Keeping the house clean, hiding the bottles she found when cleaning and taking care of her younger brother were ways Lynne tried to cover up her mother's drinking. Covering up allows the alcoholic to continue drinking without feeling the consequences of his or her behavior. Thus, Lynne's mother was able to continue drinking without interruption. The process by which family members cover up the alcoholic's drinking and rescue them from any impending disaster is called enabling. Enabling takes vast amounts of emotional and physical energy. Trying to control an active disease process without proper treatment is a little like trying to build the dam immediately following spring rains—it is a futile endeavor. As the drinking episodes increase in frequency and duration, tension builds and is stressful. Although it is possible to perform for long periods under stress, sooner or later one must have relief. Lynne found relief in Valium. Her belief that knowledge about drugs prevents addiction is unfounded. As the stress in her life continued to mount, more of the drug was required to cope with her activities of daily living.

Carnelian places a large container of ice tea on the wicker table and we shift our chairs to a shadier spot under a nearby oak. Although the humidity is low this day, the summer is beginning in earnest. The forecast for the 90s promises to be accurate. Wiping her brow, Carnelian suddenly chuckles. "My mother told me when I was growing up that if I wanted to have a drink to have it at home rather than going out someplace in public and making a fool of myself. That was the other

message. The one that said young ladies don't get drunk in public places. Well, of course you know I did! But it wasn't until I was away from home and in college that I felt free enough to experiment with alcohol.''

Although Carnelian received permission to drink at home, her human need to receive approval for what she did and demonstrate her worth remained the priority. Later alcohol would become the vehicle to ease her insecurity and promote feelings of belonging to her peer group.

Although not intended to be received as a truth, casual remarks from a parent may be incorporated into the developing belief structure of the child. ''I don't remember a time when my father didn't drink,'' remarks Lucy. I remember he used to say that beer was better for you than water. Sometimes he would drink hard liquor but mostly it was beer. There was always alcohol around and whenever relatives came there was always drinking. I used to get sips from them, but that was about it. My folks didn't give me permission to drink until I was in college but when I was left to babysit when my folks went some place, the three of us who were the oldest would sneak some of my dad's beer. I guess the first time I remember being drunk was when I was about 16. It was New Year's eve and my folks let me invite one of the girls in my class to spend the night with me. She brought a bottle of Four Roses and after we got the little one's to bed, we divided the bottle in half and it didn't take me long to drink my half! When my folks came home they thought we were just asleep and I never told them anything different. I don't remember finishing my half of the bottle or what we did during the evening besides drink.''

A refreshing breeze sends my small tape recorder and notes scattering. Breathless from the chase, we descend on the porch swing. Leaning back to enjoy its gentle soothing rhythm, the panaroma of the rolling foothills impinge on our consciousness. ''I guess basically I learned that alcohol was something that was available when adults got together but it wasn't the focus of the gathering,'' says Kelli. ''My folks were not real big on cocktail parties for the sake of drinking. Their friends and the things they did were more around something else—like play-

ing bridge or going out to dinner—there was another purpose to the gathering. I don't really remember seeing them drunk. And from what they said, from time to time, I could tell that they didn't approve of people who drank and got drunk. There were alcoholics on Mom's side of the family and I really don't know about Dad's, but I was allowed to have a sip of my father's beer whenever he had something to drink, but that didn't happen very often. I guess as I got older I was allowed to have a small glass of wine at Thanksgiving and Christmas dinner, but that was about it.''

"My parents wanted me to learn how to drink responsibly,'' says Nicky. "When I was about 11 or 12, they began offering drinks to us at home. It wasn't every day, but frequently they included my brother and me when they were having their cocktails. The attitude was that we needed to learn how to drink at home so that we would be able to drink responsibly when we went out some place. I began drinking with my friends not long after my folks started letting me drink at home. I remember that I was at a party with my friends and I got drunk and had a blackout. I didn't plan it. I was just keeping up with the way everyone else was drinking. I was about 13 at the time.''

"Drinking was a part of my family life, too,'' Zelda announces as a simple fact. "We were very social. It was the cocktail party, the drinks before dinner type of thing, and I grew up with that as a normal part of living. When my relatives gathered, it was a festive occasion and alcohol was very much a part of that. I just knew that everybody drank and it was a natural thing to do. It wasn't a good idea to get drunk, though, 'cause that meant you couldn't hold your liquor. You could drink, you could have a good time, but you weren't supposed to drink too much and get drunk. Now the word 'alcoholism' was never mentioned in our family and today I realize that I did have more than my share of relatives who were 'overserved' as the family called it! I guess I was around 15 when I was allowed to begin drinking and I just liked everything about it. I liked the whole picture that alcohol gave—it was grown up, it was social, it had a pleasant atmosphere, it was sophisticated, and I liked what it did to me. It made

me feel O.K. I felt a part of things, part of the group because in the circles that I grew up in, if you didn't drink you were kind of an odd ball. So when I could begin drinking, I was accepted into the family social circle and I was part of the group but even more than that, I liked the *feeling* that alcohol gave me. It made me feel good, it made me feel better and I could be more outgoing. I've always been outgoing but it just brought me up to another level.''

In contrast other families allowed the women to drink to excess if male family members were around to protect and take care of them. Agnes peers intently at me through wide-framed glasses. I know that she wants me to understand her family climate and her actions without judgment. Earlier in our conversation she had alluded to the notion of drinking equated with having fun and if one had fun drunkenness was expected. When I asked if she could give me an example, she paused, chose her words carefully and replied, ''In our family, having a little too much to drink was a sign of a good time. I could have beer when I was growing up and when I got to be a teenager I was allowed to drink. The message was that as long as my brothers were around to take care of me when we went to parties, I could enjoy drinking. Usually I drank beer with shots of whiskey but I remember one time going to a family wedding and having eight Manhattans. I thought that was great. And since my brothers were there to take care of me and see that I got home without harm, it was an accepted thing. Mother was very specific, though, about where I could drink and how much. She used to tell me that I could always drink at home, and if I drank a little too much there, that was O.K., but when I went out, and if my brothers were not with me, it was one drink period. And I was *never* supposed to go into a saloon!''

Alcohol was the focus of the social setting in both Agnes' and Zelda's family setting, and yet there were conditions specified about its use by women in the family. In Zelda's family, having a good time meant being able to hold one's liquor without getting drunk, whereas in Agnes' family, drunkenness was accepted as a sign of having fun. Agnes learned that if her brothers were present to protect and take care of her,

she could drink to excess. Zelda learned that drinking properly without getting drunk was the rite of passage into adulthood and acceptance into the family social circle. In both cases the human need to belong to a social group directed the women's energies.

Beer is good for you, drinking is sophisticated, wine complements the meal, to have a good time is to have a little too much, ladies do not get drunk in public, men can get drunk, doing drugs is bad, taking prscription or over-the-counter drugs is good, not being able to hold one's liquor is bad, if one drinks too much one is "overserved," being a drug addict is bad news, and there is no such thing as an alcoholic in the family—these are the messages the women really received.

Not all families allow drinking. "Alcohol wasn't served at home when we were growing up," were common statements among women whose parents had either experienced the depression of the 1930s or adhered to abstinence standards required by their church. Becky succinctly sums up comments by women from abstinence-oriented faiths. "My mother and father weren't drinkers. We're Southern Baptists and drinking is a sin. Alcohol and drugs, I mean that is a sin. You don't drink. The bible says you go to hell, you know. Dad didn't overdo it, but it was there. It was just understood. As far as going out with somebody and having a drink, that would have been very much against the rules. Probably not so much so from Dad, but it was just forbidden by Mother."

In the previous section, Sarita reminds us that abstinence oriented practices may not insulate the woman from alcoholism. Although "don't drink" messages are received, many may still experiment with alcohol. "I knew alcohol was forbidden," says Sarita. But there was something special about the way Dad told stories about his drinking days before he became a pastor. I don't know exactly what it was, but his whole appearance just seemed to change when he talked about it and his eyes sort of glistened. I got the impression that drinking would be fun. Yet when I did start to drink, I began to feel guilty. It was a very intense conflict within me. I liked the feeling that alcohol gave me. I felt warm and protected.

I felt comfortable. All the fears and tension left. Yet, I knew that 'good Christian' girls didn't drink. Somehow I was supposed to be above that temptation.''

As in the alcoholic family, perceptions of rejection and abandonment promote feelings of failing to be a person of worth and value. Initially alcohol provides relief from the stress of personal failure.

If families enforcing abstinence in their life-ways fail to communicate the knowledge that alcoholism exists in the family history and encourage open discussion of the issue, then children will not understand why they are at risk to develop alcoholism if they drink. Instead a family atmosphere similar to those families where active alcoholism is present is created. Children are astute in detecting "family secrets" and areas where discussion is not tolerated. Unfortunately the discomfort of the adults is perceived and then incorporated by children as guilt for some unknown misdoing. Ultimately these perceptions are translated into feelings of rejection and abandonment stemming from the belief that they are not worthy or valuable people. Alcohol provides temporary relief from the stress of personal failure, and yet drinking creates more guilt—and so the cycle begins.

"Yes, I did get messages about don't drink," replies Natasha. "My folks were missionaries and we didn't have any alcohol in the home and my folks didn't drink. Even though I was raised overseas I got all those same messages that said don't drink, it's bad for you, it's immoral, and it has to do with the bible and Christianity. My daddy was never very specific except that he would say that alcohol was bad for me and then I'd get the long talk about how I could become an alcoholic if I drank and he would quote all these statistics to me about drinking and alcoholism. It made me furious to think that he thought I would get into trouble if I drank. It just didn't make any sense to me. Every time he said that if I drank I would get into trouble I got angry. I was infuriated that he thought he knew me so well. But you see he never told me about his own drinking before he became a minister. And he didn't tell me that his side of the family had a generous share of alcoholics. That was a well kept secret! I remember asking

him when I got sober why he didn't give me that information and say, 'When I drank I got into trouble and I'm scared for you.' All he said was that he didn't know why, but he just couldn't bring himself to share that knowledge with me. So instead I got those real clear messages about 'good girls don't drink,' 'good Christian girls don't drink or dance or smoke or have sex before they get married.' I remember when I was about 11 having learned about evolution in school and it made a lot of sense to me and so I proceeded to talk to my father about it. It didn't take long for me to realize he did not accept nor want to discuss that notion, and I remember thinking then that there were a lot of things that we were not going to talk about in my family. I knew I would have to wait until I left home to really look at those things we couldn't talk about. I remember making a conscious decision that when the time came to leave home I would try drinking, smoking, and sex. And when I did get to college it was very obvious that alcohol was associated with social events and I wasn't about to be left out of things any more.''

Something special about alcohol, being sophisticated, having a good time, being a part of the family circle, belonging, and being accepted are some of the perceptions and attitudes the women had about the use of alcohol. In families where alcohol was used as the focus of a social gathering, having a little too much was acceptable and considered an appropriate way to have a good time. In other families getting drunk was tolerated for male family members who were considered to be ''overserved'' or who had achieved something. Drinking was also a way to celebrate accomplishment. The cultural norm that the woman should not be drunk in public prevailed. Some families accepted occasional drunkenness in women if it happened at home. Still other families tried to teach their children how to drink responsibly by allowing them to have wine with meals. In all cases the knowledge that alcoholism existed somewhere in the family was suppressed.

Attitudes about the use of alcohol were learned early in life: Alcohol is special and drinking is a sophisticated thing to do. ''Feeling warm,'' ''helping me to relax,'' ''being like others,'' and ''making me feel good'' were among the feelings associ-

ated with early introduction to alcohol. To block the pain of failure and to feel worthy were offered by many as reasons for drinking. Although Mary candidily expresses that she drank to feel worth something as a person, Beryl still ponders the question to some degree.

"I didn't listen to the "don't drink" messages I received," says Beryl nonchalantly. I notice that she has repeatedly made reference to this during the time we spend together. When asked, she elaborates: "I guess even after five years of recovery I'm still amazed at the difference between what my parents said to me and how I was really treated. On one hand, the neighborhood children weren't good enough for me to play with because they said they feared for my safety. Yet I was beaten and repeatedly raped from the time I was about 12 until I left home. And not one health professional believed me when I tried to tell what was happening to me. And today I'm angry about that. So when my parents started telling me that bad things would happen to me if I drank, I didn't believe them. Bad things were already happening to me and I wasn't drinking. How could it be worse? I didn't understand that because both my parents were alcoholic I was at high risk to become an alcoholic if I drank. But even if I had understood that, I doubt it would have made an impression. I was too busy trying to get love. I wanted to be loved. I wanted my parents to act like they thought I was precious. I wanted to count for something. I wanted to experience what it was like to feel safe. I wanted to be able to cry and have somebody soothe my hurts. Today I'm just beginning to feel strong enough to deal with these issues and begin healing the wounds inside me."

Being protected, feeling safe, being appreciated, receiving attention, receiving approval, getting love, feeling connected, and developing a sense of belonging are essential human needs in the development of an autonomous self. When these fundamental needs are not met, survival becomes the goal and understanding one's family history is the least of the person's immediate or future concerns. However, it is now widely recognized and accepted that alcoholism does cluster in families. One noted clinical investigator, Stephanie Brown, who has worked extensively with children of alcoholics, finds many

who describe the onset of their addiction as immediate. For them there is no initial period of social drinking, no invisible line to cross to addiction. Several of the women in my study had similar experiences. In retrospect Doreene acknowledges her initial use of alcohol may have been to be close to Dad, but she drank more than he did and usually drank too much. Both she and Julie acknowledge "going after it." Mary Helen, Catherine, and Geri remember that one drink was never enough—they couldn't seem to get their fill. Natasha comments that she drank heavily from the beginning and never seemed to be satisfied. Zelda states that alcohol made her feel good. Mary, Linda, and Audrey, embrace alcohol's warmth whereas Lucy and Beryl found it blocked the pain of their circumstances.

In those families where drinking was sanctioned, the messages ranged from learning to drink responsibly to drinking is a way of having fun. The transmission received was decoded as: Drinking is a normal event; and, if adults occasionally have a little too much, that is O.K. One did not "do drugs" meaning illicit drugs but taking prescription or over-the-counter medications was permissible. These drugs helped with a variety of perceived ailments. In general the women learned three things about alcohol and other drugs: First, drinking by adults is a normal event; second, alcohol is used to have a good time; and third, alcohol and other drugs are used to self medicate and cope with the problems of every day living. Permission to self medicate and relieve one's stress now becomes an entitlement.

4

Feeling Worthless

Having worth—that intrinsic quality that says I am important and I have value is a human need each of us has. All human beings have fundamental needs to be nurtured and to nurture others. Being sheltered and protected from excessive fear, anxiety, and chaos says that one is safe and has a place in the family. Acknowledging one's achievements, giving attention by taking notice of another, and showing appreciation by recognizing the contribution of another are also fundamental needs. Each contributes to building confidence—the belief that one has the ability to accomplish what it is one sets out to do. As infants we are born with a "clean slate." How valued we perceive ourselves to be will depend on how we are treated by our parents and what they tell us or subtly convey to us about ourselves.

". . . I did feel sheltered and protected when I was growing up so in that respect I felt close to my family," says Mary Helen. My father was very protective of his family and I think that was because of his victorian upbringing. He felt that as girls we were more vulnerable. Although he never pointedly told us how he felt, I sensed that girls were supposed to have less stamina to cope with both the physical and emotional

74

stresses of the world. But when I think back, I can see now
that although I was supposed to be well educated and good
enough at what I did to earn a living, the other side of that
message was that I was supposed to marry and be taken care
of. I felt that Dad did not expect any of us to be outstanding
scholars and so he tolerated our little scholastic problems,
especially those in math, much better than if we had been boys.
I know that if I had been a boy, Dad would have been more
demanding of my performance. Although I knew my father
loved me, I also knew he valued having a son more. But I was
outgoing and adventuresome. I wanted to see and experience
the world so I had these urges to move out of our little family
sphere. I think my passion for reading fueled my horizons.
It was from Mother that I learned the joys of reading. Dad was
more pragmatic in that he wanted some evidence of per-
formance, but Mother taught me the knack of going off on a
flight of imagination and I wanted to see and experience some
of the things I read about.''

''I can honestly say, Mary Helen, that I, too, felt physically
sheltered and protected,'' replies Catherine. ''Today, I'm great-
ful for that blessing. The outside world doesn't frighten me
and I can live easily in my home. But I didn't develop that
sense of closeness with my family that you apparently did.
That sense of closeness that says 'I belong.' It just wasn't there
for me. I was not an avid reader, and I'm still not, but I am
a sports enthusiast. I just love baseball and football and I, too,
wanted to be out and doing. Dad was the one who encour-
aged me to explore and do things with people of my own age
and I think that's because I had a sister with a handicap who
required a lot of care. It was probably his way of saying take
time out for yourself, and although I did do those things when
I could, I probably didn't quite appreciate what he was trying
to convey to me. Instead, I became very resentful over the fact
that I didn't have more time to do the things I wanted to. I
saw the boys out doing the things they enjoyed and having
a good time and I wanted to do that too. I hadn't started to
develop so I knew that if I put my hair under my cap I could
pass as a boy and the group would accept me. I also knew
I could blend in and not be noticed by other grown ups so

that I didn't have to suffer the indignities of being told "girls don't do that!" I could enjoy sliding into home base! Being at home always meant doing chores and I really didn't like it at home. There seemed to be too many rules to live by and too much to do. There was never any time for me. It wasn't fun. It was work, work, work. I began to feel that my mother only valued me for the work I could do. I didn't have any sense that she regarded me as a person and she certainly didn't take the time and trouble to get to know me."

"Yes, in many respects I did feel close to my family," says Mary Helen. "And I too, wanted to be out and doing. I knew Dad wanted to see evidence of excellent performance so I responded by achieving. I think underneath it all I felt that if I could achieve in everything I did then I would get the recognition I wanted. I thought my older sister was so smart and I wanted to be as good, if not better, than she was. I did have a negative self-image to the degree that I felt I wasn't as sharp as or as coordinated as or as careful or whatever else. I've always worn glasses and I don't see well so I was the child who was always falling and skinning her knee. And to overcome that, I responded by digging into my studies and getting A's and gobbling up lots of responsibility. I felt I had to do that to prove to my parents that I was smart and capable. I wanted their approval for the things I did. I wanted all the positive strokes I could get and I was super hungry for them. And to a certain extent I did get them, but doing well in school was expected, even though as a girl I was not expected to be so smart. That was there too. When I look back, I feel like I've been rushing through my life. I wanted to be the best and be recognized for that. I like people, and I like to be around them so from the time I was 13 I was out doing—going to summer camp, being a counselor, helping handicapped children, singing in the church choir, you name it and I was in it. When I responded to responsibility it made me feel good. It made me feel like I was somebody and I was worthwhile."

Again, there were cultural differences between those women reaching maturity in the 50s and 60s and those growing up at a later time. Being protected, being more vulnerable, having less stamina, not being as smart as, and needing to

be taking care of, contrasted with do whatever you do well, were subtle conflicting messages these women received. Helping others was another more direct message. In spite of the fact that Mary Helen was encouraged by her father to learn and to be productive, he did not expect her to excel. Boys were expected to have the stamina to produce, and as such, were more highly valued. Although Mother communicated the value of reading to develop Mary Helen's imagination and creativity, suppressing personal human needs to take care of others was the primary message. Though unintentional, the seeds of inadequacy were sown. Competing with her older sister was yet another factor in Mary Helen's bid to be recognized and respected for what she did. To compensate for her poor eyesight and lack of coordination in physical activities, she began to select those things she could do well. She found she excelled in helping other women her own age who were handicapped in some physical way.

Go play ball, explore, learn, reach out, girls don't play baseball and climb trees, act like a lady, remember there's work to be done here, a woman's work is never done, study hard, boys get special privileges—these were Catherine's conflicting messages. Although her father encouraged her to explore beyond the boundaries of the family, her mother's strong insistence on helping out at home sent another signal. Taking care of others was the way a woman proved her worth and gained her value. Her own needs were unimportant. Periodically escaping to the ball field masquerading as a boy, Catherine found relief for her growing feelings of discontent. For a brief time, she could be someone other than who she was. Catherine's mother, a woman of exceptional strength, expertly communicated that the role and duties of a woman did not include personal satisfaction or respite from chores. Her father's quiet, subtle urging to meet her own human needs by taking some time for herself was either lost in the transmission or overridden by her mother. Again, perhaps unintentionally the seeds of ''being less than'' were sown, first fueling resentment and then anger as Catherine realized the disregard of herself as a person.

Parents are highly influential and have enormous power.

Sharing power when raising children is not an easy task. Without a script to guide, many do the best they can. Providing a nurturing climate is the goal and this requires teamwork from all family members. An environment in which young women are treated humanely, and are noticed, loved, and respected as individuals communicates value and satisfies human needs. If she is allowed to play, take risks, make mistakes, and try a variety of roles, feeling of personal worth emerge as she grows and matures. If it is Mother who becomes the prime communicator, as in Catherine's lifeway, then father's messages may be blurred in the transmission and placed in the background of her thoughts. For the most part, young women do respect and look up to their fathers. He is the one upon whom future male comparisons will be made. If Father is the more assertive person in the family, as in Mary Helen's cultural path, and viewed as the one who bestows approval and worth, then his messages receive priority. Although Mary Helen's mother communicated the value of the printed word, her father, the "family administrator," gave approval for the things she did and assigned a value to them.

Geri smiles and her pale blue eyes take on a far away look. "I was my mother's girl," she quietly remarks. "She was a teacher and a writer and she encouraged me to use my mind. My dad was a farmer and when I could be out with him on the tractor I enjoyed that. I felt safe and secure during my early years, but I never had a sense of being real close to my family. I think after my grandparents died the closeness that I did have with my family began to fade. My father was a periodic drinker and I remember when I was about ten or 11 going into town to fetch him out of the bar and drive him home. So when it came time for me to leave home to go to college, I was ready. I knew I would have to work while I went to school and when it came time for me to leave I remember how my mother looked. I think I broke her heart when I left, but she gave me a big hug and wished me well. And when I left I never went home to live again. I wanted to be out on my own but it was such a struggle. I wasn't prepared for the world and I felt so inadequate."

Sighing deeply, Sarita removes her glasses and concentrates

on cleaning the lenses. Finally she begins to speak keeping her eyes focused on her busy hands. ''. . . I always felt that my dad's standards were so high that no matter what I did I just couldn't quite make it. He wanted perfection and I tried so hard to be what he wanted me to be. All my life I've tried to be perfect and I still have trouble with that today. There are times when I slip back into the old ways and I find myself still trying to meet his standards. He wanted me to be a good little Christian girl, a model missionary kid and I was so wrapped up in trying to please him that I didn't know who I was. I wanted his approval and acceptance and I felt like I never got it. And then when it came time for me to leave home to go to boarding school I felt like I was being banished as a failure. When I started drinking it was partly to fit in with my college crowd, but mostly it was because alcohol made me feel good. I felt like I could let the real ''Sarita'' out when I drank. I didn't have to be so perfect. I wasn't as shy and I wasn't so worried about myself. I could relax and have some fun. But more than that I found that alcohol blocked the pain. I didn't have to feel the pain. And that was such a relief for me—not to feel the pain of failure. I felt like I had failed to measure up and be worth something as a person. I had failed to live up to what my father wanted me to be and even today I'm not sure what that is, but alcohol helped to block that pain. I have such a poor image of myself and that's something I'm still struggling with today. I always felt different. I'm basically a very shy person and it's very hard for me to make friends. I've never had a best friend when I was growing up. I didn't know how to get one and I was too scared to try.''

Sarita, too, looked to her father for approval and validation of her worth. By the time she was old enough to be sent away to boarding school, the concept she held to be true about herself was in place. She had been unable to measure up. Arriving at boarding school she found her sisters and brothers scattered throughout the complex and maze of buildings. Her schedule rarely permitted her the opportunity to make contact with them. Feelings of rejection and abandonment became more pronounced.

That families suffer from either the direct or indirect effects

of alcoholism cannot be denied. Alcohol sends powerful mes-
sages. If father is the alcoholic, then messages about his own
feelings of worth, whether he is or is not the primary com-
municator, will be transmitted and incorporated by his
daughter. We not only imitate the behaviors of those we con-
sider important to us, we also incorporate elements of their
self image as our own.

Linda poignantly reflects the predominant attitude of the
women when she states: "I didn't like me even before I had
my first drink and I didn't like me when I was drinking either.
When I was growing up I got the feeling that I was not good
enough. I was not perfect and I thought I had to be perfect
so that people would like me. I had the feeling that people
didn't really like my father because he drank too much and
they might think that I wasn't any good either because he
wasn't any good. So I was going to prove to the world that
by being perfect I was good."

Being perfect is a way to demonstrate goodness and feel
one is worth something as a person. "I can appreciate where
Mary Helen, Catherine, and Sarita are comin' from," says
Lucy, "but there is a difference. My father was an active
alcoholic and he never had time for anyone. I learned from
him very early in life that my value stemmed from the work
I could do. I wanted very much for both my parents to know
and like me as a person, but I never felt that they took the
time to do this. It hurt. It still does. My father had such un-
realistic expectations for me that I always felt like a failure.
We had such a large family that there was always something
to do for someone else. I felt like I never had a childhood. I
don't know how to play and laugh. And that has come through
to my own children. It's my husband who is warm, loving,
and does things with the kids. I do the laundry and he plays
with them. He is the one who reads stories to them while I
am the one who takes care of them physically. When I recog-
nized that I was just devastated! Then I realized that I never
learned how to do anything else other than physically take
care of somebody. I made my children's clothes, I fixed
nutritious meals. I mean I made all the bread we ate in the
house, I made homemake yogurt, I made homemade breakfast

cereals. I was the 'perfect mother'—but I never played with them. When they were tiny babies I breast fed all of them because that was what I felt I should do. I didn't know how to show them that I loved them. Instead fixing meals and making their clothes became my way of showing love. I was becoming more like my own mother every day and I couldn't stop myself. But underneath it all there was something else. It was almost as if I was 12 years old again and still trying to prove to my parents, and myself, that I was worthwhile."

"As if trying to be the 'perfect mother' wasn't enough, I went back to school to continue my education so that I could get a good job. I wanted to be able to afford to give my kids a college education when the time came. I want the best for them. But I had to get all A's. I couldn't allow myself to get a B. I was trying to prove that if I got A's I was worthwhile. I had to do that too in order to be worth something as a person. And that's been my pattern all my life. When I was growing up I felt I had to excel in everything I did to be worth something as a person and I think my parents encouraged that. Except . . . they never told me that I was doing well. I never felt like I got their approval for all that I did." Her voice quivering, she stops speaking as large pearls of water cascade over pale cheeks making her hazel eyes more soulful than ever. "Don't beat yourself up Lucy," interjects Mary Helen. "At least today you recognize where you are and are beginning to make amends by changing some of the things you are doing. That's progress!" I reach out and put my arm around her.

Lucy received direct, strong messages from her father. She *knew* worth and value were earned by doing work. Assuming responsibility far beyond her years as many children of alcoholics are prone to do, she struggled to be recognized for what she did and to feel worthwhile. However, her accomplishments were never acknowledged. What she did was never enough. ". . . .They never took the time to know me, I tried to be the perfect little girl, I had so much to do, I don't know how to play and laugh, I don't feel good about myself" are some of the thoughts and feelings Lucy is finally able to recognize.

". . . If I were a happier child;" "I didn't like me;" "I didn't

feel good about myself,'' are comments repeatedly made by all the women. Earlier, Lucille shares with us her feelings of remoteness when she was not able to talk to her mother about personal matters of becoming a woman. Unable to measure up to her mother's ambiguous standards for personal appearance, she felt unloveable. The perception of herself as unloveable evoked feelings of inadequacy. Later we learn that alcoholism exists on both sides of her family. Her mother is a child of an alcoholic. Although neither of her parents have the active disease of alcoholism, Mother's past experience prevents her from becoming intimate with her daughter. Instead, Mother copes with her own inadequate feelings by taking tranquilizers. We model our behaviors. We can only show others how to do those things we know how to do. We also convey how we feel about ourselves. If we are not comfortable with a facet of our own self, we cannot transmit comfort to others. Instead, we convey the discomfort we actually feel. By the time Lucille was five years old, she had incorporated her mother's feeling of inadequacy into herself. Communication blocked, the distance between them widened until Lucille's sense of isolation deepened. Perhaps, she reasoned, her inability to measure up is the cause of it all.

Lucille's deep warm brown eyes reflect the wisdom of her previous pain to complement her relaxed composure. I can sense her growing strength and self-acceptance. ''I was basically a good girl,'' says Lucille. ''I didn't drink in high school. I had my first drink when I went away to college and I guess I was about 18 at the time. I went to a party and I got drunk. I didn't plan it. It just happened. And even though I was so sick the next day, I knew I had found *the* answer to all of my fears and feelings of inadequacy and shyness. Alcohol was gonna help me. I don't know if I would call myself a shy person but I was, and still am to some degree, uncomfortable around a lot of people. And alcohol just made it easier to socialize. I continued to drink, especially on the weekends when I went to parties on campus, and I began to notice that I was drinking a lot more than other people. After that first episode of getting drunk and then getting so sick, I found I could drink a lot before I got drunk and I wasn't as sick the

next day as I had been that first time. I thought it was great that I could drink more than anyone else and not have it affect me, or so I thought! When I went home that summer I became deceptive and started drinking in secret because I knew my mother would not approve. Occasionally I did have a drink with them, but I wanted to drink more so I felt I had to keep that from her. I knew drinking too much was a "no-no," but somehow I felt I was getting one over on my parents. I was running around with a drinking crowd and I was drinking more and they didn't know about it. By the time I went back to school that fall, I started having problems like sleeping through class. My roommates were becoming concerned and they were starting to try and make deals with me to cut back, but I couldn't cut back and that's when I started having blackouts."

Although Lucille acknowledges having received clear messages about appropriate drinking, she found during her first drinking experience that alcohol helped her to overcome shyness and helped to ease the way in social relationships with her college peers. Alcohol blocked those disquieting, yet building feelings of fear, loneliness, and inadequacy. "Alcohol made me *not* feel. I didn't have to feel. If I started to feel sad and I drank, then I didn't have to feel it. I didn't feel any pain. I didn't feel any loneliness. I didn't feel shy. I didn't feel inadequate. In a strange way what I did feel was acceptance."

In quieter moments when Lucille's painful feelings were dulled by alcohol, she could sense the acceptance that she always wanted to have. Feeling emotionally distant from those with whom we expect to be close is painful. Over time this distancing is perceived as rejection. Emotional distancing also produces a sense of isolation. Isolation occurs in many ways—not being able to talk to either parent about one's fears, keeping feelings inside, doing things alone and not having friends with whom she can share her thoughts are some of them. Each experience promotes a sense of distance, and in combination, they also produce an anguish so profound, so dispairing that it penetrates to the very core of the self.

"My father is an alcoholic," Barbara says in a matter of fact way, "and it's only recently that I've been able to look at that

reality. There were lots of things that happened to me when I was growing up that terrified me. I grew up with a lot of fear. I think fear was the predominant emotion I felt when I was growing up. I was afraid of being left alone. I was afraid of my father when he drank. He got irritable and mean and my two brothers and I just lived in fear of what he would do to us next. We could never figure out what mood Dad was in. We would tip toe through the house trying not to make any noise. It was like trying to walk on egg shells. If I said something or did something that Dad didn't like, I got slapped. If I made noise, I got slapped. Sometimes if I was too quiet, I got punched. I got sent to my room a lot and that was the scariest thing—to be left alone. I never felt that either of my parents were there to support me when I needed them. I remember one time I was almost raped. I fought the guy off and I ran, but I was so upset that I make the mistake of telling my father about it. He blamed me. It was my fault. He called me all kinds of horrible names. I was just devastated. It just reinforced the necessity to keep my feelings and what happened to me to myself. I felt so alone. All my life I've felt alone and even after I got married I felt I couldn't talk to my husband about the pain that I was carrying around. And when something comes up and I sense that I'm going to be left alone, I panic. That knot comes back in the pit of my stomach and I can feel the pain starting somewhere inside of me."

Barbara's inability to openly talk with her parents about the things that happened to her and how she felt about them was stressful. Physically beaten and verbally assaulted, she was frequently sequestered in fearful solitude. Quiet, when it did occur, was the quiet of fear and caution. When the next violent episode would erupt was unknown, adding further stress to her unpredictable, chaotic homelife. In this mileau Barbara began to believe that somehow she was to blame for all that was happening in her family.

A sad half-smile cautiously appears accenting Barbara's tearful eyes. "I remember growing up that I always felt very inferior, very unsure of myself, real inadequate. My 5th grade teacher told my mother that I was very smart in school but that I didn't seem to work up to my potential. That I seemed

to be unsure of myself. I would go just so far and stop and she thought I had more potential than that. But I was always very scared, all the time scared, and I didn't know what I was afraid of. I do know that I was afraid of one of my teachers. She would ask me a question that when I gave an answer she'd tell me that I didn't know what I was talking about. And then she'd call me stupid. I was so terrified of her that one day she asked me to spell the word "push" and I couldn't do it. I started crying and she sent me out of the room. I was so embarrassed. The rest of the kids started laughing at me and I just felt horrible. I had the overwhelming sensation of wanting to be like Alice in Wonderland and go through the floor— just leave, disappear. And that has followed me all my life. I can be working and all of a sudden I'll begin to feel unsure of myself, like I'm not measuring up or I'm not doing what I'm supposed to be doing. Nobody is telling me this, but out of nowhere I get these strong feelings of being inadequate and inferior again."

Barbara's intense anxiety and fear inhibit social integration and impede accomplishment. Tension, the underlying variable in the cultural path, intensifies and subsides with each traumatic episode producing stress. Stress, the dominant theme in the cultural path of drinking, eventually requires relief. Earlier we learned that Barbara enjoyed the smell of gasoline products and found a brief respite from the fear in her life through inhaling fumes.

Pausing briefly, Barbara takes several deep breaths and then continues to describe the violence in her life: "Things were always in a turmoil at home. I never knew what to expect. I remember I had just graduated from high school, and I was going out with some of my girl friends. We were going to a party. I don't know what got into my father but he decided that I wasn't going. I was devastated and I started crying. My mother wasn't around as usual. It seemed like she was always going somewhere and I was furious with her for not being there when I needed her. I continued to cry and finally my father started beating me and he couldn't stop. I didn't feel the pain though. I was numb to any physical or emotional pain by that time. The next morning it was like nothing had ever

happened. It was business as usual. Nothing was said, nothing was discussed. I didn't say anything, my father didn't say anything. It was like nothing had happened.''

''I still have a lot of unresolved issues and I know that I have an intense fear of anger. My father was, and still is, a very angry man. I can't stand it if anyone is angry with me. I just crumble. It's like it's all over. I've found that a lot of my fear stems from not wanting to be left alone. I have this fear that if I don't do things to please people they will go away and leave me. Then I wouldn't have any friends or anyone who cared about me. But on the other hand, I'd get very angry at myself for feeling that way. I'm also very afraid of men, but the other side of that is that I manipulated my husband and children to do things to take care of me.''

Fear of the present—what will happen at home today? Will I be safe? Fear of some future impending doom. What will happen to me next? Chaos, including physical violence at home, prevents Barbara from being able to talk to her parents about the traumatic things that are happening to her and how she feels about them. Blamed for placing herself in a position to be raped, despite the fact that she fought and got away, further validate the bad feelings she already has about herself. She hides her intense pain and suppresses her feelings until she is only able to recognize her intense loneliness and fear. Constant criticism, intimidation, and humiliation at school reinforce her deepening feelings of worthlessness and prevent her from absorbing the lessons to be learned. Finally, with one catalytic episode, her mortification becomes so profound that all she wants to do is vanish. Perhaps she is, after all, a bad person. She is inadequate, inept, and worthless.

Although laughter is an effective healing tool, many children of alcoholics do not laugh. For them laughter has been used to ridicule, transmit blame, and reinforce feelings of inadequacy. To be the object of laughter is a humiliating and excruciatingly painful experience. Barbara's episode in which her classmates laughed at her apparent spelling ineptitude is one example. Being the object of laughter means that humor is being used in a negative and destructive way. Although the appropriate use of humor in this context is as an effective tool

to release old beliefs and the feelings associated with them, it may take several years of nurtured recovery before laughter can be incorporated as part of one's healing process.

When alcoholism is present in family life, families cease to be a place where one can freely ask for and receive attention and support. The alcoholic does not have to be actively drinking to affect family life. In the first section, Beryl shares not only the perpetual violence in her homelife, but describes a family atmosphere void of touching, hugging, and other communication. Unable to openly give and receive affection, or show the pain from the beatings she received, her feelings and emotions are submerged, until the ability to identify feelings is lost. In contrast to Barbara, Beryl found a warm and nurturing school environment where she received encouragement and praise for things she did well, but her underlying feeling of unworthiness prevailed. ". . . Yes, I was kept warm and fed," she says. "I was given a lot of responsibility but I was also told how irresponsible I was. I was allowed to do certain things but I couldn't do other things. It was O.K. to be responsible and go to work as long as I was contributing to the household. It was O.K. for me to learn how to make my own clothes as long as my mother picked out the pattern and the material and told me what to do. She defined what kind of a person I was and I believed her. She told me I was worthless. I mean I really believed her. I thought I was such an asshole that I wasn't worthy of being loved. My father and mother told me all my life that they didn't want me, that they were taking care of me because they were stuck with me. So when the time came and I was arrested at work for stealing drugs, and the people I worked closely with stood by me and came to see me and told me they wanted to help but they didn't know how, I thought they were nuts. See, when I was drinking and drugging I didn't care if you loved me. I hoped that you did, but I didn't know what it was like to be loved or even liked. And I think that caring and concern for someone is part of trust and it's still hard for me to trust today. It's hard for me to believe that you will be there for me if I need you. It's still hard to risk sharing things, that's why it's good for me to talk to you and tell you about me."

Lynne gazes at me intently. "I'm going to leave the door to the office open in case I'm needed," she says. "It will be all right. We won't be disturbed unless it's important." This is our second meeting and I wonder again what inner force compels her to be so vigilant and then as she begins to share more of her life-way with me I understand. "I know you think it's strange that I want the door left open," she says, "but perhaps it will help you to understand if I tell you a little more about myself. My father started drinking very heavily and sometimes he would get violent and start tearing the house apart and occasionally when that happened he had seizures. I was home from school for some reason on a day my dad had one of his seizures and this one seemed worse than all the others. When he came out of it, he made me promise not to tell my mother when she came home from work. In the meantime my mother decided to take us and leave my dad. A few days later I told Mom that Dad had had a seizure the day we moved out and she said 'if you had told me that when I came home from work that day, we wouldn't have left.' I felt so guilty, so guilty. I didn't know what to do. I blamed myself for our leaving. It wasn't too long after that that I got sick and ended up in the hospital. When I got out, Mom shipped me off to Grandmother's for the summer saying that the fresh air and sunshine would help me to get better. And I did begin to feel better by the end of the summer. When I came home, my mother and a neighbor took me to see our priest who told me that my father had died. I remember I didn't shed a tear. I just thanked him for the information, went out, and put my arms around my mother and told her I would take care of her. And from that day on I became an A-1 enabler. Mother and I became very close. I became her friend instead of her daughter. It wasn't long after that when I noticed her drinking had picked up. She was O.K. while she was at work, but I knew that as soon as she got home I needed to be there to take care of my little brother and to watch Mom. I was eight years old when all that happened but it's still very vivid in my memory."

Among women reaching maturity in the 50s and 60s, cultural expectations included upholding social custom and

meeting the needs of others. Although women are not immune from the disease of alcoholism, at that time more men were known to be drinking and having problems with alcohol. In homes where alcohol subtly began to gain control, mother gradually became emersed in the behaviors of the alcoholic. Her futile efforts to control the drinking and keep the family secret initially included the children in the family. When the secret could no longer be hidden, all members of the family were required to help in the enabling process allowing the alcoholic to continue to drink without feeling the consequences. Times have changed. Today more women are known to drink and many are having problems with alcohol. Lynne's mother kept the family secret until it could no longer be hidden. When violence errupted she fled taking the children with her. Children are prone to assuming awsome responsibilities that are not theirs to assume. Ultimately it was Lynne who felt she was the reason why her mother left her dad. When she found that he had died, she incorrectly reasoned that she had caused his death. Her only way of quieting the guilt and promoting a sense that she had something to offer as a person was to take care of mother whose own drinking was now beginning to escalate. Now I understand her vigilance. I also knew that although she had been clean and dry for 15 months, this was an issue she would have to confront to allow healing to occur. Would she achieve serenity, that composure, that quiet, that peace of mind within that says I accept myself as I am? Only time would tell.

Drinking and alcoholism are more commonly a part of women's life-ways today than in the past. It is more likely that women who reach maturity in the 70s and 80s will have both a mother and a father who are alcoholic. When Mother is an alcoholic, her daughter feels rejected and begins to question her own worth and value. Jennifer gives us some insight into how she feels when she realizes alcohol is disrupting her relationship with her mother: ''I was watching my mother commit slow suicide with her drinking and I was getting angrier and angrier all the time. I was angry. At this point in my life, I was really angry. I think that was the predominant emotion that I had. I was really prone to blowing up. I even beat up

my boyfriend over nothing. I was angry with my parents, mostly my mother. I didn't have a mother anymore. It was like she can't do anything for me, she's not there when I need her, she's trying to kill herself, is it because I'm such a horrible person that she doesn't want to live? I couldn't depend on her. I never knew if she was gonna be smashed or dry or depressed or anything and it really bothered me. I was angry, I felt alone and I began to think I wasn't worth much.''

Suddenly Jennifer becomes slightly aggitated. Repeatedly pushing her long blonde hair away from her face, her words begin to spill from trembling lips. ''Things had been steadily going down hill for several years. Mom had always been a drinker but by the time I got to be a junior in high school she was drinking a lot more and getting smashed fairly often. And I began to notice my father was drinking a little bit more although he was never much of a drinker. But by the time I got to be a senior, Mom was getting smashed on a nightly basis and it just seemed like nobody was talking to anybody anymore. I couldn't seem to communicate with either one of them. I felt like no one was listening to me. It was like I wasn't even there!''

What could once be described as a happy, nurturing family changed when alcohol achieved the central focus of power in Jennifer's family. Communication among family members stopped, no one listened or heard anyone else. Human needs of family members were disregarded and instead attention was directed toward meeting the needs of the alcoholic. Jennifer, beginning to feel more isolated, perceived a lack of concern for herself as a person and wondered if she was the cause of it all. Whether this shift in family relationships from an open to a closed social unit is a gradual process or one into which the woman has been born, the impact on the woman's self image is the same. The depth of disintegration of the self, to the point of believing herself to be utterly worthless, appears to be contingent upon how much human need deprivation she has withstood. The more extensive her human need deprivation, the more worthless she will believe herself to be.

Cassandra emerges from the tiny kitchen in the studio apartment. Her petite frame matches her five-foot-two inches

and I can see that she exercises regularly. "I like tennis," she tells me. "I can really take out my frustrations on that ball and whack the hell out of it!" We both chuckle. Despite the humor, I can see tiny lines of tension across her brow. Her anguished hazel eyes tell me that her pain is still fresh, and indeed, she has just celebrated her first birthday in the A.A. program. "Things are really going well for me," she announces. "I just got promoted and I've been clean and dry for a year. I never thought I'd be able to do it. And if it weren't for a lot of wonderful people, I couldn't have done it." As we talk I can't help but think about how similar Jennifer's and Cassandra's lives have been in many respects. Both began to move when they were about 12 and lived in various places all over the world. But there were some differences in Cassandra's family social unit right from the start. It was filled with uncertainty, dread, and conflict. "I was the last of five children and we were spaced pretty far apart." she says. My brother is five years older than I am and the oldest, my sister, is 11 years my senior. My parents always had alcohol around and drinks were always served before dinner. It was just a part of my life."

"I was in the fourth grade when Mom went back to work and when she and my father came home the ritual was that everyone would gather for cocktails. My youngest brother was a teenager and the rest of my brothers and sisters lived close by so people were always popping in. It seemed as though we had a family cocktail hour just about every night and my brother and I had our lemonade with them. That was probably the only time that I felt kinda close to everyone. I knew I had roots. But things were always turbulent between Mom and Dad. They would fight and split up and get back together and everything would be peaceful for a while. I always lived in fear that they were really going to split up and I would have to pick one or the other to live with. I seemed to be the one to have a lot of conflict with Mom. If she wanted me to do something and I started asking questions about what it was she wanted me to do, she got real uptight and before you knew it we would be arguing and I didn't want to argue with her. I didn't like to argue with my mother so I would back down. I just couldn't handle it. It would get to be real ugly. She in-

timidated me and I couldn't handle it so I'd just repress how I felt, keep my mouth shut, and go about my business."

"I always felt that when something happened at home and I was around that I was the cause of it. Sometimes I would hear Mom talking to my Dad about me. Mom was always saying: 'If Cassandra would only straighten up, then I wouldn't be so nervous and I wouldn't drink so much.' I did have a lot of energy but I could never seem to settle down and finish anything. I'd start a project and then before it was half finished I'd lose interest and Mom couldn't understand that. She couldn't understand why I never liked to do the things that she liked to do. I didn't read very much and I hated sports. But I always had the feeling that I didn't measure up, that something was wrong with me. I felt that it wouldn't make any difference what I did 'cause it wouldn't pass Mom's scrutiny. In later years when Mom was drinking, and I could never predict when that would occur, she generated a whole lot of fear in me. She was verbally mean and could just lash through me with her words. It was painful and I felt intimidated and rejected but I didn't understand that then. I just knew that I lived in fear of her anger. But on the other hand she played the major part in my whole life. The times when she wasn't drinking and so mean and we were getting along I was her baby. I was her confidant and a lot of times I heard a whole lot of things I probably shouldn't have heard and I didn't know how to handle them."

Physical violence does not have to occur to produce insecurity, and feelings of inadequacy and worthlessness. Fear, guilt, and intimidation are powerful ways to destroy one's self confidence and worth. "Growing up I felt unloved," says Mary. "I was raised in a home where there was absolutely no affection, no touching, but yet the expectations for me were horrendous. No matter what I did, it was 'you can do more.' When I brought home all A's on my report card then they found something else wrong. I never had the feeling of success. Nobody ever supported me or cheered in my corner when I did something well. I can remember once asking my mother if I was pretty and she said, 'Oh, you'll do.' I have such a poor image of myself. I felt like I was never good enough.

Never, never good enough and that feeling has stayed with me all my life. I didn't have a lot of friends because I was afraid of people and in some respects I still am. I have a hard time trusting that people will be there for me. I have a hard time believing that people would want to spend time with me and be my friend. I remember one time in school the teacher told me I looked pretty that day and I thought, 'Oh, no, that can't be!' Coming from a Catholic background and Catholic schools most of my life, the message was that it was wrong to think of yourself as anything special. It was wrong to love yourself. Others came before you. That's been the hardest thing I've ever had to deal with since I've been sober—to know and accept that I'm important. I never felt important and I never felt accepted. I never understood closeness and I never set out to be close to anyone so when it happened and I found someone who truly cared for me, I felt compelled to sabotage it. I was not worth it. No matter what you did to try and prove to me that I was accepted and loved, it would never be enough. I had to make you dislike me and leave me because deep down I felt I was not worth having your love. When I look at it now, it's like I was two people. There was this person, the one who is sitting here in front of you now, and the person that I hate on the inside. And this person sitting here would do anything she could to hurt the person on the inside. I purposely set things up to deeply hurt myself. I always looked at others and thought they were better than me or they had more than I did. I never looked at what I had. Oh, I wanted positive strokes and when I got them I really worked harder. I wanted to be even better than what you said I was, but underneath it all I felt like I was a failure. I never accomplished anything other than being an alcoholic and an addict.''

''I guess underneath it all,'' says Agnes, ''is my belief about myself. Basically my belief was that I was not as good as I could be. I'll never have. I'll never have anything. That was my mind set. I'm from a Catholic background too and guilt is high. When I went into the convent, I felt more guilt. I had to look at my sins, my faults. I felt ashamed. I just knew I was a terrible person. Crying is thought of as bad so you never felt. And you could never feel good about what you did well. My values are

such that I had to excell at anything I did, but feeling good about things that I did well was something I was not comfortable with. I think I felt better with discomfort—well, pain.''

''I'm from an Irish Catholic background too,'' says Julie, ''and there was a lot of guilt dished out to me too. But, I wasn't having any of it. I knew there was something better out there and I wanted it. I can remember coming home from school at noon and taking a dime from my mother's purse to buy candy. I found out very early that if I had money, I had friends. I desperately wanted to have friends so I would buy penny candy to give away and as long as I had candy to offer, I had people around me. Underneath it all I was lonely and I didn't know how to be myself and reach out to people. I was always pretending to be something that I wasn't. I remember thinking that if we lived in the wealthy section of town and I would have gone to the protestant church things would have been much better for me. I would have been accepted by others and had friends. So I covered up my insecurity by trying to be the best at everything I did and that way I could feel that I was worth something as a person.''

Being shy, not feeling important or special to one's family, wanting friends, wanting to be the best, lacking social skills, being afraid to reach out to others, not feeling socially at ease with people one's own age, not being complimented for something done well and not staying in one place long enough to make friends were among the reasons the women gave for feeling insecure. Moving frequently either to another state or another country contributed to feeling different. When it came to meeting new people and making friends, feelings of inadequacy surfaced.

''I was a very shy and sensitive person when I was growing up'' remarks Carnelian. ''I know I told you that my father's job required that we move every few years and although I liked the experience of traveling all over the world, I was lonely. But it was more than just feeling lonely. I felt like a solitary being on a desolate planet. It was hard for me to make friends and I guess that's why home and Grandmother were so important to me. After she died I was just devastated. I felt I didn't have any one to comfort me. We moved every couple

of years and to me that meant that I could never have a best friend. I knew I'd be gone and writing is just not the same thing as being able to talk to your best friend in person. I just felt so different from everyone else because we were moving all the time. But I learned how to put on a mask the happy face. The one that says everything is just fine. But inside I was lonely and scared. I tried to pretend to be a happy little girl. When the time came and my father got a job that meant we would be staying in one place and putting down roots, I didn't know how to act! I didn't know how to get involved and make friends. So I didn't. I just kinda stayed to myself and I was miserable. I felt insecure and inadequate. But when I went to college, I decided that somehow I was gonna fit in and if sitting in a bar drinking beer and eating pizza was the way to do it, then that's what I would do. But something inside of me started to change. I couldn't put on my happy face at home any more. I couldn't hide how terrible I felt when I was with them. I began to be more sullen, grim, and disagreeable when I was around my folks and they couldn't understand what had happened to me. I remember going to a wedding with my mother and at the reception I got drunk. My excuse was that it was such good red wine that it just crept up on me. I remember my mother sort of looked at me in a funny way and said, ''you know, you're acting just like your cousin.' And then she never said any more about it. My cousin died from alcoholism.''

Being lonely, being scared, feeling inadequate are feelings Carnelian is now able to articulate. Being sullen, grim, and disagreeable was how she began to act when anger, kept within for so many years, began to surface. Feeling different from others was a major characteristic among the younger women although each related a somewhat different experience. Puberty with all its accompanying changes is a stressful time for young women. Feelings of insecurity, inadequacy, and being inept emerge as she adjusts to her changing body and tries to define who she is. ''. . . When I got to be an adolescent I just felt terrible about myself,'' says Jennifer. ''I was very unhappy. I just didn't like myself. I didn't trust people. I was afraid of people. We moved every year after I got to be in the

eighth grade until I graduated from high school. Every year
we were in a new place and it was just so hard. I always felt
on the outside looking in. I always took the college prep classes
so in terms of being with other kids who were of the same
educational background as I was, we were matched but they
were not as anxious to let me into their group. I felt like they
were pretty stuffy and cliquish. I just didn't think they were
fun. So eventually I said screw it, and told myself that I really
didn't care if I had any friends or not. I felt like I wasn't going
to be in one place long enough to make friends. I began to
think I wasn't supposed to have anything that's of any qual-
ity. But it was very easy to get into the drinking/drugging
crowd if you were new at any school. It was the easiest place
to slide in and belong. If you acted cool and wild and gave
the impression that you would try anything, it's like you were
accepted. That's really sick, but that's the way it is.''

"I didn't feel good about myself either," Cassandra calmly
states. "I felt as if I didn't measure up. I was skinny, I was
quiet, I felt I wasn't attractive. I always used to look at other
girls that looked like they had everything I wanted and I didn't
know how to get it. So I felt very inferior to them. I felt I didn't
have the clothes that they did, I didn't have the body, I didn't
have the makeup, I had long straight straggly hair. I mean
there was nothing about me that was attractive and I felt very
awkward. I always wanted to be glamourous—that was the
image I wanted to project but I felt so bad about myself on
the inside that I didn't know what to do to cover that up. I
always wanted to be like the cheerleaders and the pom-pom
girls in high school and I didn't look like that. But when I
drank, I was the life of the party. I felt popular and accepted.
I could be wild and crazy and get everybody's attention. I just
didn't have the guts to say my name is Cassandra and this
is who I am. If I acted out, then I got the attention that all those
other girls got who in my way of thinking were just gorgeous.''

"I probably knew that something was different about me
from about age four or five. I can remember that it was about
at this point in time when I started to be attracted to girls and
I dreaded the thought that someone would find out, Natasha
calmly states. I knew I had to be very careful about what I said,

especially since I was a missionary's daughter. I knew I couldn't talk to my folks about a lot of things and I certainly figured out that being gay was one of them. I was basically a very shy person and I was raised in another country. The family and I would come back periodially for visits and I just couldn't seem to adjust. We lived out in the bush until I was six years old and I didn't have any other children except the natives to play with. The first time we came back to the states to stay for a while I couldn't grasp what was going on here. I didn't understand the culture. I didn't know any of the things that I was supposed to know and I got very tried of talking to people about Africa. Everyone wanted me to tell them about Africa and I just couldn't make any comparisons because I didn't have any frame of reference for comparison. I just thought America was a wierd place to be and I couldn't get used to it. I knew I'd have to come back here to go to school and I was just petrified. I tried so hard to adjust but I just felt so socially inadequate and inept.''

"I've known all my life, too, that I was gay," says Doreene, "and I think being gay has a lot to do with my alcoholism. I believe that personally. My lack of self acceptance and never feeling like I fit. I was never comfortable. It was like my skin never fit right. I was never really comfortable where I was but I'd get drunk and I was always the life of the party." Natasha gives a hearty whoop! "I know what you mean! When I did start drinking, I thought I had found the answer. I thought if I could just get that right combination where I had just enough alcohol in me then I could be social and outgoing and have fun and talk. But what I found is that if I got too much then I got weird and if I didn't have enough I was shy. And I could never seem to get it right—you know, that right combination!" The laughter of wellness echoes through the room.

Within our secrets lies our sickness. It is the secrets that keep one sick and in denial. In American society there is perhaps more stigma placed on homosexuality than on alcoholism. For this reason, many women will not divulge their sexual orientation. They are afraid that they may ostracized by their social group—even if that social group is a drinking/drugging crowd. Doreene shares with us her belief that

her alcoholism has much to do with not accepting herself. Natasha, on the other hand, tried to fit into society's expectations of what a woman should be. "I wanted to be accepted so badly that I decided to try and do what society expected me to do," she tells me. Society said I was supposed to get married and so I thought, 'Well, if this is the way one does it, then I'll do it.' Society says I had to have a husband so I got one. He wasn't a winner, but I didn't have enough confidence in myself at the time to look for someone who was socially, emotionally, and educationally my equal. So I found this man who was totally nonthreatening to me in every single way. He couldn't threaten me intellectually or emotionally, and socially he was the pits. I mean he just wasn't smart enough or with it enough to provide any kind of challenge. I can remember consciously saying to myself, 'I know I don't love this guy, but he is the least troublesome of all the ones I've met.' I figured I could take care of him easily enough and if that's what women were supposed to do, then that's what I would do. We were two sick people on our way to disaster."

Being accepted, receiving approval, and feeling loved are human needs each of us has. If messages from our parents are clear, and we perceive that our human needs are being met, the concept that we form about ourselves will be clear. When mixed messages are received or communication is closed, confusion results.

Kelli told us that communication between she and her mother was not as open as she would have liked it to have been. When she did something wrong, messages were clear. Mother conveyed that when her behavior was bad, *she* was bad. If things were running smoothly, no messages were received. In reflection, Kelli still cannot sort out her feelings and describe her developing self concept. "When I stop to think about how I would describe my self image," she says, "I'd have to say it was a real mixture. I guess a lot of times I didn't feel like I was measuring up to what other people thought I should be doing and I'm not real sure why I'd be thinking that. I was doing very well in school. I was involved in a fair number of outside activities between sports and the church youth group and girls scouts. But what I was doing

didn't really connect with how I felt and how I saw myself. I guess I would have liked to have been a little bit more outgoing; a little bit more satisfied with where I was. Some of the standards that I set for myself—when I look at them now—wore really just too high. I'm not ouro if I wao the ono ootting them or if I thought that was what other people expected me to be doing. I had a fair amount of insecurity in that I was trying to figure out what it was that I ought to be doing and what it was that others thought I should be doing, instead of learning how to be comfortable with who I am.''

Not having faith in oneself, feeling insecure, being socially inept, not accomplishing anything, not finishing anything and not doing things Mother liked to do are some of the feelings and perceptions that these women shared. Overall the predominant feeling each woman had was one of rejection and abandonment by those closest to her. Most did not feel important or special to their families. Over time an enormous amount of energy was expended trying to attain perfection in the things they did in order to demonstrate their value. This struggle created a sense of unrelenting tension and stress. Ultimately the women perceived themselves as lacking value and failing as people. They felt worthless.

The family norm of using alcohol to medicate and cope with the problems of everyday living led each woman to try this for herself. At first alcohol worked. She felt secure, popular, and confident. She became the person she had always wanted to be. This momentary satisfaction led her to make the imprudent choice to continue to use alcohol until, finally, her choice was gone.

In each woman's cultural path, stress is the dominant theme. It arises from either an excess or a lack of human need fulfillment and it connects subordinate themes: absence of love, feeling worthless, and making imprudent choices. The nature of stress was found to differ between older and younger women. For those women maturing in the 50s and 60s, family rules enforced by a controlling authoritarian mother dominated homelife and contributed to increasing frustration and tension that become stress. These women learned to meet the human needs of others by suppressing and denying the

existence of their personal needs for closeness; specifically, for appreciation, attention, approval, acceptance, love, and a sense of belonging. Among those women maturing in the 70s and 80s, homelife was characterized by inconsistency, ambiguous role expectations, and fluctuating family standards. Now more mothers are openly drinking and having problems with alcohol compared with the older group where father was the predominant person who drank in the family. Homelife for younger women was pervaded by an atmosphere of emotional and environmental chaos contributing to increasing frustration, tension, and stress. Eventually the stress from human need deprivation led each woman to begin her search for something more.

Part II

COPING

5

Needing More

Leaning back into the embrace of the padded maple rocker, Mary Helen gazes thoughtfully at brightly glowing embers in the hearth. Finally, she says: ''I have an addictive personality—that's how I would describe myself. One piece of candy was never enough. I needed more. One book was never enough. I needed more. I always needed more. It was the same way with approval. I needed more. I needed acceptance. There had to be a basic lack within me that I felt had to be satisfied. My expectations of myself were that of always needing more. I needed to be more. I needed to do more. I wasn't as pretty as—I wasn't as accomplished as—I wasn't as smart as. I didn't have the sense of self that said 'hey, Mary Helen, you're O.K. the way you are.' ''

''My energy was abundant and I was constantly doing. But the doing was looking for ways to feed me. It was insatiable. I was impulsive. As a child, I'd do things first and then reap the consequences and think about it afterwards. I was hyperactive, but I was also the sunny one, the peacemaker, the caretaker. I was the spindly one and because I didn't see well, I'd stumble and fall frequently. So I became the accident prone one. But I was always rushing—to do, to be. My parents encouraged me to study and to be independent but I think I felt that if I could achieve and please them, I would get more of

ormous

their affection and recognition. So I did things to excel. I couldn't just sing in the choir, I had to have the lead in all the cantatas. I couldn't just be a scout member and participate with the other girls, I had to be the leader. I'm very good at organizing and managing so it never took long for me to rise to the top in anything I did.''

The human need for acceptance is the need for that in one's life quality that says your value and worth as an individual are recognized even when those around you do not necessarily approve of your behavior. Acceptance is communicated to us early in life by those who are the closest to us. If we can perceive that others accept us as we are, then we are provided with the foundation to acknowledge our own abilities and limitations and to be satisfied with who we are as people. Earlier we learned that Mary Helen looked to her father for acceptance and validation of her worth as a person. Instead Father sent mixed messages to his daughter. Be the best, do things well, girls do not necessarily have to do things well.

Our human need for personal recognition, esteem, and respect is conveyed through approval. When we are acknowledged by others whom we admire for our achievements, we perceive approval for our actions and know that we have value. Mary Helen knew she had to be the best—and being the best meant being first. Although she was able to develop and utilize her organizational talent to an exceptional degree, receiving recognition and approval from the one she valued most, her dad, remained beyond her reach. Worth and value are words sometimes used interchangeably yet they can have very different meanings. Worth implies intrinsic excellence whereas value suggests that excellence is attributed to something. Although Mary Helen recognized her management ability had value, she perceived her worth as a woman to be less.

Zelda leans forward prodding a hissing log. Tiny fingers of light burst forth accompanied by brisk crackling and snapping. Turning to Mary Helen, she quietly begins speaking. ''We are a lot alike. I didn't buy a lot of the discipline that the nuns handed out in school and they used to call me devilish. I've always been an outgoing person and I just loved

to make people laugh so I became the class clown. I've always had a good sense of humor. I like to laugh and I like to make other people laugh and I could just walk that edge. I wasn't destructive or discourteous, but I wanted attention and for people to recognize my talents. Even though my parents were careful not to play favorites. I wanted to be the one to receive the most love so I acted out. I would do anything I could to receive the attention I so desperately wanted. I guess basically I needed an abundance of attention and affection which I felt I never got." A contagious chuckle suddenly bubbles to the surface. "I drove my teachers to exasperation and beyond," she says. "Underneath it all, though, I wanted more attention and approval from my mother but she was such a stoic woman that I never felt like I knew where I stood with her, and my father drank himself to death. He died before he was 40. So I set out to get my needs met as best I could. I got it from my teachers when I acted out and used my sense of humor."

Mary Helen smiles, "I can understand." The warm glow from burning logs projects a softness to her face as she continues speaking her thoughts. "I didn't know how to use humor but I'm an excellent manager. I know how to organize and get things done. And over time I found out that I could control certain situations and I thought that was what I must do. If I controlled what was going on, then I could guarantee the outcome. I had an insatiable need to be recognized for the things I did. And I was always in a hurry. I didn't want to be left behind. Even after I got married I was still that way. I didn't want to be left behind. I wanted to be doing what everyone else was doing. I wanted to be a part of it all. So I learned how to smoke, and I learned how to drink, and I jumped feet first into chocolate. I couldn't get enough of anything—food, alcohol, cigarettes, love, acceptance, approval, whatever. I was a disaster going somewhere to happen!"

Needing more best describes the view that the women held to be true about themselves. The self, they reasoned, contained a flaw. To compensate they wanted others to provide constant reassurance, attention, and approval. They wanted to be accepted and loved for whom they were. To excel in what one

did was perceived by many as a way to receive the recognition they so desperately wanted. Acting out and impulsively doing things, even though they were irritating, were ways to draw attention to themselves. Each of us has a talent, or a propensity to do something well. It is our gift and helps make us who we are. Although Mary Helen and Zelda both possessed an outgoing personable demeanor, each viewed her emerging talent as a way to feed herself and meet her human need to be recognized and respected for what she did. Each of us has a human need to be fulfilled—to understand a measure of our worth. Mary Helen met these through her abilities to organize and manage; Zelda by using humor. Although unrecognized at the time, each struggled in vain to receive approval from the one parent she valued most. In many instances it was Mother whom the women perceived as having the power to bestow worth and value; in others, it was Father. As the women reached maturity, their search for love continued.

''I wanted to be loved! I wanted to feel that I was part of my family,'' cries Lucy. ''I wanted to be appreciated for the work I did! I wanted my folks to pay attention to me! I wanted them to make me feel that I was worth something! I worked so hard when I was home taking care of everybody else and I wanted to be acknowledged for my contributions to the family! But I never got anything! When I went to college I put all my energies into my studies. I had to get those A's! I wanted to prove to my folks that I had value and I also did that to prove to myself that I was worth something as a person!'' Soulful tears suddenly cascade down pale cheeks reminding me that healing is a continuous process. I can feel the anguish from the little girl within. Lucy wanted her parents to recognize her accomplishments. Her self respect depended on it.

''I drank a little in college,'' she continues in a quieter tone, ''but it wasn't very much. The fellow that I was dating and I would go out for steamed clams and a pitcher of Michelob every once in a while but that was all the drinking we did. After I graduated, we got married and then I found that hard liquor could obliterate the pain I felt. It was gradual. We were both struggling to earn enough to live and our jobs were im-

portant to us. My husband was a music major and he played in a band and he was gone a lot. Sometimes it seemed to me that he was gone all the time. I taught school during the day and worked as a waitress at night for money. I had a day during the middle of the week free and it seemed that I would come home from school to a house that needed so much done to it that I found myself having a drink the whole time I was cleaning up the house. I was faced with a week's worth of dishes and laundry plus cleaning the house. It was a disaster and the only way I could face it was to have a drink with me the whole time.''

Overwhelmed and overextended best describes Lucy's new homelife. Unable to communicate her needs with her new husband, she also is unable to perform her new role from an interdependent perspective. Once again she assumes the responsibility for total home management and she adds to this the role of breadwinner to support them while her husband is getting established in the music world.

''My husband got drafted not long after he finished college and we began to move. The process of going through boot camp, commissioned officer's training (OCS), and another special school took about nine months but each was in a different area of the country. I was able to get a job as a teacher's aide at a junior high school in those various places. Nobody wanted to hire me for a portion of a school year so I taught seventh grade and remedial reading as a teacher's aide for half the pay. And once again, I felt that my talents weren't appreciated. I didn't drink very much then. But after OCS training, he was sent to Texas for some more special training before being sent overseas and we all lived in the same complex and there were a lot of parties. I enjoyed that. I began to feel like I belonged. And I began to drink more, but still I did not see it as a problem at that time. Several more years passed before we started to have a family and after I had my first baby I began to realize that there were times when I knew I had way too much to drink, but I still didn't have any idea about what was happening to me. I began to make promises to myself by saying 'next time, I'm not going to drink so much' because I didn't like the way I felt the next day. I'd get horrendous mood

swings, be exceptionally irritable, and just be very difficult to be around. I still couldn't piece together what was happening to me. My father drank, and everyone in the family knew that my father drank, but if anyone had ever said my father was an alcoholic those would have been fighting words. My father was a college professor and they weren't alcoholics! I really didn't have any idea about what was happening to me. And I hadn't lost anything. I was never fired. I was still teaching. I was raising a family. I was still married to the same man. I just knew that I drank too much by the way I felt the next morning and I began making promises to myself not to drink so much the next time. I could abstain from drinking for long periods. I didn't drink during any of my pregnancies. But if I did drink, I never knew what was going to happen. I just couldn't seem to stop. And most of the time I never knew how much I drank, I just knew it was too much. But still, I didn't make the connection—the fact that I binged and kept needing more. I was too concerned about how lonely and how empty I felt inside. Life just wasn't a happy experience for me.''

Wanting to be treated with consideration and gentleness, wanting encouragement and wanting to receive acknowledgment for those things we have done well are human needs each of us will strive to achieve. If we perceive that they will not be granted by those closest to us, the pain of that realization leads us to seek relief. Lucy felt defeated in her pursuit of human need fulfillment. Neither parent acknowledged her worth and value. Following her father's example, she married a musician who spent much of his time away earning a living. Unaware that she had set herself up to continue the pattern of her childhood, Lucy began to look for ways to relieve her intense loneliness and to ease the burden of living. Alcohol brought relief. It blocked the pain and for a time she did not have to deal with it. ''I didn't have to feel,'' she says. Lucy's preoccupation with finding relief for her intense pain dimmed awareness of her body's response to alcohol. Although she began to notice that when she did drink she consumed too much, she was not able to discern the reason. She only knew that she had had too much by the way she felt the next day.

Nodding in instinctive understanding to my question about recognizing her merging dependence on alcohol, Julie begins by saying: ''I couldn't be an alcoholic, I was too young! I was too pretty! I was a successful model! I couldn't possibly be different! I just had a tremendous capacity for alcohol. I always needed more than anyone else to make me feel good and I didn't see anything unusual about that. I just thought that was the way it was with me. I didn't know anything about alcoholism. In those days it was a subject one didn't discuss. My father drank and it took a lot to make him feel good too. I didn't think our family was any different. I wasn't abused. I had some misconceptions about our family and I thought we were dirt poor when in reality we weren't. My father was never fired. Although I didn't feel free to talk to my mother about how I felt, I knew there was something better out there and I was going to find it, wherever 'it' was.''

''My first apartment was in the Village and I worked in New York City. My lifestyle was such that I would come home from work and I would make it as far as 'Joe's Tavern.' I would stop there and I would drink. I had a tremendous capacity for alcohol and some nights I never made it upstairs to my apartment. I just sat either in the bar or outside and I loved being in a crowd of people. It made me feel like I was holding court. I was the center of attention. I loved sitting at the front of the bar surrounded by all these people with all this superficial bullshit going on. I was young. I was pretty. I got a lot of attention and I had a *wonderful* time.''

''I wanted to have a steady boyfriend but I didn't make any effort to get one for a long while. It was more comfortable for me to be in a crowd. I've been a loner all my life and way down deep I didn't want anyone getting too close to me. One side of this was that if the person really knew me, he or she would find out just what kind of a terrible person I really was. But the other part was that I would have to make a commitment to the relationship and I couldn't do that. I didn't know how. I didn't know what loving someone was all about. I didn't know what it felt like to love someone even though I wanted to be able to give and receive someone's love. I was terrified to have someone love me, yet I wanted it very much.

I think deep down I felt love would be the way to fix me—to fix how I felt about myself. I didn't know anything about the concept of loving myself first. I was brought up that my needs didn't count. So I put the responsibility on other people to do that for me. I wanted somebody outside of myself to give me inner peace. I thought that's what a man was supposed to do but eventually I married a man who would let me do what I wanted to do—drink.''

Julie's ability to use her beauty to make herself the center of activities partially satisfied her human need for attention. The root cause of her unhappiness, the ability to know and accept herself as she is, remained unattended. We strive to meet our human needs as best we can. Among those women reaching maturity in the 50s and 60s, being superwoman, being perfect, and being exceptionally dependable were seen as ways to be recognized and valued. In contrast, those reaching maturity in the 70s and 80s found that ''conning you,'' ''buying friends,'' and ''lookin' pretty'' were effective ways to get what they felt they needed. Although they expected more from others when entering a relationship, their inability to trust enough to risk sharing something of themselves to keep the relationship going prevented them from having one. Continually searching, their energies were directed toward seeking more. Frequently disillusioned when others did not live up to their unrealistic expectations, they continued to drift from one relationship to another seeking ways to fulfill their human need deficit.

''Even though I gravitated towards people who played and partied the way I did,'' Julie continues, ''I always got to my classes and to work. I was working part time along with going to school and no matter how late I stayed out, no matter how awful I felt, I got the body to where it was supposed to be. I was responsible and dependable. That had been ingrained in me. That much I did. When I finished college my mother wanted me to move home and I said no way. I got a job and moved into my own apartment and the first thing I did was stock a bar. That was *very* important to me. By this time I was feverishly concerned about receiving approval and I thought that being a good hostess was the way to get it. When I had

a party, it was important that you came and had a good time and say 'My, what a wonderful hostess Julie is.' So I would go into debt. All you had to do was bring you. And my idea of a good time was starting a party Friday night, filling the bathtub with beer and just partying and playing until Sunday afternoon. And I did this fairly often."

Being a "pillar of the community" through reliability, exceptional performance and vast accomplishment were highly valued ways older women sought to be recognized and earn respect. "I never cut any of my classes in college," says Geri. "It was important for me to be there. I never missed a day of work either, that was important to me too. It was important for me to convey to you that I was exceptionally reliable and dependable. Well, I didn't miss any work until my drinking got to the point where I couldn't control it any more. But up until that time I never missed a day of work. And I worked a lot of overtime. That was important to me. To be responsible and dependable. My job was everything and my standards were high. My work was such that what I did was very quickly recognized. And when that happened I strove to be even better than what you expected. If you said that I could do something, then I was going to do it to the best of my ability and then some. I had to do that to prove to you, but more to myself, that I was of value and worth something as a person. And you had to recognize me for doing all that. My evaluations had to be top-notch. I couldn't accept anything less. And when you did come through with the excellent evaluation, then I would knock myself out to do even more and to make sure it was done perfectly. I couldn't accept anything less from me, and I couldn't tolerate it if you didn't agree with me. It was an exhausting merry-go-round and you were caught up in it too. The more I did, the more I had to do, and then you had to compliment me for it. I could never be less than perfect. I could never be human."

Codependency is a fairly recent term denoting a process in which a person totally organizes his or her life around another. One's own personal human needs are suppressed and the individual becomes overconcerned with another's needs. To express the concept in a simpler way, the codepen-

dent wakes up each morning and checks the feelings of another to determine how he or she will feel. Then, he or she tries to anticipate and fulfill the other's needs. A loosing battle! As the dynamics of alcoholism become more fully understood, this concept originally thought to apply only to the spouse has been gradually extended to other family members. It is time to extend the dynamics even further. Alcoholics go to work. Just as alcoholism and other dependencies can take control of a family, a worker's impairment can take control of the work unit. Before the impaired worker is identified, the manager and other staff members may experience a great deal of unexplained frustration, as alcohol and other drugs ursurp control over the work unit. The impaired person manipulates the manager and co-workers, quietly arranging a schedule and activities to accommodate the addiction. As a result, the manager and staff often end up spending a lot of time dealing with the impaired person rather than getting their jobs done. Geri illustrates one form of manipulation to meet her human need to be recognized as being the best. Although unintentional, the manager has been caught in the cycle of codependency. Constructive criticism or a change in any procedure deviating from the established way of doing things will not be tolerated. As the woman's chemical dependency grows and undependability, unpredictability, and absenteeism become the norm, co-workers will find themselves assuming responsibility for her work. As their frustration mounts and turns to anger, the stage is set to meet myriad, never-ending expectations of the alcoholic. Employees and managerial staff now find themselves on the giving end without reciprocity. Nothing helps, nothing satisfies, and it's never enough.

Among the younger women, "conning you" and "buying friends" were perceived as ways to feel like somebody and to be accepted. "It didn't take me long to figure out that money bought me friends, at least until the money was all gone, but it gave me a sense of being something for a little while," Beryl tells me. Pausing briefly to adjust her glasses, she begins to laugh quietly. "My mother wanted me to come home every time I had a free moment, but I kept telling her I was studying for exams. I was *always* studying for an exam! And the

times when I didn't have one to really study for I would go to the bar across the street. Most of my drinking at that time wasn't to the point of blacking out, but it was excessive drinking. I had a high tolerance from the very beginning. I don't remember how much I was drinking at the time but my friends told me that they always ordered two pitchers of beer—one for the four of them and one for me. But I felt at home in the bar and I found it very easy to go into one. I could go into a bar dead broke and come out very drunk and $25 richer and never turn a trick to do it. I found that if you slobber over a guy long enough and promise him most anything, he'll buy you a drink. I went to the same bar all the time so I made some friends and after a while I was able to have a bar tab and that helped. A lot of times the fellas who frequented the bar would say: 'I've got to leave now, but here's $5 to buy the next round.' I just put that in my pocket 'cause there was always somebody to buy the next round and I needed to have some seed money for the next day.''

Buying friends was the way Beryl perceived she could be accepted in a social setting. Personal recognition came through "conning you." It also met her need for the money to continue her activity. Although the quality of the relationships was questionable, she was meeting her personal requirements as best she could.

As I approach the red brick ranch house nestled in a cul-de-sac, Marissa motions for me to take a seat beside her in the empty rocker. ''It's nice to see you again,'' she says. ''I thought we could sit here and talk, it's such a lovely morning.'' And indeed it is. The warmth of the morning sun highlights the remaining night's moisture on the well manicured lawn, illuminating exquisite azaleas surrounding the porch. Their energizing red exudes both warmth and gaiety indicating loving care. A towsled haired toddler appears and runs to mother. The child warily eyes the approaching stranger. A warm smile emanates from Marissa as she leans forward to help the child into her lap.

With a twinkle in her deep green eyes, she begins to respond to my request that she clarify an earlier statement about her lack of self-awareness in her developing chemical

dependency. I wanted to understand how these developing behaviors went unnoticed not only by herself but by others too. "Of course," she says, "I was never going to drink like my father did. I was never going to be an alcoholic. And up until the time I was about 15, I had the occasional glass of wine at a special dinner and that was it. But something happened along the way and that changed. By the time I was half way through high school I had started to drink like everyone else did when they went to baseball or football games. I lived out in the country in a very small community and drinking became the thing to do when we went to local events. From the beginning I drank to get shit faced drunk because I thought that's what one did. That's what my daddy did. And that's what everyone around me did. And so from the beginning I drank to get drunk. I can remember my mother who was, and probably still is, a classic enabler telling me to switch from Whiskey Sours to Tom Collins because they came in taller glasses and they would last longer and I wouldn't get so drunk. Well, you know they didn't last any longer. I just continued to gulp down whatever I had in my hand to drink! But deep down I wanted attention. My father's alcoholism was called his 'nervous condition' and periodically he would get shipped off to the VA hospital and my mother would take all of us kids on a 'cultural opportunity.' So, Daddy would go to the hospital and we would go to Europe or New England or some place like that. It didn't take long before it got to be a guarantee in my head that being sick meant something positive for me." Suddenly smiling, she continues: "I was around 13 when my father began his recovery and that did not seem like a very positive thing to me because all of a sudden he was around the house all the time and he had those A.A. people with him. I couldn't manipulate him any more. But I could see that all the way through this it was my father who really got all the attention. Even though we got to go on 'cultural opportunities' when he went to the hospial, what it really translated to me was that he was getting attention from others and for a time we were free to do our own thing. And I didn't see us getting any attention. It was never our turn!"

"The time came when I started to abuse my body so that I could get medical attention too. I remember having a couple of medical tests for which I was given intravenous demerol and valium and I found it gave me a tremendous feeling of well-being. I couldn't care less, you could have done anything to me, it felt so good. It was a euphoric rush before a nod. I was determined to find a way to get more. I wanted to feel that good again! So I began to con all the doctors into giving me prescriptions for anything from back pain to nerves—and for quite a while it worked. And when it didn't, I stole a prescription pad and started writing my own."

Being appreciated and receiving attention are two important human needs. Appreciating a person and giving that person individual attention says that I have taken critical notice of you and I acknowledge your importance and uniqueness as a person. I keep affirming that you are important and that in and of itself bestows worth. Each of us will search for a way to receive our due share of attention from those who are close to us. Marissa realized that being sick meant getting attention. Abusing alcohol also got attention. The life of her family revolved around it. But when Daddy got to be more than the family could handle, he went to the hospital where the experts gave Daddy attention. Although the by-product of Daddy receiving attention from the experts was getting a family "cultural opportunity," it was still Daddy who got the bulk of the attention. Later, as Marissa began to drink herself, she abused alcohol too. She also found she could abuse her body and receive attention from medical experts. Her one exposure to a narcotic combined with a tranquilizer provided her with the feeling of well-being and the promise of making life easier. The pattern was in place—to drink excessively and then to seek medical help for problems unrelated to alcoholism.

Cassandra and I are sandwiched among the piles of books and papers in her studio apartment. I can sense her new determination and her nervousness as she prepares to reenter the professional world with new skills. "As I said before, I was a very shy person and in many ways I still am. I've been a loner all my life," she says. "I just felt I couldn't measure up

to anyone's expectations 'cause I certainly felt I couldn't measure up at home. I honestly believed that I was not good enough to have a friend. I didn't think anyone would want to be my friend. And I felt bad about myself because I could see that I just wasn't accomplishing anything. I wasn't the all around beauty queen, I wasn't the sports queen, I didn't have any hobbies or activities that were all consuming and made me want to spend time doing them. And I felt bad about that but I just wasn't interested in sports and I thought I should be. I did know people. I did get out and mingle often but a lot of my contacts were not very deep. I made sure I kept my distance so that no one would be able to get too close to me. And I guess I expected too much from others. I expected them to meet my need to feel worthwhile as a person. I'd meet someone and think 'well, maybe she will be my friend' and then something would happen, she would let me down. I'd get disillusioned, say the hell with it, and then go off on my own with a whole new different set of friends. I was always looking for something—always searching. I'd start wandering around to see what another group was like—it was like a rub-off from my mother. My expectations of people were so high that when they wouldn't do something for me that I thought they should do, I'd be devastated and then I'd say well, forget you, I'll just go on my way. I'd forget that I'm human and so are others and that I can't place such high expectations on others to meet my needs. That sets me up for failure and disillusionment and that's been a pattern with me all my life. But when I was drinking I felt accepted. I felt very popular, well liked, and I had the confidence to be outgoing and talk to people. Like I said I'm very shy and insecure, but just let me get a couple of drinks in me then I can get outside of myself a little bit and be outgoing, carefree, and flirtatious.''

Looking to others to quell the inner discontent, yet at the same time afraid to risk letting people become close and get to know her, Cassandra searched for someone whom she could trust to meet her needs. Unable to perceive that she was worthy and had value, she erected a barrier to keep others distant. Following her mother's example, she drifted from person to person expecting others to do what she could not do for

herself—accept her as she is with all her strengths and limitations.

"I knew I had to clean up my act," says Jennifer. "I was in a work study program and it was getting to the point where I would be spending more time in the work place than in school. It's amazing what you can do when you are in early or middle stage alcoholism. If I had a commitment or a deadline to meet, I'd just meet it. I just found other times to drink. I was busy and the time went so fast. It seemed like I just turned around and it was time to graduate. Now I was out in the working world and it was a shock. For the first time I realized I was now an adult and I was supposed to be responsible. And I didn't want to be an adult. I felt I was still growing up. I still thought of myself as a kid. I was still waiting for my mother to sober up long enough to give me the attention I felt I needed! But I knew I was supposed to be thinking of myself as a woman and I was just terrified. I was petrified about managing money and the thought of getting my car serviced was a real anxiety trip! I didn't know how to go through the motions of day-to-day living and my first job was high stress city! I worked evenings because that was the place where this company started all its new people. I was so tired when I got home that I just went to bed and I found myself sleeping until it was time to get up and go to work again. I began to think life and adulthood were terrible, there was nothing to do. I was missing the whole world! I didn't know that if I worked evenings I needed to get up by 9 A.M. so that I could have some sort of productive, fulfilling day before I went to work so I wouldn't feel that way. And then I figured out that I could start partying after I got off work at 11. I just went nuts for a whole year and partied, partied, partied. I had six boyfriends and it was great. It was a real ego trip for me—these guys were beating my door down. I was finally getting the attention I always wanted to have."

During my second interview with Lynne, I wanted to explore my growing conviction that she was never able to break the bonds of servitude and receive attention in her own right. Her response to my question about this confirmed my thoughts. Although she did go to college, her investment and

concern about what was happening at home led her to make repeated phone calls to see if her mother was drinking. The chain of codependency tightly forged, Lynne's energy remained directed toward home instead of where she was. "I thought I could break the strings by going away to college," she says, "but I found that I couldn't. If mother felt she needed me, all she had to do was to say so and I would drop everything and rush home to be with her. I felt I had to call her everyday just to make sure everything was all right. I could tell if she was drinking by the tone of her voice and I knew that when she really started to drink she got depressed and would try to kill herself, so I would drop everything and go home to be with her. It's a wonder I graduated from college, I spent most of my time going home." "Were you able to make friends in college?" I ask. "No," she replies, "I was too wrapped up in what was going on at home."

When one is in the depths of codependency, all decision making, beliefs, values, and perceptions center on another until one's own individuality is lost. Boundaries—where one person begins and another stops—become blurred and unrecognizable. Lynne's codependency hampered her own personal growth and the opportunity to find and know herself. I wonder how she feels about herself now and so I ask. "It took me several months in recovery to realize that I was also an alcoholic," she says. "I could easily admit to being a drug addict, but I was bound and determined that I was not going to be an alcoholic like my mother. That recognition was painful." "Are you still involved in your mother's life?" I ask. "Not as much as before," she replies, "but we are still close."

Changing my perception of reality, easing emotional pain, making my life easier, and wanting more out of life were perceptions held by the women about drinking and/or the taking of other drugs. They needed more, always more, to help them cope with the unpleasantness of living.

"When I went to college I suddenly discovered I was free from home and their domineering ways," Mary calmly remarks. "All I had to do was keep up my grades, be in the dorm by curfew time, and I could do pretty much what I wanted to do. The first party I went to I got loaded, absolutely

smashed, and I smoked continuously. I was away, I was free, and I really let loose! In the early days of my drinking, alcohol made me more outgoing, more free to enjoy life and the only problem that it caused was that I got physically sick every time I drank. It didn't make any difference if I had one drink or a lot of drinks, my system just seemed to reject it from the beginning. But there was something about it and I kept drinking. After I graduated and got my first job, I was just impossible. I had to be perfect at everything I did. I had to work harder, longer, and have everyone compliment me on what a fine job I was doing. I had to be above perfect. But underneath it all I felt so insecure and alcohol helped to ease those feelings. Even after I was married and had children I continued to drink to ease the total unhappiness in my life. I found myself getting to be more like my mother every day. I was so filled with self anger and I focused it all on other people. Nothing anyone did pleased me. My husband was a successful businessman and in the early years we socialized a lot, but as I became more hostile and angry I found myself becoming more isolated and excluded from his life. I became abusive to my children. I thought nothing of smacking one of them and telling them that I hated them and that I had no use for them. I was beginning to treat my family the same way my mother treated me. I could see it happening and I was powerless to stop it. And I didn't want to be like that. I wanted more out of life.''

Being free, wanting more out of life, being angry, and hating me are thoughts and feelings many of the women had. Unsuccessful in her struggle to break with the past, Mary repeated the pattern of her childhood.

''I was always looking for ways to fix me,'' says Barbara. ''I'd get a good job and put my whole self into it. It seemed as though I was driven. I didn't know what was driving me so hard but I *had* to succeed. I wouldn't admit that anything was too much for me to handle. I'd just figure out a way to do it and get the job done. I had to prove to you that I had worth and I wanted you to regard me as a valuable employee. So I'd work hard and long hours. I'd volunteer for overtime. I became a work-a-holic. And I could hold back my drinking when I was doing this. But after a year or so I'd be exhausted

and I didn't know how to say this is too much. I'd begin to get bitchy and I would snap at people and that was not how I was. I was a people pleaser deluxe. And then I'd begin to dread going to work and my abseentism would go up. Then I'd begin to feel guilty about slacking off so I'd start drinking and then I'd really feel guilty. Finally I'd quit and start looking for a new job. I was always looking for something more. I didn't know what that more was but whatever it was, I wanted it."

Feeling driven, being perfect, being above perfect, working hard, and trying to be the best are feelings and attitudes held by many of the women. Mary and Barbara are not unique in this respect. If, as children, we are allowed the freedom to adopt a variety of roles depending on the circumstances, then our human need for confidence, the belief in the reliability of one's self and one's ability develops. We can trust ourselves to know what it is we do well, what our limitations are, and how much physical energy we have to spend. If confidence is replaced with feelings of inadequacy, the woman may strive to do more than she can do thus ensuring failure.

"I was taking a management course and it had a practicum to it and I was having a hard time measuring up to what the professor and the people who were guiding me in the work area wanted me to do," Natasha says. "I just couldn't seem to keep everything together. I needed to escape from my reality and I needed to be able to come home and take an afternoon off. But I didn't know how to take the afternoon off and do something relaxing for me. I only knew how to take the afternoon off with alcohol and alcohol was beginning to cost me too much. It was at that point that I got a migraine headache and the doctor gave me some codeine and you know that stuff was *nice*. I didn't have a hangover and it got rid of my headache! So I began to figure out how I could get some more. I went to another doctor and told him that I had back pain and he gave me valium; then I went to another and told him I had a migraine and he gave me percodan. I took the valium as it was ordered and held the percodan in reserve. In a few days I began to think that something was dreadfully wrong

with me. I started walking into walls and saying wierd things. That scared me so I stopped taking the valium and went back to drinking. I wrapped the valium and the percodan in a pair of old socks that I had and put them in my bureau drawer. It never occurred to me to throw them out. It also never occurred to me that most people put their drugs in the medicine cabinet and not in their socks. I was starting to hide drugs and I was beginning to figure out ways to get more. I needed more. I wanted to have energy to do things that other people did. I wanted to feel good. I wanted to feel like I did when I took that codeine!''

Feeling good, getting me through the day, having energy, and being able to take the afternoon off were Natash's desires. Unaware that alcohol is a depressant, she continued to drink large quantities while resorting to other medications to enable her to feel better. Dependent upon a variety of chemicals to maintain activities of daily living, Natasha soon found she needed more and more to allow her to function. ''I became a 'pot head,' '' she says. ''I didn't really have a drug of choice anymore. I'd take anything, just anything.''

In contrast, being all things to everyone and preventing others from having pain are goals many of the women from an older generation had. ''I was just exhausted after my second baby,'' Cecelia tells me. ''I was having trouble losing the weight that I had gained while I was pregnant so the doctor gave me some amphetamines. They were *wonderful*. Now I had the energy to be everything to everybody. I began to play chemist. When I needed energy I took the amphetamines. Sometimes they made me feel very nervous and up-tight, so when that happened, I took a valium or a drink to take the edge off and calm me down. It wasn't long before I figured out that I could change my mood so that I could be whatever my family wanted me to be. I loved my family and I didn't want any of them to ever have a hurt. I wanted to fix everything so that they wouldn't ever have to feel pain. I wanted us to be the perfect family. But life isn't like that and things just continued to get worse. Nobody was happy in our family. I couldn't hold everything together. I began drinking more

to cope with the unpleasantness of what was going on in my life and I was taking uppers and downers. I didn't recognize what was happening to me. I truly didn't.''

Nanette welcomes me as I step into her spacious second floor apartment. Coffee pot in hand, she guides me to her balcony, which is nicely protected from the spring sun by an enormous magnolia. Her sincere brown eyes are complemented by the dark brown of her wavy hair, which struggles to escape its confinement from a pony tail. ''I remember that when I was growing up I pretended a lot,'' she says at one point in the interview. ''One time when I was about nine years old I remember standing in front of the mirror in my room drinking vinegar out of one of my mother's sherbert dishes. I don't know where I got the idea to do that because my folks are southern Baptists and drinking was certainly not done in our family. I remember I broke the glass and my mother was just livid when she found out what I was doing when that happened. My father's expectations for me were so high that I felt I could never measure up. I never felt comfortable talking to mother about personal matters and when I started leaving the little girl behind and going to young teenagehood, I had some horrendous hormonal and mental changes. My periods had started and my breasts had started to grow and I just felt so strange. And every time I'd try to talk to her she'd just tell me that everything was going to be all right and not to worry about it. But I did worry.''

''I was 15 years old when I took my first drink. I was out on a date and everyone else was drinking and I decided to drink too. I found that alcohol made me feel good. I was comfortable with myself for the first time in my life. So when I got my first taste of alcohol and found out how good it made me feel, I wanted more of that. I got drunk that night and went into a blackout. I remembered going to the party and having my first drink and I remember dancing a little bit, but that was all, that was all! I also remember coming out of it long enough to realize my father was giving me a beating and then I'd just black out again. I really don't remember much of the beating and up until that time my father had never hit me. I was always fearful of my father's authoritarian stance but now I was really

afraid of him. After that episode he took the door off my room and would periodically come in. I felt I didn't have any privacy any more and I began to be afraid that he would hit me again. There came a time when I did ask my mother if I could see a counselor or psychiatrist to help me sort out my feelings about myself. My mother was incensed at that idea. She told me that if I just listened to her and followed her instructions everything would be all right. She couldn't see that everything was not all right. I felt like I was drowning. I couldn't get a handle on what life was all about and I certainly didn't understand where I fit into all of it. And I felt under so much pressure. The stress was horrendous so I started taking pills. They were easy to get at school.''

Unable to freely talk to her mother about the physical changes in her body and accompanying emotional feelings, Nanette felt bereft of emotional support. Afraid of her father's intense anger in response to her behavior, she looked to her peers for support and reassurance. Each of us has a human need to be protected from excessive fear, anxiety, and chaos. We experience fear when those whom we perceive to have authority over us threaten to do us harm. If we perceive that we are powerless over the situation, then fear builds and produces stress. Stress consumes precious energy by keeping the body constantly mobilized to react and requires relief. Afraid that she would be beaten again if she drank, Nanette resorted to other drugs to ease the stress in her life.

Barbara also discusses her harrowing fear when she is surrounded by anger. ''I have an intense fear of anger,'' she says. ''Seething anger immobilizes me especially if it is directed at me.'' ''I can't tolerate anyone being angry with me. I just crumble. It's like, it's all over. I'm done for. My father is an extremely angry man and I'm still not comfortable trying to talk to him. He never shared his feelings. The only thing I ever saw was his anger. I was frequently beaten and sent to my room. I still feel like I don't know this man and now I don't really want to know him.''

Anger is a primary negative emotion that is expressed in homes where alcoholism is present. Those women who experienced intense anger in their homelife were the women who

also experienced the highest level of human need deprivation. Mary, Barbara, and Beryl are three examples. Although Nanette became more afraid for her physical safety after her drinking and blackout episode, fear was present, to a lesser degree, throughout her homelife. ''I learned very early that my father was very autocratic. I mean I just did what he said. I was afraid that he might harm me if I didn't,'' she states.

Although anger may be a person's response to mask his or her own fear, the inability to relate to others within the family structure is intimidating. Intimidation through the use of fear is a powerful negative tool depriving others of their human need fulfillment. When individuals are deprived of basic human needs, their own frustration and emotional pain first smoulder then grow into anger, and later become rage at the injustice done to them. The longer these feelings are repressed, the more filled with rage the individual becomes. ''I had suppressed my feelings for so many years and then the drugs helped to keep me quiet too, but the day came when I started to express my anger. And it was rage. I had become such a negative, rageful person that nobody wanted to be around me,'' says Nanette very quietly.'' Anger was the predominant emotion expressed by all the women—and, those who had experienced the most human need deprivation were the angriest.

Alcohol and/or other drugs blocked fear and eased the stress in the women's lives. As tolerance developed, they needed more to produce the same effect. While most of the younger women drank and used other drugs as a means to cope with their lives, some of the older women used tranquilizers to ease emotional hurts and the loneliness they felt. Their effects eased the stress for these women of putting others first and trying to be everything to everybody.

6

Fitting In

Each of us looks for some way to fit into a group. We want to be part of the family and the society into which we are born. Fitting in is an inherent human need that all of us have. It meets our requisite to be connected to something outside of ourselves, to belong, to nurture and to be nurtured, and as such, all human energies are directed toward meeting this end. How we go about fulfilling our intention will depend, to a great extent, on the image we have of ourselves. Do we feel that we have what it takes to fit in and be accepted in the group of our choice? School is the focal point of a child's life. It is here that one first encounters the challenges of life. Lack of approval and acceptance at home lead to a desire to find it among one's peers. The perception of one's low self-worth, however, prevents acceptance of challenge in areas that require skill development such as athletics or intellectual pursuits. Unfortunately, the easiest group to fit into is one that is involved in some form of substance abuse. There one is accepted at face value.

"I had just turned 17 when I was sent to college and it was very obvious to me from the day I arrived that alcohol was associated with a lot of social events." Natasha replies. "I was not about to let on that I didn't know how to deal with this

drinking business. I mean everybody else seem to know how to drink and so I just talked like I drank. I just said to people 'Oh, sure, I've done such and such' or 'when I was in school we drank' and I just pretended to everyone around me that I knew how to drink. But the reality was that up until that point in time I hadn't had anything to drink.''

''One day I had a biology test that was really a stink-a-roo and a girl with whom I had become friends asked me to go out and have a drink with her after it was over. And of course I went. And I thought,'oh,'I'm really going to have to do this now. I think I drank six or eight beers and got totally wiped out. I didn't like the taste of beer, it was awful. But I'd drink and gag and drink some more. I think I had a blackout that night because I don't remember how I got home and the girl I went with was drinking more than I was and she couldn't remember either. But I felt socially accepted, that was the whole thing in a nut shell. I don't really remember much of what it was like to be drunk that night but I do remember that I was part of the crowd.''

''Over a period of time, I learned that when I drank my shyness disappeared. I was a real shy person and I learned that with a couple of drinks I could talk and just be the life of the party. But as I said, a lot of it was just fitting in, just being a part. And I didn't get the part about you don't have to get drunk to fit in so when I drank I'd get drunk. And that may have had a lot to do with where I learned to drink. I learned to drink with other alcoholics in a college environment where most of the drinking was weekend party drinking and heavy drinking for the purpose of getting drunk. I didn't learn from people who had social drinking skills. But I doubt if that would have made a difference. I really believe I was an alcoholic before I took my first drink and that it wasn't the process of drinking that made me one. I feel that I had the predisposition to do it anyway and even if I had had wonderful role models, my body would have handled alcohol differently. My drinking history was just different from someone who does not have that predisposition to alcoholism. But there is another side to all of this. I never really felt that I was a part of college life. For some reason, I didn't feel that I had what

it took to be socially accepted even though I knew I was smart enough to do the work, so I gravitated to people who were on the fringes. If I had a date we either went out to a bar some place or we went over to see one of his friends who was not connected with the college and we watched TV and drank So I was never really a part of the college scene.''

Wanting to fit in, yet fearful that she would be unable to do so, Natasha pretended that she drank. When the occasion finally arose and she had to make a choice, she drank without regard for the consequences. Her aim was to fit in, to be accepted, and to belong. Getting drunk, she perceived, was what one did when one drank.

Earlier Natasha shared with us her frustration in not being able to openly and honestly discuss matters of importance to her with her parents. Trust and intimacy were unknown entities in her life-way. She also held the knowledge that she was attracted to other women, a matter she was definitely not able to discuss with her parents. She also told us that she grew up in another culture. Her periodic visits to America left her confused and homesick for the familiar surroundings she had enjoyed while growing up. Home was a known entity and as such it felt comfortable. Feeling different and alone in a strange setting, Natasha struggled to fit into a new way of life—the culture of her birth right. She wanted to be accepted. Her unanswered questions about who she was, together with her belief that she was less than, combined to produce feelings of social inadequacy that prevented her from accepting the challenge of assimilation. I asked Natasha how she handled the awareness of her sexual desires while she was in college. ''I didn't,'' she replied. ''I thought I would never have the opportunity to explore who I felt I might be. I was afraid to let anyone know so I'm sure that was another factor in staying on the fringes. I remember there was a woman in one of my classes who was gay but she was so different from me and I didn't want to be like her. She took a lot of verbal abuse from the straights too. I was afraid if people got too close to me they'd find out and I couldn't handle that.''

Dating people on the fringes, drinking to get drunk, and drinking with other alcoholics were ways in which Natasha

sought acceptance. Not feeling good enough to be a part of the college scene, she dated others who also saw themselves as "less than." Her image of low self worth prevented her from seeking the company of those who were involved in intellectual pursuits and who may have used alcohol in a different way. Instead, she gravitated to the group whose focus of social activity centered around abusing alcohol. "I wasn't really a part of what was going on in college," she says. "I drank very heavily and I drank several days of the week as well as on the weekends. My drinking went very quickly from being a thing that was supposed to be a social event to hanging out with the alcoholic crowd. And to be a part of that crowd I drank a lot, as much as possible. I remember being inducted into the secret fraternity of the heavy drinkers so I wasn't doing the normal social things that other college people did. I was doing social things with other alcoholics and trying to be accepted by those wild people—the heavy drinkers."

"I can remember when I was about 12 having a small glass of wine at Thanksgiving and Christmas dinner," says Kelli. "It was sort of saying that I was growing up and that made me feel good. I didn't have anything more than that and I certainly wasn't out lookin' for it at that time," she continues. "It was the summer before I entered senior high school when I got to go to my first party that wasn't a birthday party type of thing. I guess I was about 14. I smoked pot for the first time and really enjoyed it. I also got drunk. I didn't plan it, it just happened. Drinking and smoking didn't make me sick, in fact it made me feel very good. I felt 'together' inside. Everything worked right. I had the confidence to meet people and I felt I was in control of my behavior. I was definitely shy and always felt a little bit uncomfortable in new situations where I had to go and introduce myself or get involved with something that I wanted to do. I found that alcohol made it easier for me to meet people. It was also an easy way to be accepted as a part of a group. By this time in my life it was becoming much more important to have friends and to be a part of a group. And that night I really felt a part of everything and I felt good. It's hard to separate the two—alcohol and pot—

they just made it a lot easier for me to ease into a group and to be accepted.''

"I love sports and I wanted to be on a varsity team. Drinking was a part of that, unfortunately. Where I went to school, people who played sports drank. Even today, whenever someone mentions rugby, I think beer. I wanted to play on the varsity volleyball team. Going for practice and competing with strangers was one of the most difficult things for me to do at that time. And alcohol just made that a little bit easier for me to do. As I got more involved in high school, I began to go to various school functions like basketball and baseball games with my friends. It was at this point in time that I started to be deceptive about where I was going and what I was doing. I knew what my parents wanted to hear and I never lied about who I was going with or where I went, but what was never included was that we were going to be drinking on the way to the function. Every spring the church just down the street from where I lived had a fair and I would tell my folks that I was going to it and I'd tell them who I was going with. They knew my friends so as long as the names sounded O.K. and the places sounded O.K., they tended to trust me and say go ahead. You see, I knew what kind of information my folks would be happy with and which people met with their approval. Again, what didn't get included was that we were going to be drinking on the way there and afterwards. Most of the drinking that I was doing was either in somebody's car riding around or at one of the parks or at somebody's house if their parents were out of town. It was a very deceptive kind of thing. But I belonged.''

Wanting to belong to her social unit and be selected to be on the varsity volleyball team were Kelli's aims. She understood drinking to be part of the requirement to belong and she found that alcohol did other things as well. It helped her to overcome shyness and provided the confidence to handle new situations.

"In the beginning, drinking was something I did occasionally with my friends. I remember, though, that it didn't seem to take long before I was drinking junk like lemon extract 'cause

I could walk into a grocery store and get it. And a couple of ounces of that was enough for somebody of my build to definitely feel. It was gross stuff though! I also found for somebody my age that it was a lot easier to get and use drugs. There was no age limit on it and the drugs were basically accessible to whoever knew the right people and there were certainly a lot of people at the high school that I went to who were using various things. It was also easier in that the average teacher or parent didn't pick up on the fact that somebody was using drugs. Most people would pick up on the smell of alcohol, but if I were high on pot or speed no one picked up on that. I could go to my classes, go home and talk to my folks, and it was just a little bit easier to hide. Things were O.K. until I hit my senior year in high school and then I began to notice that something was going into my system almost on a daily basis. But it still didn't occur to me that it was excessive and of course by this time my friends had shifted and we were all doing drugs fairly often.''

''I made the varsity volleyball team in senior high school and was accepted as part of the group and alcohol was a part of that but not the most important part. As I got older, alcohol began to be easier to get but playing the game and winning were still more important. It wasn't until I went to the university where I found all this free alcohol at parties that I thought I'd died and gone to heaven. I always liked alcohol better than other drugs and now that I could get it, I was off and running.''

Making it easier to socialize, being able to measure up, being a part of a group, being accepted and feeling like I belonged were statements Kelli made about drinking. Although she had taken other drugs, alcohol remained her drug of choice. She found it to be an effective social lubricant. Alcohol gave her confidence and the feeling that she was accepted by others. She had the knowledge that she belonged to the social group she chose. Together, these drugs and her sense of acceptance from others in the sports group gave her the personal recognition she was seeking and with it the worth and value of being a contributing person.

In many respects, Lucille and Kelli have parallel patterns in their life-ways. Lucille, too, was shy and perceived a lack

of emotional support from her mother. Her questions about what it feels like to be a woman went unanswered. What is it like and how does one feel when one is connected to the heritage called women, she wondered. What am I supposed to know about this? Perceiving her physical body to be unacceptable, emotional and spiritual development remained unchallenged. "How would you describe your view of yourself," I ask her. "I think I felt as though I didn't fit in anyplace," she answers. "Somehow I got the impression that I wasn't like other kids, although now I realize that many kids feel this way when they are growing up. I think what made the difference, what set me apart, was that I felt emotionally more immature than my peers. They always seemed to be more mature, more grown up, and more comfortable with themselves. I did not feel comfortable with myself and I couldn't pin down the reason. I just felt a lot younger or more immature than everyone else and that feeling persisted all the way through college. It was the alcohol that took away those feelings. I felt more confident about myself when I drank. I felt others accepted me no matter what my body looked like. It didn't make any difference if I was a little chunky in spots and didn't look like Miss America. Drinking helped to change my perceptions so that I felt that I looked as good as everyone else and I was on their level of maturity. I didn't drink to get drunk, but it seemed to be a guarantee that everytime I drank hard liquor I'd get drunk. So I started drinking beer. But I'd still manage to get drunk. My mother took valium and when I was growing up I stole some from her periodically, I remember that. And drugs were easy to get in school so I started taking them. It made me physically relaxed but at the same time I felt rather euphoric. It was very similar to the way alcohol felt before I got drunk. And I found, in the beginning, that when I took drugs, I didn't drink as much."

Lucille found that when she drank she felt comfortable, as mature as others and that she had confidence in herself. Recognizing that when she drank she frequently became drunk, she began to take tranquilizers and other drugs to enable her to move with ease amongst members of her peer group. She was able to get back in good graces with her room-

mates because she was not drinking to oblivion every time they went out. Drugs changed her perception of reality and she felt secure in who she was and comfortable with herself as a person. She believed that she was functioning and fully participating in the world around her.

The ability to accomplish a goal through expenditure of special effort fulfills one's human need for challenge. This human need was a factor in Doreene's life-way. "I got interested in the theater group at school and that gave me something to do," she tells me. "If my teachers saw that I had all my schoolwork done then they would let me go from class and work on scenery and sets and costumes and all that sort of stuff. You see, I was a gifted student but even though it was the 70s, we didn't have a place for people like me to go to school so I was in with the mainstream. I'd finish my work in nothing flat, then I'd have time time on my hands and that's when I'd get in trouble. So when the teachers saw that I was interested in drama, they allowed me to use my creative talents, and I did. I really enjoyed the theater and it kept me busy. We got to be a special group, a clique within a group, and I belonged. I had talent and it was recognized. We had a special room backstage where we could gather and that's the place we'd drink and smoke pot and the music director was right there doing it with us. So that was the life I led during the remainder of my high school years, but all my parents saw were my successes and they were really ignorant of my behaviors. They couldn't see that I was a full blown alcoholic and that underneath all the bravado I was miserable. They couldn't comprehend that. They just wanted me to be O.K. and they thought: 'Well, she's working, she does all these things, she's getting straight A's, she must be O.K. She'll grow out of her drinking sprees.' But I didn't, things just went from bad to worse."

To realize one's desires through one's own effort brings self-fulfillment. Realizing Doreene was a gifted student, her teachers allowed her the freedom to exercise her imagination and be challenged by participating in the school's theater productions. They attempted to meet her human need for self-fulfillment as best they could. But alcoholism invades every

facet of life. Permission was granted for the drama clique to smoke pot and drink alcohol while working on theater projects because the teacher in charge was an active alcoholic. Unaware that their daughter was an alcoholic, Doreen's parents patiently waited for her to grow out of her ''adolescent drinking sprees.''

''When I first started to drink it was to fit in and belong.'' Cassandra says. ''It was later that I began to realize alcohol relieved the stress and helped me to feel better about myself. I felt very accepted by the group of people who were regulars at the bar that I went to and I began to feel pretty good about myself. I finished growing up in Europe and there were places where young Americans went to hang out and I went there too. My father wasn't too crazy about the idea but by this time he and my mother were wrapped up in their own drinking so I just went my own way. I was a junior in high school when I became a regular myself at 'Pete's Place,' and pretty soon everyone knew me by name. They knew who I was. I was recognized. That made me feel good. They knew me. I was accepted. I felt very popular; people talked to me and I danced, and drank too, but I had a good time. And I started to feel good about myself. So I started going there every night because I wanted to be someplace where people knew me and I felt accepted. And that lasted for about a year. My brother came home to visit and he introduced me to amphetamines so now I was both drinking and speeding. Somewhere in there I began to feel very insecure and inadequate sexually. I didn't think I was good enough to be anything and so I became very promiscuous. I began to feel like that was the only way I could be accepted. So I started sleeping around a whole lot and from there it was all down hill. I began using sex to get attention and to get my positive strokes but underneath it all I was disgusted with myself for doing that. Now I really had a reason to hate me.''

Feeling confident, being popular, and fitting in were perceptions Cassandra had when she became a regular at ''Pete's Place.'' However, feelings of inadequacy returned as she struggled to understand her feminineness and its relationship to herself as an integrated and whole being. Feelings of guilt

and disgust emerged as she began "sleeping around," giving her reason to hate herself even more.

Fitting in and being accepted by those outside the family are vital human needs. One fits in by doing the social things that other members of one's group do. Drinking may be one of those things. Women maturing in the 70s and 80s had one thing in common—drinking was a way to fit in and belong. Getting trashed was perceived as the way to fit in. "I got trashed my first weekend at college," Carnelian calmly remarks. "I mean I was absolutely blasted. I had never gotten drunk before and I just wanted to see what it was like. But there was something else behind all of it. I felt part of the group that night. I felt like I belonged. And I wanted to belong. I wasn't gonna be a stick in the mud the way I'd been in high school. I was gonna cut loose in college and have fun and if sitting around a bar eating pizza and drinking beer was how to get into the group, that's how I was gonna do it. So that first time I just kept drinking and drinking and drinking and got absolutely wasted. It was *wonderful*. I had a *wonderful* time. I wasn't driving and we weren't that far from the dorm anyway. I found that alcohol really helped me loosen up. I could say anything and do anything—I could get up and dance, and I did. I didn't go to any of the dances in high school because I was scared to death to get out there and do that sort of stuff. But I found when I drank that I could talk to the guys and I could share with the other girls a little bit of what was going on inside of me—but not too much because I didn't want them to think I was weird. For me, alcohol was a nice way of getting rid of tension and stress. I didn't get drunk every weekend in college, but there were many weekends that I got trashed."

Getting trashed meant getting drunk. It was the way to belong to the social group Carnelian had selected. Alcohol helped all the women to "loosen up." Although the quality of the social encounters were questionable, both Carnelian and Cassandra perceived that alcohol was the mediator helping them to successfully interact with their peers.

Thoughtfully, Jennifer begins speaking. "I think basically what alcohol did for me was to take away the inhibition and give me a feeling of confidence in myself. When I first began

to drink I was a happy drunk 'cause I was having so much fun. I *loved* the feeling alcohol gave me. It gave me confidence, took away my inhibitions, and I wasn't afraid to say what I thought or how I felt. It made it easier to meet people. Well, the quality of the encounter was always in doubt depending on where I was in the night because I always drank to get drunk. I couldn't wait to get drunk. It was the process leading up to getting drunk that I enjoyed. I'd say the first four drinks were euphoria, then it was like maintenance and my goal was to maintain that euphoria—that good feeling. And I was able to do that all through my senior year in high school. But as my tolerance got up and I became more experienced with being drunk, it wasn't a new experience any more. It wasn't thrilling or exciting. It was just—yuk!''

''By the time I was a freshman in college I decided this had to stop but I found I was unable to change the routine. I would continue to go out night after night and get drunk even though I knew I had a lot of studying to do and I didn't want to be hung over the next day. But I'd still do it. Some weeks my roommate and I would party all week and by Sunday just be really wiped out, exhausted, and sick. And we would both say we're gonna stay in this week and get to feeling better and we'd make a pact between the two of us to do that. But the next opportunity we'd have to go out and get loaded, we'd do it. Talk about being powerless!''

''By this time, the crowd that I was running around with was doing the same thing. I set myself up in a group of people who didn't have any other way to entertain themselves either. We were all well into our habits, but by the time I was a freshman in college, I didn't know any other way to go out and have a good time. I didn't know how to entertain myself or to have fun without drinking. Aside from swimming and a few of the activities I did in high school, I didn't have things to do. I didn't have hobbies or interests that were compelling enough that would keep me out of the booze and the drugs because I started at such a young age. I hadn't really learned what most people have learned by the time they are just getting into college—like gee, I like to wind surf every chance I get and I just love to do that. People who aren't addicted have

those things that they just love to do and I didn't have any of those things. I could identify that other people had hobbies and normal habits and relationships, but I didn't have those things and I felt stuck. I didn't know what else to do so I just kept on drinking. And from time to time I tried to make friends with people who did have the things I wanted in terms of healthy patterns in their lives, but it always came down to the drinking and drugging crowd being the most important group. And I kept going back to them."

Feeling confident, being able to talk to people, having fun, and feeling good were ways Jennifer used alcohol to cope with her growing feelings of low self worth. She sought the company of others who drank like she did, and she enjoyed the feeling that went with getting drunk. It made her feel good. It gave her the ability to socialize with others although she recognized that the quality of her relationships was not the best. In less than a year she found herself unable to change the routine. She had crossed the line into addiction.

"My teenage years were rough," says Nanette. "After my initial experience of being caught by my father and beaten for drinking, I started smoking pot. I only did LSD twice and I really liked it. I never had a bad trip at all. I enjoyed it because I could just kind of get into my own mind and look at all those colors that would go floating past. Things looked so different to me than the boring reality I had to live with and I guess that's why I liked pot, it wasn't boring reality. Pot was also the drug of choice for the group of friends that I wanted to be with too. I've always been very outgoing when I was growing up and popular with a number of groups of people. Almost everyone liked me but when I got to junior high school I had an identity crisis. I was in with a larger group of people. There was more competition for grades and all of a sudden I felt very ugly. There was something wrong with me compared to other girls and I hated that feeling. I knew I had to change that and I did. I knew exactly who I should go and try to be friends with in order to become one of the popular little group. And by the time I got to high school, I had made it."

"The group that I wanted to be with were probably from a little bit more well-to-do homes than mine. I guess you could

say they were upper middle class whereas I was just middle class or something like that. But, to me, they had nicer clothes than I did but I was able to copy that. I was able to get my mother to buy me the things I wanted to wear to fit in. It also seemed as if their parents were a lot more lenient with them than my parents were and to me they looked like they were having a much more exciting life. And I wanted to be a part of that. They were into smoking pot and so I started doing it too. And pot became widely used in the high school I went to. At first it was just alcohol, but sometimes alcohol was hard for us to get because most of us weren't old enough to buy it. But when we could get it I enjoyed the parties 'cause when we drank everyone was more outgoing and sociable.''

''I went to all the parties I could. Everyone was dancing and drinking and they looked like they were having a good time and I wanted to have a good time too. And for a while I was careful not to drink too much 'cause I didn't want to get another beating. It was gradual, but pretty soon a lot of people gravitated to marijuana and then there was kind of a division of groups—those who continued to drink and those who smoked pot. The marijuana group was considered to be the hippie group where it was considered cool to smoke pot and the drinking group was more the preppies. Most of the girls whom I wanted to copy were smoking pot and I looked up to them and I wanted to be a part of that. I don't know why, but I always looked up to girls who were from very rich homes and wore their old blue jeans to school and looked like they were on drugs all the time or the fellows who played in the bands and looked like they were high all the time. I thought that was just heaven. I had some kind of admiration for people who were junkies. And the crowd that drank were called the juicers and they were looked down upon by the druggies. I know that's twisted thinking, but that's the way I thought at that time. That's the way it was.''

Although Nanette experienced popularity and acceptance in earlier grades, the transition to junior high and high school, along with puberty, was stressful. It brought the realization that she would have to use her social skills at a time when she felt the least prepared to do so. Feeling inferior to the group

she wanted to emulate, she was in fact able to get her mother to buy her the clothes she felt she needed to be accepted. Underneath it all, the code of dress and pretending to be "cool," it was her perception of their freedom that she valued. She felt that the girls had choices in what they did that she did not. Having an exciting life and being free were highly valued. Although Nanette was determined to be accepted in her new environment, her feelings of low self worth prevented her from seeking connections to groups other than those that drank or took drugs. By copying style of dress and taking drugs, she easily became a part of the group she had selected. Taking drugs also served another purpose. It brought relief to the overwhelming fear of imperfection. It was "time out" from the stress of every day living.

Failure to fulfill human needs produces stress and requires relief. Failing to measure up, being afraid of Father, being unable to talk to Mother about personal matters, and facing the discomforts of puberty were experiences that contributed to many of the women's feelings of low self-worth. Feeling worthless inhibited their ability to form friendships and connections important in emotional development. Some women used sex as a way to fit in and make themselves feel worthwhile only to later admit that using sex was another form of self-hate.

"I became sexually active when I was 15 and that's another whole part of the picture of how I felt about myself," continues Nanette. "I went with this fellow for about two years when I was in high school and now I can look back and say he was just like my father. He was overbearing and a perfectionist which didn't help my self-esteem any. He called me stupid. He called me dumb any time I said anything so I decided it was better not to say anything, just to smoke and get high—that way I could get away from it all and get some relief. He wanted me to be the perfect beautiful girlfriend and if I had a blemish on my face, he wouldn't take me out or want to be seen with me. Well, of course I had lots of pimples, especially around the time I had my period so I was really ostracized during that time and felt like I was an outcast."

Not being perfect, being an outcast, and not being good enough to measure up made Nanette feel rejected and aban-

doned by those closest to her. "By the time I got to college,"
she continues, "I decided that I needed to be awake. I was
living in a dorm and constantly around people and I wanted
to feel good again. I wanted to be up. I wanted to know what
was going on so I started taking harder drugs like barbiturates
and I just *loved* them. They made me feel absolutely wonder-
ful. My personality came out and I could be that wonderful
sociable, knowledgeable person that I always wanted to be.
And I took barbiturates for a long, long time. I liked speed
too. I went to the campus doctor and told him I had put on
ten pounds since I had arrived at college and I was depressed
and I couldn't concentrate on my studies and he gave me
speed. They were just *wonderful*. I was more talkative and
outgoing and they just put me on a higher level."

"Somehow my folks found out about all my activities and
they pulled me out of school. I asked for help. I wanted to
see a counselor or psychiatrist or somebody, but my folks
became indignant and I knew that was a closed issue. I ran
away from home and I've been on my own ever since. I got
a job as a chamber maid in a hotel and started drinking beer.
I found I had a tremendous capacity for beer and I just loved
it. Occasionally I would steal pills from the guests and I was
beginning to be aware that I wanted to take pills all the time
and I just couldn't understand what was happening to me.
As time went on, I think I tried every street and prescription
drug available at that time. When cocaine came on the market,
I had an instant love affair with it but I began to think that
I needed to do something with my life. By this time I was a
single parent and I knew I had to provide an income to sup-
port my little girl. I was drinking a lot and at first doing a lot
of cocaine, but then I decided I'd better concentrate on going
to college and learning how to do something. I was able to
stop doing cocaine but I had trouble not drinking. That I
couldn't seem to control so I continued to drink. I began sell-
ing cocaine and that's how I got the money to live and go to
school."

Feeling thwarted in her efforts to seek help, Nanette ran
away and tried to make it on her own. She coped the best she
could. Alcohol and other drugs provided some relief. Once

she became aware that she wanted to take pills continually, she was left confused about what was happening to her. As time passed, her alcoholism bloomed and she was unable to stop drinking once she began. A resourceful entrepreneur, she sold cocaine to finance her education and to enable her and her daughter to live.

Although most of the women drank to fit in, not all did. Whereas Mary drank specifically to feel worthwhile as a person, Beryl, and Barbara drank to reduce their stress and ease the pain of living. "When I finished high school, my mother insisted I become a nurse," says Beryl. "All of us were so busy that we didn't have time to socialize, but occasionally we did have get togethers and I'd get drunk. I never planned on getting drunk and I didn't drink with my classmates for the purpose of fitting in. I didn't have any concept of what it was like to feel emotionally close or a part of a social group. I think what closeness did develop came through the work we did. It was more the pulling together to survive and graduate kind of thing. The nuns didn't cut any slack! When we did go across the street to the local tavern, my classmates would leave when they had their fill and I just seemed to stay. As I said before, I was comfortable in the bar. Most of my drinking at that time wasn't to the point of blacking out, but it was excessive drinking. I had a high tolerance for alcohol right from the beginning."

"I did want to socialize with people on my own age," relates Barbara, "but my father wouldn't let me loose long enough to learn what it was like to do that. I was expected to come home right after school and if I didn't then I got a beating when I did come home and sent to my room. I lived in such fear that I don't think I would have been able to make friends even if I had had the opportunity. I knew that the only way for me to escape from home was to get married and get the hell out of there. And I did, right after I graduated from high school. I went back to school and got my education after my little girl was about two years old. To help me through my young years, I sniffed glue and I sampled my father's Nyquil. It was only after I got married and we were out on our own that I was able to experiment with pot and alcohol.

Alcohol and pot brought such a tremendous relief. I didn't have to feel all the pain I was carrying around inside me."

Wanting to be free, Barbara escapes from her father's domination the only way she knows—through marriage. Lynne, on the other hand, is unable to break the bondage with her mother even though mother encouraged her to socialize with people her own age. "I drank," she says, "but it wasn't often. Mother wanted me to go out, have dates and have a good time but I just couldn't do it. I guess underneath it all I wanted some kind of structure from home. I wanted my mother to be a mother and say no to me once in a while. Sometimes I'd think about how I wanted our relationship to be and then I'd begin to cry. I'd also feel very, very quilty because I made a promise to my mother that I would take care of her after my father committed suicide and I didn't want to break my promise. I just had to be strong. I was super-responsible and super-dependable when it came to taking care of my mother. I don't know how I feel about my father's death, I still haven't been able to look at that. I did notice that I was becoming more preoccupied with what might be going on at home and my behavior was getting to be ridiculous. I was living at the university now but yet I would call mom and ask permission to go to a party on the weekend!" "What did she say?" I ask. "She always told me that it was my decision to make. I can always tell by the way her voice sounds if she's been drinking and the times that she wasn't drinking I began to think, just for a brief second, that maybe, maybe I had my mother back. But deep down I knew that wasn't true." "Were you able to enjoy yourself and get to know the other men and women who were at the party?" I ask. "No," she replies, "I always ended up getting drunk. I either passed out shortly after I began drinking or I went into a blackout. I never remembered the party or how I got home. If my roommates didn't get too drunk, they would tell me what happened."

Feeling sad, feeling guilty, wanting my mother to be a mother, and needing structure are some of the emotions and needs Lynne was able to verbalize. Grieving for what was not to be yet feeling hideous guilt, Lynne continued to look for guidance from her mother. Unaware of the high probability

for her to activate the disease of alcoholism because of her family history, she began drinking at the point of addiction.

Women maturing in the 50s and 60s differed from those reaching maturity at a later time both in the what it meant to them to fit in and how they went about accomplishing it. For most of these women, fitting in to one's group was in the context of marriage, family, work and the social activities surrounding those circumstances. Being involved by belonging to associations and doing committee work were viewed as ways to fit in and be somebody. Many of the women were active in church events as well as doing other community work. Being above perfect by being supermoms at home, super-professionals at work and superwomen in the community became the norm. Many felt the effects of the Depression so that having money was important to them. As drinking became a more socially acceptable thing for women to do, each woman began to serve cocktails before dinner and occasionally have them when she was out at luncheons.

In Zelda's homelife, drinking was a normal part of her daily activity. Fitting in meant drinking as the family drank. "Drinking was just part of my family life," she informs me. "I liked the taste of it. I liked the atmosphere. I liked everything about it—the picture that alcohol gave—it was grown up, it was sophisticated, and I liked what alcohol did to me. It made me feel O.K. Just really made me feel O.K. I felt a part of things, part of the group because in the circles that I grew up in if you didn't drink you were kind of an oddball. But more than that, I felt accepted. I was accepted by my family and by our circle of friends. I felt comfortable. I belonged."

For other women, fitting in meant participating in community activities. "I carried my way of doing things into adult life," says Mary Helen. "I was a super responsible person and I continued to achieve in everything that I did. When my children were old enough, I felt a responsibility to expose them to Sunday school as well as other activities for their age and like everything else that I had done all my life, I jumped in feet first. I was in the choir, I was on the Christian education committee, I was teaching Sunday school, I was into cub scouts, you name it, and I was there. And once again, I didn't

have any balance in my life. It was go, go, go, and do, do, do. And participation meant, of course, being the leader. I had to run everything. I had to be in control. If I were the leader, then I could control the outcome, or so I thought, and therefore I'd get the praise and recognition I felt I needed. But it was never enough. I was very hard on myself. I expected a lot of me and that spilled over to others. I expected a lot from other people. I expected them to be perfect too and when I discovered they weren't, then I'd become disillusioned, frustrated, and angry. I just reinforced the feeling that I had to do everything myself if it was going to come out perfect. I had to concentrate on the outcome. I just couldn't take credit for my efforts and let it go at that.''

In Catherine's life-way, heavy drinking became the norm early in marriage. "My husband and I drank," remarks Catherine. "It was a normal part of our life-style. If we were going out, we always had drinks before we went as well as when we got to where we were going. I didn't think that was unusual at the time. If we went to a party that didn't offer booze, we never stayed very long. If booze was served, we were always the last to leave. And I remember that we always checked out the restaurants to make sure they served drinks otherwise we wouldn't go to them.'' Suddenly Catherine grins and her eyes dance mischievously as she continues: "One time a neighbor of mine invited me to attend what he called an open speaker's meeting. There was a surgeon coming from New York to speak and he thought I might like to hear him. Well I went and I did concentrate on what the man was saying and I thought, 'My, how bad it must have been for him,' and 'How hard it must have been for him to turn his life around!' '' I smile now too. "Was it Dr. Bob?'' I ask. "Yes,'' she answers. "It's too bad, but I still was unable to look at my own drinking and I didn't connect that I had a developing problem too. Nobody at that meeting ever said anything to me about it, they just smiled and said 'keep comin' back' and I didn't have the foggiest notion about what they meant!'' We both smile and the warmth of our knowing brings us closer.

"My husband's job sent him overseas for a few months,'' she continues, "and since we had young children I decided

to stay put. I remember being extremely nervous during that time and I went to our family doctor who sent me to see a psychiatrist. He prescribed a tranquilizer and told me things would clear up when my husband came home and our life settled down. I took the pills and continued to drink. When my husband came home, he remarked how totally different I was but I didn't attribute it to the pills and the alcohol. Things continued to get worse and I remember thinking that it would be much better to be a little bit crazy than an alcoholic so I got myself admitted to a psychiatric hospital. That was the first of many admissions. I was so strung out on tranquilizers and alcohol that I almost died before my alcoholism was treated. That was in the early 70s and treatment for alcoholism was in it's infancy. I really didn't go through a treatment program, it was a woman's A.A. group that finally was able to break through my denial.''

Being perfect and producing an exceptional quality of work was also perceived as a way to fit into one's work group and be accepted. If the woman felt that she couldn't perform according to her own exceptionally high expectations, she frequently quit the job and went elsewhere in search of a place where she could demonstrate her perfection. ''I've spent a lot of time and energy running away from things because I couldn't be perfect in what I did,'' Mary relates. ''I felt I had to walk into a job and know what to do instantly. And if something changed on the job, a new way of doing something, a different way of doing the paperwork, I'd panic. I remember when computers were introduced to my department. I just couldn't seem to catch on to how to do things. I couldn't remember from one day to the next how to work the stupid thing. And I began to panic. It meant I couldn't be perfect. I couldn't see ahead to the fact that it would make my work easier in some way. And I couldn't humble myself to say well, this is just something I don't know how to do yet, and I don't understand it yet, but I'll work with it. I couldn't do that. If I couldn't be perfect at it with the first try, I'd run away. I wouldn't be able to fit in. I wouldn't be accepted if I couldn't use it perfectly. So, I'd panic and quit my job and then I'd

reach for the bottle to make me feel I was still worth something. I wasn't a failure."

Geri nestles among the large sofa pillows, deftly removes her shoes using her feet, and then props them on the coffee table. "Shoes bother me," she says with a genuine smile. Thoughtfully caressing her forehead with her left hand, she begins to describe the way she acted to fit into her husband's family: "The fellow I married came from a family that had their cocktails before dinner every evening and partied on some weekends. And when we started going out together I began to have my cocktails too. I wanted to fit in. I wanted to be a part of his family and social set. I had finished school and I was working so I didn't drink every night, but when I knew I didn't have to go to work the next day, and we had a date, I would drink. I liked the feeling that alcohol gave me. I felt relaxed. I felt I could dance better if we were out dancing. I couldn't really, but I just felt like I could. I could be humorous. I was rather straight-laced and serious when I was not drinking and alcohol just helped me to loosen up a little bit. When I drank with his family and his friends, I felt part of everything. I felt like I belonged. I could really hold my liquor, though. I remember one time drinking him under the table and I thought it was just great that I was able to drink more than he could. After we got married our income was pretty limited until he got up into corporate management, but I was busy raising a family and alcohol just didn't seem important to us. But as time went by we got into a social crowd that enjoyed drinking like we did and so we began to have more occasions to drink. And getting drunk in my crowd, even if you were a woman, was not frowned upon. I didn't get drunk very often, but there were a few times that I drank too much."

Emulating the behaviors and dress of the "big crowd" were ways Julie found to fit in and be accepted. Julie's wide amber eyes soften as she begins to tell me how she went about fitting into the group of her choice. "It was always very important for me to belong to the 'big crowd' at school," she says. "I was 13 and a freshman in high school when I had my first drink. I went to a beer hall with some friends and since every-

one was drinking beer, I drank too. And I smoked cigarettes. I got sick and passed out, more from the cigarettes than the booze, but I was bound and determined to learn how to smoke because the big crowd smoked. At that time the big crowd didn't drink very much. Smoking was the big thing. So, I didn't drink again until I was in college. I was away from home and I didn't have the restrictions that I had at home. The first thing I did was look around for the big crowd and here the big crowd drank. And I wanted to impress you. That was how I was gonna get in the big crowd. I remember going to a Christmas party and I drank three glasses of rye. They were eight ounce glasses and I drank it without water, ice, or anything added to it. And I knew what I was drinking. I was very aware of what I was doing. I went to the ladies room after I drank the third one and that's the last I remember until I woke up in the dorm. I was told the next day that I went into the ladies room, took off all my clothes, and I wouldn't put them back on. Somebody tried to dress me and I bit them. But somehow or other they got me dressed and back to the dorm. I was concerned that maybe the house mother had seen me, but if she did she didn't say anything so I played it real cool and sort of pieced things together and realized that I was not going to get into trouble. But it was never discussed. It was an issue that was forgotten."

"The best way for me to describe my attitude towards my drinking," she continues, "is to say it was like hanging off a cliff. One more drink and I'd fall, but one more drink and I might not fall so screw it, I'd have one more drink. And so I played and I partied a lot in college. I went to a lot of fraternity parties. I knew a lot of people. I knew a crowd from the engineering school, I knew a crowd from the dental school. I knew all the big crowds in all the different schools and I gravitated toward the people who played and partied the way I did. I remember meeting a very nice fellow, but he only drank socially and I knew he wouldn't approve of the way I drank. Every time we went out together I hid the amount of alcohol I consumed by sneaking drinks. If we were at my apartment, I made sure I had an extra full glass and a bottle in the kit-

chen. If we were out, I'd pick up an extra drink on the way to the ladies room. I decided this deception was too much work so I dumped him. Finally I met a man who didn't object to the way I drank and we began to do a lot of things together.''

Fitting in is a way to meet our human need for approval, acceptance, and belonging. All of us will do the things we feel we need to do to be accepted and belong to the group of our choice. Most of the older women perceived that drinking was a normal thing for adults to do and a sophisticated way to have fun. Although the cultural norm that the woman should not be drunk prevailed, many families did in fact permit the women to drink to excess as long as they were protected by other family members. Persistent drunkenness was frowned upon, but occasional episodes were sanctioned. Younger women had a slightly different perspective. Although drinking and taking drugs were ways to fit in and belong to their desired social group, using chemicals to cope with the problems of every day living had become a right.

7

Trying to Control

Many women describe the onset of their alcoholic drinking as immediate whereas others report it as a more of a gradual process. Why this happens is not fully understood although alcoholism has been found to cluster in families. One view holds that the predisposition to develop the disease lies in the person's body chemistry and many women do report severe reactions with their initial drinking episode. "I became violently ill the first time I drank," was a statement repeatedly emphasized by many of the women in my study. However, all the women hastened to tell me that they were able to "drink through" this allergic type of response, meaning that they continued to have something to drink each time they were in a social gathering until the time came when they could drink without becoming ill.

In addition, many women described their high tolerance for alcohol from the beginning, implying that they could drink a lot more than others before they got drunk. They were proud to be able to drink others "under the table" and they described themselves as "having a hollow leg." "Outlasting everybody" became the norm. Drinking more than others also meant drinking too much, getting high, and getting drunk. They drank

their drinks quickly, looked forward to their glass being continually replenished, and consumed large quantities with each drinking occasion. ''My friends told me the next day that I drank forty Manhattans within two hours,'' relates Marissa. ''I thought it was great that I could do that even though my friends told me I went crazy. I climbed onto the bar and started running back and forth; I was screaming and yelling. Then I went behind the bar and started sweeping all the glassware to the floor. It took three policemen to subdue me. My friends bailed me out of jail and my mother paid the bar bill. They were good enablers too. I don't remember any of that. When I was told what had happened, I paid attention to the part about being able to drink forty drinks and I thought that was *wonderful!''*

As the disease of alcoholism progresses and the body's metabolic functions are overtaxed by large quantities of alcohol, many find that a reverse effect occurs. Some describe their inability to drink large amounts before getting drunk by saying ''my tolerance has broken'' indicating that it now took a small amount to make them drunk. The word tolerance is also used to denote the developed ability to consume more and more of the drug to achieve the same effect. It is this tolerance that creates the compulsion, the need to consume more and more, and produces the drinking behaviors.

The other aspect of tolerance is withdrawal. When the amount of alcohol in the body falls below a certain level, unpleasant and painful symptoms occur. Being extremely irritable, having intense mood swings, experiencing severe headaches and feeling jittery are common ones. Nausea and vomiting also happen when drinking episodes are excessive. In spite of these responses to drinking, the thought of stopping does not occur. Instead, the woman's goal becomes one of devising ways to control her drinking so that she may continue to drink socially as others do. Although each woman creates her own elaborate plan about when, where, and how much she will drink, the outcome remains the same—once she begins to drink, she cannot stop. She has lost her ability to drink socially.

When and where she drinks has much to do with her

perceptions about the purpose of drinking. If she views drinking as a way to keep a pleasant disposition or portray happiness that she does not feel, she may exercise more elaborate controls than one who drinks solely to provide time out from feeling devalued as a person. Women maturing in the 70s and 80s began drinking earlier than the older women, and problems surfaced earlier. Societal expectations for their conduct were limited to finishing their education and reaching maturity without mishap. In contrast, women who grew up in the 50s and 60s began drinking later. They obeyed their parents wishes and did not drink until they were either nearing the end of their education, were married, or involved in their own professional work or community activities. Hence societal expectations were different. If one drank, then drinking was to be done in a social context with other people. Therefore, the women perceived that drinking alone was an unacceptable thing to do.

"After I got married," Linda reflects, "my husband and I started having Martini's before dinner and occasionally we would have a drink after dinner. My husband was in the military and we moved frequently and somewhere along the way I began meeting him after work at the club and we would have a couple of drinks before dinner and it just became the norm. Our neighbors drank, too, and it just seemed that every place we went—to visit friends, neighbors, or just to the club—it was happy hour. I decided that I could only drink if other people were around. That was my control. Somehow drinking alone did not seem to be a good thing for me to do. It would mean something was wrong with me. So I began to invite my neighbor over early in the afternoon and we would sit on the porch and watch our kids play and have a drink. This didn't happen every day, but it happened many days. I didn't realize I was beginning to plan the times I could drink.

"Gradually I did notice that when it got to be four o'clock my body began telling me it was cocktail time," she relates. "It was a subtle internal vibration, and I *knew* it was time for my drink but I was afraid to drink alone. My husband was a pilot, and he was away a lot so eventually I just rearranged my thinking. I thought, 'Well, he's having happy hour

wherever he is so I'll just have my cocktails here!' It was so easy to give myself permission to drink alone at four o'clock when he was not around! That was the first readjustment to my control. I didn't have to wait until my husband got home from work to have a drink.''

"The wives club met monthly and we had luncheons and I began having something to drink at those too. Before too many years went by I had adjusted my life so that I could drink whenever I wanted to drink. Most of the time I made sure other people were around and were drinking too—that was my control. I began to think I might be in trouble when I started taking a thermos of Bloody Mary's with me to the morning bowling league. I rationalized by saying that I didn't like to drink beer. But it was more than that and deep down I knew that I had to have my morning drink and then I started my other type of control—maintenance drinking.''

As the need to obtain more of the drug occurred, Linda quietly rearranged her life to accommodate her need to drink. She extended her drinking time by inviting a neighbor to spend the afternoon with her, participating in luncheons where drinking was accepted, and carrying a thermos of Bloody Mary's to her morning bowling league. Her rationale for carrying the thermos was that she didn't like to drink beer and that was all that was to be had. She continued to meet her husband for happy hour when he was available. If he was away, she reasoned that he was having his cocktail at four o'clock and she gave herself permission to have one too. Keeping the control of being with other people to drink, Linda gradually extended her drinking time. Being where she could give herself permission to drink without violating her control was one of the attributes in Linda's evolving drinking behaviors.

Once the women in my study began to drink, the time it took to reach alcoholism was relatively short compared with accounts of men. Many reasons have been offered for this "telescoping" effect, but it is still not known why women become alcoholics faster than men.

"It seemed as if the compulsion to drink just quietly took over my life," Catherine informs me. "I remember my first drinking experience, I got violently ill on two drinks. I was

dizzy, I didn't feel good, and I can remember thinking if this is what drunk feels like, I don't want any part of it! It was probably about a year later when my husband and I started having a drink before dinner. I didn't have the reaction to it that I had previously and so I kept going with it. I can remember the day when I mixed myself a drink before my husband got home from work. I had three little children by this time and this particular day was a hard one for all of us. I was up to my ears with toddlers. I wanted 'time out' so I fixed myself a drink. It tasted good going down and I remember feeling instant mellowness. It was instant peace. It was an overwhelming feeling that everything was O.K. When my husband came home, of course I had another one with him but it was not the same. I never experienced that feeling again. I can remember thinking when I took that drink that something was wrong with me. Here I was drinking by myself. There wasn't anything social about it. It wasn't long after that when I told myself a little sherry would help me cope with the stress of these little children. I began to sip sherry when I was doing my ironing and many times I'd be drunk by the time my husband got home from work.''

Catherine's use of alcohol to cope with the stress in her life added another dimension. Alcohol was used both in a social context and as a medicine. ''I decided that I would only have one drink with my husband when he came home from work,'' she says. ''I wanted to be able to enjoy his company and having a drink was our time together. But if I had had a very stressful day with my little ones then I'd tell myself that it would be all right to have a drink to calm me down before he got home. I thought if I used alcohol as a medicine I wouldn't get into trouble.''

Telling herself that she was not going to begin drinking until a certain time was another form of trying to control emerging drinking behaviors. ''I felt if I just rearranged my life a little I could control everything,'' Zelda tells me. ''The first thing I did was to tell myself that I wouldn't have a drink before my husband came home at five o'clock. That was how I would control it. When that didn't seem to work any longer, I decided to change what I was drinking. I thought, 'Well, if I can't drink

scotch any more then I'll just drink wine.' So I got into the champagne. I was not a cheap drunk! Some how I thought that if it was wine I couldn't get into trouble. Drinking wine was gonna be my control. When that didn't seem to work, I switched to bourbon and then beer. And for a while each time I changed to something else it worked, I didn't drink as much. I was able to stop drinking for brief periods too. That was another control. I could stop drinking for about two or three weeks at a time. One time it was six weeks. I'd begin to feel better and even my children began to notice the difference in me. When that happened I'd think I was O.K. and I'd pick up the first drink and be off to the races again. Eventually my friends started saying things like, 'Aren't you drinking too much,' or 'I've never seen you drink like that' so I began hiding and sneaking my drinks. We had a full bar in the house yet I started keeping a half gallon under my bed.''

All of the women in the older group were concerned with societal expectations for their conduct, and ''keeping up appearances'' was a major concern. When friends began to notice a change in Zelda's drinking behaviors, she began covering up by hiding the amount she was drinking even from herself. ''Having Martini's ready when my husband came home,'' sneaking drinks by keeping extra alcohol in the kitchen, making sure to help clean up after a party, buying half gallons and pouring it into smaller containers, buying two bottles and hiding one, watering down the contents of the bottle, hiding bottles under the bed, in the kitchen, and all over the house were some of the ways the women tried to cover up their drinking. ''I remember during those last few months of my drinking keeping a pint of vodka hidden between the mattress and box springs,'' Cecelia says. ''I'd drink myself into oblivion every night. It didn't take much anymore. My tolerance had broken.'' ''I knew I had to have my supply with me,'' says Zelda. ''When I traveled, I had a case and the first thing I did when I got to the hotel was have several drinks.'' ''I had it stashed all over the house. I had something in every room,'' Linda tells me. ''I even filled small glass medicine bottles with vodka and put them on my spice and extract rack. I wanted to make sure I would be comfortable wherever I happened

to be and I didn't want anyone to know I was doing maintenance drinking.''

Covering up included switching drinks in the hope that the woman could control the amount she was drinking. This included changing from short mixed drinks to tall mixed drinks; switching from beer to fortified wines; switching from wine to bourbon or scotch; switching from bourbon or scotch to wine. The combinations seemed inexhaustable, yet they tried them all. ''I thought the wine was giving me headaches so I switched. I ended up with scotch, then gin, then vodka,'' Linda remarks. ''I began drinking wine. I thought I could handle that,'' says Catherine. ''I mean bourbon was my drug of choice but I knew I was having trouble handling it.'' Suddenly Catherine gives a hearty chuckle. ''I got to the point where I finally started switching liquor stores! I was embarrassed because I was shaking so badly in the morning but I had to go and get it. I needed it to stop the shakes.'' ''I always switched around,'' muses Agnes. ''I'd drink some sherry, I'd drink scotch, I'd drink anything. But if I switched around then I never had to face how much I was really drinking.''

Many of the women made promises to themselves that they were not going to begin drinking until a certain time. Occasionally they were able to hold out until the appointed time arrived. More frequently, though, intent was replaced by broken promises. Only a few were able to stop drinking for brief periods of time and described themselves as periodic alcoholics.

Being around others who do not drink excessively is yet another form of control. ''I remember thinking that if I had a boyfriend who didn't like to drink then perhaps I wouldn't drink so much,'' says Julie. ''I found a very nice man who seemed to be genuinely interested in me and sure enough, he didn't like to drink the way I did. I decided he was gonna be my control. It didn't work. I couldn't stand it. So I dumped him and found someone who didn't drink quite the way that I did but yet didn't object to the way I drank. I just rearranged my control to suit me! He was a young businessman going up in the world and his whole life revolved around his business. And I thought, 'Isn't this great, I can drink when

I want to drink.' So, I married him. When he wasn't working from seven in the morning until midnight then he was out on the golf course and pretty soon I began to feel isolated. But now I felt even more isolated than before. At least when I had been single I could sit in the bar. So I started drinking at home. I was trying to control how much I drank since I wanted to know when he came home, so I would pour some alcohol into a smaller container and tell myself that that was all I would drink. It didn't work and finding me passed out became the routine.''

Seeking ways to control her compulsion, Julie tried to associate with others who used alcohol in a social way. Unable to do this, she found another companion who, in the beginning of their relationship, allowed her to drink as she pleased. Natasha, on the other hand, recognized that when she drank she said and did embarrassing things. Her control was to not drink when she was in a social group unless she felt it would be acceptable for her to get drunk. ''I was beginning to realize that I got so out of character when I drank,'' she tells me. ''I decided it was time for me to do some control drinking. I'd drink tonic with lime when I went to parties so that people would think I was drinking but I wasn't. I knew that when I drank I did embarrassing things. It wasn't my behavior so much as it was what I said to people so I was beginning to be very careful where I did my drinking. I decided that I could only drink in situations where I knew it would be all right for me to get drunk. I didn't drink to cope with my anger or because I felt scared. I drank to try and cope with my socially inadequate feelings. I was so shy and I just felt so socially inept and inadequate. I knew alcohol would loosen me up and I was constantly trying to get that right combination. I knew if I drank too much I got weird and if I didn't get enough I was shy. So I wanted to be able to drink so that I could socialize and I just couldn't seem to get that right combination.''

Whereas Linda combined drinking in a social context and maintenance drinking at home to control her growing obsession with alcohol, Mary Helen began to put the responsibility for how much she drank upon her husband. ''I, too, decided that drinking alone was not an acceptable thing to do,'' she

says. "When I knew that my husband had to work late, I would invite friends in and he would come home to find a party in progress. Even when there were just the two of us, I always managed to have a *hearty* drink before dinner. I spent a lot of time hunting for just the 'right' glass. And as time went by I would also have a drink after supper. I can remember my husband looking at me in an odd way one time and saying, 'Oh, Mary Helen, you don't want another drink now.' My standard reply was that it helped me to sleep better, that was my excuse."

"I also tried to put the responsibility for my actions on my husband. When we went out, I would say to him, 'Please don't let me have more than a couple of drinks,' and he was a good enabler. He tried but I didn't cooperate. Once I started to drink there was no stopping me. I was a happy drunk in the beginning, very gregarious and outspoken. I know that there were many times when I embarrassed the quiet man who was my husband."

Having others around when she drank was important to this older group of women. It sanctioned drinking and allowed them to be the charming, witty people they always wanted to be. Having a hearty drink before dinner meant having a large one. Hunting for the right glass became a favorite shopping pastime. The ultimate acquisition would hold 12 ounces while looking like four. Short wide glasses were appealing.

Protecting one's supply by ensuring availability was paramount. "I became preoccupied with making sure I had my supply of alcohol," Mary Helen continues. "We went on picnics fairly often in the summertime and I would fix a picnic lunch. I'd prepare a couple of chops and have them ready so that when the coals were just right I could put them on to bake. My husband did some fishing up and down the stream and I'd paddle around in an inner tube on the stream and it was a pleasant time for both of us, but there was *always* a large thermos of Martinis. I planned. I protected my supply."

Being with people who liked to drink meant being where alcohol was always served. Going to parties, dinners, fraternity dances, carrying alcohol in a travel case, keeping wine in the car, keeping the bar at home well stocked, hiding extra

alcohol and buying alcohol before one went home were some of the ways the women ensured their supply. "I started to be a clock watcher," Kelli tells me. "When 11:30 at night rolled around, it was a matter of figuring out if I had enough or did I have to make a quick run to the 7-11 before it closed."

The deep brown of Mary Helen's honest eyes hold humility as she begins to tell me about her total unhappiness. "Gradually I began to become deeply unhappy with myself," she says. "I projected this onto others. No one could do things to suit me and after a while I found myself taking on all this responsibility because nobody could do anything right according to my standards. You see, my standards were so unrealistic that I had to expend all my energy trying to meet them. I became impatient with everyone at work. I tried to conceal this with what I call thinly veiled patience. I was just tense all the time. I couldn't relax. I couldn't laugh and joke with you anymore. The pleasant side of me seemed to disappear and nobody got a compliment for doing something well. I couldn't even accept a thank you myself."

"I began to promise myself each morning that I was not going to drink, but yet, deep down I knew I would. So I began to change what I was drinking. I thought that maybe if I drank something I didn't like, I wouldn't drink as much. So I went from wine to scotch to bourbon and finally to beer. I remember thinking too that if I switched from a Martini to a Tom Collins, it would last longer because it was in a taller glass. Well, you know it didn't. I just gulped it down like everything else."

"I knew I was beginning not to smell good. The booze was beginning to ooze out of my pores and I was afraid my husband would begin to find me unacceptable to live with. I was also afraid somebody would say something to me at work but they never did. My husband, though, was beginning to say things like, 'I've had enough, I can't deal with this any more. You're killing yourself and you're hurting me. I ought to leave but I just can't right now, but I'm going to leave.' But occasionally the nicer and the stronger Mary Helen surfaced and my self-imposed control did work and I didn't drink. Then I began to feel self-righteous about the whole problem. I could lick it. I could do it by myself. I just had to exercise a little will-

power. But I found I was powerless to do anything about it!"

"As my drunken episodes became more frequent, my husband started refusing social engagements and began working at the office more. And I began to ease off on my commitments. I wasn't getting up to get my husband's breakfast and he started staying away in the evenings now. I was routinely late for work and some days I never made it to work. But I would always call at the last minute and I always had at least three excuses for why I couldn't come to work. I resigned from the choir and soon I was resigning from this board and that one. A lot of the meetings that I went to were luncheon meetings and my hands were shaking so that I was embarrassed to have other people see me in that condition. It wasn't long after that that I was fired for going to work inebriated."

Inviting friends in to drink, having a hearty drink before dinner, beginning to continue drinking after dinner, and protecting her supply by carrying a thermos of Martini's were signs of Mary Helen's growing dependence on alcohol. Telling herself that she was not going to drink that day, giving herself a time when she could begin drinking and putting the responsibility for her drinking on her husband are ways Mary Helen tried to control her drinking. Unable to heed her husband's pleas to do something about her drinking, she became increasingly afraid that he would leave the marriage which he ultimately does. Her fear and intense unhappiness with herself were projected onto others as irritation and impatience for what they did not do. She perceived that no one was able to do anything right. Resigning from various clubs and associations, she began to become isolated and drink more. Her tardiness at work eventually became unexplained absences. Finally she was fired for arriving at work drunk. The cultural expectation that the woman should not be drunk still holds and carrys severe consequences when violated. Being fired is one of them. Many employers will fire the woman when it becomes known that she has a problem with alcohol or other drugs instead of offering help.

Knowledge about alcoholism means that people can recognize the developing behaviors of addiction and affords the ability to intervene early with gentle firmness. Unfortunately, this

knowledge is not common. We do not see the signs indicating trouble ahead.

One sign of impending trouble is the gradual change in one's life-style to accommodate drinking. "I can understand now how easy it is to rearrange one's life around drinking," says Barbara. "It wasn't until after I was married that I got into drinking and smoking pot on a fairly regular basis. My husband was in the service for a few years and we socialized a fair amount with our neighbors and the other families in my husband's unit, and drinking was a part of that. Our next door neighbors introduced us to marijuana and I remember liking the feel of it. It gave me a numb feeling. I just didn't feel anything. It was an exciting thing to do and kind of dangerous and taboo but I liked it. But it also scared me. The numbness was too numb. I liked to go to parties. I really believe that I was addicted to excitement long before I was addicted to any type of alcohol or drugs because I *loved* to be where the excitement was—where people were having fun. I just wanted to go, go, go all the time. I couldn't get enough, I wanted more. Always more to feed me in some way. But my husband was just the opposite and he did a pretty good job of keeping me in tow and he just didn't seem to want to drink like I wanted to drink. My husband was my control for many years but gradually I out manipulated him. Alcohol just sort of took over and I couldn't seem to do anything to prevent it."

Jennifer looks at me and then calmly says, "I grew up with parties. In some respects you could look at me as Linda's daughter or Zelda's daughter. Drinking was portrayed as a sophisticated thing to do. And I grew up expecting to be a part of that. I think the thing I notice among the young people today that alerts me to a problem is the gradual change in activity levels to almost a frenzied state of searching and seeking. This is the person who begins to have an extremely active life-style. It's the person who's all over the state or all over a large metropolitan area during a weekend in search of parties, experiences, and people. And it's all alcohol related. This person never says, 'I'm tired. I think I'll just stay home tonight, and read a good book.' That doesn't happen."

"From my own perspective, parties were extremely impor-

tant to me and I told people at work about the parties I went to, who was there, and how much was consumed. Today, I'd perk up my ears if all I heard about someone's social life was that they went to parties.''

Listening to the informal comments made by people to each other in the work setting provides clues about how alcohol is used in their lives. People talk about their social activities at work Jennifer reminds me. All we need to do is to listen to what is being said.

A broad smile enhances Lucille's warm brown eyes. When she speaks, her voice radiates her knowledge of experience. ''When I think about what happened to me,'' she says, ''it makes it easy to spot those things in others. I had been drinking heavily all through college and I was beginning to physically feel very, very sick. I would wake up in the morning nauseated and begin to vomit my insides out. Nothing would stay down now, even water. I was having a lot of blackouts and although I would wake up in the morning in my own place, I couldn't remember anything that had happened the night before. I'd have some very vague memories and then start hinting around to my roommates trying not to let them know that I couldn't remember and usually they would tell me what I did. They didn't seem to catch on that I was having blackouts and I couldn't remember what I had done. And sometimes it wasn't too nice. Sometimes I got into arguments and became abusive. It was my roommates who always brought me home and they were beginning to let me know in no uncertain terms how they felt about my behavior. Although I could intellectually connect that my life had gotten worse, I couldn't connect it to my drinking. I began to think that if I could cut back on my drinking things would begin to get better and my life would be more manageable. I decided I would just have to exercise some willpower and control what I was drinking.''

''It was getting near the end of my senior year in college and I had started working and I didn't want to go to work drunk, but somewhere deep down inside of me, I knew that I was drunk when I went to work and that bothered me. So I began to try and figure out some method of control that would

help me cut back on my drinking. In my senior year, I married the fellow that I had been dating since my sophomore year. It seemed as if our marriage began with my making pacts with him to quit drinking and of course I repeatedly broke them. He'd get extremely angry with me and we'd have a big fight. I'd make a promise once again and for a little while it would work. I was able to cut back to two beers a day. But that didn't last. I could only control it for short periods of time and then I would be right back at it again. Today I am very tuned into someone who goes to parties and the next day starts hinting around wanting to know what happened. That makes my personal antennae go up. I'm also aware when another woman starts talking about all the arguments she's having with members of her family. I don't know what it is but all of a sudden my gut twitches and I *know*.''

Recovering women are astutely aware of the disease in others especially if they can see the behaviors they themselves exhibited. Hinting around to find out what happened after a social event tells Lucille the problem is alcohol. Beginning to have arguments with husband or other family members over myriad problems supplies more information. Having experienced the compulsion to get more and more, she understands the woman's inability to keep her promise not to drink and the ensuing disruption in family life.

Although Lucille began to believe that feeling physically ill was normal, she was growing more afraid of having blackouts, which were beginning to happen each time she drank. Upon entering the workforce, she wanted to contribute and be a responsible person who had worth and value. She didn't want to go to work drunk and yet she realized she had lost control of her ability to safely drink.

''I can vividly remember how I felt when I graduated from college and got my first job,'' Jennifer responds to my question about entering the working world. ''It was like I was in another whole different world. I was supposed to be an adult and be responsible and I didn't feel ready for that. I still thought of myself as an adolescent although I knew it was time for me to be a responsible person. I decided that I had to control my drinking so that I could do some of the things I now

had to do. So, I just found other times to drink! It's amazing what you can do in the beginning and middle stages of the disease. If I had to study for an exam or if I had to perform some function at work, I could do it. I might be functioning on dexadrene and coffee in the morning, but I would be there to do what I had to do.''

The transition into the world of work is a stressful time for many young women. It is the time to adopt new roles for which many feel ill prepared. If alcohol has been used in the past to relieve stress, then its use may increase. Finding herself suddenly in the mainstream of adult life, Jennifer's anxiety soared and she began to seek out more parties where she could drink.

''I had also begun to date a couple of guys who weren't alcoholic,'' Jennifer continues, ''and although they never said anything to me about my drinking, I could tell the difference between us. I always wanted to go the limit and just party until I dropped even though I had to be a work by 7:00 AM. But they were like, well, two beers and I've got to go, I've got to get up in the morning. I was flabergasted because as far as I was concerned, the party was just beginning! But I was starting to meet other people my age who had different life-styles and they didn't party all the time. And they were happy. I always thought that you had to have so much fun to be happy and that's what gave you the sense of fulfillment and satisfaction. I didn't know any other way to meet my needs. I didn't know that a quiet Saturday at home or going for a walk in the woods or just going out to dinner or a movie could be wonderful. I began to feel guilty. For a long time, I had the sense that my life was out of control, but since I only associated with other people who drank like I did, I thought it was O.K. But when I began to meet other people who had different life-styles, I really began to get the sense that my life was totally out of control with alcohol. And I wanted to get off the merry-go-round. I wanted some sense of peace. I wanted to be happy. I wanted what they had and I didn't know how to get it, or if I had the courage to try and find out how to get it. I was interested, but I was still having a romance with alcohol. It was only later, when the consequences started

catching up to me and I was allowed to feel them, like getting arrested for driving while drunk, that I began to question what was going on in my life.''

Each of us has the potential to be a role model for another. Meeting people whose lives did not revolve around parties and alcohol, afforded Jennifer the opportunity to see how others live. She began to perceive a difference.

''I was working, too, when my drinking really took off,'' says Cecelia. ''When I see others acting the same way I did, it rings bells with me. My homelife and my worklife were both well on their way to hell in a handbasket and I talked about these things a lot to others at work. I was always complaining about something my children either did or didn't do. I didn't have any praise for anybody. The household appliances started wearing out and had to be replaced but I couldn't even get my thoughts together to either call a repair man or go out and buy a new one. My rage erupted whenever I had another inconvenience or problem in my life. My husband traveled a lot in his job and negative thinking just took over and got worse and worse. I began to think he was out having a good time enjoying himself and here I was stuck with the house, the kids, and my job. So I started blaming people at work for the fact that my life was falling apart. I began to get irritable with my children and everyone around me at work. I felt that everyone else was doing stupid things and making life a burden for me. I tried to cover up my impatience but there always seemed to be something to cause me to blow up. I was tense all the time. Life was now so stressful that I couldn't seem to get through a day without going into a rage over something that was really very insignificant. I started making mountains out of molehills and disrupting everyone around me. And I was never satisfied. Nothing that anyone did pleased me. Nobody at work could make out a schedule that suited me. I never liked my assignment, I always felt that I had too much to do compared to everyone else. But if you tried to relieve me of some of the stress by changing my work schedule or not giving me so much to do, I'd get violently angry and complain to the union representative that you were

discriminating against me. I knew my life was falling apart but I couldn't seem to hold it together anymore. My control was slipping.''

Cecelia graphically described how alcoholism permeated every facet of her life. Increasing irritability, frequent angry outbursts, and projecting blame onto others were vital clues especially as this was a change from former behavior. Cecelia's unsuccessful attempt to control myriad events in her life affected her total being. Her pleasant, warm, and comforting demeanor disappeared. If she was teaching school, the children suddenly wanted to avoid her; if she was in a position to wait on customers or provide some type of service to a client, others would notice that people began to shy away from her and request someone else to help them. Her peers at work began to feel uncomfortable around her and would make plans to avoid her if it was possible. Isolation built as all available means of support were withdrawn. Cecelia demonstrated how the unmanageability in her life finally errupted discharging negative energy similar to the venomous snake ejecting his poison. These were obvious indicators that should have alerted those in the workplace to assess the reason for the growing unmanageability in her life.

Geri looks at me with an intensity that begins to make me feel uncomfortable. "What's going on?" I asked. "I'm feeling strange." Her piercing blue eyes soften, she takes a deep breath, and when she speaks, she chooses her words with care. "You're a manager," she says, "and I want you to understand not only what was going on inside of me, but how I acted at work. How I tried to control everything around me and how I manipulated you. I was in dire need of an intervention, but instead I almost died before I got help." I reach out and put my hand in hers. "Help me to understand," I reply. "I began to procrastinate and put things off," she says. "It became more difficult for me to do the essential tasks to take care of my family and do my job. I tried to manage and control everything around me but instead things just kept getting worse. Nothing in my life seemed to be going as it should. I seemed to be going from one crisis to another. The car kept breaking down because I didn't take the time to do the

necessary maintenance to keep it going. I could never make it to work on time. I was *always* at least a half hour late and if you readjusted my working hours, I'd still be late. There were some days when I didn't even show up at all. I couldn't get up in the morning to even take care of my family and they had to fend for themselves. My excuse was they are just about grown and it's time for them to be responsible for themselves. I drank each night until I passed out. It didn't take very much because by this time my family doctor had me taking librium to ease the stress in my life. I conned him too, you see.''

Geri attempted to project an aura of self control to others at work when in fact she presented a tense, tightly controlled appearance. She was continually "holding herself together." Each movement of her body and each word was carefully chosen to enable her to appear in control. Unable to get up in the morning, she began to be consistently late or she failed to show up at all. She had excuses for every situation. "I always had an excuse for my boss," she says. "I could really give you a story. I don't know where it came from, but I always had at least three excuses." "Could you give me an example?" I ask. Chuckling as she speaks, she begins to rattle them off: "I couldn't get my car started and it had to be towed to the garage;" "the traffic was heavy to begin with and an accident tied up traffic;" "I couldn't find a parking space and my baby sitter didn't show up." I smile. If I added all that up, Geri, you wouldn't have arrived until noon!" "Yes," she replies. "Now, you're getting savvy!"

Geri continues, "On the days when I could get up in the morning, I would take a long look at myself in the mirror and what I saw was pure disgust. I knew I was drinking too much but I couldn't seem to do anything to control it. I started calling the department where I worked telling them that I was in another work area and I would be there shortly when I hadn't even left home. When I did arrive, I had several good reasons why I was someplace else. I was always wandering about. No one could ever find me if I was needed for something. And I began to leave early. There was always a meeting I had to attend, a doctor's appointment or some other excuse. Going to the dentist was another reason to leave early—and

I had false teeth! I didn't bring a flask of alcohol to work very often but when I did, I made a lot of stops at my locker. We had our lockers in the hall where we could keep our handbags and personal things so I'd carry my soda with me and say I was taking a five minute break. I'd go to my locker and put a little vodka in it and swig that baby down, then chew a breath mint."

Spending time on personal affairs; inconsistency between statements and actions; a compulsion to justify one's actions; increasing irritability; isolating one's self from social contacts; wandering about (on-the-job absenteeism); presenting a negative outlook on life; projecting blame onto others; creating a smoke screen by monitoring another's work to ensure that it is being done properly while neglecting her own; keeping co-workers busy by creating conflict; keeping the attention of her immediate supervisor diverted by creating problems that only the manager can resolve, e.g., attending to union complaints; leaving work early to keep various appointments; disappearing; arriving late; being absent; and, becoming visibly depressed are behaviors indicative of alcoholism that can be observed in the workplace. But there is more to the developing pattern of addiction. Alcoholics, and others addicted to various chemicals, have a knack for placing themselves in vulnerable positions. Traumatic events begin to take place around them. It is not unusual for alcoholics to be robbed, have their automobile stolen, have their house broken into, have at least one automobile accident, possibly receive a drinking under the influence citation (DUI), sprain an ankle, break an extremity, or have a fire in their home. Individuals who are in control of their lives may suffer an injury every few years but seldom can boast of such a list within a short period of time. "I perk up if I begin to put a picture like this together," all the women comment. "I look for bruises on the person's body too," Linda remarks. "I notice bruises, unexplained bruises on their arms and legs. Nine times out of ten the woman will not remember how she got them, but I'll tell you how she got them. They came from bumping into walls and corners when she was drinking."

"Things just started happening to me," says Lucy. "I began to have lots of accidents in my home. I fell down the stairs, hurt my leg and sprained an ankle. I forgot to open the garage door one day and really made a mess of things. I couldn't understand why this little black cloud seemed to be following me. My life was not what I felt it should be. I was trying to cut back on my drinking. I worked part time and I didn't want to go to work having liquor on my breath so I decided to give myself a drinking schedule. I allowed myself to drink just a little one day, not drink the next, and go to work on the third day. And for a while it worked but then I noticed that when I wasn't drinking I felt terrible. Today I know I was experiencing withdrawal symptoms. When that started happening, I began to carry some wine in the car so that I could have a couple of slugs before I went to work to help me smooth out. I'm sure others could smell it but nobody ever said a thing. On the days I worked, I always volunteered to come in early and open up the office. Then there wouldn't be anyone around to notice if I was hung over or if I had a couple of slugs of wine to settle the shakes. There was a time when I believed that I never drank on the job or that drinking never affected my performance. But the more I thought about it, I would have enough in me that I could be calm and be able to do the work."

Having a supply of alcohol or a stash of other drugs readily available becomes a necessity for the addicted person. "My sister and I kept wine in the house and we'd have a couple of glasses of wine in the evening," states Carnelian. "I'd always end up getting drunk at the end of the evening and she couldn't understand how that could happen when we only had two glasses of wine each. What she didn't know was that I had a fifth or two of vodka in my bedroom and everytime I'd go upstairs I'd sneak to my room and down a good bit of vodka. Then I'd take a little sip of wine to sort of hide the vodka breath. Things at work were beginning to get too hot for me. I could sense that my boss wasn't going to put up with my shenanigans much longer so I got a job in a nearby city and moved on. This time I got a roommate who didn't drink and drug the way I did. I figured she was gonna be my control.

Things did calm down a bit for me. She let me know right from the beginning that if we were out and I behaved badly she'd leave. I called her my wet blanket but she was definitely a control for me. I enjoyed being with her. She was fun to go out with but if I got drunk, she'd leave me, get a taxi and come home. But the time came when I knew I had to drink and so I moved into my own place. I was working evenings now. The liquor stores were open to midnight in the city. I'd get off at 11:00, stop by the liquor store, get whatever it was I wanted to drink, get home, and drink the entire fifth before I went to sleep. I had a terrific headache one day and told the doctor it was a migraine. He gave me something with codeine in it. It was *wonderful*. I knew I had to get more and I did. It wasn't long before I got to the point that when I got home from work I would consume a fifth or two of booze, take whatever pills I had, and then go to sleep. I'd wake up about an hour before it was time to go to work and then I'd start the process all over again.''

Attentively listening to Carnelian, Beryl nods in acknowledgment, communicating her understanding of addiction. Radiating warmth and compassion Beryl conveys an empathy that comes from having walked the path. When Carnelian becomes quiet, she says: ''I became an expert at concealment. I was stealing drugs from where I worked so that was a necessity. I was also going to my family doctor and getting him to write me prescriptions for various ailments. It was nothin' for me to shoot up 2500 mg of demerol during a shift, drink two fifths of booze when I got home from work, and take a number of other pills. I was finally caught and a friend of mine bailed me out of jail. My lawyer said it would look better for me if I could demonstrate that I was getting help so I agreed to be admitted to a psychiatric hospital for my 'problem.' I told them I had a little problem with demerol and the sad part about that was they never asked me about my drinking.''

Turning to me with this same warmth, Beryl continues: ''I feel it's important for me to share with you how I was able to smuggle drugs into the hospital when I became a patient. I want you to understand so that someone else doesn't have

to go through what I went through." "I'm ready to listen and hear what you have to say," I reply. Settling back in her chair, she directs her full attention to me. I feel like the novice that I am. "Before I got admitted to the hospital I was able to go home without supervision to pack my bag. I made sure I got my stash. I bought enough percodan and some other pills to last me three or four more days. I put the pills in my cigarettes. I cut the filters off the cigarettes and stuffed the pills in with the tobacco then I put the filter back on. I left some cigarettes untouched so I could smoke them during the admission process. I knew the first order of business would be to search me and my belongings so I was ready for that. When I walked in I handed my bag to the attendant and proceeded to sit down and light up. I placed my cigarette case on the table and waited. It worked." "How was your withdrawal?" I ask. A wide grin emerges. "I hit alcohol, barbiturate, and demerol withdrawal about the same time and went nutso. I was hallucinating. I saw my mother chasing me with a knife so I started running and no one was prepared for that. I ran off the unit and right through a plate glass window leading to a portion of the roof. It was one story high and so I jumped down to the street and tried to run in front of an 18 wheeler when I got tackled. I came out of it two weeks later in an 'I love me jacket.' I spent two months in that hospital looking into why I was taking drugs, but no one ever asked me anything about my drinking."

There was a difference between the women who took other drugs and continued to drink alcohol. These differences are visible to co-workers and others who are astute in their observations and are prepared to acknowledge that what they see, hear, and intuitively feel is correct. If other drugs are involved, and the supply is where one works, this person is never absent. Not only does this person always show up for work, but she will volunteer to work overtime if needed.

"I always volunteered to work overtime," says Mary. "I could read the supervisor's body language and I knew when she needed someone to work overtime or another shift. I'd always be the first to volunteer even before she asked anyone. Today, that behavior in someone else alerts me to their problem. I'm also sensitive when someone starts telling me how

tired she is and how much stress she's having in her life and then she goes and volunteers to work overtime or another whole shift. It's this difference between what she says and what she actually does that tips me off. Things just don't jive. Then I really take a good look at her and I'll probably notice her skin coloring isn't what it should be. It's not fresh and clear. It's got a haze to it. It has a greyish tone. It's pasty, muddy, and I begin to realize that she isn't taking care of herself nutritionally. I look at the way she's dressed and I see someone who looks like she slept in her suit. In my mind I can begin to see a difference from the way she used to be to the way she is now. And then something within me clicks and I *know*.''

There were other subtle differences between the women that had a bearing on their developing addictive behaviors. Not making an effort to control their drinking was one of them. Marissa explains it this way: ''I didn't try to control my drinking,'' she says. ''I think that had a lot to do with how I approached it. I drank to get drunk. I saw no purpose in drinking if you didn't get drunk 'cause drinking gave me cortical permission to lose control and do a lot of stuff that I felt I couldn't do when I was sober. As a child of an alcoholic, I grew up with a lot of 'don'ts' and I wanted time out from that. I wanted to be able to giggle, to be silly, and to have some fun. Getting drunk also meant that other people had to take care of me for a change and I think that was my main purpose. I wanted other people to take care of me like they took care of my daddy. But I really feel that I was an alcoholic before I was born. Once I started to drink, I was already there. I didn't have a line to cross. The first time I was confronted at work I came up with a song and dance about how stressed out I was and had all kinds of excuses. I was told to select a psychiatrist and begin to work out my problems. So I did. I made sure I got one who didn't know a hill of beans about alcoholism. We discussed everything but my alcoholism. I went to see her twice a week for a year and I lied through my teeth to her the whole time. I told her I was only smoking pot once in a while and the sad thing about it was that she bought that.''

When alcoholism is in control of family life, children rapidly learn to suppress their human needs to meet those of the

alcoholic in the family and to obey the family "don't rules." One of them is don't have fun, giggle, be silly, or learn to enjoy life. On one hand, Marissa wanted to be able to enjoy herself, and on the other hand, she correctly perceived that others would take care of her if she got drunk. Finally she figured out how to meet her human needs. She could receive attention and have fun by drinking. Getting drunk, she reasoned, served both purposes.

Half of the women in the younger group described themselves as alcoholic from their first drink. They either did not try to control how much they drank or they were able to do so for short periods if it fulfilled a purpose they perceived as beneficial. Doreene reminds me that she drank according to the man's standard and getting drunk was something she perceived as a normal thing to do whenever she drank. Although Beryl was adept at diverting substances from the workplace and conning her family physician, she did not attempt to control her drinking unless she perceived a particular purpose in doing so. "I was very good at controlling my drinking when I went out on a date or when I knew that I had to watch what I was doing," she says. "And so a lot of people really didn't know until the end that I was both an alcoholic and a drug addict. I had gotten to the point where I'd drink anything. If I were visiting you and you offered me a drink, I would look to see how much booze you had. If you didn't have at least a half gallon of liquor or two cases of beer, there was no need for me to start drinking. You wouldn't have enough to satisfy me." Marissa did not try to limit her drinking either since it served a deeper purpose.

It is known that more women are beginning to drink at a younger age and are having problems with alcohol. Doreene describes herself as being a full blown alcoholic by the time she was seven years old. Marissa began drinking when she was 12 and describes herself as an "instant alcoholic," whereas Jennifer states that she was an alcoholic by the time she was a freshman in college. Most of the younger women were either drinking or taking other drugs by the age of ten. Those who became drug addicts in addition to alcoholics describe their journey into addiction as very rapid once they began using

other drugs in addition to alcohol. Once these other drugs were added, the ability to control their drinking disappeared within a very short time. Over half of the younger group were addicted to other drugs as well as alcohol by the time they entered the workforce.

"When I wasn't working and stealing drugs, I was drinking," says Nanette. "I had to get enough drugs to last during my time off but I could never keep anything. If I had something in my pocket, I had to use it. I was not able to bring any of the drugs home very often because I shot up at work. It's amazing that I never hurt anyone because some days I was taking 2500 mg of demerol and 300 mg of morphine if I could get it, plus a fifth or two of vodka when I got home. And I survived that. I don't know why, but I did. I'm flabergasted every time I think about it. By this time I didn't have a drug of choice. I would take anything but I preferred downers rather than uppers. But, whatever drug was the easiest to get, that's what I'd take. I knew my drinking was out of control but I still thought I could stop the drugs any time I wanted to. Oh, how wrong I was!"

Not all those who used drugs took them at work. "I didn't want to violate my ethic by taking drugs while I was working so I waited until I got home to shoot up," says Marissa. "Of course that meant that I went through withdrawal every night around 11 before my shift ended and I would be puking in the bathroom. And that, of course, was just my chronic stomach problem. I used the chronic illness bit. I had a problem with my blood and that's why I had needle marks. And I would tell everyone that I was going away for the weekend and lead them to believe that I was going to the medical center in the city for treatment when indeed I would be locked in the house shooting up all weekend."

"Being both a drug addict and an alcoholic can get to be a real hassle," comments Beryl. "I was constantly in a dilemma. On the one hand, I wanted to stay home and drink, and on the other, I wanted to go to work so that I could get drugs. I had an attendance record that graphically looked like a heart attack. First, I began to call in a lot and my absenteeism went up. When I felt that my boss was about to get on me for tak-

ing so much time off, I'd start going to work and stealing drugs at work. I became exceptionally dependable about showing up and I worked a lot of overtime. I talked constantly about my various ailments and about how poorly I felt. I always had diarrhea 'cause I shot up in the bathroom and I didn't want you to question why I was always in there. And then I'd make sure you understood that I had the flu, too, 'cause that took care of the paleness and the sweating and the diarrhea too. My judgment was starting to be affected and I made some serious errors and nobody really looked at why that was happening. I always had a good excuse and people just seemed to accept it. The people that I worked with were excellent enablers. Oh, some of them got angry but by the time I finished with them they began to feel that they made the mistake. I was very good at turning things around. I had to be. I didn't want anyone to get too inquisitive. It wasn't until I started stealing a lot of drugs that I got caught. The time came when I just couldn't keep my fingers out of the 'candy dish.' "

It is true that if one steals drugs from the workplace, especially narcotics, she will be caught. It is equally true that if alcoholism is the only problem, an intervention will not be done. The woman is still fired when it becomes obvious that alcohol is the problem. Once she is fired, money for treatment is unavailable. The conspiracy of silence among professionals is of concern to many who understand what will happen if the disease remains untreated. It is this silence that allows the woman to drift from job to job until she is no longer employable.

8

Having Consequences

Early morning is my favorite time to drink in the freshness and splendor of each day. This morning is exceptionally clear and crisp. As I enter the university grounds, sunbeams greet me with graceful leaps and pirouettes. Heavy frost covers the ground turning the campus into a soft white blanket. Winter is knocking at our door. I nestle further into the upturned collar of my coat and briskly move toward the apartment buildings surrounding the north end of the city campus. This is my second visit to Cassandra and I wonder if she will be able to shed any light on a fuzzy concept that is beginning to form within my own mind. Greeting me with a hug, she takes my wrap and places it carefully on a hook near the door. "Brisk, this morning isn't it," she says! I nod in agreement. As she begins to review my work on her cultural path, I help myself to a cup of freshly brewed coffee, its aroma gently permeates the small studio apartment. Moving a pile of books and papers from one end of a worn beige sofa, I settle back to await her comments. "You've certainly captured my life," she says without looking up. "It is so strange to see it written." She becomes extremely pensive and a quiet sadness envelopes her entire body. "I don't know how I was able to graduate from high school," she whispers "I was in the drug culture by the time I was a senior and getting wasted on a regular basis. I skipped a lot of my classes that

last year but I managed to hold my life together long enough to pass my exams. Out of the 350 students in my class, I ended up ranking 40th. We were still living in Europe and after graduation my folks sent me home to go to college. I spent the summer with my favorite sister and we had a good time. When it came time for me to attend the university's orientation program, I felt so sad. I enjoyed my sister's company so much. She made me feel wanted; but now once again I had to leave. I cried all the way to the college. When I arrived I found that everyone seemed to have their parents with them and that made me feel even more alone. I decided that I did not want to be with them, it was too painful, so I looked around and immediately plugged into where I wanted to be.''

As with others who detect denial of their human needs and withdrawal of love by those whom they most cherish, Cassandra left the university orientation to escape the pain of sensing that she was an outsider. Unable to perceive that she had worth and value in her own right, she drifted to people she knew would accept her without question. ''I met a fellow who was a drug dealer and we started going out to all these different night spots to drink and dance all night. I hadn't done any drinking or drugging for about three months and I was beginning to feel better, but I didn't connect that not taking anything was the reason I was beginning to feel good. I started out by taking LSD and mescaline and smoking pot. I didn't care for any of it very much. It made me feel paranoid and too out of control. I couldn't control what was going on. It was a very frightening experience for me. I liked alcohol better. It made me feel relaxed and gave me a feeling of peace; everything was gonna be O.K. I could party and have a good time. When someone introduced me to quaaludes, I knew I had found my drug. Between that and alcohol I felt wonderful. I could function and I didn't have any of the 'I can't's.' I had energy. I felt popular. I was confident that I would do well in college.''

''During my first semester I was able to pay attention to my studies but when the second came along I had to move off campus to an old apartment building owned by the university. It was like having your own place. It turned out that all

the people who were living there were oriented to drugs and alcohol instead of scholastics. That's when things started to go down hill and my life started to come apart. I had to tell my folks that I wasn't going to make it. I went out on the streets and got picked up by one fella and stayed with him a little while but finally I packed my bag and moved on. It was cold in upstate New York in the spring and I was sick. I finally walked up to a house and asked them if they would take me in. I told them I didn't have any money but they said O.K. It was another drug house. The house was initially rented by two guys. One was a junkie and the other a speed freek. Finally another couple moved in and then a guy and a gal so it was sort of a mixed bag. We were all doing our own thing and no one was working regularly so there were a lot of fights over cigarettes, beer, dope, and a whole lot of dishonest stuff going on. People were stealing things and selling them to get money for drugs. I began to feel like I was really sinking and in trouble. I didn't know how much longer I could survive. I didn't know whether I had pneumonia or I just felt so bad from all the drinking and drugging that I had done. There was a time when I could stop for brief periods but now I couldn't seem to do that. I felt an overwhelming compulsion to be drinking and drugging all the time and I couldn't fight it. I was being swept along with the tide. I began to be afraid. Many times I woke up in strange places and I couldn't remember what had happened or how I got there."

Being broke is one result of taking drugs that many of the younger women experienced. "I got into cocaine." Natasha tells me. "I spent over six thousand dollars in a month and a half and each week I spent every bit of my paycheck to get it." Relying on strangers, stealing things, and living on the streets became a way of life for many. Out of money, Cassandra left the university at the end of the semester and disappeared onto the streets.

"My sister finally found me and took me to a hospital. I was treated for pneumonia and nobody ever said anything about the drugs and alcohol. When I got better, my sister paid for my plane ticket to go back to live with my folks. They were still in Europe so back I went to the same mess. They were

drunk all the time now. The loneliness and emptiness I felt were excruciating! I got a job and of course got in with another drug crowd. I'll never forget the time I tripped with window pane acid. I was with a couple of guys when we bought it. It's a four-way hit and you were only supposed to take a section of it but none of us knew that. We took the whole thing and went into hell. I was never so scared in all my life. At one point I felt myself leaving my body and I thought, 'Oooh! I've really done it this time!' I thought I was dead. I did come out of it several days later. I woke up on the floor of this old house and I didn't know where I was. I was alone. I don't know what happened to the two guys, I never saw them again. That was the last time I did LSD. I went back to drinking alcohol.''

Combining other drugs with alcohol can be lethal. I like to think that Cassandra's out-of-body experience was her psychic energy attemtping to make her aware of what was happening to her. Only one other woman in the study reported having an out-of-body experience. ''I overdosed on a stash of valium and washed it down with a fifth of vodka, ''Mary'' calmly tells me. ''I was filled with so much self hate that I didn't want to live anymore. I vividly remember floating over the top of my body and seeing myself lying there on the floor of the apartment. I didn't have any thoughts about seeing myself like that, just knowing that I was dead. Then I saw the emergency squad working over me. I came out of it in an intensive care unit at a nearby hospital. I was hitched up to all these wires and tubes and I started crying. I was so miserable. I wanted to know why I had lived.''

All of the women experienced undesired effects of alcohol. The initial feelings of confidence, popularity, and security were short lived as consequences began to be felt in every area of home, social, and professional life. Feeling miserable, hating oneself, and wanting to end one's life are sequelae of the addictive process. ''One of the fellows on the emergency rescue squad turned my name into the substance abuse division of the mental health department,'' Mary continues. ''They kept buggin' me to come see them and so I finally did. I was confronted about my alcohol and drug problem but I still couldn't

believe that I had a major problem. My denial was so high.
I was so filled with self-pity and self-hate that I couldn't ac-
cept another view of things. I kept saying, 'If you'd led the
life I have, you'd drink too!' But I was running out of options.
My mother and father didn't want to see me, my husband
took the kids and left, and I suddenly realized I had done what
I set out to do—I was totally alone—nobody was around to
care for me. It was devastating. I couldn't handle it. I wouldn't
go to A.A.; I wouldn't agree to go for treatment. I ran out of
the counselor's office. One of my weird friends was waiting
for me and he gave me a ride back to my apartment. He had
a bunch of valium with him and I took all he had, and this
time drank a gallon of vodka and that night I was blitzed out
of my mind. I was right back into it again. I don't remember
anything that happened but I woke up in the intensive care
unit again hitched up to a ventilator and all kinds of other
things. This time my cardiac arrest was documented. But I still
thought I could take care of the problem myself.''

The inability to see herself as she really is prevented Mary
and Cassandra from accepting help. Instead, they were stuck
in their grieving process wishing for the life they never had.
They wanted love and yet repelled it when it was offered, feel-
ing that they were not worthy.

Half the women contemplated suicide. Several made super-
ficial attempts to slash their wrists. Having a post partum
depression and being asked to leave by parents or friends were
reasons given for planning a suicide. ''I was beginning to think
suicide was attractive,'' says Linda. ''I began thinking about
how I would do it. I had a lot of librium, over a hundred cap-
sules, and I thought that would do the job, but I hate to
swallow pills and with my luck my husband would find me
and I'd end up having my stomach pumped out. So, I dis-
carded that notion. Then I thought about cutting my wrists.
That really gave me reason to panic—if I cut a tendon, then
I wouldn't be able to hold a glass again! You see, I was trying
to figure out a way to take my booze into my afterlife, that's
how crazy my thinking had become!'' Five of the women ac-
tually attempted suicide by taking an overdose. Mary and
Cecelia were two of them. ''I took an overdose of pills at least

four times," Mary tells me. "I have a very difficult time dealing with any kind of loss and when I perceive that I'm losing something—a job, my kids, my husband—I can't handle it. The first thing I think of is that I'm such a bad person no one can stand to be around me and it isn't long before I'm running for the pills."

Getting wasted by drinking too much were experiences that all of the older women had. Attending church and other civic activities drunk and going to work with a high level of blood alcohol were common occurrences as alcohol began to interfere with their ability to live the life they wanted. "I was starting to get bloated," Zelda says. "I knew I smelled of stale alcohol but nothing was never said to me about that. The only thing my boss mentioned one time was my high absentee rate. She told me that if it continued she would have to look for someone else to do the job. I think she tried to do as much as she knew how to do but she never confronted me about my alcohol abuse. I do remember that she did ask me what was wrong and what was going on with me and suggested that perhaps I shouldn't work until I got myself straightened out. But I had every excuse in the book. I could whip up a story for you in nothing flat. When I think of what I did to protect what was really going on with me, it's incredible!"

Being afraid was a focal point in these women's lives. They feared that other people would find out about their drinking and they would be confronted and fired. The fear centered around "loosing everything." Zelda became expert at generating excuses to keep her boss distant from the truth of the matter. Although all of the women in the older group were afraid of being found out, their fear extended to more than being fired from the job. Being discovered meant they had failed as people to uphold cultural standards and meet the needs of others. All felt exceptionally isolated, alone, and under intense emotional pain from the unrelenting stress of trying to hold their life together. "I can remember going to church and there were times when I offered private petitions," muses Zelda. "I said: 'Please dear Lord, don't let me be an alcoholic!' I never did that for anything else, so that says something was goin' on with me!"

Although "getting wasted" for the younger group also meant drinking too much, they differed from those who were older by also taking other drugs. "I smoked pot in grade school but I didn't like the effect. It made me sleepy and I sat through my classes stoned. When I was old enough to get involved with alcohol, I found it gave me energy and I loved it. I enjoyed getting wasted, that was my goal," says Jennifer. "I hung out with my crowd on the weekends and I drank as much beer as I could. I really worked on getting drunk. I had this wild streak in me and I thought that was the way one had fun—to be nuts and wild and crazy. I liked speed because it gave me extra energy and I could really be the life of the party. I took speed for many years and then I got into cocaine. Cocaine made me feel *so* good! I felt so positive about myself without any of the jittery side effects of speed. I didn't want to eat, I didn't want to sleep, I just wanted to be doin' coke. But I acted like a jackass. I can spot someone who's doing cocaine in a minute! She's intolerably arrogant. No one can tell her anything! She knows it all. She is so obnoxious and she doesn't realize that's how she's comin' across to me. She's monopolizing the conversation. Her voice is loud, practically shouting, and she's acting in a monarchal way. And she thinks she's just fine and wonderful."

"Yes," agrees Natasha, "there is no such thing as fatigue when one is doing cocaine. I just loved that stuff. It made me feel absolutely *wonderful*. Cocaine is the one drug I still have incredible euphoric recall about. I know that if someone drew cocaine out on a mirror right now, I'd have to leave. I can be around someone doing other drugs. I can be where people are drinking and it doesn't bother me, but I can't be around anyone who is doing cocaine. I still have memories about that drug which are pleasant even though in reality it wasn't pleasant. There is just something about that drug that has tremendous pull for me. I felt like doing cocaine and drinking champagne was a classy thing to do. It appealed to that grandiose side of me. And I could drink again. I had had trouble drinking for a long, long time but when I started doing cocaine, I could drink again and I didn't get drunk as fast and for a little while it kept the blackouts from happening."

Having blackouts, waking up in strange places, doing dangerous things, missing school, and flunking out were consequences of "drinking and drugging all the time" by the younger women. "I wanted to change to routine," many of the women say, "but I was unable to do so and I was afraid." Being afraid centered around doing dangerous things leading to accidents either hurting others or themselves. Their fear focused on being hurt. They, too, felt isolated and alone. When drinking became a problem, many took other drugs to enable them to continue to drink in the manner they felt they should be able to do. Natasha found that when she used cocaine she could drink again without disasterous effects from alcohol. For a little while, it seemed to be the answer to her dilemma about drinking. All, however, experienced blackouts as their drinking and drug taking progressed into full blown addictions.

Blackouts are memory lapses and are common as alcoholism progresses. They tend to happen when the toxic properties of alcohol accumulate faster than the body can act to eliminate them. Blackouts may vary in intensity and duration. Kelli explains hers this way: "I can remember one morning during my freshman year at the university waking up and having no clue whatsoever as to how I got home and where my contact lenses were. And that began to happen on a fairly frequent basis. All my friends thought it was funny. They didn't understand just how serious it was because I really hadn't gotten to the point where I became obnoxious or started doing dangerous things like stalking off in the night and going to bars in unsafe neighborhoods. But that time came."

Blackouts were described by the women as "having a poor memory," and "not remembering incidents" that happened at a party or elsewhere. Being brought home following a drinking bout, being put to bed, having sex and not remembering it, not recalling spending large sums of money, and not remembering being at work are illustrations of the difficulty each had. All the women hid bottles of alcohol during a blackout and spent time the next day frantically searching for their stash to ease the increasing severity of their withdrawal symptoms. "It was a horrible feeling," continues Kelli. "I was convinced that I was gonna do something that would really hurt some-

body else. It got to the point that I knew that every time I'd drink I'd end up blacking out but yet I couldn't stop drinking. I was just compelled to drink. I was terrified because I had no way of controlling it. I didn't have any way of even realizing what I was doing. I'd hear about it later and there were some things that were very embarrassing."

Blackouts may be partial, with small amounts of time lost, or they may be complete, meaning that an entire evening or several days are wiped from one's memory. "I don't remember exactly when in my drinking I started having blackouts," says Natasha, "but I do remember a few specific situations. I remember being at a party and shortly after I began drinking I blacked out. I came to around midnight in the middle of a conversation and I didn't have the foggiest idea of what I was talking about. I was talking to five other people who were sitting there looking at me very intently—just hanging onto every word—when all of a sudden I snapped into reality. In a split second, I said: 'Oh, I just lost my train of thought, let me go get another drink!' Of course I blacked out again. That next day I had this tremendous feeling of remorse. It was like, 'Shoot, what did I do?' I had ghosts from that night on and they stayed with me all the rest of the time I lived in that town. I met people on the street who would say, 'Oh, Natasha I met you at so and so's party.' And I would think: 'Oooh! I wonder what I was saying or doing when you met me 'cause I sure don't remember you!' "

"I had a lot of what I call 'greyouts,' " says Linda. "I didn't remember pieces of conversation. I could remember where we went, what we did, and who was there, but I didn't always remember who I talked to or what we said. Toward the end of my drinking I may have had more severe blackouts. I didn't always remember what happened in the evening but then I passed out a lot of times. I was home and alone most of the time doing maintenance drinking and if I didn't get it just right, I'd pass out." Cassandra refers to hers as "brownouts." She felt that she basically remembered what she did and where she went but some of the events in the evening were hazy. Jennifer, on the other hand, felt a blackout was a blackout no matter how brief. "I may have had some blackouts earlier in

my drinking," she says, "but I know I definitely started having them once I got to be a freshman in college. Once I started having them, they continued for the rest of my drinking. It seemed to depend on how much I drank and how tired I was. Most of my blackouts came late in the evening. A lot of times it happened between the bar and going home. Sometimes I would forget what I had done but if someone prompted me then I'd remember the whole sequence of events."

Spending money, waking up in strange places, and having sex are some of the things the women talked about. Both Cassandra and Mary awakened in unfamiliar surroundings at several points during their drinking and drugging episodes. This happened to many of the women as their alcoholism progressed. "Not too long before I went into treatment I began to spend large sums of money," relates Lynne. "I went through five thousand dollars and I can't tell you today what I spent it on." "I was 23 when I had my first blackout," says Carnelian. "I had been drinking bourbon and I had more than I usually did. The last thing I remember was looking at the clock and noting that it was 10 PM. I was with a group of people and we were just sitting around drinking and talking. I came to around 5:00 the next morning in bed with this fella in a strange city and I didn't have any clothes on. I assumed the obvious but I don't remember that time span between 10:00 and 5:00 in the morning. I have absolutely no recollection of what happened."

Using alcohol to "settle the shakes" by having a couple of slugs of wine and "somehow getting that drink to stay down" were attempts to ease the aftermath of a heavy bout of drinking. "I was getting so I had withdrawal symptoms in the morning," Geri tells me. "I would shake so much that I couldn't write my name and I couldn't hold anything in my stomach. But if I took 10 mg of librium when I got up, and if it would stay down, that would get me through part of the morning before I had to take more."

Linda chuckles. "I can remember in one place I worked we served client's coffee early in the morning and we used china cups and saucers. I remember one morning I was really in withdrawal. I was shaking so badly that the cups were rat-

tling in the saucers and coffee was spilling all over the place. It was horrible. That was the day I tried to give some assistance to a blind person and she asked me why I was so nervous. She could feel my tremors."

Hallucinations may also occur following a heavy drinking bout. "This time," says Mary, "I couldn't stop drinking. My depression was heinous; my voice changed and I didn't sound like the same person anymore. I began to see myself talking out of the side of my head." "I started to hear music emanating from the fireplace," says Linda.

Having frequent mood swings producing irritability and crying jags was another aftermath of continued drinking. Some of the women became extremely violent and started abusing their own children. "I don't know what would come over me." Mary says softly, "but there were times when I found myself screaming and throwing my kids against the wall, pulling their hair and pushing them fiercely. I just couldn't control myself. By this time my husband and I were fighting all the time. I was so angry. And I could sort of step outside of myself and see myself doing it but I was powerless to prevent what was happening. I think those episodes just helped to reconfirm my belief about how worthless I really was."

Inconsistent behavior marked by being late for work, being unable to work, calling in sick especially at the last minute, and looking hung over when at work are sequelae of alcoholic behavior. "When I started to drink and I knew that I was scheduled to be at work the next day, I just called in with some wild excuse," Zelda tells me. "I did not want to go to work under the influence and by this time in my drinking history I knew that when I started to drink I couldn't predict what was gonna happen. I was afraid that if the people at work recognized that I was drunk, I'd be fired. Some weeks I was dependable, showed up every day and did a good job. There were plenty of other times, though, when I didn't show up at all." "I'd like to say that I didn't miss a day of work because of my drinking," says Catherine," but indirectly I did. I got a lot of severe bronchial problems and couldn't go to work. When I was confined to home with a legitimate illness, I'd just start drinking and continue until I passed out."

Many of the women, fearful of being confronted with their absenteeism, used elaborate means to keep their bosses away from this subject thus protecting their jobs. "My supervisor was getting very concerned about my absentee record," says Lynne. "I decided that if I were going to drink or use drugs heavily, I'd better cover myself. And I did. I made sure I had a medical excuse for being out of work and taking drugs that was documented. I had kidney stones which I blew all out of proportion so that I could be admitted to the hospital where I could also get lots of medication; I was in an automobile accident and had fractured ribs; I was bitten by an animal, you name it and I made sure if it were possible, I'd be covered with a medical statement and the opportunity to have drugs, lots of drugs 'cause nothin' ever satisfied my pain."

Recognition of impaired judgment was an exceptionally painful issue with all of the women. Initially they were adamant that their drinking did not interfere with their work performance in spite of the fact that their blood alcohol level was high when they were working. As the woman developed a bond of trust with me, I was able to ask a question requiring honest reflection: "When did you stop drinking to get ready for work?" I asked each woman. Linda smiles. "I worked evenings so I'd get up at 6:00 in the morning and I'd drink until 10:30 AM. I knew I had to be at work by 3:00 in the afternoon and I didn't want alcohol in my system when I went to work." "When did you move up your drinking time?" I ask. "I was able to drink like that for about a year," she replies. "But then I noticed that I had to move up my drinking time from 10:30 to 11:00 and gradually it got to be 1:30 or closer to 2:00 in the afternoon when I stopped. If I stopped any earlier, I'd start into withdrawal before I finished work. My hands would get so shakey that I couldn't write or do any tasks requiring any fine manual dexterity."

"I didn't drink before I went to work," says Catherine, "and I didn't drink while I was doing my job either. I tried to do my job as best I could and at the time I thought I was doing just that. I was in recovery for quite a while before I could admit to myself that although I didn't drink when I was at work, or just before I went, I would have enough in me

that people did not get the best from me that they should have received. It took several years before I could own that one. And I didn't look good either. I had a hangover just about all the time and my appearance was not what it should have been. I was growing more afraid with each passing day. I was afraid that I would be confronted about my drinking and fired.''

In the final analysis, all but three of the women had to agree that they went to work with high blood alcohol levels. As Linda was eventually able to tell me how she gradually extended her drinking time so were others. Three of the women not only worked but also went back to school to obtain a higher degree. They agreed that it was a monumental task to juggle drinking, work, and academics.

All of the women in the older group were afraid that people would find out about their drinking and they would be fired. Ultimately many were fired when their alcoholism became known. In contrast, those who were younger worried about trying to become a responsible adult when they still felt like a ten year old waiting for attention from Mommy. ''I didn't want to be an adult,'' exclaims Jennifer. ''I knew it was time for me to be responsible but I was still trying to find out who I was. I felt like I was split between three people. One was this wild hippie child, one of them was the jock, and one was me and I didn't even know who I was.''

''My alcoholism always led me up to the point of losing jobs because I 'drank too much.' That was always the vulture in the background,'' says Catherine. ''I remember the day I got a new boss and we all went out for lunch. Everyone had something to drink but I guess I overdid it as usual. The next day my new boss told me that she didn't think this was the place for me to work. She didn't come right out and confront me with my drinking but I knew. She told me I could come back to work when I got myself straightened out so I guess that was a nice way of being fired.'' Geri chuckles. ''Yes,'' she says, ''I know what it feels like to be fired in a nice way. I had been through treatment twice when I had another relapse episode and my boss called me in and said 'I think we've done everything we can and I don't think it would be good for you

to come back here.' And this time I had to agree with her, high stress city was not the place for me to be.''

Having accidents, setting the house on fire, getting arrested, and getting a driving under the influence citation (DUI) are among the traumatic events that frequently happen during the addiction process. ''One night my husband came home late after a meeting and found me passed out in one of the overstuffed chairs,'' Mary Helen tells me. ''He smelled smoke and found the arm of the chair smouldering. The next thing I knew he yanked me out of the chair and I just flew across the room. He got the door open and wrestled the big chair outside. And all during this he was shouting at me: 'Damn it, Mary Helen, what are you doing?' He was so frightened and angry and I was just shaking by this time. I had been drinking and had fallen asleep with a cigarette burning. It was then that my husband just blurted out 'Mary Helen, don't you know you're an alcoholic!' I was crying by this time. He asked me what I was going to do about it and I said I didn't know. I honestly didn't know what to do.''

Two of the women were arrested for driving under the influence but over half of the women had automobile accidents directly attributed to their drinking. ''I had an automobile accident,'' says Lynne. ''I passed out behind the wheel and hit a telephone pole and ended up in the hospital after that drinking bout. But I really didn't mind 'cause now I was in a place where I could get lots of medication for my pain and you can be sure I had lots of it.''

Divorce has been repeatedly found to be one result of alcoholism in women. Over half of the women in the study saw their marriages disintegrate, children leave, and parents cast them out. They lost it all.

''My drinking had really taken off,'' says Julie, ''Now I *knew* when I got up each morning that I would drink—it was just a question of when I would begin. My husband was involved with his business and I began to see less and less of him. He told me much later after I was in recovery that he would call me periodically to meet him for dinner but I would always stand him up and he would come home to find me either passed out or sitting on the couch waiting for him to arrive.

I don't remember any of those times and there were other times in my life that I don't remember either. The blackouts were beginning to occur more frequently but neither my husband nor I could take a look at that. He just started staying away more and more and became immersed in his work. The day did arrive, though, when he told me to shape up or ship out. I decided to go to Florida for a vacation and dry myself out. It didn't work. I bought a bottle as soon as I got there and remained drunk for a month. When I got back home, my husband filed for a divorce."

"Next I tried a geographical cure," she continues. "I went to New York and got a job. At noon time instead of eating lunch I would walk up to Second Avenue and buy two or three miniature bottles of alcohol and drink them in the ladies room for lunch. I did some part time modeling and I also worked in a clinic. It was usually quiet on Saturday's so I would bring a bottle with me to work. One day I was caught drinking at work and was fired. I was told to go quietly and nothing would appear on my work record. This was the first of many jobs I lost because of alcohol. But alcohol was beginning to catch up with me. I was starting to have an irregular menstrual cycle and I wasn't eating right. In college I had gained some weight and the doctor put me on amphetamines. They were *wonderful*. Not only did I lose weight but I had all this energy to do my work and go out partying too. I'd always had a tremendous capacity for alcohol but now I could really put it away! I couldn't sleep, my sleep cycle was getting disrupted, and it seemed like I was awake all the time. I lost my modeling job when I started missing appointments and I didn't look refreshed and youthful when I did show up."

Being restless and moving about are more results of addiction. Recovering persons refer to the process of frequent moves as "taking a geographical cure." It is the method the alcoholic employs to run away from one's alcoholism. The person thinks that a fresh start in another location will eliminate the problem. Julie's move to a large city was one such example. Cassandra expresses the concept this way: "I got to the point where I was never happy. I was restless. I was looking for something and I didn't really know what I was looking

for but I felt if I were someplace else I'd find it. This was when I started movin' on and taking a whole bunch of geographical cures, but my addiction went right along with me.''

When the geographical cure does not seem to be working, other methods are initiated: "The next thing I did was try maintenance drinking,'' says Julie, ''but if I didn't get it just right, trouble lay ahead. I was returning to the city from visiting my brother and his wife. When I got off the train, I remember that my legs felt funny. I don't remember anything that happened after that but apparently I got off the train went across the street to a liquor store, bought a bottle, went into my apartment building, spoke to the doorman, got on the elevator, and when it opened on my floor and I got off, I went into a grand-mal seizure. I came out of it in the emergency room at Bellevue. My folks finally decided that they had had enough and so they admitted me to a private psychiatric hospital for a ''nervous breakdown.'' We never did deal with my alcoholism but I learned how to make moccasins, wooden bowls, and all sorts of other junk. And of course just as soon as I was released I went right back to drinking again.''

Having seizures, losing feeling in the arms and legs, being sick all the time, feeling rotten and feeling that they were going crazy are experiences each woman had. ''I was having a hard time holdin' my life together,'' says Geri. ''Drinking was starting to catch up with me. I'd work long enough to accummulate four hours of sick time and I'd think, 'Oh, goodie, I can stay home today and drink.' I sat at my dining room table from early morning with my arm on the table sipping vodka. One day I noticed my little finger and the one next to it began to get kinda numb. Then I noticed that one of my legs was kind of numb too. It went away after a while, but it would be back. It never dawned on me that it was related to my alcohol use so I went to my family doctor and told him about the problem. I told him I wanted to see a neurologist. He said O.K., but first he wanted to talk to me about my drinking. I had gained weight, my blood pressure was up, and he was getting concerned about me. I was indignant! He gave me some blood pressure pills and a consult to the neurologist. The neurologist did some nerve conduction studies and then

said he wanted me to see a psychiatrist. And I thought: 'He's not going to help my arm feel better,' but I went. On the second visit, the psychiatrist wanted me to tell him about my drinking. I jumped up and ran from the room! My husband had left me by this time and I began to realize I was going to lose everything if I didn't do something about my drinking. But I didn't know what to do. I didn't think there was anything I could do. So I didn't do anything.''

''The day came when my husband filed for divorce and I was just devastated. I just knew it was my fault that my marriage had failed,'' says Mary Helen. ''I felt so guilty and at the same time I was afraid of the future. No one in my family had ever gotten a divorce before and I knew I couldn't tell my parents what was going on. I didn't have any close friends and the isolation and loneliness were just overwhelming. I did the only thing I knew how to do—I buried my feelings and went on trying to pretend to everyone that nothing was wrong.''

''I knew I would have to go to work and so I approached my gynecologist and asked him if there was something I could do in his office. He was kind and gave me a job and I worked for him for almost a year before I got fired. I was drinking every evening and I know my performance in the office left much to be desired. I'd always had a position of responsibility. I was always at the top of anything I did and now I had to learn the routine in a doctor's office and be just one of the staff. One day a woman stopped to talk to me who was having trouble deciding if she should have a hysterectomy, and of course since I had had one, I went into how good I felt after having it done. Of course I was out of line and I can remember really getting a tongue lashing for that one. But that wasn't the reason I got fired. It was the office Christmas party. I started drinking and went into a blackout. To this day I don't know what I did, but I was asked not to come back to work after the holidays and to do something about my problem.''

''It was about that time that my right hand and arm became numb and I started vomiting all over the place. A neighbor took me to the hospital and I was put in the psychiatric ward. Talk about cold turkey behind locked doors! I thought I would shake out of my skin. After I had been through hell the

psychiatrist told me to stop feeling sorry for myself and he discharged me with a prescription of valium. My alcoholism was never discussed and never treated. I started taking the valium and I didn't drink and I thought I was doing very well. I went to a concert with my cousin and after we got home she told me that it was obvious that I was drunk. Well, I hadn't been drinking! I was being a good alcoholic and just taking the valium! Eventually I stopped taking the valium and went back to drinking. I lost several more jobs before I finally found a place that would help me. It was a psychiatric hospital but there was an A.A. person there who kept hammering away at the establishment to let her begin working with some of the patients and finally they agreed. I like to think that I was one of Marty Mann's first clients."

Although Mary Helen's first exposure to the A.A. program formed a lasting impression, she had more to endure before she finally embraced recovery. Many of the older women were given tranquilizers by family physicians for complaints of "being up-tight," "nervous," or "on edge," whereas amphetamines were readily prescribed for dieting. Some of the older women used amphetamines to give them the energy they needed to be all things to all people. Alcohol, however, remained their drug of choice. Younger women have been exposed to a wider variety of drugs as well as alcohol. Many used speed while still in grade school to give them the energy to feel "normal" and be able to do some of the things they saw others their own age doing. Others smoked pot and from which they derived needed relief from the stress in their lives. All who used drugs went on to experiment and become addicted to more powerful drugs. Everyone, however, drank.

Part III

BEING AFRAID

9

Becoming Aware

Taking deep breaths of early morning fresh air, I continue walking around the grounds of the small hotel nestled in the foothills of the Blue Ridge Mountains. Fall is hovering close by and I can feel the crispness and see foliage beginning to dawn their festive coats of many colors. There was a time when I found fall to be a very disturbing time of year. Now I am grateful to be able to drink in the sights and smells and look forward to this beautiful time of year. A salute to my own healing process. The warm energy radiating from the many brilliant colors and sunlight indicate that this day is going to be one of nature's very best. I begin to think about my upcoming meeting with Lucille. This will be our second meeting and I am particularly interested in finding out when she became conscious about what was happening to her. Surely, I think, her body must have sent some early signals that went unheeded. When did her knowing emerge and could she, in reflection, look back and identify any early warning signals?

Awareness is consciousness. It is a process by which we are able to interpret what we see, hear, feel, and touch. These perceptions enable a knowing to emerge. Knowing fosters the

connection among our thoughts, feelings, and the attitude we have about ourselves. It provides the means to access situations in advance and make appropriate plans. All of us have these experiences—or do we? How and when does awareness begin for the woman alcoholic? It was this part of her cultural path that I now wanted to understand. I am aroused from my thoughts by someone calling my name. I look up to see Lucille coming toward me and I turn to meet her. ''I brought a thermos of coffee,'' she says. ''Let's find a spot to sit outside, it's going to be a beautiful day.'' I have to agree with her. We find a sunny spot on the old weather worn veranda and reposition two rockers. ''I can get drunk on sunshine and the smells this time of year,'' I casually remark. ''Careful,'' she says, ''you'll have to pick up a white chip!'' We both chuckle. I explain to Lucille how I want to begin our session. ''Let me give you an example of something that I noticed about myself and perhaps it will help you to understand my confusion.'' She nods, her warm brown eyes attentive.

''There was a time when I, too, was in the habit of having my cocktail around 4:00 in the afternoon. One day I had some work to finish and I decided to go into the office later in the afternoon. I was busy, happy, and feeling good that day. I finished talking to a manager in another department about a project that we were working on and I was walking back to my own area of the building when I began to notice how strange I suddenly felt. I felt a little light headed and weak. It was just a passing feeling but it alerted me. Then I felt tremulous. It went through my body like the gentle ripple in a quiet pond. 'What is this? What is going on?' I asked myself. I didn't feel ill. I began my internal search for clues. Finally recognition dawned. This was my cocktail time! I searched for further meaning and suddenly I knew! I realized that if I continued, alcohol might begin to control my life! For me there was no question. The booze had to go!'' Lucille smiles a smile of quiet understanding and then she says: ''For me, alcohol was the answer! It was the solution to all my fears and feelings of inadequacy and shyness. Alcohol was going to help me achieve in life. I was never able to say to myself, 'Lucille, you've got this feeling and it means that if you keep on you

won't have any choice.' I was never aware that I had any choices. That never came through to me. It just wasn't there. I didn't begin to have any awareness until I had some pretty traumatic things happen to me. Only then did I begin to question what was going on. But I still didn't realize that alcohol was at the bottom of all of it. You see, right from the start, alcohol made me feel better. When I drank, everything inside worked right. It was the answer to why I felt so bad. It was love with the first glass. Alcohol was my friend and would help me feel better about myself. When I drank I could relax and the fears were gone. I wasn't so shy or fearful. I could talk to people. Without alcohol, I was filled with fear. And I couldn't share those feelings with anyone. I was afraid that if people really got to know me they would find out what a horrible person I really was and I would be rejected. I couldn't handle that. I couldn't face not being worth anything as a person. I was so filled with fear that I didn't have any inner thoughts. But there came a time when I knew I had to drink, that I knew, and I was paralyzed with more fear. This time it was the fear that comes from knowing that I couldn't continue to drink like I was drinking. It was a horrible feeling. I knew that if I kept on I was gonna do something while I was drinking that would hurt somebody else. It got to the point where I was blacking out every time I drank and doing things that were real embarrassing and dangerous. I was terrified because I had no way of realizing what I was doing and controlling it. I knew that I had to stop drinking, but I couldn't. I was caught in a trap and finally I knew it. When that reality arrived, I shook from the sheer terror of it all. I knew I was going to die. I would have taken my own life at that point in time, but I couldn't even think how to do it.''

In reflection, Lucille is able to point out some of the differences between us. Alcohol, reacting differently in her body, functioned to make her feel good. When she drank, ''everything on the inside worked right.'' She felt physically connected and together. Many women alcoholics relate similar experiences. Others, however, tell about severe reactions to their first drinking episode. Jennifer points out to me that in the beginning of her drinking she became extremely ill but was

able to "drink through" this initial reaction. "When I first started to drink," she says, "I got violently ill." "It didn't seem to make any difference if I had one drink or several drinks, the result was the same. After a while I noticed that I didn't get sick any more and I could enjoy getting drunk. In lookin' back, I think that my body was trying to tell me something, but I wasn't able to pick up on it."

The depth of knowledge about alcoholism we have when beginning to drink, how secure we feel with those close to us, and the belief we have about our worth will determine, in part, our readiness to receive information and act on new insights. Earlier, Lucille tells us that growing up she felt somehow she was not quite right. Her mother's own self-perceptions about appearance, although unintentional, were communicated to her by continually urging her to diet to reach some ideal standard of physical beauty and perfection. Instead, Lucille felt unacceptable and unloveable. Alcohol provided relief from these feelings. It subdued the stress from trying to attain an illusive standard and allowed her the opportunity to feel acceptance from her peers. For a time, alcohol worked. It blocked those disquieting perceptions, dulled the pain within, and helped her cope with life. Then, traumatic events directly attributed to alcohol forced awareness of her dependence on it and further validated her unworthiness. This realization produced sheer terror. Depression and thoughts of suicide surfaced.

Suicide among alcoholics has been estimated by Dr. Seixas, a noted researcher and professor at Harvard Medical School, to be 32 times greater than in the general population. Although the exact number of suicides in women alcoholics is not known, it is presumed to be high. Acknowledging the true nature of one's problem, especially if it is alcohol, is extremely painful. This recognition of loss of control over one's life erodes hope. The feeling that things will get better disappears. Self-confidence and self-respect vanish. Suicide may be viewed as the only way out.

Gracefully adjusting her lawn chair to a more comfortable position, Cecelia reaches for her glass of ice tea and quietly says: "I felt I was going crazy. I could not longer function

without pills or alcohol or both. I was afraid my husband would put me away permanently in a mental institution and that my children would abandon me if I didn't get straight. I didn't know what to do or where to turn. I was suffering from the most overwhelming depression I ever hoped to experience and the pills and the alcohol wouldn't take it away. I took a lethal dose of Ascriptin and Dalmane washing them down with a fifth of vodka. My family found me when I was semi-comatose and rushed me to the hospital.''

Woefully depressed, a chilling, devouring fear swept through ''Cecelia's'' entire being as she realized that alcohol and other drugs had assumed control of her life. Her bid for release thwarted, she had to face the task of living. As she awakened in intensive care, her daughter's gentle kiss combined with ''Mama, I love you,'' penetrated the rage of finding herself still alive. A glimmer of hope is restored, her anger subsided permitting her to receive help.

When alcohol is identified as the problem by co-workers, and those persons have not examined their own feelings and biases about the disease, then the reaction may be punitive rather than humane. Such thinly disguised disapproval conveys rejection of another which produces unwanted results. Sighing deeply, Mary's anguished blue eyes betray her pain. ''I decided I'd feel better about myself if I got a job and so I did,'' she tells me. ''During orientation, I was called to the administrative office and the head of the department asked me why I didn't tell her about my drinking problem. I was devastated! She said she was going to watch me; that, to me translated to, 'She's going to find a way to get rid of me!' I went home and overdosed. I had a cardiac arrest. I woke up in the intensive care unit intubated and hitched up to all these tubes and things.''

Judgment of another who has an unfashionable illness projects disapproval and unacceptance, and leaves one without hope. Hope is an essential ingredient in life. If the woman's human closeness needs have been partially satisfied while growing up, a slender thread of hope survives. Although thoughts of suicide may be present, other avenues to find relief will be sought. Jennifer's piercing blue eyes sparkle like gems;

searching my own countenance for acceptance and finding it, she begins to share her innermost feelings with me. ''I was in enough pain,'' she says. ''It was like I'd do anything, just get me relief from this pain! I think at the time I was 25 and I was trying to figure out what bridge to jump off. But I didn't want to do that 'cause every now and then I would have days where I would come up for air, feel good about myself, and feel good about life. I knew that I had poor self-esteem but I also knew that I could manage it and I could still have fun. I talked to a friend of mine who was a psychologist and he sent me to a woman who was experienced in counseling. This woman was more than a counselor. She was astute in the field of alcoholism. Together, one woman helping another, we started to take a look at what was going on in my life.''

Although contemporary American women are gaining freedom from social constraints, society is still merciless with those having problems with alcohol or other drugs. The standard that the woman should not be drunk still prevails. Nowhere is this more apparent than in the area of human services where women's needs continue to be minimially met. Women are acutely aware of this fact. The struggle, then, becomes one of finding an ''acceptable'' reason to seek help. Carnelian describes her turmoil by saying: ''I can remember several months before I went into treatment lying in bed thinking that there was something wrong with me. I began to wonder: 'Am I crazy or am I an alcoholic? Am I an addict?' I mean, which is the most acceptable of the three? What's wrong with me, something's wrong but how do I ask for help? I can't ask for help because that means something's wrong with me.''

In Carnelian's statement, we can begin to witness her turmoil. She tries to balance the emerging awareness of her problem with an acceptable reason to seek help, yet at the same time deny the true nature of it. Denial is one of the psychological mechanisms by which we are able to protect ourselves against the loss of something we perceive as having intrinsic or inner value to us. It protects our self-concept, the image or belief that we hold to be true about ourselves. Denial allows us to preserve a measure of self-respect. Self-respect, self-love,

self-worth are terms we use to mean self-esteem. Self-esteem, in effect, says how we feel about our self-concept. When human needs for closeness are denied, self-confidence and self-esteem crumble. Losing control over one's life is the final straw in the battle to retain some measure of self-worth. It is terrifying. Terror, combined with the body's toxic reaction to alcohol, further erodes the last remaining threads of self-worth. The fear of not being able to live without alcohol and knowing how society feels about women who drink too much combine to prevent her from seeing herself as she really is. She becomes immobilized. "I was so afraid to ask for help," Zelda quietly but decisively tells me, "I had to keep up that appearance that everything was O.K. Everybody including my family knew that I had a problem with alcohol. It's just that inability of the alcoholic to see herself the way she really is. It really is that simple."

Although knowledge brings awareness, accepting this awareness is excruciatingly painful and frequently beyond the woman's present abilities to cope. Affectionately stroking her poodle as he nuzzles for attention, Agnes' brief smile is quickly replaced by a pained expression. "I went to a workshop about alcohol and drugs in the city where I worked," she says. "I was hoping to get some information about how one drank socially. It really never occurred to me not to drink. The thinking was to learn how to do social drinking. I liked to have friends in for dinner because then I could do the pouring, but I was beginning to realize that strange things happened to me when I drank. It seemed as though it didn't take very much for me to forget the rest of the evening's events. I guess I went to the workshop looking for some answers but what I learned made me even more uncomfortable. I remember there was something about the disease concept and then several women shared what happened to them. At the end of the workshop, we had to do this free association bit and write down the first words that came to mind when we saw the word alcoholic. I remember looking at the word on my piece of paper very carefully and then in very tiny, tiny letters printed 'm-e.' I knew, now I knew! It was a big relief. It was like there was

the missing piece! Part of the requirement for this workshop was attending an A.A. and an Al-Anon meeting."

"I truly hadn't accepted the fact that I was an alcoholic, I just had a drinking problem and I really believed if I could just learn to drink right, everything would be O.K. But I had promised one of the girls who went to the workshop with me that I would go to an A.A. meeting with her and so I did. By that time several days had gone by and I hadn't had anything to drink. I was feeling better and I began to think that I was crazy for having thought that I might have a drinking problem. I began to get angry with myself, why did I ever agree to go to that dumb meeting! All during that day I could feel my anxiety going up and when it came time to go, I panicked. The fear was ghastly. I just couldn't be an alcoholic. I guess if I had gone to an A.A. meeting that first night after the workshop things might have been different, but I doubt it because my wall of denial was still there. I don't remember anything that was said at that meeting because I was in such a stew. When everyone introduced themselves, instead of keeping my mouth shut and just listening, I told them that I was a concerned person and if there was anything that I could do to help them, I certainly would. Nobody laughed, they just said, 'Isn't that great, keep coming back!' And under my breath I said, 'Not on your life!' After the meeting, people kept giving me their phone numbers and told me to call them, and they gave me some literature. I think they saw my intense fear. I bolted out of there as fast as I could, came home and hid everything that they had given to me. I just couldn't face it. It was too painful. It took another six months and a DUI charge before I decided that maybe, just maybe, I might have a problem."

The resolve to be accepted socially will initially block the woman's ability to recognize that alcohol has assumed control of her life. "I think I can explain it this way," says Linda. "I knew for probably a couple of years that I was drinking abnormally and I didn't want to drink that way. I wanted to be able to drink socially again like I used to at the beginning of my drinking. I wanted to have a drink if I went out to a party or was with my friends and leave it. But I realized there

came a time when I couldn't do that. When I needed to drink. When I couldn't function without it. And it scared me. The fear was crushing me."

The haunting dread when the inability to drink like others is perceived produces shuddering, oppressive fear. At first, this knowledge about herself is suppressed allowing her to search for alternative reasons for her misery. Her goal, if need be, is to find a way to conceal the fatal flaw of her imperfection. Many women are driven to excel. As their dependence on alcohol to cope with feelings of inadequacy and low self-worth increases, she may feel compelled to compensate by becoming "superwoman." Being "superwoman" is a way of being in control of others. Trying to be in control of others, and at the same time manage one's own disintegrating life, takes a tremendous toll in energy and raises stress. Over time, prolonged stress does contribute to physical irregularities. As the woman searches to find reasons for her total unhappiness, she finds solace in anticipating that something physical and "acceptable" may be the cause of her misery. Barbara's radiant smile and warm brown eyes belie her frantic search: "I began complaining that I didn't feel good. I had laryngitis that just wouldn't go away so I went to an ear, nose, and throat specialist and he couldn't find anything wrong with me. Then I began having stomach problems and I went to another doctor. Every time you turned around I was going to the doctor, having lab tests done, and everything was coming out O.K. Then I got obsessed with running. I had to run every day, and I ran miles. I started having arrhythmias. My heart would just take off and pound. I felt like it was beating its way out of my chest. But, again, everything checked out O.K. Then I fell and hurt my knee and had to have surgery. Now I was really grounded and my problem was still with me."

Wanting to find a physical reason for the problem is a common desire. Many women make countless visits to physicians in search of anything that will keep reality at bay. Unless an in-depth alcohol history is taken, alcoholism will be missed. I notice a shadow spreading over Catherine's face, lending a quality of pathetic wistfulness to her voice. "I wanted it to be some other problem," she says. "I was very depressed and

anxious. I knew all the symptoms for gall bladder disease so I went to a local surgeon and told him I had all these symptoms. After three visits he finally put me in the hospital, but all the tests were negative. I remember I just felt awful and I ached a lot, I guess I went through withdrawal and neither the doctor nor I could look at that.''

Awareness penetrates denial in various ways. For some, it may be a letter, a spot television announcement, or honest feedback from a friend. Geri sighs deeply, her voice subdued as she recalls her difficulty in accepting reality: ''I was watching television and I saw one of those public announcement type of things. It was a woman who was frantically looking through all the kitchen cabinets and I knew instantly why she was desperate 'cause I hid my bottles and then forgot where they were. I took down the number and I called it. I felt like the person at the other end could just see through the phone and when he asked me if I was an alcoholic I said 'no,' but I knew deep down that he knew. He sent me some information and I remember taking it to my room and locking the door while I read it. There was no one home at the time so that certainly says something about the way I felt. There was one piece, a letter to an alcoholic woman, and it seemed like it was written to me. I sat there on the bed and kinda let it sink in that I did have a problem with alcohol. But then I stuffed the envelope in a bottom drawer for another six months while I continued my destructive behavior. I just couldn't face the fact that I was an alcoholic.''

Glimmers of awareness for another may be a violation of what one considers to be reasonable and appropriate drinking. Most alcoholics begin drinking with a sense of what is reasonable and appropriate consumption. As the self constructed norm is violated, the woman may at first become angry with herself feeling that she ''should know better.'' Zelda chuckles and then becomes extremely serious. ''When I switched from scotch to wine,'' she says, ''I knew deep in my heart, I knew damned well that a drink is a drink is a drink. I had seen all these things happen to members of my family and other people that I knew and I could see it happening to me. I felt that I should know better.''

Awareness also brings disbelief. Zelda continues by saying: "I was confused. I was bewildered. I *knew* what was happening. That word alcoholic was in my head. But I thought, 'No, no, I'm just drinking a little bit too much.'" Doreene, too, nods in agreement to my probing question. "I couldn't be an alcoholic," she tells me. "I was too young; I was too pretty; and, I was a professional. I had a very responsible job. I was a rising young star in management. I was on my way up the corporate ladder. I just couldn't be an alcoholic!"

As awareness develops, the woman may deceive herself by thinking that she is still in control of the drinking. Linda ponders briefly before speaking: "I think I realized that drinking was a problem when I started drinking after my youngest son left for school each morning. I also knew that if I had a morning meeting to attend, I had to have my drink before I left the house. When that began to happen, I knew in my head that I had a problem. I mean that's when I told myself, 'You're in trouble, you're drinking early in the morning.' But I still thought I was in control of everything."

Others received internal messages by looking at their reflection in a mirror. Catherine laughs as she thinks about her denial: "I looked in the mirror one day and I *knew* I was going to become an alcoholic. But I thought I had lots of time left before that happened." Doreene's smile broadens into a wide grin. Her strawberry blonde hair accents mischievious blue eyes and she breaks into a grin when remembering an earlier time: "When I was in college I took a community health course and we had a couple of hours devoted to alcoholism. I remember I started thinking that I might have a drinking problem. We went over the 'twelve steps' and I looked at the first one and said to myself, 'Well, I am powerless over alcohol but my life is sure not unmanageable' so I kinda dismissed it from my mind. I remember getting uncomfortable when the teacher gave us 20 questions to answer about ourselves and if you said 'yes' to more than one, you had a problem. I got uncomfortable 'cause I said yes to over half of them. I remember that night I looked at myself in the mirror and said, 'Doreene, alcohol's gonna get you one of these days.' But I thought that would happen when I was around 60 or so."

Perhaps more frequently than we care to acknowledge, women who become aware of their growing difficulties with alcohol resort to taking other drugs while continuing to drink. Lucille leans back in her chair, becomes pensive for a moment, and then says: ''I did not connect my total unhappiness with taking drugs although on some level I knew that. Intellectually I knew that I had a problem with alcohol and drugs. If they weren't there (drugs and alcohol), then I'd feel better and I'd be happier. But then I had to try all the ways that I knew to continue to drink. The drugs and alcohol were the only way that I could cope, the only way that I knew how to cope with anything. I couldn't face giving that up 'cause I didn't have anything to replace it with.''

Natasha deftly retrieves two cups, a bag of cookies, and the coffee pot as we make our way to the porch to enjoy the warm spring day. Her tabby scoots across the room, slipping past our feet as we make our exit. Perched on the nearby railing, he surveys his territory for activity. As Natasha pours us each a cup, I wrestle with a resistant cookie bag: ''I've been thinking,'' she says. ''There was a time when I was in college that I didn't drink for a whole year. It was a conscious decision not to drink, but I don't remember what happened that made me think I needed to quit. I went back to it, though, and it didn't take long for things to get worse. I can remember one semester that was very stressful and I needed to escape from the reality of that. I needed to be able to come home and take the afternoon off, but by that time alcohol was costing me too much when I would take the afternoon off with alcohol. I didn't know any other way to take the afternoon off other than to get high. About that time I had a migraine headache and the doctor gave me some codeine. It worked. I felt great. And I could drink. But deep down I knew this wasn't good. I can remember one afternoon going up to the attic and writing a paper to myself. I saved it and I reread it just before you arrived. I really described what it was like to be addicted. I understood the feelings that were tied into it, I understood how the compulsion got set up, and how the cycle fed into feeling bad about myself, taking the drug, feeling better, but then that taking of the drug made me feel bad about myself

so I took more drugs. And I wrote out all these wonderful interventions on myself to stop the cycle. It was maybe if I get a good hobby, or maybe if I make more friends, or maybe if I get healthier, and part of it was maybe if I don't use drugs. But you see, I didn't have any concept of how not to use drugs. And I didn't think anyone could help me.''

In spite of these first glimmers of awareness, all the women at first suppressed this new knowledge and denied reality. What they suspected and felt did not exist. What they found out applied to someone else not themselves. ''I was concerned about my mother's drinking,'' Jennifer tells me. ''I hadn't really identified that I was an alcoholic because I had always identified her as the one. She was the one in the bathroom, on the couch, missing work, drinking for amnesia, drinking for sleep 'cause that's what she did, she drank to sleep, to knock herself out. And I thought I was O.K. I couldn't see myself. It wasn't until I got a DUI for driving drunk that I began to ask myself what was going on with me.''

As painful experiences resulting from the use of alcohol escalate, awareness that a problem exists heightens—but the true nature of that awareness may continue to be a mystery. Lucille thoughtfully reflects: ''In my mind I could see that my life had gotten worse and I knew that it was connected to my drinking. I thought that if I could cut back I would feel better about myself and people would like me and crazy things wouldn't happen. I was also physically ill at the time and I was going to work drunk and for all those reasons, I thought I needed to try and cut back. I never thought of stopping.''

There are traumatic events that frequently happen to alcoholic women. Being arrested for driving under the influence (DUI) is one of them. Nervously running her hand through her long blonde hair, Jennifer shifts in her seat and becomes more tense as she remembers an earlier time: ''I was beginning to realize that I just couldn't party the way I had before. I was getting in touch with the fact that I didn't want to get thoroughly wasted every time I went to a party and I was also beginning to realize that I couldn't drive that well when I was drunk. I had just dumped my latest boyfriend 'cause he wanted to have a relationship and I was terrified

of that and I was driving home alone from the party. I wasn't as drunk as I usually got at a party, but drunk is drunk. I got pulled over for driving under the influence and that was a real shocker for me. It scared me to death. I was so upset. It was like I gotta be really professional in my work and what does this mean? Most people driving around don't get arrested when they've had a few drinks."

Jennifer's DUI and subsequent attendance at a court ordered Alcohol Safety Action Program (ASAP) inaugurated a process of "lookin' in." Lookin' in forced her to begin to wrestle with the meaning behind her present state. Initially, she resisted the new information, but gradually a crack appeared in her resolve to ignore reality. She continues by saying: "Getting that DUI sure slowed me down a bit. I went to court and the judge ordered me to class but now I was being a good little alcoholic; I was only getting drunk once a month and I made sure somebody else was driving. But I was also beginning to realize something else. Although I didn't want to get thoroughly wasted at a party any more, I was beginning to realize that way down deep inside of me I both wanted and needed to be totally obliterated and that scared me." Chuckling, her blue eyes become mischievous as she continues: "In class I was beginning to learn some very interesting things—like how to calculate my blood alcohol content and that was really awful. Now when I drank all I did was sit in the bar and try to figure out how drunk I was. What I was learning was beginning to spoil my drinking!"

Learning about alcoholism, and other drug dependencies, is not a comfortable process. Sooner or later one is forced to examine where she fits in the scheme of things. Jennifer's stress level, already high from feeling the consequence of her drinking, escalated as she was forced to learn about the disease of alcoholism. "The more I learned, the more uncomfortable I became," she says. "I was scared. I started blaming everyone else for how I felt and what was happening to me. I thought the people at work were assholes, my friends were assholes, and the world was terrible. Of course, it didn't have anything to do with me! I was beginning to be in a lot of emotional pain and it wouldn't go away. My self-esteem was at rock bottom.

I was depressed. I was just depressed all the time. And I was angry, big time angry, and I just stuffed it. I didn't know what else to do with it. I did have enough sense to realize that it's not O.K. to make an ass out of yourself in public. But I was beginning to realize that a lot of how I felt had to do with me. I knew my reactions to others and my behavior were a reflection of how I felt about myself but I didn't know what to do about it. I didn't know that I *could* do anything about it and that was the frightening part of it for me so I didn't do anything about it for another six months.''

Getting fired or suspended from work as a consequence of drinking is an awakening. Julie, concentrating on an earlier time, calmly relates: ''After my suspension from work I was too scared to drink. I started feeling better. I was living at home now because I didn't have the finances to have a place of my own and I was afraid to live by myself at this point. I got up in the morning and went to work and came home in the evening. I wasn't going to A.A. I didn't have a support group. I was angry, fearful, lonely, isolated, and unhappy. I was white-knuckle dry.''

When full recognition occurs, and the reality of one's present condition is acknowledged, recovery begins. Julie explains it the best when she says: ''I went to an A.A. meeting. I don't know what it was at that particular time but when I walked in to that particular meeting and looked around, the reality was that I *knew*, and I ran. I was afraid. I went to a bar downtown and I tried to pick up these two guys. Oh, I really tried. And the reality hit me that the rest of my life was going to be spent looking for love, looking for someone to love me, and looking for someone to care for me, and I wanted to be able to love somebody back. But the even bigger reality for me was that my Bowery was my bedroom within my four walls. Then I realized something else. I knew I wouldn't even make it as a street person because street people share. I wouldn't share my booze with you. If I had a party, and people came, there was one bottle for the party and one bottle for me. And let me tell you that if the party booze ran out you weren't getting my bottle. So, the reality hit me that night that if I wanted what they had, as the saying goes in A.A., I'd have

to do it their way. I went back to A.A. and the desire to drink left me. I began to learn everything I could learn about this disease of mine, and in the process I learned about myself.''

Acknowledgment of one's present condition is the beginning of recovery. Acceptance of this reality is yet another matter. For many, the road to acceptance is a long and painful process taking between two to three years. In this beginning, the recognition of one's mortality stimulates an honest appraisal. At first glance, Julie's insight appears to happen instantaneously. It was, however, preceded by several years of emotional turmoil in which reality was submerged to maintain old beliefs and attitudes that allowed her to continue drinking.

Intensive education in any area of health is valuable. Most of us grow up with knowledge of the family's history of diabetes or heart problems. Learning to minimize these risks by adjusting one's life style is incorporated early in family life. We agree that education is the key to making intelligent decisions leading to a balanced life. Only recently has education been applied to alcoholism and other drug dependencies. Unfortunately, most people remain reluctant to learn about alcoholism unless they have been personally or professionally hurt by it. The stigma asssociated with the disease still leads many to pretend it does not exist. One honestly may not know if there is alcoholism among siblings of a parent or a grandparent, especially if the person is no longer living. Yet the devastating effects of alcoholism permeate future generations in subtle but equally destructive ways. A parent who has not learned to feel good about herself cannot convey worth and value to her daughter. When the human needs for closeness are absent or minimially met, family members do not feel free to discuss their feelings. Hence, perceptions about who one is and the value of the person become distorted. Old feelings and behavior patterns from a previous generation continue to permeate the family as though an active alcoholic were present.

Today, many opportunities exist to learn about alcoholism and other drug dependencies. Lucy's calm voice is in stark contrast to busy hands quietly shredding an empty matchbook:

"I was sitting in a class about alcoholism in college and it was like all these things were falling into place. It scared me to death. I took the mast test and when I realized where my scores fell and what that meant I panicked. It was almost like I couldn't accept it. Part of our assignment was to spend some time in a chemical dependency unit. I had more classes. And I knew. All the crutches were gone. I knew. I now knew all about the disease of alcoholism and all of a sudden I realized that I was an alcoholic and I could not ever safely take a drink again. It was a shock. It really was. It left me depressed. I was very, very depressed. I felt like it made me less of a person to have this disease."

One woman took an elective in college and received more than she originally intended. Kellie remembers: "My last semester in school we had some electives. I took the one called Alcohol and Drugs in Society because it sounded a lot more interesting than the other electives. I figured I drank real well and I could breeze through this. But the man who taught it was in charge of a treatment unit and he was very thorough. He approached it from the point of care of the alcoholic whether the alcoholic was a client who had come to you for something or was your next door neighbor. Part of the requirement for this course was that you had to go to two or three A.A., N.A., or Al-Anon meetings. I put that off for a long time because I was hearing things in this class that I really didn't want to hear."

For others, the chance encounter and discussion with friends who happened to work with persons recovering from chemical dependency resulted in the recognition so desperately wanted, but yet so long denied. Nicky says: "I was visiting with friends and we were sitting around talking. They were both recovering and it started out very unintentional playing the counselor and the client. They were going through the signs and symptoms and all of a sudden the one playing the counselor turned to me and said, 'O.K., Nicky, when did you have your first blackout?' And I said, 'I think when I was about 14.' And all of a sudden everyone realized this wasn't a joke anymore. And they told me later fear was in my face when I realized it wasn't a joke. It had been a real honest response

without filtering. Then they started asking me about how I drank and when I drank and what happened when I did. And I talked about my experiences with alcohol. I knew in my gut immediately what was going on. It was like there's the missing piece. But I couldn't go to AA at first. I couldn't accept it. It was hard. I tried to ignore it. I found all sorts of excuses why I couldn't talk to someone in A.A. But eventually I did. I talked to a friend of mine. She was the person I felt the safest with. I felt like she would understand and be totally accepting of me.''

There are many internal and external clues bringing awareness. Although its meaning was not immediately assimilated, a chance encounter with a recovering woman who accepted her as she was, perhaps for the first time in her life, made a lasting and positive impression. ''I met a woman at one of the many business meetings I attend,'' Agnes tells me, ''and we seemed to hit it off. For some reason I couldn't understand at the time, she let me know she was recovering. I didn't know what to make of that, I mean why she told me. But I could sense that this woman had something that I wanted. I didn't know what it was, and I didn't know how to get it, but I seemed to be drawn to her. She was happy, she was kind, she had kind of an aura of calmness about her and she had a way of making me feel good. And she would call me from time to time to ask how I was doing.'' After a pause, her hazel eyes begin to twinkle complimenting her broad smile. ''Eventually I did begin to go to A.A. and I began to feel tremendous but I did not connect the fact that the acceptance I felt from the other women and the fact that I wasn't drinking had anything to do with how I was beginning to feel so it wasn't long before I thought I was 'cured.' I stopped going to the meetings and of course it wasn't long before the old fears, distrust, and paranoia came back. You see, I was dry, not sober. I had given up the alcohol but I hadn't accepted the reality that I was a woman alcoholic. I still hadn't hit bottom.''

10

Hitting Bottom

itting bottom is a term used by people in Alcoholic's Anonymous (A.A.) to describe the final realization, the true, unfiltered knowing, that one is an alcoholic. Hitting bottom has two aspects to it: First, being forced through education; and second, through the help of others. If the drinker receives help and understands what is happening to her early in the drinking years, the bottom is described as "high." When help arrives late in the course of one's drinking and/or drugging history, the bottom is said to be "low." Reaching the woman before she descends into the depths of dispair; before she loses her friends, family, and job is the goal of those who understand the devastation that alcoholism brings. Help from family, friends, and co-workers is essential for the woman to receive humane treatment and support early. In the previous section, Lucy and Kelli illustrate how a period of intense education helped penetrate their wall of denial. The support from those who understood the disease was vital to them. Without it, both doubted their ability to recover. Kelli leans forward, her calculating eyes probing mine as she starts to speak:

"I'm not very sure of what made me make that call," she says. "It was around midnight on a Saturday and I was home alone. I was very, very drunk and very, very miserable and I'd flat just had it. I called this fellow that I had seen at a meeting and who was a classmate of mine. When I think about the events now, I am amazed. There was a higher power at work to help me. This fellow shouldn't have been home that weekend because he was supposed to be someplace else, but for some reason he didn't go. He was also taking a shower at the time I called and he told me later that he never hears the phone when he's in the shower. But he did. But the fact that I reached out and called at all still amazes me. I talked to him for quite a while that night and I have no idea what I said but I know that I was making it very clear that I was very, very miserable. I remember he said, 'Kelli,' if you think you've got a problem then you need to start going to meetings and you'll find out.' Well, I did. That next afternoon I went. And for several months I kinda hemmed and hawed around the whole thing. It was, 'Well, maybe I have a drinking problem' and then I thought, 'My drinking is a problem because of the stress of school and also trying to work, that's why drinking is a problem for me. I'll use A.A. to help me quit drinking until I get my life in order and then everything will be O.K. and I'll be able to drink again.' "

Initially Kelli viewed A.A. as a way for her to learn how to drink appropriately. Her emotional pain, soaring beyond limits of her endurance, subsided over the ensuing months as her physical health returned. Yet she was still unable to perceive alcohol as the culprit in her life. Those initial, fleeting, and terrifying thoughts of not being able to drink like others were suppressed, pushed to a dark hidden recess in the mind beyond awareness and knowing. The knowledge that one abstains from drinking while enjoying a fulfilling and rewarding life remained beyond her comprehension. Her plan: to learn the secrets to acceptable drinking from "those who must know." On a treacherous path to hopelessness, she had stumbled onto the steps to recovery.

Rationalization and intellectualization are attempts to make

plausable explanations or interpretations of an event. They are ways of reducing the unrelenting tension and intolerable stress by giving permission to one's self to try variations of the same theme while looking for different results. Kelli's search for the secret to successful drinking is not unique. Sooner or later, all face this dilemma. Kelli describes her search this way: "I guess for the next eight or nine months it was an on again off again type of thing. I'd drink, but not for long. It would only be for a short time. One time I'd try wine, another time I'd try vodka, and then I'd try beer. I'd try it with people around, like at a party, and I'd try it alone. You know, any combination I could think of to see if it was maybe the circumstances. I played around with that for eight or nine months and it just got progressively worse. My blackouts were horrendous. I became very self-destructive and began to do things that were very dangerous. But what made it worse was that in the back of my mind I knew I was an alcoholic. I knew this wasn't going to change and I began to feel very trapped between what I knew I should be doing and what I was doing. It was like living with two different people. I don't know what clicked, but it became very, very obvious to me that alcohol had to go and so I started going back to A.A."

Kelli's description of her attempts to control her drinking and be like others who are able to do so illustrates the marshalling of inner resources to protect one's disintegrating self. The overwhelming desire for Kelli to realize her human needs for closeness through reassurance, approval, solace, and acceptance from others propelled her to try every measure that she could think of to learn to drink appropriately. When her human need for closeness was met by others who were not drinking, this supportive climate allowed her to acknowledge the problem for what it truly was. With Kelli, hitting bottom was a process taking almost a year. The social support and acceptance she received from those who were living without drinking helped her face the reality of her self-destructive behavior. Now she was able to begin a process of learning to cope with the problem of everyday living without the use of mind-altering chemicals.

Hitting bottom is a problem-solving procedure in which

negative thoughts, feelings, and attitudes about one's self are inspected. Changing these negative views to more positive ones is the cornerstone of the rebuilding process. Intervention, the act of interrupting self-destructive behavior, initiates the process of hitting bottom. Intervention may be a planned occasion where co-workers or family and concerned others gather to present the facts in an objective, nonjudgmental manner, or it may be abrupt following a traumatic event such as a serious illness directly attributed to alcohol abuse. Edna's strength and determination, now visible in her posture and voice, was in sharp contrast to the picture she describes of an earlier time: ''I knew! I knew I was an alcoholic for a long, long, time! I just didn't want to accept it. I wanted somebody to tell me that my problem was something else, anything else. I could accept being crazy. I would wake up in the morning so sick, and deep down I knew why I was sick. I would wake up every morning and say you're not gonna do this again tonight but by the time 5:00 rolled around I would be feeling better and I'd tell myself that it would be different this time. My insanity was that I was doing the same thing over and over again expecting different results. But I always got the same results and I always felt the same way the next morning. I was hospitalized with pancreatitis and in a way that turned out to be the beginning of my intervention. When I got better, my doctor gave me an ultimatum—go to treatment or die. I'm a single parent and I felt I didn't have any choice but it wasn't until I could feel the acceptance and love from other women in A.A., and trust that it was genuine, that I bottomed out and realized that it was O.K. to have this illness.''

Giving themselves permission to be ill is novel for women who have been led to believe that putting others before themselves is the only way to affirm acceptance. Learning that they have physical and emotional needs is an awakening. Learning to take care of these needs and put themselves before others is yet another matter. None of this can occur until the active disease process of addiction is interrupted. Intervention is the method to interrupt this destructive process and is a necessary antecedent of recovery.

Although entrance to a variety of occupations are now open

to women, many are still attracted to the helping professions: medicine, counseling, teaching, nursing and social work to name a few. Clothed in this mantle of perfection and giving, it becomes more difficult for the woman to acknowledge her humanness, recognize her human needs, and make provisions for meeting them. Admitting loss of control over a substance diminishes respect in the eyes of colleagues. For women, "hitting bottom" is a humiliating and intensely mortifying experience. Her total inner sense of self is atrophied. Her worst fears are confirmed. She is nothing. This emotional emaciation extends to the very core of her being. Her humiliation is so profound that she accepts, without question, her self-imposed verdict of guilty. She has disgraced her family, if one remains; her profession, if she has been engaged in one; and the cultural unit to which she belongs. She has become an outcast. Her sin is imperfection. Her pervasive yet persistent negative perceptions about her worth and value are confirmed. She is worthless. This experience is called shame. Hitting bottom and experiencing shame devastates the woman. She enters treatment, or begins her A.A. experience without self-respect, self-love, and self-approval. Her self-esteem is zero.

Speaking very softly, her melodious voice reflecting traces of lingering pain, Agnes says: "When I finally agreed to go to treatment, it had to be in another state where no one knew me. I was so ashamed. I was so upset that during the admission procedure I pleaded with the person admitting me not to put down alcoholism as a diagnosis. She smiled and asked me if chemical dependency would be all right. I didn't know what that was but it certainly sounded more acceptable, so I said O.K. I was shamefully mortified and it took many weeks for that pain to ease. The elevator door would open and I would peer out to make sure no one was around that I knew— but I was over a thousand miles from home! I firmly believe that there is no shame like a woman's shame. It is all consuming."

Shame, the feeling and the knowing of disgrace, combine with fear and guilt to permeate to the very core of her being. No longer able to push her emerging awareness to the deep recesses of her mind, these emotions flood to the surface bring

reality to the here and now. The aroma of freshly brewed coffee permeate the room. Her hands gripping the coffee cup, Mary Helen ponders the depths of the dark brew: "I stopped drinking for a period of time, but I wasn't going to A.A. I got a job in another city and moved. I felt I was doing so well that I had a drink to reward myself. It didn't take long before I was back to my old ways again. I went to work on this particular day and was confronted by my boss because he said I reeked of alcohol. I was fired. I was so ashamed. Now I really felt unworthy. I couldn't control my drinking, I couldn't maintain my marriage, I didn't have perfect children, and now I'd been fired. I was losing control and I was beginning to realize that I had to do something about my drinking."

Feeling shame elicits resentment, hurt, sadness, loneliness, and guilt. Underneath it all lies a fear so overwhelming, so paralyzing and excruciating that it can only be called sheer terror. First, there is the dread that one's secret, the inability to drink like others, will be discovered; and then there is the horror of becoming aware that she cannot be what others would like her to be. Many women have allowed others to define them according to their needs for so long that their own individuality has been lost. "I was trying so hard to please my husband and not drink," says Yolanda. "I tried to keep our home the way he wanted it be, take care of the kids, work part time, and be his social companion. I didn't drink. I managed to stay white knuckle dry for about three years. But I was miserable. I didn't have any friends, the loneliness and the fear were just overwhelming. I always felt that my husband was disappointed 'cause I couldn't go out and have a drink before dinner like he could and he wanted me to drink with him. One day he brought home the Rand Report and said, 'It says here that some people can learn to drink again.' I still said 'no' but on our anniversary he bought some champagne and I decided to have a glass. Well, it wasn't long before I was off and running again, and it was all down hill for another three years. My husband finally ended up leaving me. I'll never forget the morning he left. I was standing in the kitchen and I felt like I was four years old and mommy had lost me in the supermarket. I was terrified. I felt so ashamed. I had failed

to make my marriage work. I don't know how long it was after that before I went on my last binge. I don't remember much in November and December of that year—the holidays were a blur. It was mostly me drinking in my room and going out and buying more bottles. But I got to a point when I started realizing this wasn't fun. It was buying bottles, drinking and getting rid of bottles. I began to think, 'Yolanda, you just can't keep going on like this.' It was especially bad in the morning. I'd get up sweating and shaking. I couldn't even brush my teeth. No way could I have gotten in the shower, I would have fallen. I had to get enough liquor or wine in me to stop the shaking. I would drink a glass of wine and of course it would all come up. I'd be hanging over the commode. Finally I'd get enough in me to take away that awful feeling. I thought I could detox myself and pace my drinking, but this time it didn't work. I finally called my doctor for help. He convinced me to get treatment for my alcoholism and I finally agreed to go. A neighbor took me. I remember being very, very depressed, feeling guilty about all the drinking that I had done and very, very shameful when I arrived. But I'll never forget the nurse who met me. She just put her arm around me, gave me a hug and said, 'It's all right Yolanda, you have a disease and we are going to help you learn how to manage it.' I didn't remember anything for a week after that. I don't know what made me want to listen to these people when I finally did come out of it, but I was ready. I knew I would die if I left that place without help.''

Some women are able, for a brief time, to cease drinking and switch their growing dependency to another substance, e.g., food. Nicky's soft European accent reminds me that fear and guilt pursue one across continents to arrive unruffled. "When I was working that was my whole identity,'' she tells me. "I really worked hard and was rewarded with promotions for my efforts. The times when I was able to stop my drinking and drugging I just substituted food. I mean that was a real escape for me. I got to the point where I felt about my eating like I did about my drinking. I felt guilty and began hiding it. I switched to different foods. I rationalized about how much stress I was under and I needed it to keep me

going. I minimized it, I said just one piece of pie wouldn't hurt, but then I'd eat the whole pie. I just switched one addiction for another. But I had to do this for a while until I got the courage to tell the people that I knew in A.A. what was going on with me. I was afraid to tell them about me because as a woman I felt they wouldn't understand my fears and my hurts."

In an effort to deny and suppress the knowledge that alcohol is indeed the problem, Nicky gravitated to food to heal the discontent within. Other women may chain smoke, go on impulsive spending sprees, gamble, or turn to other medications for relief. "I never had any trouble getting jobs," Barbara tells me, and I got good ones that paid well and had good benefits, but after I'd been in them for a while I became restless and dissatisfied. I was always looking for something else. I began to go from job to job and I began to spend money. Spending money and floating from job to job were ways to fix me. I used to buy things compulsively—shoes, handbags, dresses. Everything had to be expensive. I ended up creating a debt that took a number of years for both my husband and me to clear up. Finally I stopped that and just started to drink again." And Mary adds: "I was pregnant with my last child and I knew I shouldn't drink so I began to eat. My doctor was so upset with the weight that I was gaining that he put me on these diet pills and gave me some phenobarb to take at night to bring me down so I could sleep. I thought, 'This is great, I feel wonderful, this is the way to be.' I worked right up until the day I had my baby. I had lots of energy. I was able to work harder and longer than anyone else around me who was pregnant. But after the baby was born, the doctor cut me off cold turkey and I knew I had to do whatever I could to get more. And I started drinking again. Now I was popping pills and drinking."

Recognition and acknowledgment of the problem for what it is occurs in a variety of ways. Barbara explains what happened to her: "I was asked by my boss to take on the task of being staff advisor to employees with drinking and drug problems. I became the employee assistance person and at first I acted as the liaison between the rehabilitation hospital and

work. I began to get interested in it and I decided I should know more about it. My company started sending me to these classes so that I could learn more. Everything that the teachers were saying in class sounded so familiar but I still couldn't relate it to me. Every time I came home from class I would talk about it with my husband and we both agreed that all this stuff I was learning was beginning to sound familiar. But I seemed to be the one who was really getting uncomfortable with it and my teacher suggested that I get some counseling to help me better understand what was going on. She recommended a place and I called and got an appointment. I'll never forget the day I went for my intake interview. It was horrible. I was in such pain. Just sitting there and filling out the application and answering all those questions brought tears to my eyes. The counselor asked me to bring the family with me the next time so I argued with my husband and finally he agreed. That next week my husband, son, and daughter went with me. The counselor was very patient. She started out by going over how alcoholism clusters in families and when she asked me if there were any alcoholics in my family I said, 'No, of course not!' Then she asked if there were any heavy drinkers. Well, that was a different story and I started listing them all, beginning with my father. And then my husband started talking about his family. I could begin to see that we needed help if our marriage was going to make it. We started going every week to see the counselor and things started to get better—for everyone else but me. Everybody was setting goals and handing out duties and things were just fine—for everybody else. I began to find that I couldn't manipulate things anymore. If I didn't feel like getting supper and it was my turn, supper didn't get made, or at least I didn't get invited to the table to eat. And I was angry, big time angry. We started having violent arguments but he dug in his heels and wouldn't give in. So these types of things started creating a problem for me. My husband wasn't playing the game anymore and I couldn't manipulate him to do things for me.''

''I was still drinking on the weekends, but now the weekend began on Thursday and ended on Sunday. My job was going well but I was beginning to think that I didn't want

to learn any more about this employee assistance business. It was too uncomfortable for me. The next thing I knew the company sent me away to a week long conference on alcohol and drug abuse. I remember trying to pack. I was so immobilized by this time that I couldn't even pack my suitcase, my husband had to do it and then he gave me a list of what to wear each day. He even drove me to the airport and made sure I got on the plane. I had been there almost a day when this one speaker really touched my pain and I began sobbing. I just sobbed and sobbed for the speaker had just described me and my family and I suddenly realized I was the alcoholic in the family! That conference was my bottom.''

For many, insight to their problem and hitting bottom are simultaneous. Barbara's efforts to learn about chemical dependency and involve her family in the process brought recognition before her illness had devastated her life. She is one of the more fortunate women who, with the help of three intervention tools—intensive education, counseling, and the support of understanding others—was able to recognize and acknowledge her problem for what it was.

Lucy also had the advantage of education to bring the knowing to the forefront of her consciousness. She describes her experience this way: ''I remember sitting in a class about alcoholism and as the teacher was talking about it, it was like all these things were falling into place. It scared me to death. I was really afraid. I got up the courage to talk to my instructor and she sent me to one of the counselors. I went, but you see, I really wanted the counselor to tell me that I was not an alcoholic. But that's not what happened. We started talking and she asked me some questions. I took this test and when she showed me where my scores fell and I panicked. She suggested that I go to A.A. and start an outpatient program but I couldn't do that, I was too afraid. It was like I couldn't accept it. I couldn't face it. I had all these excuses—I was trying to maintain a straight A average, raise four children, and keep our home together. That's why I drank periodically. It was the stress of all that. It was like if I do this, go to A.A. and outpatient treatment, then that's really admitting that alcohol is the problem. And I couldn't do that. So I didn't do anything

about it. I continued with my studies, and I learned more. I learned all about the disease of alcoholism and in my clinical rotation I worked three months on the alcohol unit. And then the day came, my husband was away, the kids were in bed, and I had some time off. I remember sitting on the floor in front of the liquor cabinet with the key in my hand. I was lonely and scared. My first instinct was to open that cabinet. And then it all clicked into place. I knew. I knew I was an alcoholic. It left me very depressed. I felt like it made me less of a person to have this disease. I was glued to the floor. I just couldn't move. I sat there and I fought that impulse to open the cabinet until I knew I wouldn't be able to hold out much longer. I finally got up enough courage to move and call the A.A. hot line. I got this wonderful woman who talked to me for 45 minutes and talked me out of opening it up. My denial evaporated and I started going to A.A."

Learning occurs in a variety of ways. Lynne's darting brown eyes compliment her petulant demeanor. She says: "As a good child of alcoholic parents, I was an A-1 enabler. My job, so it seemed to me, was to protect and take care of my mother especially after my father committed suicide, and I carried this attitude into my adult years. The stress of trying to learn how to live my own life, raise my own family, do well at work plus manage my mother's life, of course, allowed her to continue drinking while I got tied up in knots. Naturally, I was never going to drink like my mother and father did, but I found that alcohol made me feel good, helped me to relax and took away the stress of trying to be everything to everybody. But I began to realize as time went on that it took more and more alcohol to help me relax enough to go to sleep at night. Eventually, our family physician recommended that I see a psychiatrist and of course that's where I got introduced to tranquilizers. With tranquilizers, I was able to really cut back on my drinking but it only took me six months to go from the way they were ordered to abusing them and this continued for a number of years. I don't know why on this particular day, but one afternoon I was watching a soap opera while getting ready to go to work and one of the women in the story took a whole handful of pills. I didn't think much about it at the time, but when

I was getting ready for bed that night, I looked down at the load of pills in my hand and that scene on the television suddenly flashed into my mind. I was stunned! Suddenly I knew! I also knew I needed to find out how difficult it was going to be to come off this stuff, but I had no idea that I would find myself in treatment and embarking on a whole new way of life.''

Many women who are recovering today have not had the experience of an education process designed to penetrate their denial early and bring the true nature of the problem to the forefront of conscious thought. For them, hitting bottom arrived late in their drinking life when they realized they would die without help. The final stage begins by readjusting limits of unacceptable drinking behavior. When there are no more limits to readjust, and the consequences of drinking are painfully felt, the bottom arrives. Zelda explains it this way: ''My blood pressure had gone out of sight and my doctor gave me some pills for that and told me not to drink while I was taking them. I thought, 'O.K., no problem.' I took two of the pills and I didn't drink over that weekend but by the time Monday rolled around I threw the pills away and said I've got to drink! I drank that day and when I went to get into bed I tripped over the bedspread and fell. I hit my head on the side of the dresser and the blood drained down my face and I had a black eye. That was the first time I'd ever fallen or hurt myself while under the influence and that was it, I couldn't deny it any longer.''

''I know how it feels to hit bottom,'' says Linda. ''I was thinking about suicide and going through this whole process about how to do it while I was sitting in my drinking chair. I started hallucinating and hearing music coming from the fireplace and I thought, 'Well, I'll have another drink and think this over.' I had always said that I was not a falling down drunk and for some reason that was one thing I hadn't done. In my head you had to be a falling down drunk to be an alcoholic but I was running out of excuses as to why I wasn't one. I got up to fix myself another drink and I fell. I can remember being in the living room on my knees when I accepted the fact that I was an alcoholic. All the excuses were gone. I could

finally accept the fact that I was an alcoholic. That was my bottom.''

When intervention interrupts the active addiction, hitting bottom occurs at a later time. "I was caught swiping narcotics from the place where I worked," "Carnelian tells me. "This time I couldn't wiggle out of it. They did some lab work and when the results came back I knew my goose was cooked. I was given the option of going to treatment or going to jail so of course treatment sounded like a much better option. I thought that it would be nice to take a month's holiday and come back to work and everything would be hunky dory. Someone came home with me while I packed my bag and then they drove me to a hospital in another part of the state where they specialized in professionals who had both a drug and alcohol problem. On the way there I had it all figured out. I would stay a week then leave treatment and really have a fine time for myself. I ended up staying five months. And detox—those people had the temerity to take away my clothing, to go through my suitcase and my purse, and to make me wear those God awful blue pajamas! And they put me in detox with other peope going through withdrawal! I mean, how could they! That was something you did to those other derelicts, but I wasn't one of them! I did start out being nicey-nice and cooperative but by the end of the second day, nicey-nice was going away and I was getting pissed off. 'I want my clothes back, now! I'm going to pack my bags and I'm gone!' I knew I didn't have any money and I didn't have a car, but I didn't care. I was gonna leave! Nobody would cash a check for me and they wouldn't let me use the phone. People just smiled and said things would get better! Get better! I began to rant and rave. I wanted out! I could hear myself screaming—'I'll stay in this God damned place until the weekend and when my sister comes to visit, then I'm gone! I didn't find out until later that they wouldn't let anyone see me for a couple of weeks either.''

''I swore up and down I wasn't going through any form of withdrawal even though I couldn't sleep at night, I was shaking like a leaf, and I had vomiting and diarrhea that wouldn't stop. It was: 'You can't sleep? Why don't you sit

up and talk to the nurses for a while Carnelian? You have diarrhea? Well, go to the bathroom. You have to throw up? Well, go to the bathroom.' These people just wouldn't co-operate with me! I couldn't manipulate them! The only thing I got in detox was a shot of mag sulfate and some vitamins, B-12 I think it was. Talk about cold turkey, it was rough! After three days I got my clothes back and the first outfit I put on, I'll never forget it, was a pair of camouflage pants, matching shirt, red bandana and boots. I wasn't too angry—I was just going to show them that I was ready to rip them apart! I came charging out of my room and made a B-line to the nurses station and said: 'This is what human beings wear, not those damned pajamas!' And one of the nurses laughed and said, 'Go look at yourself in the mirror, Carnelian.' I did and I said, 'Well?' She said, 'You look like you're ready for a jungle war.' 'Yeah,' I said. 'What are you so pissed about?' she asked. Through clenched teeth I replied: I'm not pissed!' All through treatment I kept denying that I was angry. And that's something I'm still working on today because I'm so good at suppressing how I feel, especially when I'm angry or afraid. Somehow I had it in my head that normal people didn't get angry and were not afraid. I've seen members of my family get angry, but somehow it wasn't O.K. for me to get angry so I just stuffed it, I didn't know what else to do with it. But I could show you that I was angry by the way I dressed. I had to look tough to protect myself so I gave off this very bad-ass image. And that wasn't me at all, but I didn't know that then. I don't know where I got the idea but I certainly believed that people wouldn't like me if I got mad at them or if they knew I was afraid. I thought people would laugh at me if they knew I was afraid and I was absolutely terrified of being the object of someone's laughter.''

Carnelian's attempt to allay her fear and protect her innermost self from the prospects of rejection and harm led her to present a tough, threatening image to others. Anger, once assigned to a secluded spot within, oozes forth proclaiming itself in her manner of dress.

Carnelian walks to the window and speaks to an incessant blue jay wanting the feeder refilled. Turning slowly, she

wistfully says: "Sometimes I wish I could have repeated the first three weeks of treatment. It took that long for my anger to subside to the point where I could begin to listen to what was being said. Then I felt like the kid in school who arrived late for class—only it took me another three weeks to figure out what was going on." Smiling broadly now and with her eyes twinkling, she tells me: "I wanted to get my 'A' and get out of there, but on the other hand I was afraid to leave. They finally pushed me out the door after five months! Still, I just couldn't figure out what the counselors were talking about. I was frustrated, angry too. I kept asking them what they wanted me to do and one in particular kept saying, 'Carnelian, you will know when the time comes.' I knew I had to stop isolating from everyone and begin to open up and share in the group but I just couldn't seem to do it. I was still angry. I was like the cat ready to pounce and I couldn't seem to do anything about it. The counselors wouldn't let up on me either. They kept asking me why I was so angry and I kept denying that I was angry. They kept telling me that I didn't have any sparkle to me. It was like I was a living, breathing, walking, talking organism without a soul. I didn't have the foggiest idea what they meant. Then one of the counselors began asking me to look deeper, did I want to live or did I want to die. I didn't know. Eventually I did get to the point where I could say I wanted to live instead of I don't want to die. One of the counselors really made me feel uncomfortable. I didn't know what to do. I kept asking her what she wanted from me and she kept asking 'What is it that you want Carnelian? What do you want from you?' I couldn't figure out what she was talking about. And I was so frustrated. I was trying to look at this episode in my life as a college course and I just wanted to take my test, pick up my diploma, and be cured. And I couldn't figure out what she wanted to hear. Today I realize that a lot of the stuff that I was doing in treatment was trying to please everyone. I wanted to be in good with the teacher. I was trying, but I just couldn't seem to get the hang of it."

"One day I got a letter from my sister saying that she wouldn't be able to come and visit me and I was furious. I just blew up. I tore her letter into shreds. I screamed, I yelled,

I took my clogs and threw them across the room. And one of the counselors pulled me aside and said, 'See, you're angry!' But it wasn't until many months later that I began to realize my anger was out of proportion to the episode. My sister had promised to visit me and she broke her promise. It didn't get through to me that she had to work that weekend and wouldn't be able to drive the long distance to see me. It was that she broke her promise. Somewhere along the line it became vitally important for people to keep the promises they made to me and that kind of self centeredness got me into trouble when I finally did go home.

"When I got finished with treatment and my half-way house experience, I had to go back to my home across the state. My family was gone, the only person I had left who would have anything to do with me was my sister. I was still angry and resentful. Even after all that time in treatment and the half-way house, I just couldn't seem to open up and look at my anger. So when I got home, I just said, 'Screw it, I'm gonna do it my way.' I still hadn't figured out what that one counselor wanted me to do so I didn't do anything."

"I didn't go to any A.A. meetings, I didn't make any contacts with anyone in the program. I just came home, found a job and began working. I was gonna do it my way. Well, I stayed dry. I can't say I was sober but I stayed clean and dry for six months. I got so depressed that I seriously began thinking about suicide. If this was what it was like living without booze and drugs, I didn't want any part of it. One night everything just sort of crystalized and I decided to kill myself. I filled the bath tub with warm water and I had razor blades. I did write a note to my sister apologizing for the mess she was gonna have to clean up. And I don't know why, but I called this one person. I knew he was in the program and told him what I was going to do. He said, 'Why don't you drain the tub and put the blades away, get dressed and come over. I'll see you in about half an hour.' And then he hung the phone up in my ear! I thought, 'Well, he's supposed to come to me! I'm the one asking for help!' In looking back I can see that I was the one who had to make the final decision—do it, or don't do it. Well, I drained the tub, got dressed, went

over to his place and cried all afternoon. I was so unhappy.
I hated everyone. I hated myself. I was such a worthless piece
of garbage, why was I still alive? He let me cry. All he said
to me was, 'Open the Big Book and start reading it.' He
dragged me to a meeting that night—in fact he took me to a
meeting just about every night for about a month. And I began
to feel a little better, but then the time can when he told me
it was my responsibility to get myself to meetings and to par-
ticipate more than I was doing. He said he wouldn't be tak-
ing me anymore and he just seemed to suddenly disappear
from my life. I was devastated. About that time my roommate
up and moved and I didn't know where I was gonna get the
money to pay the mortgage. I hurt. I hurt so badly and I was
angry. The two people in my life that I had started to depend
on suddenly took off. And I hadn't really reached out to
anyone in the program. I was too afraid. I couldn't trust that
they would accept me if they knew what was really going on
with me, so I was always 'just fine' if someone asked me how
I was doing. And inside I was saying, 'What am I gonna do,
I'm gonna lose my house, where am I gonna live, I haven't
got enough money, what am I gonna do, what am I gonna
do!' I was hurt and I was angry and I drank. I only had a half
bottle of wine, but a drink is a drink and I had to go to that
meeting, stand up, say I had a drink and pick up a white chip.
I felt worthless all over again. Here it was, 18 months to the
day, to the very day, when I drank. But nobody threw me out
and nobody spit at me. No one said to me get out of here we
don't want drunks around. They just put their arms around
me and loved me. I think for the first time in my life I felt love
and acceptance from people I really didn't know. It was
wonderful. I cried real tears. They were the tears of happiness
and joy. Tears because somebody loved me. The only tears
I'd every known were the tears of anger, fear, and sadness.
And to be able to cry when I felt loved was overwhelming.
I received a tremendous amount of love and support from peo-
ple I didn't know until I had enough strength to begin to love
myself. It took a long, long time for that to happen and I had
a lot more to learn. But they helped me along the way and
I learned how to reach out to others. When I went back to that

meeting and people accepted me even though I had had a drink, I think that's when I really hit my bottom.''

Deciding to live—the ultimate decision. Once Carnelian was able to make this choice, she was able to begin the painful process of reconstructing her life. Hitting bottom occurred more than 18 months after her initial intervention and treatment experience. Tension builds and subsides in the woman's cultural path. This unrelenting stress produces blistering anger that turns into thundering rage. Carnelian's anger, suppressed for so many years, errupted in a seething force to shout objection to her perceptions of rejection. Alcohol, once her friend, had turned against her too. Intense anger was experienced by all the women as they hit bottom. "I was angry," says Sarita. "Big time angry. Part of me was really grateful that I was getting some kind of help, but I was very angry that people were saying I was an alcoholic. I was still fighting the whole way. When I got admitted to treatment, I called my counselor and called him all kinds of names. I felt I didn't need to be there. I felt I hadn't drunk enough and done all the things that an alcoholic does. But when people in treatment started talking about the emotional pain and their feelings of low self-worth, those were the two things that I could identify with the most.''

Treatment for alcohol and other drugs in a medical setting is a recent phenomenon. Not all recovering women have had the opportunity for medical support during detoxification. Beryl shares her memories: ''I was taking drugs, trying to cut back on my drinking and trying to work. I was having horrendous blackouts and I was afraid that something would happen to my little girl while I was in one of them because I had no idea of what was going on when I started drinking and drugging. I was at work and this fellow came in to see another person who worked in the same place that I did. When he left, he handed me a sealed envelope and told me to open it when I got home. I put it in my pocket and it fell out when I was getting ready for bed so I opened it. It was very simple, it said if you want to get clean and sober, call me and it gave a number. I was shocked! How could he know! But I called. Two couples showed up and they sat with me and also took

care of my daughter while I went through withdrawal in the corner of my living room. I mean I was shaking and shimmering and puking my guts out, but they stayed with me and kept feeding me orange juice and karyo syrup. It was rough!"

Alcohol has been found to cause hypoglycemia. Many women find themselves "craving sugar" as the initial withdrawal symptoms begin to subside. Jennifer relates: "I had an immediate sugar craving. I mean it was like *immediately* I got into sugar. I went from drinking on the weekends to eating M & M's everyday, twice a day. And I'd never eaten sugar, I'd never been into sugar and it was like this is incredible, how did I get into sugar? And that continued for about six months, the bit with the sugar."

Crying and feelings of irritability are frequently mentioned as occurring after chemicals had been withdrawn. Many women experience periods of intense anger. Episodes of screaming, shouting, and throwing things were frequently described. Jennifer recalls: "My withdrawal was really rough. I didn't go into treatment. I did it on my own. I remember I was driving around in my car with a 16 oz, six-pack of diet Pepsies and I drank the whole thing in 12 hours. Weekends were terrible for me. I remember one weekend I was just a wreck. I screamed and yelled and got real mad. Everything pissed me off. But after that I saw that there were things I could do on weekends other than drink. But I was still moody. I was still irritable."

In contrast, some women began to devise ways to avoid withdrawal symptoms while working as drinking progressed. Both Geri and Julie found that they could take librium or another tranquilizer to ease the "shakes" so that they could write and perform tasks requiring manual dexterity while working. "I found if I kept taking librium throughout the day it would stop the shakes so I could write and I could function at work. But eventually it got to the point where I did not have to shake a thermometer, I just had to hold it. I shook so badly all the time that I didn't know what to do."

"It's strange how one hits bottom," Marissa thoughtfully comments. "I sort of did it in stages. When I was drinking and drugging, I just never thought about it, I never had any

awareness that anything was wrong even though I was drinking and shooting dope in my arms, legs, feet and anywhere I could find a vein. I didn't have any awareness that anything was wrong. I got caught forging a prescription and that was my intervention. Even though this happened in the early 1980s, intervention wasn't as polished as it is today so I was able to manipulate everyone and select where I got help. I picked a psychiatric hospital guaranteed, at that time, not to address my addiction. I just told them that maybe I had a little problem with alcohol and drugs but really I was depressed and the sad thing about it was that they bought that. I was in the hospital for ten days and of course my addiction was never addressed. I did stop using, out of fear of getting caught again, but my drinking took off. It wasn't until I realized that the time was getting close to go to court and I knew I had to do something about my drinking or end up in jail so I went to A.A. I knew A.A. worked because it worked for my daddy. But I still hadn't hit bottom. It wasn't until I had been in the program for about six months that it hit me. I had a terrible cold and cough and the doctor gave me a prescription for codeine. After I got the prescription filled, the first thing I wanted to do was take them all at once and I then knew, I knew I was where I was supposed to be—in A.A. That was the day I bottomed out, took my first step and began to learn about this disease of mine.''

Nanette's broad grin softens the anguish of an earlier time: ''My friend and I went to the beach together for a weekend and it was one of my I'm gonna stop this time weekends. I had some time off from work and I thought I would be able to clean up my act within two weeks. Well, we'd go out to a bar at night and I'd end up having five or six drinks and want more. My friend commented that I seemed to be drinking all the time and I told him that it was because I was withdrawing from morphine. But I woke up one night while we were at the beach in bad withdrawal. I remember the cramps in my legs and gut. My whole body felt awful and I said to myself, 'This is it, no more.' My friend suggested I go for treatment 'cause he thought I needed some help, but I said, 'No, I think I have it under control now.' But of course I didn't.

I worked nights so I'd come home in the morning, drink until I was obliterated and go to sleep. I needed the alcohol to bring me down from the high of the morphine. Morphine was like a stimulant to me. I had so much energy, I could get a lot done when I took morphine. But it made me jittery until the high passed so when I got off work I would drink until I passed out. My friend came over unexpectedly on this particular day and I was blitzed. He was so concerned that he stayed and when I woke up hours later he told me that my breathing was awful and he was very worried about me. He packed me off to the doctor and didn't give me a chance to refuse. So, I had to walk in and tell my family doctor that I was having a bit of a problem with alcohol and morphine and from there I went to treatment. I didn't fight it, I was ready. I realized I couldn't come off the stuff by myself. I had bottomed out.''

"Getting off drugs requires help" says Lucille. "God knows I tried to do it by myself! I had been to several N.A. meetings and was trying to come off the drugs, but I just couldn't seem to do it. I was also trying unsuccessfully not to drink so much. I did well for a couple of weeks and thought I was home free when suddenly, for no apparent reason, I stole some barbiturates, stayed home from work and just took them. I don't remember much of that time at all but when I started coming out of it my husband and a friend of mine from N.A. basically sat me down and said, 'O.K., you are going to treatment. Now, what's it going to take to get you to agree to that?' I put up a bit of a struggle but they had all their bases covered and met my excuses with reasons why they weren't valid excuses. We had insurance, my boss would give me the time off, I could have medical leave, and I hadn't been able to do it on my own so now it was time to try their way. I was still real doped up at the time with all the barbiturates so I imagine my struggle didn't last very long. They also had a 'reservation' for me in a treatment center so the next thing I knew, they bundled me off to treatment before withdrawal started setting in. It wasn't until much later that I began to realize how enabled I was at work although it was coming down to

the point where my fellow employees wouldn't be able to cover up for me any longer. I was fortunate, I didn't get fired.''

Silence fills the room as Doreene reflects on her own private thoughts. Finally she says: ''I was selected to go to an intensive week long program on alcohol and drug abuse, I really didn't want to go but my boss insisted so you know how it is, I went. Like many others, I'm sure, I was getting uncomfortable with some of the things I was hearing in this class. I remember one of the speakers saying something like, 'That fine line between abuse and alcoholism is when you don't drink to feel good, you drink to feel normal.' And I didn't like that at all 'cause I was having' to drink to feel normal. Every night we had to go to a different type of twelve-step meeting. I knew I didn't fit with the narcotics group 'cause I had never used drugs and I knew I didn't belong in Al-Anon. I had never been to an A.A. meeting, but I had visions of what drunks were like and what the places were like where they held their meetings. I wasn't disappointed. This particular meeting was held in the inner city and the accommodations were far from being ritzie. I was such a snob! Well, this old timer who must have been a hundred years old and probably that much sobriety too, got up to speak. He asked if there were any newcomers in the group and one of the people from my class got up and said who he was. Then he looked at me and I just said I was in the class too. He spent the whole hour lookin' at me and I was uncomfortable and scootin' around in my seat. He'd say I did this, this, and this and then he'd look at me and say, I bet you never did that did you honey? I'd say, 'No, I never did.' There was this big mirror on the wall with red paint that said 'yet' on it and this old fella just kept saying 'yet, yet,' after everything he said. And then he would look at me and add, 'You just keep going honey.' I was so uncomfortable that I started to get defensive—'I'm just here to observe, I'm in a class.' But that night when I got home I really felt good and I happened to look in the mirror and I saw this smiling face—it was mine, and I felt good. And then I said to myself how come you feel this good? And I remembered that I hadn't been drinking while I was going to this class and I'd been without alcohol

for three days. And then I thought, how long have you been drinking, Doreene? I figured it up. I'd been drinking for over 15 years—more than half my life. And that's when I fell apart 'cause then I really took a look at myself in the mirror. When I got past the smiling face, I could see that I weighed about 90 pounds, my hair was falling out of my head 'cause I was so malnourished. I hadn't had a period since forever. I mean I was a wreck. I knew! I could see my reality in the mirror! Even though it was midnight by that time I called my instructor and said, 'I got to be admitted.' I had reached my bottom.''

''I was in such pain,'' says Audrey. I notice tiny lines of lingering fear creeping softly from crevasses near her eyes to disappear in the dark brown of her wavy hair. Taking a deep breath she continues, becoming stronger in her resolve to share her life with me: ''I was drinking everyday now and I drank to escape the pain of living. I was beginning counseling and although I tried to hide the fact that I was drinking everyday, the counselor picked up on some things I said and began to recommend that I try A.A. I didn't want to do that, but the pastor at the church I went to suddenly, it seemed to me, fixed me up with a contact in the program so I felt like I had to go. My boyfriend was gone on a business trip for three months so I decided this would be a good time to get myself in shape. I went to A.A. for three months and didn't drink. I didn't want to stop drinking, but I knew I had to because the periods were coming closer together when I couldn't control my maintenance drinking. I'd binge, have a horrendous blackout, and wake up not knowing where I'd been or what I'd done. I'd have temendous guilt every time that happened. Well, my boyfriend came home and we went out to dinner. He said I looked so great that I couldn't be an alcoholic so of course that was just what I wanted to hear. That gave me permission to enter hell for another year and a half. My bottom finally arrived when I was invited to be in a wedding. My roommate got married and I got totally wiped out at the reception and went into a blackout. When I came to, everyone started telling me what I did and they were really angry. I was petrified of loosing them as friends. The fear and the pain were excrutiating. I didn't have many friends left! So I went back to

A.A. I did it kicking and screaming all the way, but I went back out of fear. I knew I would lose everything I had and perhaps even my life if I didn't stop drinking.''

''I'll *never* forget my bottom,'' says Cassandra. ''After my divorce, I took my little girl and came back home to live with my folks for a while until I could decide what to do. I knew I had to go back to school to learn how to do something so I could support myself and my daughter. My folks did help by financing my way though college and it was when I was in school that my alcoholism really took off. I was lonely and I found happy hour at one of the local places near the school. I got to meet people and once again I thought I was real popular. I started dating this fellow and it was the first meaningful relationship that I had had since the divorce. I felt like I was on top of the world. But I couldn't seem to stop after I'd had one or two drinks and it got to be a nightly thing that I was drunk. This fellow finally walked out on me and that really sent me over the edge. I did some serious drinking over that one and I just got so depressed I was almost nonfunctional. My girlfriend made me go to the doctor and of course I didn't tell him about my drinking and he put me on antidepressants. So, now I was drinking and taking the antidepressants, which of course didn't work. Finally, the doctor introduced me to a very knowledgable psychiatrist who started asking me about my drinking. I don't know why I didn't run, but I didn't, and I started seeing him twice a week. My bottom arrived not too long after that. I'll never forget that day.''

''It started out with me getting shit-faced drunk instead of going to my classes. I had my daughter in a day care center and evidently she had had a bad day too. She was starting to have some behavioral problems because of my drinking and the people in the day care center of course didn't know that. They just knew that I arrived drunk to pick her up and it was like that was the final straw for everybody. The scene was horrendous. So, of course I proceeded to take my daughter and go out and drink some more. I thank my higher power today that we were not in an accident because I was driving loaded. When I did get home, I called my doctor and he was quite frank with me. I needed to get some help for my drinking.

Before I knew it, my mother and the doctor arrived. The options were lose my daughter and be committed to an institution or go into treatment. Well, treatment sounded like the best option—and I was ready."

Francesca nods in agreement. "Hitting bottom is painful, but it's surprising what turns out to be the final straw! My twin sister had just gotten out of treatment for alcoholism and she kept saying to me that she couldn't believe that I didn't have a problem with alcohol. I used to ask her why she was so concerned about it and she never answered that one, or I didn't hear it. But I was beginning to realize that when I drank I just couldn't seem to get enough of it. I had gained a little weight and I was taking diet pills at the time but deep down I thought that maybe my sister was right. Since we were twins, I did need to pay more attention to what I was doing. I don't know what it was but on this particular morning when I got up I threw out the diet pills and stopped drinking. My depression was massive and I came very close to committing suicide. I've never been so depressed in all my life. And I began to notice now that when I woke up I wanted to have a drink and that bothered me. I decided to give A.A. a try for 90 days and then think about joining the group! How naive! Well, whatever it takes to get you there! I don't remember much of what was said at my first meeting but I do remember that whatever it was, I felt I had to think about it. And of course as a good alcoholic I decided to 'think' in a bar. I had four beers and ended up driving the wrong way down the interstate. I decided I'd better go back to A.A. and pay attention—the state trooper agreed with me."

The excruciating fear of not being able to live without alcohol and the knowledge that one will die if the drinking is not stopped precipitates the final crisis known as hitting bottom. Wanting to live is the beginning of recovery.

"I said I'd never be an alcoholic," Geri tells me. "I'd never be like my dad. And for many years I was able to control it. My husband was in the military and we socialized just like everyone else did. I was raising a family and alcohol didn't interfere with my living. We had our cocktails before dinner and that became a routine thing to do. I didn't notice that our

social life was beginning to totally revolve around alcohol. And I didn't notice that I was beginning to drink more than everyone else. I remember there was a point in time when my husband said, 'I wonder if you are an alcoholic' and I can remember getting very indignant over that.''

"One day I, too, saw a TV commercial. The woman in it was looking through the cabinets in desperation and I knew automatically what her desperation was. I could identify with her immediately because I hid my bottles a whole lot of places in the house and then forgot where I hid them. I continued drinking and my husband eventually picked up and left me. I was faced with going back to work after all those years of not working. My children were in college by this time and I was left alone. My doctor gave me some librium for my nerves and I got a job working evenings because that was the hardest time for me. I'd go to work but when I got off it seemed like I'd always end up drinking and that would continue until I passed out. When I woke up I'd take the librium and that would help when I went to work. I didn't drink at work because I was afraid of getting caught. I knew I'd be fired.''

"I did stop drinking for a while and I did find my way to A.A. I bought the book but never opened it. I hid it when I got home. And I didn't stay to meet anyone or get to know anyone or ask for help. But I began to feel good. And gradually I began to think, 'I'm not that bad, I'm not really an alcoholic, I just drink a little too much. I just won't drink quite so much and it will be O.K.' So I stopped going to the meetings and I began buying bottles again and said to myself, 'I just won't drink very much. I'll make a bottle last a whole week.' And then I thought, 'I'm having a problem because I'm working evenings. I need to work during the day time just like everybody else and I'll be O.K.' And so I got a job during the day and I was able to control my drinking for a brief time. Well, maybe about six months. But this one day I was coming home from work, and I just don't know what happened, but I do remember thinking, 'If the car goes straight ahead at the next intersection, I'll stop at the liquor store and get a bottle, and if the car turns I'll go home.' How dumb! I said to myself, 'O.K. Geri, you can drink this weekend and then you will have

to do something about your drinking.' Well, I didn't know anything for a week. Not one thing. I didn't eat, I didn't take a shower. I didn't pick up the house. I didn't go to work. I just drank. When I came out of the blackout and saw all the bottles around, I figured that somehow I had driven to get more. And I was sick. I was so sick. I couldn't sit, I couldn't stand. I couldn't sleep anymore. I was shaking so badly I wanted to jump out of my skin. It was a horrible feeling. I thought I was going to die. I was shaking all over. I couldn't hold anything down, every nerve in my body was screaming. I couldn't keep any alcohol down and I was getting weak and I knew I couldn't go out and buy any more alcohol. I needed help and I knew it. My due had arrived."

11

Learning to Live

In the cultural path, fear is the dominant theme of recovery and is present throughout. First, there is the sheer terror arising when the paradox of the need to drink and the need to stop is acknowledged. Then, there is the profound horror of recognizing one's mortality—the knowing that one will die without help. Finally, the undisguised sickening dread of not knowing if she will be able to live without chemicals and be rejected by even those who understand her illness. Fear, in all its forms, is present as the woman begins to restore her life.

"Those last few months before I started to get involved with A.A., I was hysterical," Jennifer tells me. "I really was. I hit my emotional bottom and I felt totally alone in the world. I finally had to face reality, and the reality was that I didn't have any friends. I had been acting out for so many years that I had alienated a lot of people and they didn't want to be friends with me. I was working with a counselor who was very astute about alcohol and she kept saying to me, 'Jennifer, if you think you have a problem with alcohol, why don't you try stopping for a while and see how it goes?' I tried. Lord knows I tried, but I couldn't seem to do that by myself so I finally agreed

to go to A.A. I thought maybe I could use A.A. to help me solve my problems then it would be O.K. for me to drink again. I felt totally alone and I was just miserable. I was afraid. The anxiety and the fear were just overwhelming. I felt like everything inside of me was tied into one big knot. I had a hard time breathing. I couldn't eat. I couldn't sleep. Finally I dragged myself to a meeting. I must have looked like a wreck 'cause I certainly felt like one. I just sat there. I couldn't even speak to anyone. I started looking around for the drunks and I couldn't find them. I thought maybe I was in the wrong place—all these people looked happy and they were well dressed. Then the meeting started and I figured out I was in the right place but I still couldn't believe it. These people didn't look miserable!''

Panic-stricken and consumed by chilling fear, Jennifer agreed to attend her first A.A. meeting. Wondering how alcoholics could be so well dressed and happy, she was skeptical. Perhaps she was in the wrong place. When the meeting did begin, she dissolved into tears. ''I don't remember much of what was said,'' she continues, ''but somebody must have said something that really pushed my buttons 'cause I started crying and I just couldn't stop. I remember one woman putting her arm around me and telling me it was gonna be O.K., and that made me really bawl. I started going to meetings. It took about a month for me to stop crying. About that time I noticed that I was beginning to feel a little better and my life was beginning to improve a little. That's when I climbed on my pink cloud. I was getting what I needed from this group of people and I was learning how to solve my problems.''

Beginning to feel better, Jennifer perceived, much to her astonishment, that she was welcomed by the group and found solace freely given. For the first time in her life, she felt accepted. She was allowed to bask in the comfort provided by those who understood her needs for the amount of time that was necessary for physical and emotional healing to begin. Climbing onto a pink cloud is an expression frequently used by recovering people to describe their first experience of relief when they find they are feeling better and life is improving.

"The compulsion to drink was still with me," she continues, "but I was taking antabuse and I knew I'd be sick if I drank so I didn't drink. The weekends were the hardest time for me, especially Friday night. The work week was over and I had all this free time and that's when I would feel the loneliest. I started going to ten meetings a week and a lot of them were on the weekend. I was beginning to feel—well, I was still lonely but I began to physically feel better and it was like, 'Wow, I'm not drinking!' 'It's working!' 'I don't have to worry about the fact that every time I freak out I'm gonna drink.' That's what I always did—every time I had any kind of emotional upset in my life I'd go back to alcohol. Now if I got emotionally upset over something, I knew I could go to a meeting. I might have to go to two meetings in a row, but I knew it would work out and I would be O.K. I began to realize that I might have to give up my notions of learning how to drink. Maybe that just wasn't in the cards for me."

Surprised and pleased with herself for not drinking, Jennifer wisely filled her free time by going to meetings to be among other recovering persons. Learning to live without using chemicals, one day at a time, Jennifer began to cope with the vexations inherent in everyday living. Although she still wanted to learn how to drink socially, she began to question the wisdom of this desire by giving herself permission to try on a new identity: "Being alcoholic." She was where she was supposed to be.

"I fell off my pink cloud at the end of six months," she tells me. "It was about that point in time, too, when I began to think that it was time to start dealing with my problems. I sort of woke up one day and began to realize that all these things that had been in the background of my life were coming to the surface, and I would have to deal with them before I got any peace. I was terrified but I knew I had to do it in order to be able to move on. The first thing I had to do was start reachin' out and I began by talking to other women who were at the meeting, but I was still terrified of picking up the phone and calling someone to say hello. I couldn't seem to bring myself to do it. I'd just retreat and isolate. I'd spend after-

noons at home and just be anxious and obsessed with the fact that I was so lonely. I knew I had to change but every time I thought about it, I'd panic. The fear was hideous. It was overwhelming and it just consumed me. I wanted to call people and talk to them, but every time I thought about it my gut would tighten up and that big knot would be back. I just couldn't bring myself to pick up the phone and call anyone. It was like I couldn't breathe. Supposing she rejected me? I couldn't take that risk. It's strange—the old and knowns are safe even if it's painful and you hate it. I knew I had to change my behavior and take responsibility for reaching out to others and make friends. I needed to find the courage to use those telephone numbers I'd been collecting. And this type of behavior went on for about five months, but gradually I became a little more open and started talking to other people.''

Once more immobilized by harrowing fear, Jennifer battled with herself to use the telephone to call other women whom she had met in the program. It is well past her first birthday before she was able to do so. In the meantime, she cautiously tested the waters of acceptance by becoming involved in a woman's A.A. group.

''I was such a needy vacuum,'' she says. ''I could go into a meeting and get all the strength I needed and it was like, 'Oh, thank you, thank you God!' I decided to get involved in a women's group and that was good for me because I always felt threatened by other women. I said to myself, 'Jennifer, you're a woman alcoholic and it's about time you started identifying with other women.' I did begin to get involved in other women's recovery and I started to let them help me too. When this happened, I met the woman who ended up being my sponsor. I knew I had to look at those first three steps, find out what they meant for me, and then start doing something about them, but I also knew that I couldn't do that alone. I was overwhelmingly terrified of men at this point and I didn't want to get involved in any kind of a relationship because I knew I would spend all my time trying to fix his problems and I needed to be fixing my own.''

Listening to other women discuss their fluctuating thoughts and feelings helped Jennifer understand that she was going

through a normal process. Having the ability to share her own thoughts and feelings was yet another matter. Before she could do this, Jennifer had to experience what it was like to feel safe. Feeling safe is an unaccustomed event and for many women an entirely new sensation. Although Jennifer discovered A.A. in general to be a haven from the harshness of the world, she found security in a woman's group where she could begin to discuss her fears with other women who understood her human needs from the woman's perspective. Finding a sponsor, she was encouraged to use the telephone to talk about her problems. Sponsors are recovering people themselves who work with the newcomer by sharing their experience, strength, faith, and hope to enable the recovering person to surmount each difficulty as it arises.

"I began to call and talk to my sponsor," she says. "She was very patient with me. She kept saying, 'Jennifer, I'm glad you called and we had the opportunity to talk but try calling me more often, before you get so anxious and depressed and feel like you're loosin it.' I tried. It took another four months after my first birthday to be comfortable doing that. I'm amazed! It took 14 months for me not to be afraid to call her and tell her where I am and how I'm feeling. I've also just started to get the courage to process things with her—like 'guess what "Mary Lou," I just flipped out for a couple of hours and got really angry and I need to talk to you about it.' "

Sharing thoughts and feelings with a sponsor or counselor allowed Jennifer to hear what she thought. It provided clarity to the problem and allowed her to inspect the accompanying feeling. Facing her fear, Jennifer was at last able to pick up the phone and talk to her sponsor about what was happening to her and how she was feeling. She found she was accepted and the voice on the other end of the phone provided reassurance and gentleness, and it guided her on the path of understanding. Although the time it takes for newly recovering women to begin using the phone to talk to others varies with each person, most agree that it takes a considerable length of time for this to happen. It is not uncommon for at least a year to pass before this can occur.

Smiling softly to herself, Mary Helen lights a cigarette and

exhales slowly. For a brief time, she looks at the ceiling. When she turns to me, the warmth in her eyes conveys limitless wisdom. "I think for the first month or so the body was being taken to the meetings," she tells me. "I wasn't hearing a lot right away. I was busy experiencing acceptability. I was being accepted unconditionally and I could feel hope. Just being around people who were really talking to each other was mind boggling for a while. I had been so accustomed to my own thoughts and they had been going around in circles getting nowhere and here was a brand new direction and it was exciting. A little fearful, yes, and I think at first I covered up my fear with some heavy intellectualizing. I didn't recognize that I was still unwilling to get into the real me. But I was willing to get to meetings and be exposed to the atmosphere of hope and caring. I knew the message, whatever it was, would get through to me sooner or later if I just kept on going to those meetings. And so I felt encouraged. And the other women in the group, especially two of them, were so good to me and had faith in me that I felt motivated to respond by getting well."

Wrapped in the comfort of unconditional acceptance, hope transcends affirming that things will get better. Mary Helen began to have positive thoughts, bringing a more optimistic attitude toward life and her part of it.

Whether the woman begins recovery using only the A.A. experience or has an initial foundation from a treatment center, learning to live without drinking or taking drugs, one day at a time, *is* the central focus of the woman's life. Maintaining a balance and learning new social activities not centered on drinking or drugging are vital elements in recovery. "Deep down inside I knew I needed more balance in my life," Jennifer tells me. "I recognized that I couldn't keep going to ten meetings a week for the rest of my life. I had to get out there with everyone else and live. But it wasn't until I had over a year in recovery that I was able to do this. Gradually I began to cut back on my meetings and substitute something else. I like to play soccer and I like to jog, but I knew I needed to do something where I would be involved with other people so I joined a soccer team."

Walking to the stove, Carnelian removes the cover from a simmering pot of stew, stirs it gently, and then pours us both a bowl. As we sit basking in the aroma of freshly ground spices and warm French bread, she openly shares her amazement at the simple things she learned she could do to instead of drinking. "Learning how to live a sober life in treatment and the half-way house was really important for me," she says. "I learned that there were things I could do to break the compulsion, to break the obsession, like calling people, writing, doing something physical such as going out for a walk, taking a swim, playing ping pong. There are all sorts of alternatives to drinking. And, that if I really wanted to do it, it was all there. And that was a surprise to me—that the only thing that was going to stop me from drinking was me. Nobody else could keep me sober. That was the big thing 'cause when I walked into treatment I said, 'Well, make me sober now, cure me.' And it doesn't work that way."

Zelda pauses, visibly musing about her past three years of recovery. When she speaks, the intensity in her voice reflects both her determination and the work that she has had to do to get to where she is at this moment in her life. "I came out of treatment frightened but hopeful. I was trying to learn how to live one day at a time and mainly in that first year how *not* to drink one day at a time. Although my compulsion to drink had subsided, I was scared to death that it would just reach out and grab me again. I had to concentrate on my thinking. Before, I was thinking about drinking, now I had to think 'not drink.' I had to change my thinking. I had to start changing my playgrounds. I had to do a lot of changing but I followed direction and did what I was told to do."

Afraid that her compulsion would once again take over her life, Zelda concentrated on reprogramming her thinking. "Changing thinking" and "following direction" are vital aspects of early recovery. With practice, Zelda was gradually able to alter her thinking to one of not drinking while following a balanced recovery plan. Recovery plans are guides for living that organized her time. It scheduled time for attending meetings, keeping medical and counseling appointments; it provided for going to work, having leisure activities, getting

rest, eating properly, and doing exercise. Before leaving treatment, each woman, together with her counselor, made a workable plan tailored to meet her needs."

Following direction by attending meetings, listening, learning, sharing, becoming involved, getting a sponsor, continuing with counseling, and becoming honest with one's self are crucial elements in beginning recovery. "Bring the body and the mind will follow" is a frequent comment to the neophyte. At first, she attends meetings to listen and take in new information. She is encouraged to read and is guided in the type of materials to bring understanding. She is comforted by those now close to her who have walked in her path. She feels acceptance and commenses to identify with the group. A bonding to her new family, perhaps the first in her life, occurs. Shyly she embarks, gradually participating and becoming involved in group activities.

Making the transition from the closed treatment community to home and the larger community in which we all live is tormentingly frightening, and requires practice and continuing support. "I was very fortunate in one respect," Zelda tells me. "My home, family, and husband were still intact. What happened to me caused my husband to look at his drinking and decide to pick up a white chip. I was also fortunate and grateful that I didn't have to go back to work right away because I needed that time to work on me. My self-confidence was completely shattered. When I left treatment, I did exactly what the counselors at the treatment center told me to do. I was told to go to A.A. meetings and get a sponsor. I made a contract with my aftercare counselor to go to four meetings a week, get a sponsor, and make A.A. contacts—and I did it. They told me I needed to do this to be sober and I wanted to be sober.

"I was more afraid getting out than going in. In there it was safe. Now I was going out in the big bad world—you know, the world didn't care. And I had all those 'what if's.' I'd be thinking of things like, 'What if my husband and I go out socially and the next thing I know we go to a bar—what am I going to say? What am I going to do? Well, I'll just have to make up some story to keep up appearances!' I'd fantasize

and play out all these scenes in my head to allow me to keep up appearances and not let anybody know my big secret— that I'm an alcoholic!" Smiling broadly, Zelda exudes the happiness she feels. "It turned out that my husband and I kept away from slippery places like a bar," she says, "and I also found out that nobody gave a rip that I was an alcoholic, so I stopped being so uptight about it. I fired my internal 'script writer' and decided to have some faith in me and trust in others. But that didn't happen all at once. I knew when I left treatment that I needed to follow direction and do what I was told to do. I was like a child and I needed that structure because I didn't know how to stay sober."

Zelda was fortunate in that her family and home were intact. She had their support as she embarked upon her recovery work. Having structure is a necessary element in recovery. It is the form through which the woman learns how to live a balanced life. It organizes her time and provides consistency by having meals at regular times. It includes suggestions for a balanced diet designed for weight loss, gain, or maintenance as appropriate. It provides for activity that may begin as walking until the body is physically able to do more. It allows for periods of rest and helps her schedule the meetings which she must attend at regular intervals. Aftercare is part of this process. It is offered by the treatment center for newly discharged persons and provides continuation of support following a 28 day inpatient or partial hospitalization treatment program. In the partial program, people spend the day at the treatment facility but do not sleep there. The purpose of aftercare is to support the person making the transition from a closed community to the open community in which we all live. The length of time people remain in aftercare varies but usually it is an 18-month program in which the recovering person agrees to participate in a group meeting once or twice a week to discuss the problems and concerns of living and working in the community without using mind-altering chemicals. This is in addition to attending A.A. and/or other twelve-step recovery programs and having a sponsor within that person's program. Recovering health professionals are also encouraged to attend Cadeusis meetings where specific issues relating to

their profession can be discussed. Questions of licensure, board hearings, and legal problems connected with their respective profession are some of the topics frequently addressed.

When asked about some of the issues that one might discuss at a Cadeusis group that did not pertain to licensing problems, Lynne reflects briefly and then replies: "It was about two months ago when I brought a problem that I was having to the group. I felt my serenity slipping. It was nothing I could put my finger on, it was a very strange, vague feeling of uneasiness. I began to get very anxious at stop lights, I began to feel very pressed for time, and gradually over a month's time I began to feel that there wasn't a whole lot of pleasure anymore in life. And I couldn't understand it because my husband and I had just bought a house and I was learning how to become a gardener of sorts. This was something I always thought I couldn't do but I found that it was fun and I could get things to grow so I began to spend a lot of time fussing in my garden. I told the group I didn't know what was going on with me. I was following my recovery plan: four meetings a week, getting rest, staying on my diet, going to work. I couldn't see where anything had changed and I was puzzled. The group began to question me about my activities more closely and what turned up was that gradually I was spending more and more time in my garden and making a job out of it instead of a way to relax. In my mind, I had two jobs and was well on the way to working another eight hours in my garden. It was getting to the point where I was starting to turn down dinner invitations to work in the garden. When the group was able to point out how I had shifted a bit in my thinking—that my garden was a job, then my behavior started to reflect that. I was spending all the daylight hours I could in the garden and it was becoming another job instead of a leisure activity. I was getting inflexible again, making things all work and no play, and not meeting my own needs. When they were able to point that out to me, then I was able to do something about it."

A vague feeling of uneasiness enveloped Lynne's entire being, alerting her to a problem. Aware that somehow her life may be out of balance, Lynne enlisted the support of her

Cadeusis group to help her determine the cause. Through gentle probing, she was made aware that she was turning the pleasure of her garden into a job. Her growing resentment was exhibited by becoming anxious and feeling pressed for time. Each member who had had a similar problem then shared how he or she managed it, and in so doing, provided Lynne with ways to handle her problem. How she did it was still up to her.

Pondering my question about early recovery, Natasha reaches forward putting her coffee cup on the small table in front of me. Leaning back into the comfort of large pillows strategically placed on the multicolored sofa, she closes her eyes. I can see that she had retreated to an earlier time. When she speaks, a slight guiver in her voice betrays the calmness with which she describes her struggle to remain clean and dry. "I was working part time after I got out of treatment. I didn't have any choice, I needed the money to live. I'll never forget it. I got a job in a hospital as a nurses aide. There were some empty stadol bottles lying on the counter near the medication cabinet and I took a look at them and said to myself, 'Natasha, you are going to have those tiny little drops that are left in those vials.' I don't know what got into me! I picked up one of them, put it in my pocket and a few minutes later wandered into the bathroom. I took what was left. And damn, there wasn't enough drug in it to do anything, but it was that old drug behavior again! I was terrified after I took it. I couldn't believe that I'd done it! It was so quick! And I knew better! I had just been through 28 days of treatment plus I had just started living in a half-way house and I knew better! I knew I'd be kicked out of the half-way house if I told them what I did and it wasn't even enough to get me high. I was so angry at myself. And I was afraid. The only word that I can think of to describe my fear is petrifying. I started to panic. I couldn't understand how it could have happened and I think that's when I finally realized how gripping a compulsion it is. I knew that I had reached another level of awareness, perhaps a bit of acceptance too, and I *knew* that I didn't have enough experience at living clean and dry to make it on my own."

Automatically returning to her old behavior, Natasha realized that she did not have enough experience in abstinence

to make it on her own. The knowledge that her addiction remained active and the compulsion to use was still present produced sheer terror. "I made a conscious decision right then and there," she says, "that my slip would have to be my secret because I knew that if people at the half-way house found out about it, I'd be kicked out and I knew I wouldn't be able to stay sober and clean on my own. I didn't know where else to go or what else to do so I made a conscious decision to lie by omission. I knew I would have some guilt, but I decided I'd just have to deal with that later. I needed to be where I was and learn how to live without using and drinking. When I look back now, I realize that for the first six months, every single day was a struggle for me. I wanted to use drugs so badly. I lived one hour at a time. I'd tell myself, not this minute, maybe after lunch, just wait until tomorrow—anything to help me get through the day and get to a meeting.

"I stayed in the half-way house for seven months. It took me that long to learn how to live without using. I was almost immobilized with fear when the time came for me to leave. I learned a whole new set of skills but I still felt unsure of my ability to use them. I had finally learned to reach out within the limited community of my half-way house and I'd been going to A.A., but I hadn't learned anything about reaching out in A.A. I had been able to go to these meetings and stay completely isolated by surrounding myself with my recovery people from the half-way house. But now I had to transfer those skills that I had learned in a real small community to a larger community and it was real frightening, real lonely, and real scarey. Work for me was real peripheral. I went to work, I did my job, but I was just 'there.' "

Hiding within the sheltered framework of the half-way house, Natasha felt unprepared to begin living in the world at large. Leaving forced her to participate in the larger community of A.A. When this happened, she was engulfed with harrowing fear. The prospect of yet another change, finding her own apartment, plus her secret knowledge of the one occasion she used immediately after she left treatment combined to produce sheer terror. She was almost immobilized with fear.

"I realized that I had to reach out to other people and that was scary for me," she says. "I had always processed alone and my sharing was always after the process. So I would only open up to people after I had it worked out so that I was in a sense, in essence, never really taking a risk. And I remember when I decided to do it differently and call people and take a risk I went through a phase of learning how to take risks and what that felt like. I never knew what it felt like 'cause I'd never done it. And it was the most frighening damned thing that ever happened to me. I'd call someone and say, 'I got angry and I haven't even processed anything about it, can I talk to you about it and process it?" And I'd just talk about it as I was working on it and I'd have to listen to what they had to say back to me. I was afraid of what people would say back to me and I was afraid because I didn't have the answers. I didn't have any answers about a lot of stuff. And then it got to be talking about how frightening it was to be doing that process and just asking people to sit with me through it 'cause I really got frightened. It was one of those things where I felt like everything was shaking apart and I was coming unglued."

Taking the risk to openly discuss her emotions, Natasha exposed her vulnerable self to another. When she was received without judgment, she was able to clarify her thoughts, explore the relationship of them to her feelings and develop appropriate behavioral strategies. She learned a vital lesson— none of us have all the answers.

Nanette, too, illustrates her experience as a novice in recovery when she says: "I don't know what got into me. I had only been out of treatment less than a month. I was going to A.A. and trying to do all those things they told me to do. I got a sponsor and I was going to a meeting almost every night. I was really feeling good. I was on my pink cloud! I was back in my apartment, things were fine with this man whom I loved, and things were good with my daughter too. I got a job keeping this elderly woman company during the day and at first I felt good about that. But as time went on I began to get bored and I began to wonder if this was all there was to life. She had some codeine in her medicine cabinet and

one day I just reached in and took one. I couldn't believe that I had done that. It happened so fast! It took me three days to get up the courage to tell my sponsor and my counselor."

Among the women in the study, it was not uncommon for many to have a "slip" during the first two to four months of beginning recovery. The term "slip" is used by members of A.A. to denote drinking or drug taking following a period of abstinence. Others in the treatment community refer to such an episode as having a relapse. By itself, the term relapse means to slip or fall back to a former condition. It implies that someone or something has gotten somewhere first. Initially, learning to live without taking mind-altering chemicals takes practice. Both Natasha and Nanette reminded me how difficult it is to replace a learned response with another especially when they were neophytes in living without chemicals. Recovery is a life-long endeavor. Most recovering women refer to recovery as "recovering" to remind them that it is a process without end. Early recovery is the groundwork the woman does to regain balance in her life. Many people believe that it takes at least one year, perhaps longer, to reach a balance and accept the reality of being an alcoholic, drug addict, or both. As such there may be slips and spills, stops and starts along the way.

Early recovery, then, is a time of repairing, preparing, and rehearsing. It is the time when the woman's body is repairing itself and beginning to function again as it should. The use of licit and/or illicit drugs in addition to alcohol increases the time required to clear the body of these addictive substances and may prolong physical recovery. This is also her opportunity to become acquainted with emerging emotions although she may not be able as yet to identify them. Mastering activities of daily living without chemicals requires practice. Therefore, it is not uncommon to view early recovery as a process extending far into one's second year. Much will depend on the woman's willingness to succeed, how well she proceeds through her grieving process, and the support she receives from her A.A. sponsor and knowledgeable health profes-

sionals. Family support is equally vital and if family members are in a program of recovery too, the work all have to do will be easier.

Connecting a thought to its feeling is a new and difficult task. Initially, the woman may not honestly know how she feels. "I went to aftercare groups for nine months when I got out of treatment and I didn't really feel a whole lot that first year Lucille calmly states. "I really didn't. I couldn't name any feelings. I didn't understand what everyone was talking about when they said you've got resentments. I didn't know what a resentment was. The second year, though, I started having a lot of mood swings and a lot of anger and things coming out that I really couldn't identify. It's only now, three and one half years later, it's taken me this long to come out of the fog. I really do see things now for what they really are and I'm just beginning to feel the way I felt before I ever started drinking—way back when I was a teenager. I've only begun to feel good again. I've just started therapy and I don't think I could have done that any earlier, I really don't. I wasn't ready."

"I was on a real emotional roller coaster," Jennifer replies to my question about her recovery process. "I was all over the place. I was dry but not sober during those first 14 months. I didn't go to treatment. I worked with my counselor and I needed that help to start opening up and looking at those horrible feelings that I had about myself ever since I was 11 or 12. I was going through puberty and woke up one day feeling socially inadequate, fearful of the world, of people around me and of myself. I had the pain of moving around and my mother's drinking. I was able to look at all that and realize that it was O.K. to have these feelings. I didn't know when it was O.K. to get mad 'cause I'd been mad and acting out for so long that any strong emotion just terrified me. To me it automatically meant that I was really screwed up and I wasn't handling something right. I'd always used drugs and alcohol to handle that and since I wasn't getting drunk or using on the weekends anymore, I had to figure out what to do with myself during all this free time. It was like can I dance if I'm

sober? Can I sleep with someone if I'm sober? I didn't know how to do these things sober. I was ready to start looking at these things.''

Being ready, her level of awareness and the ability to allay the fear of exposing herself to her inspection, will determine when she is equal to the task and how extensively she will challenge old beliefs. Being ready is a crucial element in rebuilding the woman's life. Healing and rebuilding take time. The woman's concept of herself as a person who does not have worth and value requires exploration to dispel old myths and beliefs. The fact that she may have been treated less than humanely while growing up cannot be denied. To understand that what happened to her was not her fault is a necessary, and very painful, part of her recovery. To comprehend that her behavior, a way of coping with a multitude of factors in her environment, combined with her genetic predisposition to lead her to addiction, is also painful. Now, relieved of the pressing compulsion of her disease, she becomes aware of her emotions.

Getting in touch with feelings is an overwhelming and shudderingly fearful experience. Responding to a whimper from a nearby room, Marissa returns with a towsled haired toddler fresh from her nap. The child, snugly nestles against her mother, and warily eyes the stranger sitting on the couch. After a few moments, a grin appears and she reaches out to grab my extended hand. "When I first got into the program," Marissa says, ''they said read the literature and I read a lot of literature. But it didn't tell me about feelings, it taught program, how to live one day at a time without taking a drink. It was the people in the program who taught me about feelings, bit by bit. I learned about the disease by taking some classes that were offered at one of the treatment centers. But it was a good year before I started to sense my feelings and it was overwhelming. I remember the day I got in touch with my anger. Suddenly I was ranting and raving and throwing things. I tore the living room apart. But there is always something under the anger and I finally figured out through talking to people that what I was experiencing at the time was jealousy!''

"I think that one of the first positive feelings I honestly felt was shyness," Marissa says in response to my question. "It was like wow, that feels real good! It feels O.K. to be shy and get in touch with that. My husband and I were in the bedroom and we were getting ready to make love and he said take your clothes off and all of a sudden I felt shy about that. I probably felt that way before but I just repressed it. I was always scared to have a feeling because somehow I felt that having feelings wasn't normal. We didn't have feelings in our house. We never talked about my father's drinking. We never talked to each other about the crazy things that were happening. I just assumed that ours was a family like everyone elses and you didn't have feelings and you didn't touch. We didn't do any touching or hugging either. So to have a feeling like shyness and be able to get in touch with that, and allow myself to feel it, was thrilling for me. I spent so many years hiding feelings under drugs and alcohol that now it feels good to be able to have feelings even if sometimes they are not good feelings."

Having feelings even if they are not good feelings is a new experience. When she becomes aware that all human beings have days when they feel less than wonderful, she is surprised. Experiencing fatigue, for example, is a revelation. "I remember one day I had really worked hard," Jennifer tells me. "We had a report to get out and it was really a busy day with all of the other things that I had to do. When I got home I laid down on the couch to rest a bit and went to sleep. I didn't wake up until the next morning. I remembered that's what my mother did. She would drink and pass out on the couch. She was always on the couch. I had a horror of spending my life on the couch and when I was drinking I wouldn't go near the couch. Even in my early recovery, I wouldn't lie down on that couch. When I woke up the next morning and found myself there I just panicked!"

When I broach the subject of feelings to Beryl, I notice that she is suddenly engulfed in sadness. "It took me over a year to let myself experience feelings," she tells me. "We didn't have any feelings in our house when I was growing up. The messages were you don't feel, you don't laugh, you don't cry. I never saw my mother and father hug each other. I had to

learn how to let A.A. people help me to experience and identify feelings 'cause I had never done it before. I had to learn how to hug. I had to learn not to hit people when I got clean and sober. I had to learn about common courtesy. I knew all about anger. I grew up with it but it took me a very long time to realize two things. There were other feelings besides anger and there are times when it's O.K. to be angry.''

Although anger is the most feared emotion women in recovery have, it is especially so for the early recovering person. Learning that anger is a normal emotion that may be expressed in culturally acceptable ways is astonishing. Her need to be reassured that her anger does not mean she is regressing into her former ways is vital. ''When I went back to work full time,'' says Natasha, ''I had to learn the difference between being assertive, being aggressive, and being angry. I wasn't a new manager, but I had been on drugs and alcohol for so long that it was as if I were learning how to be a leader all over again. I started noticing that when I became angry with people for no specific reason, they got angry right back and let me know how they felt.''

''I really used meetings a lot during that period of time and I talked to people who I knew had had problems with anger and who had been sober longer than me. And I just talked about what was going on with me and what it was that I needed to do. I had to finally realize that the payoff in the work situation for me was to get angry at you and make you feel bad then I would feel O.K. Then, I didn't have to confront a lot of the things that I didn't like about myself such as how manipulative I am. I had to look at my investment in getting to work extra early so that I could go over the staffing schedule and make sure that I had assigned the best staff to be working with me. And people aren't stupid. The other managers knew what I was doing and it wasn't long before they really let me have it! So I had to get very honest with myself about the level of control I was trying to exert over my life and over everyone else in my life. And there also came a time when I had to learn that it was O.K. to get angry and let people know why I was angry.''

Receiving honest responses from the other manager's with whom she worked, Natasha was forced to look at her own behavior. "I had to learn how to state what I wanted and what I needed," she says. "I had to realize that in the beginning I still had lousy coping skills and I didn't always know how to walk away from a situation that I couldn't deal with or to say I don't know how to deal with this. Instead, I reacted by getting angry. And when I did people got angry right back. I had to start making instant amends which was real galling to me. I had to do some real embarrassing things like approach one of my employees and say to her, 'Yesterday when I did such and such that was wrong and I want to let you know that.' And sometimes people took it very well and other times they said, 'You're damned right you were wrong!' And I had to swallow that. And sometimes I'd have to say, 'You know what made me act like that yesterday was that I was being very selfish and it's wrong of me to be that selfish.' And that just humiliated me. But out of having to do that, I began to look for different ways to do things. I'm more comfortable at work now and I get along with my staff. I don't scream and yell any more when I'm having a hectic day. I'm beginning to get more balance in my life and not be afraid to meet my own needs. Meeting my own needs at work as well as in my private life and being considerate of others is my responsibility and it took me a couple of years to figure that one out!"

Learning appropriate uses of anger forced Natasha to look beneath her own outrage for its reasons. She found it used to mask behaviors in herself that she did not like. Meeting human needs while maintaining a balanced life extends to one's worklife. It is instrumental in getting work done through others, which is the leader's job. Now that alcohol and drugs were no longer part of Natasha's life, she had to learn a variety of leadership skills. For the most part, women do not tolerate "work abuse" and will retaliate if mistreated. Natasha abruptly found that her old ways of coping with stress by getting angry did not work. Using her sponsor and A.A. group, she began to process what was happening to her, how she felt about it, and she received suggestions for action. Making amends is

a term used by recovering people to denote the action of making a sincere apology for mistreating someone else. When Natasha was compelled to make amends for her actions, she began looking for better ways to do things.

Leaning back in her chair and simultaneously running her hand through her dark brown hair, Lucille takes a deep breath before replying to my question about her recovery. When she does so, it is with deep feeling. "It's amazing how long it takes. I didn't do a whole lot that first year. I think I had a lot of physical recovering to do from those years of drinking and drugging. It was doing the basics of just getting through the day without using drugs. I went to meetings, meetings, meetings that first year. That first year I probably went to a meeting just about everyday. That's really what I did. I went to meetings and I worked at my job. I worked as a salesclerk in a department store. That was not a challenge for me, but I needed that time to work on myself. I did all the things that A.A. tells you to do. I got a sponsor and I worked on those first three steps."

> . . . We admitted we were powerless over alcohol—
> that our lives had become unmanageable.
> . . . Came to believe that a Power greater than
> ourselves could restore us to sanity.
> . . . Made a decision to turn our will and our lives over
> the care of God as we understood Him.

Those first three steps are the foundation of the woman's philosophy of living. For many, the experience of admitting powerlessness over a substance and acknowledging an unmanageable life is emotionally devastating. When these things are recognized, guilt, shame, and fear surface. The woman feels guilty for what she may have done to others; shame for her imperfection as a human being, and fear that she will be unable to change. "I was really very defensive and scared when I got out of the treatment facility," Zelda tells me. "I was afraid and ashamed. And that guilt! I felt guilty because of what I did to my children and how they were affected. I guess I never really realized that even though I was not

physically or verbally abusive, I did abuse them through sheer neglect. And they had to watch me deteriorate. I felt shame and a whole ton of guilt for a long, long time.''

Feeling guilty, Zelda was aware that she had deeply hurt her children whom she loves. Believing that she had violated a personal value, she was fearful that the harm done could not be repaired. Her shame, the self-judgment, permeated to the very core of her being. Perhaps she is, after all, worthless. Now she was asked to assume a new identity, a woman alcoholic which at first she could not do. ''Even though I had finished treatment and knew in my head that alcoholism is a disease, Zelda goes on to tell me. ''I still hadn't accepted that fact in my heart. Now I had to accept that my behavior and what happened to me was not my fault. And I had a real problem with that because it was so ingrained in me that being an alcoholic was being a morally bad person. I was not perfect. I had let the whole world down.''

Slipping into the identity of woman alcoholic is not an easy thing to do. Anger, fear, guilt, and shame stand in the way. Kelli's slender frame now silhouetted in the fading sunlight reflects humble strength adding credence to her struggle to find sobriety. ''When I did settle in and started attending A.A. regularly, the first three months were really hard. I was very angry and very bitter about where I found myself. A lot of the socializing that goes on at work is done at bars, done out at parties 'cause we tend to be a fairly young staff, and a lot of people whom I work with are single. I guess I just felt real angry and left out because I wasn't really comfortable going with them. I tried it a few times, you know, to go out with them but there's no point in my sitting in a bar at happy hour—iced tea or no iced tea—I just don't do very well with that. I felt left out of all the social things that were going on at work.''

''It's easier now for me to meet people and to talk to them. I can socialize now without needing to be drunk or even drinking. I'm a lot more comfortable with myself now. I know what my limitations are and I can pick up when I'm startin to get a little edgy soon enough that it doesn't get out of control. When I went out, I used to try and force myself to stay and

enjoy it, but by the time the evening was over, I was not having a good time. Now, I'm comfortable saying earlier, 'I need to go, I've talked to all the people whom I want to talk to and I've had enough.' I think I've become a little bit more aware of myself, how I feel, and where I stand in recovery. I think some of the bitterness is still there but it's certainly not to the same extent it was that first year."

Finally, Kelli began to question the reality of her situation. Is she really a woman alcoholic? "I was very glad when spring rolled around this year," she says. "I'm not sure what it was. I was getting a little antsy, I think, in my recovery. The doubts had come in about am I really an alcoholic? Do I really need to do this on a lifetime basis? Maybe I just got fooled along the way? At that time I was trying to reach some kind of an understanding with my husband about what I needed to be doing in my recovery. That's still very much unsettled. He's very supportive of my going to meetings, but at the same time he still manages to give me the impression that he wishes I could drink or wishes that I didn't have to go to meetings as often. He has a hard time understanding why I get very uncomfortable in certain situations especially if drinking is going on, and we are still going through that but I think early in my recovery it was just more intense."

The ardent desire not to be alcoholic persists as the woman attempts to come to grips with the reality of her situation. All the women inspected the identity of being a woman alcoholic during their first year of recovery and all questioned if it were really true. In the final analysis, it is the woman herself who must be willing to walk the recovery path. For many in my study, the first 15 months were a struggle as she was brought face to face with the reality of her new identity: Being alcoholic. Trying on this identity is one thing; accepting it is yet another.

Marissa smiles, her kind brown eyes reflecting a special understanding. "I had been in the program for about six months when I had to go to the doctor. I had a terrible cold and I was coughing all the time. I couldn't get any rest. He gave me some codeine tablets to take so that I could get some rest. After I got the prescription filled, my first thought was to take them all at once. The compulsion just sort of washed

over me in a brief second and I realized, I finally realized and could accept that I really was a drug addict. All the doubts and the questions were answered. It was like I suddenly understood what that first step meant. I was powerless over drugs. I didn't have any doubts about the alcohol and now the rest of the doubts were gone. I gave the pills to my husband so he could dish them out to me when I was supposed to have them and I called my sponsor.''

Acceptance is the pivotal point in recovery. "It's amazing how long it takes" was echoed by all. Accepting things as they are requires making major changes in one's thoughts, feelings, and attitudes. As the mind thinks and believes, the body begins to reflect in feeling. Walking over to the window, Kelli retrieves a diet Coke from the cooler I have brought. She deftly pops the lid and takes a long swallow before she continues. "I'd been clean and sober for a year and a half," she tells me. "I was working in the same place and not really having any problems. But for some reason I really began to be tempted by the idea of taking narcotics. I had used them before and I knew that they worked. And here they were and it was the same type of thing as when I went to the university and found all these parties and all this free alcohol. And I was having a very hard time getting around it. I'm not sure what was going on in my life—nothing stands out. I was adjusting to a new position. I had gotten promoted. By that point in time I was one of the senior people in the department. It was winter, January/February, and I don't do well in winter, it's just not my time of year. But the doubts had come back about am I really an alcoholic, do I really need to do this on a lifetime basis? Maybe I just got fooled along the way.''

Getting fooled along the way. Kelli again questioned the reality of her situation. Is she really an alcoholic? Questioning reality is a natural part of the recovery process preparing one to enter acceptance. It is her time to try on the identity of being alcoholic. A decision point is near. She is now physically feeling better, relationships at home have stabilized, and her performance at work is recognized through positive evaluations and promotion. Yet disquiet remains gently probing forward movement. The time has arrived to accept herself as she

presently is and forgive herself for the past. It is a painful time. She knows drugs will make her comfortable by blocking this awareness and temporarily dull the pain of living. She is not sure if other measures will work. Kelli continues by saying: "I found that I seem to get very depressed in winter. I did it again this past winter. It was almost like clockwork. January rolled around and I didn't want to get out of bed. And I began wondering if it was worth all the effort. I'd try to remember if my drinking was really as bad as I thought it was. It's a very hopeless, out of control, stuck feeling. It's poor me, this is what I'm stuck with. Fortunately, it doesn't last very long anymore. I have enough people around me to tell me to stop feeling sorry for myself. But that's when I have to increase my meetings, make sure I do my exercises, get rest and eat right. Living is work!"

Intensely working her recovery program by increasing her attendance at meetings to ten that particular week, talking to people in the program and letting them know what is happening to her, having private conversations with her sponsor, doing exercises, and making sure she had balanced meals and proper rest are the things that Kelli does to help her pass through her present discomfort. She also talks to her supervisor at work and together they go over her work schedule to make sure that she is not working too many consecutive hours or too many days before she has time off. They discuss her assignment and the types of work she is doing to look for stress points. Her immediate supervisor and department head are viable parts of her recovery team.

In retrospect, Kelli becomes aware that she was grieving for the way things were. She continues by saying: "All that first year it was 'why me?' But then I started to wake up and appreciate what I have. I finally came to the conclusion that I could sit around for years and say 'why me' and nothing was gonna change. And it was a waste of energy. I finally started noticing that there were other recovering people around me who were having a very good time and I decided that there was no reason why I couldn't have a good time, too. I still miss some of the people, places, and things that I used to do—those activities that I was involved with that were associated

with heavy drinking, and as much as I miss it, I'm also O.K. with the fact that I can't go back to it. That's growth!" And I have to agree with her.

"I'm really only just starting to appreciate what I have," she tells me. "Part of what helped me is that one of my friends came to visit me and it was nice to realize that we could still go out and have a good time and find things to talk about. Life doesn't have to revolve around the social scene at the bar or cocktail lounge. I realized that I'm a decent enough person and I can go out with friends and do something besides drink and have a good time at it." Over time, Kelli sees other recovering women who, like her, have invested time and energy in themselves to arrive at the point where they are serene and happy. Finding role models for sobriety, Kelli allows herself to proceed through the grieving process reaching resolution. As she comes to terms with her identity as a woman alcoholic, she finds that others who may or may not know about her alcoholism accept her as she is. Thoughts and feelings of worth replace negative ones and she commenses to perceive herself differently.

Julie chuckles in response to my question about her recovery process: "My first year in recovery I was insufferable. Fortunately, I had a very good A.A. support system. These people constantly said to me, 'Lower your standards and everyone's performance will come up to meet it.' I fought it for a while, but then I found it to be so because I was pushing myself. I was gonna be perfect. I was going to have the best department and we were going to be better than number one. And I was pushing everybody else along with pushing myself. I was into control. Everything belonged in a little cubby hole because if there was neatness and orderliness then everything was O.K. As long as everything was tidy, everything was O.K. Even my apartment looked like a funeral parlor. The magazines were lined up straight; I had a cleaning lady and I cleaned before she came in. I slept on top of the bed covers so that I wouldn't mess up the bed. You see, if you came into my house, then everything would be in order. And I carried that same type of theme into my work situation. Values became super important to me when I got clean and dry. I couldn't

exaggerate any more, which is a form of lying. Instead, I had to risk and tell you the truth without omitting things. I had built a brick wall around myself and even though I was willing to change, that brick wall came down one brick at a time.''

Trying to atone for the past, Julie endeavors to be the best and pushes those with whom she works to do the same. With the help of her A.A. support system, she is able to lower her standards from super-perfect to doing the best as humanly possible and have more flexibility in her life. Recovering women frequently mention taking down their brick wall one brick at a time, meaning penetrating personal denial to begin the process of self-examination. In the process they find their worth and value and begin rebuilding their lives.

"That first year of my recovery I was dry, not sober,'' Julie tells me. "Although I had accepted the fact that I was an alcoholic and could never safely take a drink again, I hadn't been able to look at me. I didn't really know who Julie was. I didn't even know if I liked her much less accepted her. And it almost killed me. But at that time, that first year, I probably was incapable of looking inside and getting to know me. So I started out in A.A. by following the same pattern that I had followed all my life. It was how I looked and what I projected to you that was important. I was into image that first year. Again, all the external things. I dressed right out of Vogue magazine and I had to look like those models too. I was perpetually afraid of gaining weight so I didn't eat and I took diuretics around the time of my period so I wouldn't look bloated. I had to look lean. I figure that's what it took to be accepted by the 'big crowd' in A.A., and I was gonna be sophisticated and fit in with the 'big crowd.' But even though alcohol was my drug of choice, I guess I have this thing about pills, too. If one is good, two are better and ten are dynamite. So, I started taking more of the diuretics to be sure I wouldn't hold any extra fluid and look fat. If it's possible to become hooked on diuretics, I was off and running. By this time I was beginning my second year in the program. I was very involved in A.A. I was chairing a beginner's meeting, I was going to meetings every single night, and I was beginning to date a fellow who was also recovering. I really looked like I had it

all together, and I thought I did. But I began to do the same thing with the lasix that I had been doing with alcohol. I was taking more and more. I had constant ringing in my ears, I had pains in the calf of my legs, I had this tremendous fatigue, and huge dark circles under my eyes. I looked awful and I began to get bloated and puffy. Deep down in my inner most thoughts I was genuinely afraid that I had damaged my kidneys. I went through another period of awareness just like when I was drinking. I knew I had to stop taking the lasix, but I thought it was too late I was afraid to tell anybody about it. The day came when I collapsed at work and had to be rushed to the nearest emergency room. Why I didn't die from potassium depletion I'll never know. I was in the hospital for about a week on a metabolic unit and it gave me a lot of time to think. You know, approval has to come from within me. It's not how I look, it's not what I wear, it's not what my job title is, it's not any of those things. It's what's going on inside of me and how I think and feel about myself. And I had people around me, both professional and those in A.A., who were caring and supportive while I went through this process. Nobody sat in judgment. Finally I came to the conclusion that Julie was a decent person and I could like her. That was my initial step to total acceptance.''

Forgiving one's self for one's past way of life is a necessary antecedent to assuming the identity of being alcoholic and is the first phase of acceptance. Accepting herself as a woman of worth and value follows. As she tempers her intense desire to atone for past behaviors, she incorporates a more flexible understanding of her life by releasing control of others around her. She begins to feel accepted by others who may not know about her alcoholism. Finally she knows that approval comes from within and she is ready to make peace with herself. Now comfortable with who she is, she is able to enjoy the benefits and reciprocity of a best friend.

''One of the things that has been very rewarding to me after I was able to accept myself,'' she says, ''was to have a best friend. And I went through all the feelings of having a best friend. I thought she was prettier and smarter than I was and she became a very special best friend to me. When she got

a beau and started seeing a lot of him I was upset and angry because initially I felt he took my best friend away from me. But then I learned how to be a real close friend with both of them. I probably have five exceptionally close friends in my life today and that's all I really have room for 'cause being a close friend takes a lot of work and a lot of energy.''

Learning to conserve energy by prioritizing activities of daily living and making choices to maintain balance in one's life requires guidance and practice. As the woman becomes more secure in who she is, she is able to focus outward and observe actions of others in the world around her: "It's just amazing the things that I'm learning now that I'm sober," comments Carnelian. "I've always been one to rush around and try to get everything done on the same day. It's like, if I have ten things to do, I'm compelled to do them all in one day. And for me to learn that things don't always have to be done immediately is mind boggling. When I talk with 'earth people,' those who don't have this disease and who seem to know intuitively what to do, I am amazed. Someone who's not in the program will say to me, 'You don't have to do this today, don't kill yourself getting it done today, that's something that doesn't really have to be done until next week.' And I just open my mouth in astonishment! It's like I have to go to meetings to learn how to live a normal life and here is someone who seems to just intuitively know how to do this! Today I'm learning how to verbally express myself in a group of people. It's easier for me to say something meaningful in a one-to-one relationship than it is in a group. I'm still afraid of showing people, even in A.A., who I really am. It's still too much of a risk. But it's getting better. I'm learning to live.''

12

Accepting Self

ccepting one's self with all one's strengths and limitations is the key to turning life around. Acceptance means total surrender to the knowledge that one's life is in chaos and that the root lies in the disease of alcoholism. It is this insight that makes recovery possible. Acceptance has many facets and is viewed as a continuing process, deepening with the experience of living. Self-respect is one facet. Recovering women all agree that self-respect is a vital part of acceptance, but it is the totality of acceptance that is the key to sobriety. yet, the road to total acceptance has many pot holes. Fear, denial, questioning reality, anger, and bitterness are among them. The sheer terror of realizing the need to drink and the need to stop is replaced by the trembling anticipation of being unable to live without chemicals and rejection even from those who understand. As time passes and the woman begins to feel better, doubts emerge: ''Maybe I'm not really an alcoholic.'' Trying on the identity of being alcoholic requires time, patience, and the support of those who have walked along her footpath. There is anger, bitterness and the grieving that one must do in giving up a former way of life. Facing one's bitterness and anger takes time. Earlier Lucille relates that it took her a year or more to be able to recognize her resentments, inspect them, and begin her recovery journey to acceptance.

Releasing anger is the first step to freedom. Carnelian tells us about her inability to acknowledge and inspect aspects of her rage that hindered her recovery. In remaining on a path to destruction by trying to handle the problem on her own, she almost loses her life. She planned suicide but calls someone before the final act is completed. Again, she embarks upon her recovery path—this time with A.A. Staying emotionally distant from others in the program, she is still unable to begin the work that she must do to reach acceptance. Within six months she drinks to subdue her pain and frustration, feeling that life is not what it should be. Once she does allow herself to feel love and acceptance from others who are recovering, she makes her choice to live and begins the work she must do to reach sobriety. Kelli, on the other hand, makes her decision to begin recovery before events and feelings culminate in self-destruction. She, too, has bitterness especially over her inability to attend happy hour with her work group. A visit from a friend is the catalyst in changing her thinking. She finds she is accepted by friends who do not go to a bar to have a good time. Having social experiences in which one perceives acceptance from those who may not know of her alcoholism, produces feelings of being included and valued in the scheme of things. It is the wellspring for change.

"Acceptance is a process," Geri tells me. "I almost died before I was able to settle down and begin my recovery work. The first time I went to treatment I thought I was listening, but I really wasn't hearing what was being said. I went to save my job the first time; the second time I went to save my life. That's the difference. I knew I would die if I didn't quit drinking and I wanted to live. It's just that simple." Turning to watch children playing in the courtyard below, she becomes pensive. I can feel her quiet serenity. After a few moments, she continues: "The second time I went through treatment, I was intent on knowing. I did everything the counselors told me to do and eventually I lost that compulsion to drink and it was such a relief. I felt I was free, free at last."

Being free from the compulsion to drink brings tremendous relief and allows one to begin a process of self-inspection. Mary Helen's pensive demeanor gives credence to the lines of hope

etched softly in her face. When she speaks, her soft utterances convey the strength and the freedom she has achieved. "I really experienced a change when I had two years of sobriety. It was a lifting of something and things really changed for me in how I was feeling. It was like the burden had lifted and I was suddenly waking up and seeing more of what was going on around me. I can distinctly remember the first time I realized that the compulsion to drink had gone. I had been to visit my sister and I was flying home and a drink was offered and I said I'd have gingerale—and it just sort of washed over me in a flash that I didn't even have the desire to have a drink. It felt so good. That relief is so hard to describe but it felt like the tremendous load I'd been carrying was lifted and finally gone. Now I could make choices. I could honestly choose not to drink!"

Having the ability to make the choice not to drink is rewarding to both Geri and Mary Helen. They gain some control over managing their lives, which is what each wants to do. If the woman has other motives, the outcome will be different. "I think you have to look at the mind set," says Linda. "The first time I went to A.A. I knew I had an alcohol problem, but in my mind I wasn't an alcoholic. I couldn't accept that. I decided to use A.A. to find out how they helped people to stop drinking. But I was gonna use this information to help me drink socially again. I wanted to be able to drink again like I did at the beginning of my drinking. I figured that if I didn't drink for a year and a half that somehow the body would heal itself and I would be O.K. to drink socially. I did attend A.A. regularly and I got involved with the group, but I was sort of marking time until the day arrived when I would be able to drink again. I wasn't really listening to the message and I never got past the first step. I learned how to talk the talk and walk the walk, but I didn't accept any of it that first time. I had a sponsor 'cause they said I had to have one, but I didn't use her. I was always 'fine.' I never let her get close to me so we never got down to the nitty gritty of how I really felt about me. I do remember hearing over and over again that alcoholism is a progressive disease, but nobody could tell me what that meant and this wasn't so very many years ago. Well, I cer-

tainly found out those sober people knew what they were talk-
ing about! The day came when I figured I was well so I had
a glass of wine. Then I was off and running right straight into
hell.''

At the time Linda was beginning her A.A. experience, in-
formation about the disease of alcoholism was limited to the
experience of those who had practical knowledge about its
devastating effects. Although she listened to what was being
said, the meaning behind the words remained hidden. Keep-
ing her sponsor at a distance, Linda learned to "talk the talk"
and "walk the walk" giving an outward appearance of under-
standing and acceptance. In spite of the fact that she complied
by not drinking while she attended A.A., she had yet to begin
the work leading to a sober life.

Sobriety, whether it is learning to live without the use of
mind-altering chemicals, or learning to give up the futile ef-
fort of trying to control the chemically dependent person, is
work. It is the work that all of us must do to acquire serenity—
that peace of mind that is the foundation of a balanced life.
A.A. members use the terms "serenity" and "sobriety" to
refer to someone who is successfully "working the program."
"Working the program" is the business of achieving balance
in one's life by learning to live, one day at a time, without
the use of mind-altering chemicals. Serenity emanates from
sobriety. In leading a sober life, the woman acquires serenity—
that composure, calmness, and peace of mind within that
maintains her balanced life and denotes acceptance of herself
and her disease. The underlying assumption here is that the
recovering woman is finally able to recognize her worth and
value, understand her strengths and limitations, and accept
herself as she is. Acceptance of self and one's condition is the
key to serenity and the impetus to turn one's life around. Ac-
ceptance is the necessary ingredient to relinquishing the iden-
tity that says, "I'm not an alcoholic" to one that says "I'm
a grateful recovering alcoholic." Acceptance says that the
woman has recognized her worth and value as a person and
is comfortable with who she is. As one woman said to me,
"Now my skin fits."

Many of the women in the older group, raised in an atmosphere of unquestioning obedience, had difficulty in making decisions benefiting themselves. "I knew I wanted to be happy," Catherine tells me. "I wanted to be like those folks I saw coming to meetings. But I couldn't understand what they were talking about for the longest time. I had lived so many years of doing things for everyone else, that just the thought of being able to do something for myself was mind boggling. At first I couldn't even think of what I would like to do for myself. It took about a year and a half before I could think of some things that I wanted to do for myself and then do them without feeling guilty. And it took about that long for me to realize that I was a pretty nice person after all."

Getting comfortable with one's self brings independence. First, the burden of her insatiable quest for alcohol is lifted, allowing her to candidly inspect her numerous problems. Learning how to structure her activities of daily living to bring balance to her life is one of them. Learning how to regain her status in the family and cope with the guilt and the blame she feels for what she has inflicted on them is another. Being lonely, angry, and resentful are initial feelings all the women experienced. "When I left treatment," Yolands tells me, "I went back home to deal with all the problems that were waiting for me. My husband was gone. My kids were angry. My power as mother in the household was gone and I was scared. But I did what the folks at the treatment center told me to do. I went to meetings, meetings, meetings that first year and I got a sponsor. It wasn't until I had almost two years in the program when I began to notice that I did have a choice. I could now choose not to drink and that was such a relief for me. It took me almost that long, too, to make amends with my kids and become a mother again. I had to earn their trust."

All the women agreed that getting comfortable with one's self, meaning that they were able to like and approve of themselves, took a considerable amount of time. It was not unusual to find that it took between two to three years before each could accord herself the dignity she deserved. Adjusting her glasses, Mary Helen leans back in her chair and folds one

arm to support the other while graceful fingers gently stroke her chin. I notice that a wisp of greying hair creeps softly from it's assigned place to nestle in the furrows in her brow. "I guess I really began to grow when I heard more about the clinical aspects of alcoholism. Intellectually I was able to understand where my values and even some of my morals had been violated and why that had affected my self-respect and confidence. When I had some anchors of understanding, then I began to understand what made me tick. Like any other alcoholic, I wanted to be well instantly and it doesn't work that way. It took many years to get to where I was and I had to accept that I would get well little by little and I began to realize that it wasn't necessarily going to be on my timetable."

"I began to notice little things," she says. "After several months, I began to hear pride in the voices of my family when they talked to me. There were other small evidences that my perseverence was paying off and I had to acknowledge that I wasn't doing this alone. I began to hear what was being said at meetings like my higher power was working through his instruments—other people, and some of the old quotations from the bible that I had learned as a child began to take on an entirely different meaning than they had before. It was a much deeper meaning and I could understand the message instead of getting lost in the parable. It was like putting pieces of a puzzle together—what is it saying to me, the overall thing. I didn't have a dramatic spiritual awakening but I had a series of many small things happen to me that made me realize that somehow I was part of a larger fabric. I came to believe slowly. My defenses against a higher power as such, particularly with a name, were higher than I realized. I had to overcome my intellectualizing and take the risk of a leap of faith. You know, no matter what, it couldn't be any worse than it had been—it just couldn't be. I didn't want to go back to where I had been now that I'd had a taste of what it could be like. And eventually I came to believe that a power greater than me could restore me to sanity and I became willing to turn my life over to the care of this power as I understood it to be."

Feeling safe and experiencing trust are vital elements of acceptance. A.A. women freely give this to the woman who is

new in the program. They honor the newcomer by trusting that when she experiences what it is like to feel safe and be loved, she will be able to begin her own recovery journey. Since this trust is extended to the woman before she demonstrates her ability to recover, faith is born. If family members or those at work too do not begin their own program of recovery as in Al-Anon, the reverse occurs. The fledgling must earn trust by demonstrating her ability to recover—no small task even with the faith of those in her support group. To be successful, faith must be extended by all. Yolanda tells us that it took almost two years to earn "trust points" from her children. The support of those in A.A. was vital during this period. Earlier, Mary Helen told us that she felt two of the women in her A.A. group had faith in her to recover and she did not want to disappoint them. Only later did she perceive trust eminating from her own family. In time, Mary Helen gathered courage to take a leap of faith and risk trusting a higher power. Turning her will and her life over to the care of God as she understood Him to be was her next step and the third in the twelve to a better life.

Leaning forward, Linda puts her hand on my arm and gazes at me intently. Her mischievous blue eyes are literally dancing when she speaks: "I remember the first time I called A.A. They said they would send some people over to talk to me and two exceptionally well dressed women arrived. I thought hrrmph! They don't even send drunks to talk to drunks! I just couldn't believe it when they took me to a meeting and said they were recovering. I just didn't believe it. They were too happy! They were too well dressed! I found out later they were also in the same profession that I was in and that really blew me away!" With that, Linda leans back in her chair and turns her gaze to the earth movers below us preparing ground for yet another shopping center. After a brief pause she turns to me and says: "I think it all goes back to what I thought about me. I was a woman and I just hated myself because I thought I was a bad woman. I felt inferior. I felt I had to constantly strive to prove myself. I had to be the perfect mother because with my drinking I had to put on appearances. I didn't want anyone to say that I was not a good mother. I didn't really

work hard at being a good mother and I often think back now, especially about my youngest boy, maybe he would have been more this or more that if I hadn't been drinking. But I don't put myself down anymore. I don't have to 'cause I like me today. I know that if I took a drink again I would be right back where I was before—having to prove myself to other people. Today I have faith and confidence in Linda. I can accept myself as I am."

Having faith and confidence in herself, Linda is now able to view life differently. It took another drinking episode before she was able to surrender and accept the knowledge that she is alcoholic. When she reentered A.A., she was ready to do the work she had to do to reach sobriety. "If you want to know how I felt," Linda tells me, "I guess the truth of the matter is that I was terrified from the day I was born. If I wasn't afraid of something, I was worrying about something. Today I may be concerned about something, but I don't let it interfere with my being happy. Sometimes I'm disappointed in people or things or what have you and that's O.K. too, because they are possibly disappointed in me. But that's their problem! Today I have a choice. I can go back to my worrying if I want to or I can go back to my drinking, but on the other hand I can be a sober, happy lady and I think I like that better. Today, I can accept myself as I am."

Feeling safe, feeling loved, restoring self-respect and in-specting the identity of being alcoholic are facets of acceptance. Accepting the reality of being alcoholic may occur after a traumatic event. "I was still angry about a lot of things," Catherine replies to my question, "but I started going to A.A. and I began to feel better. By this time I had 15 months in the program and I thought I had the world by the tail. I heard someone say in a meeting that in order to keep it, you had to give it away so I decided I was gonna cure the world. I didn't realize I didn't have it to give away! I really hadn't begun my own recovery work. I didn't have a sponsor and I hadn't even opened the Big Book. I had a friend who was in the program about as long as I and we teamed up and started to do some twelve-step work. Talk about the blind leading the blind! We were trying to fix everyone that needed fixin' and that got both

of us into trouble the day I got a call from a nine year old asking for help because his mother has passed out from drinking.
"I called my 'partner' and we went. We fixed something to eat for the children and then started the process of trying to get some soup into the mother. We got the first little bit down and I went out to the kitchen to get some more. There was a bottle of vodka on the kitchen counter and I remember picking the bottle up, but I don't remember putting the bottle down. I went into a blackout that quickly. My friend told me later that I started acting strangely and she figured that I had gotten something to drink and now she had two drunks on her hands. She didn't know what to do. I left the house. She tried to keep me from driving but to no avail. I came out of the blackout sitting in the police station talking to this very disgruntled sergeant. I can remember asking him what was the matter with him and he just said, 'Lady, if you had been through what I've been through with you, you'd have a frown on your face too!' It turned out that I hit a row of parked cars, beat up one policeman, and raised quite a ruckus at the police station after they finally brought me in. I became a wild woman. It was at that point that I surrendered. There were no doubts. I knew I was an alcoholic and I took my first step. My life was unmanageable and I was powerless over alcohol. I went back to A.A., got a sponsor, and started reading the Big Book."

Catherine's experience brought home the realization that she was indeed an alcoholic and could never safely drink again. Now she began to question the wisdom of taking tranquilizers to manage her life and gave those up too. For both Catherine and Linda, acceptance meant recognition of their present circumstances and total surrender to the reality of their disease. Among the older group of women, acceptance frequently occurred following a traumatic event in which they realized that the only option left was to live or die. These women did not have the advantage of the numerous education and treatment services available today to help them understand their disease process. Instead, understanding was acquired through those having achieved sobriety acting as role models and mentors for neophytes. Faith, the confidence that life will somehow

be better, emerged slowly. Over time, helping hands provided each woman with the strength to risk trusting an unseen higher power.

Each woman's recovery is different. Jennifer's reminiscent smile broadens as she reflects on her miraculous growth. "It took about 15 months for me to begin to realize that I pick relationships with men who are equally terrified about commitment. I pick them that way so I can have a big crisis in my life. So, part of my sobriety is recognizing that I do that—that I pick men who are not going to meet my needs and do not want to become involved in my alcoholism or who do not want to be involved in long-term relationships. Now that I recognize that, I have to change that behavior. But first, I need to look at what's going on with me and why I do that. That's a real piece of acceptance for me. So, when I mess up and make "Joe Blow" the most important thing in my life and start to feel emotionally shakey, I know I'm not taking care of me. I have to remember that I'm the most important person, go to my meetings, and continue to make friends with women as well as men. It used to be that men and work were the only two things I had going for me, and if anything was messed up in either of those departments, I was messed up and unhappy."

Feeling more comfortable in her sobriety, Jennifer is able to recognize her pattern of behavior and implement positive action to bring her life back into balance. "My perspective is a lot better now," she tells me. "I don't have to be perfect and fix everything to suit me. I used to be obsessed with the notion that I was a failure as a manager because the people who worked for me were having problems. Somehow, I thought that when you worked for me, I could fix and take away all your difficulties. Well, I've learned I'm not perfect and neither is anyone else. We all have aggravations. I give you permission to have yours and I'll take care of mine." Learning to get work done through others without becoming emotionally involved in their personal problems is another lesson for Jennifer in her growth process. Now, she is able to tend to her own emotional needs to keep her life in balance—and to let others do the same.

"I was always angry," Jennifer continues, "so intolerably angry at the world because of the way the world was. Now, I can accept it a little bit better rather than get all upset and angry about why does it have to be this way. It's like it *is* this way. Accept the things you cannot change! In terms of my self-worth, I've gotten a lot better about giving things to myself. I finally traded in my car and bought a new one and moved to a decent apartment. I can give those things to myself now because I deserve them. Before, I never felt like I deserved them. I was just a screw up and I didn't deserve a thing. I was always waiting for the bomb to drop. Even in my early recovery I was always looking over my shoulder for some big calamity to come along and prove to me and everyone else that I wasn't worth it. I didn't have it together. I felt totally inadequate and I really believed all that garbage. Sometimes, even now, two years later, if I feel like I'm having too much fun or I get too happy, I begin to get a little anxious and fearful. When I took stimulants and alcohol, it just blocked all that and I didn't have to feel for a little while. Now when I have those feelings I know that it's O.K. to have a bad day, everyone has one now and then. I get a couple of hours of fresh air, go jogging, go to a meeting, call up some friends and talk to them for a while, and eventually I come out of it like everyone else does. Early in my recovery, it was so frightening for me to have a bad day because I thought: 'I'm going right back into it again—I'm crazy again!' I had to give myself permission to have a bad day." Beginning to realize she has worth and value, Jennifer gives herself permission to move to a better apartment in a safer neighborhood and to purchase a new car. She also recognizes that all humans have "bad days" and she learns to accept these feelings as a part of living. Getting rest, exercise, talking to people, and attending meetings are activities to restore her. Jennifer is practicing procedures for remaining abstinent and developing a more positive attitude toward herself. She is beginning to lead a sober life and in sobriety finds her serenity.

Learning to cope with myriad vexations without the use of mind-altering chemicals requires practice and an alteration

in the woman's belief structure. Building skills to deal effectively with social pressures from others to drink requires a conviction that she deserves something better. She must graciously permit herself to believe that alcoholism is a chronic illness from which recovery is possible. Until she has practiced the procedures for remaining abstinent, has replaced negative thoughts and feelings about herself with something more positive, and has accepted the reality of her chemical dependency, she is vulnerable to resort to old and known ways of coping. As such, episodes of drinking and/or drug taking may happen again.

Carnelian's quiet energy belies the anger and the fear of an earlier time: "It took me two years before I could express my anger to someone. I finally figured out that I didn't have to please others anymore. What I really had to do was please myself and take care of me. I had to be comfortable with me. I had to approve of myself first. I think the big part was realizing that it was O.K. for me not to like someone. And that some people may not like me and that's O.K. Today I am in the here and now. I'm letting tomorrow worry about itself. Yesterday is a part of who I am today, but it's not all of who I am."

"I've had a hard time getting the concept of spirituality," she continues. "I think for me I have to look at it this way—that we are all a part of the universe. Christ was a very wonderful teacher and a very special holy man, but I have trouble believing that he is *the* son of God. I think we are all children of God. I feel that my higher power, whom I choose to call God, is within me. I have to look within me to find the answers to a lot of things. And there are some things that I may never find the answers to, but if I am ready, perhaps I will know."

Spirituality is a way of living. It integrates body, mind, and spirit and permits one to enter into an interdependent relationship with one's self. Each part is dependent on the other to complete its job; in this case the job of becoming a whole person. The concept expands to include a higher power. Wholeness implies a relationship between the self and a power greater than the self. To begin, the woman learns to take care of her body and develop a positive mental attitude toward life. Next, she has a relationship with her essence or core being

and later extends this relationship to an ultimate power that is both within and outside of herself. She accepts her higher power into her heart. Carnelian has reached the point of having a relationship with herself and feeling that the God of her understanding is within her. She finds that her life is more comfortable and is now able to trust that somehow her life will be better for her than it has been. She is approaching the point in recovery that has been described by many as a ''leap of faith.'' This is the point where she is able to turn her life over to the care of her higher power as she understands Him to be. When she does this, she will accept and ''take'' the third step—''Made a decision to turn our will and our lives over to the care of God as we understood Him.''

The concept of spirituality is something that all struggle to comprehend. Both Mary Helen and Carnelian eloquently present their understanding and are able to articulate how they have applied this concept to their lives. Barbara describes her process as a series of awakenings. ''At the end of my second year, I found my life in balance,'' she says. ''When I look back, I realize that those two years were rough, especially the first six months. I had accepted the fact that I was the alcoholic in the family, I was going to a meeting every evening, I was seeing a counselor twice a week, I was working part time, and I was miserable. One day I just started crying and I couldn't seem to stop. Finally I cried out to God to help me. I was in such pain. I thought, 'If this is what it is like not to drink, I'd rather be dead.' And then something seemed to happen. I felt calm. I wasn't anxious or uptight anymore. It just seemed to leave me. And instantly I knew what that third step was all about. I had been struggling to turn everything over and let it go, but I didn't know how to do it. It seemed that in that one instant, I knew what I had to do. It was so easy to let go of the worries and the frustration. I still had bad feelings; I still had a lot of anger so I began to talk about it with my sponsor and my counselor. I went to a workshop on anger, too, so that I could understand the dynamics better. I began to be able to express myself when I was angry and let people know how I felt. I was able to look at the anger I carried for all those years when my father beat me and sent me to my room to

be alone. I could begin to understand and put a name to some of the feelings I was beginning to have. It was scary, but I wasn't afraid. God was in my corner and I could work through the things I had to do to feel better. I could begin to meet some of my needs after all these years. I could begin to feel safe. I had lots of small spiritual awakenings along the way. People just seemed to be around to help me when I got to a point where I needed help. I was growing and I wasn't afraid any more.''

Spirituality is reached in stages. The concept of "letting go" is one level, whereas the slogan "let go, let God," implies another level and has a deeper meaning. "Letting go" means that there are things in this world that the individual is unable to do. The woman learns to first "let go," then later she is able to "turn it over" by sharing her awesome burden with a higher power whom she may choose to call God. Edna's serious brown eyes still show traces of anxiety. At first she is reluctant to talk about spirituality saying that she doesn't understand it well enough, but as we continue I am able to ask her to share how she is working her recovery program. "The first six months I was like a bag of jelly," she tells me. "I just did what everyone said to do. I just kept listening to what everyone was saying at the meetings. I do believe you learn in A.A. I guess when the people in the program say 'keep comin' back, you'll get better,' it's true. I kept hearing the same things over and over again and I guess that was good for me. Even though I've just had my first birthday, I know I have a lot more to learn. I don't have the spiritual aspect of the program down by any stretch of the imagination but I've heard people say 'let go' so much that I'm beginning to look at what that means for me. Right now I'm better at distinguishing between things that I can do something about and things that I can't. I've learned to get go of the things I can't do anything about instead of driving myself crazy over them. I don't have the spiritual aspect clear in my mind yet and I don't feel comfortable talking about a higher power. Today, I can't tell you that I have one. But I know that when I'm ready, things will become clear to me.'' On a path to recovery, Edna is beginning to have a relationship with herself and is open to having

one with a higher power. She is getting the courage to make her "leap of faith." As a "one year old," she is where others have been in the quest for serenity.

"I can't begin to tell you what the A.A. program has done for me," says Cecelia. "It's given me a pattern for living that I never thought was possible. I have a closer relationship with the God of my understanding than I've ever had before. The twelve steps have given me the kind of life I've always searched for but never knew where to find. I believe God truly works through people. I've learned that I'm not perfect and that's O.K. I've learned to forgive myself for becoming chemically addicted and to realize that even though I hurt my family by my behavior when I was using, I did the best I knew how to do during those bad times. I've found forgiveness and peace of mind through knowing myself better." Reaching acceptance, Cecelia is now able to accord herself the dignity she deserves. It has taken her seven years to reach a level where her spiritual development and all aspects of acceptance intersect in harmony.

At the time we talked, Beryl had four and a half years of sobriety to her credit. "What does it feel like now to be a woman?" I ask her. "Today it's kinda neat," she says. "I have feelings. I can laugh. I can cry. I can hug my kids and I can love my kids. I am more at ease with myself. I can actually believe that someone loves me for who I am and that I'm a decent person. I know I've damaged my body. I have ulcers. My pancreas is impaired and I have difficulty in handling sugar. I have nerve damage. One side of my left hand and arm are numb from shootin' up as well as several areas in both legs. My body is covered with scars from having had abscesses and a cat scan showed brain damage. But my life is so much better now. I have serenity. I don't mind sharing the fact that I'm a recovering alcoholic and addict with others because I'm grateful that I was given a chance to live. Perhaps in sharing I will be able to help someone else. Today I have a high power and I'm going to need Him every step of the way. I have more work to do to become a whole person. I'm just starting therapy to work on my incest issues."

The process of acceptance deepens for Beryl as she begins

to come to grips with her incest issues. It will take her another four years to emerge with a new identity. Recently she called me to relate where she was in her life now. "I have a new name to go with my new identity," she told me. "I'm finally a whole person." I wished her well and told her I loved her and that she was special to me. Our tears were those of joy in celebration of her new personhood.

"Now that your burden has been lifted, Lucy, how are you working your program?" I ask. "I get up every morning and I read my *Each Day A New Beginning*," she replies. I take time for me and I feel my wellness. I look at what I have. I experience an overwhelming gratitude for all that I have. I think I can best explain how I feel by giving you an example. I was coming home from the village the other day and it had been raining and the sun came out. I began to see a rainbow and I was looking at it and thinking how pretty it was. Then I noticed that it was a double rainbow, a very faint second one, but oh, how beautiful! Just taking in God's beauty gave me a lift. I could hardly wait to get home and get the family to enjoy this with me. It is so wonderful to be able to take in all of God's beauty. It gave me a joyous feeling." She describes how she was able to share the moment with her family and how they, too, were enraptured by the rainbow. Feeling joy— an overwhelming elation and the wanting to share it with others to celebrate its significance. Sharing joy is a way to bring people together. Today Lucy is enjoying her children and learning to have fun in the things she does with them. Together, they are finding love.

"I think the best part of being a recovering alcoholic is the opportunity I have to make recovery look so good that people want it too," says Linda. They just can't live without it. If I can convince just one alcoholic that being sober is more fun that being drunk, then I've done a good job. That's my own personal feeling. And I think that's where it's at. The alcoholic is losing her very closest friend—alcohol. It's my job to help her replace that with some kind of joy. She has to have something to look forward to." Joy, the emotional experience indicating well-being, is Linda's goal for herself and others. When she helps others along the recovery path, she is help-

ing herself. Linda retired recently from her place of employment and she now spends her time sponsoring women in her profession who are struggling to understand spirituality and reach acceptance, one step at a time. And for some, she is their liaison or advocate when they return to work.

Returning to work embodies change and requires a major adjustment. There are fears of a different sort. Will I be able to remember what it is I'm supposed to do? Will people be kind to me? Will I be accepted? These are some of the questions she asks herself as she prepares to return. "I wanted the head of the department to welcome me back," Zelda tells me. "Although that is not something that a department head would normally do, I had been gone for over four months. I wanted to know where she was with her feelings about alcoholism because when I went through treatment, it was not an illness that is the usual acceptable one. It had a stigma attached to it and I wanted to know how she felt about it." When Zelda wants to know how her department head views alcoholism, she really wants to know if she will be accepted by those with whom she will be working. She is "testing the waters" to see if her human need for acceptance will be met.

Explaining job expectations, providing an orientation, setting attainable goals, ensuring equal treatment, having periodic evaluation conferences and unobtrusive monitoring are ways to support the woman when she returns to work. "I think that if it's possible the supervisor should be encouraged to come to a discharge conference," Julie says with exceptional seriousness. "As the supervisor, you need to come and the three of us, you, me and my counselor, need to talk about what your expectations are of me when I come back to work. And I think you need to make this very clear to me from the beginning. If I am on probation, then I need to know this. If there are some tasks that you do not want me to do, then I need to know this right up front. In the same manner, I need to tell you specific things that would make me uncomfortable such as working a lot of overtime, or working a night shift. As the supervisor, you will need to know that I'm going to aftercare three nights a week, and A.A. meetings four nights a week, and that I have appointments to see my counselor

and it's important that I keep those appointments. But as the supervisor, you need to say, 'We have a staff meeting on Tuesday's at 2 PM and you will need to be there.' Together, we can make a schedule that both of us can live with." Julie speaks with the knowledge and conviction that teamwork makes a difference. After receiving higher education, she is currently working as an employee assistance coordinator to facilitate reentry.

"I think it's my responsibility to tell my boss what I need to do for my recovery if it's in the realm of reason," says Geri. Should the whole department change just because I'm recovering? No! I just want to be treated in a fair manner. I want you to accept me as a person who has worth and dignity and when you do that, it helps me to accept myself." Today Geri is comfortable with herself and her sobriety. "Every once in a while I think about the future," she says. "And I have to admit that the clock is not running with me, but I don't dwell on it. I am able to work and I am reasonably healthy inspite of the drinking so I am able to count my blessings." Presently Geri is working part time, fixing up her condo, and beginning to brouse through travel magazines. "There are some places I would like to see while I'm still able to do so," she told me recently.

Returning to work requires adaptation to the organization. One method to help accomplish this task and meet her human need for adaptation is to provide a period of orientation. All the women agreed that they needed a period of "easing in" to the job again. Initially, all wanted to have limited responsibility until they felt comfortable in the work situation. "Ease me in very gradually," Lucille says. "Although I probably wasn't as competent as I thought I was when I was drinking and using, I was pretty functional in my job. I got it all done and then some. But coming back I didn't have that confidence and was very unsure of my ability to work. I needed to ease in gradually. It was almost like starting all over again with my first job." She has done well in the intervening time since we first talked and has received several promotions making her way up the corporate ladder.

Being welcomed back, being accepted, receiving respect, and knowing about her aftercare plan are ways to meet the human needs of women as they return to the workforce. Meeting her needs demonstrates understanding and is an attribute of supporting recovery. It is one way in which both staff and management can support the woman as she reenters the workforce. "I wanted to be able to talk to my boss about the fears I had in returning to work," Zelda tells me. "I was afraid that I had lost my skills, that my mind was not what it had been because I had a hard time concentrating. When I first got out of treatment, my attention span was terrible and I couldn't remember things. I blocked a lot. I couldn't even remember the meaning of common words and I couldn't understand much of what was in the newspaper. And I wanted to be able to share that with someone at work. My mental abilities came back and I didn't forget my skills, but it took about a year before I felt I was functioning smoothly again." Zelda remained at her job and did well. Now comfortable in her sobriety she decided to help others having a similar problem. Presently she is working in a treatment setting where her expertise is appreciated and her warm vibrant energy is graciously accepted.

Having patience is another attribute of supporting recovery. All of the women agreed that cognitive function returned long after they physically began to feel better. Having a short attention span and the inability to remember verbal directions headed their list of perceptions about themselves. They found they could remember old skills following a brief orientation period, but that they needed to make themselves a list of the things they had to do and cross each item off when it was completed, otherwise they would not remember to do it. The realization that they were not functioning cognitively as they felt they should produced profound fear. They wanted to feel free to talk to another professional at work who would understand these fears, but suspected they would be judged in a negative way instead.

Developing organizational skills requires practice. Many of the women frequently talked about their human need for

guidance and support in this area of their work life. Helping the woman to set realistic goals by receiving an assignment that could be finished gave each a feeling of accomplishment. "When I went back to work I was anxious and hyperactive," says Cathcrine. "I wanted to prove to you that I could still function, so the minute the phone rang I felt compelled to answer it no matter what I was doing. My boss was very patient with me. She kept saying, 'Slow down and finish one thing before you start another.' I had a tendency to start five things and then of course none of them got done so then I'd begin to feel bad. I was fortunate. Everyone where I worked was patient with me too. I felt that people cared about me and that helped a lot. It took me a long time to learn how to focus on one task and see it through to completion, but once I could do that, I began to feel as if I was contributing and that made me feel good."

Communicating by giving affirmations, providing honest feedback, and setting expectations were other attributes of supporting recovery. "I spent so many years feeling bad about myself," Catherine relates, "that it took about a year and a half before I began to hear the positive feedback that was directed to me. During one of my conferences with my boss, she asked me to repeat what she had said to me. I repeated what I heard. Then she pointed out to me that I was filtering out the good things that were being said about what I was doing and only tuning in to the 'negatives'—what she wanted me to do to improve in certain areas." All the women were unaccustomed to being praised or receiving a thank you for a job well done. When they were able to hear affirmations and realize they were truly meant, it reinforced their sense of worth and value.

Honest feedback can be presented in a kind way that communicates caring. "I'll never forget when I was caught stealing drugs, how caring my boss was," says Natasha. "She told me there would be an investigation and I would be asked a lot of questions. Then she said the nicest thing to me: 'I know, Natasha, that you will be as honest as your disease will let you be.' And she was the first person in my whole life who made it very clear to me that she believed that what I had done

was because of my disease and that was not me. I was a person who was very different from my disease. There was a part of me that wanted to cry when she said that. Of course she told me I could not come back to work but two days later she called me and said: 'I just want to check on you, how are you doing? How is it going for you?' I knew what she meant. I knew she meant, 'How's your withdrawal going? Are you O.K. physically?' It felt so good to know that she cared. And I gave her an honest response. I told her that it was a bit tough but I was O.K. with it. I didn't have any money and I hadn't worked at this place long enough to qualify for insurance so she helped me get Title XX funds and find a place that I could afford to begin treatment. And she told me I could come back to work after treatment, and she kept her word! That meant a lot.''

Although Natasha's intervention was aimed at her drug abuse, her employer wisely recognized her alcoholism. The offer of support through helping her to get treatment and having a job to come back to were done in a caring and concerned way. ''Treatment sounded a lot better than jail,'' says Natasha. ''When I was able to go back to work, I was put in another department where I didn't have to be around drugs and that helped. I didn't want to tell people about what had happened to me right away, but when I got to feeling comfortable and I knew that those I worked with accepted me, then I told them. I was lucky, my boss supported me and that made my transition to work much easier.'' Today, Natasha is not afraid of letting the people with whom she's working know that she is recovering. She has become a reference point for others who are able to approach her with questions about their own alcohol and drug use.

Although all the women wanted to have input into the things that affected them personally, they did not want to be singled out for any ''extra special'' consideration just because they were recovering. ''Don't treat me any different than anyone else,'' Geri affirms. ''I'm responsible for my own recovery. It's up to me to make sure I don't get too hungry, angry, lonely, tired. But I need feedback because sometimes I don't think I see things in myself. One of the ways my boss

and others who work with me can help is by giving me feedback. I think there is a thin line between enabling and supporting me. If the people around me aren't knowledgeable in the disease process, I don't think they will be able to understand that. I want to be told if I start acting a little crazy, don't humor me, tell me what you see. I think it's good when others feel comfortable saying, 'Look, your behavior has been such and such, is there something going on? It's not going to hurt me if you are seeing different behaviors. It tells me you're concerned and I need to take a look at what I'm doing or not doing. Being concerned isn't enabling.''

All the women expected to be monitored for a period of time when they returned to work and wanted it to be done in an unobtrusive and humane way. "A freshly recovering professional is sensitive about somebody looking over her shoulder all the time," Mary Helen tells me. "I would like the monitor to be humane. I would like whoever it is to be honest and say something like: 'It is my responsibility as well as yours that I monitor you and I will do it in a responsible but caring way because I want you to get better.' '' Those women who took other drugs too also expected to be asked to participate in random drug screens and they supported this action.

Becoming knowledgeable about the progression of chemical dependency makes it easier to provide periodic conferences and provide feedback. Every employee expects to receive feedback and recovering women are no different. "I wanted to have my boss talk to me face to face and give me quality time," Lucy says. "But that didn't happen. Every three months I found an envelope on my desk with 'performs work satisfactorily.' I wanted to know what that meant. I wanted her to tell me how I was doing and to be able to talk to her about that. But her door was always closed to me."

Recovering women are exceptionally astute in detecting anger about alcoholism and addiction to other drugs. Sixty-two percent of the women returning to their original place of employment were not accepted or respected. Instead they were met with anger, distrust, hostility, and in many cases, outright rudeness. Eventually they sought employment in areas where

their expertise was valued and they were treated more humanely. As one would expect under such circumstances, most of the women did not feel comfortable sharing the fact that they were recovering and closely guarded their anonymity. "I didn't feel comfortable about breaking my anonymity with anyone at work," says Jennifer. "I would feel their anger when they talked about anyone who was addicted and even though I could hear a lot of myths and biases about addiction, I felt it would not be to my benefit to say anything." "I think the hardest thing was not being in a setting where I could talk about my fears," Kelli comments. "I didn't feel comfortable about sharing what was going on with me and how I was feeling with any of the people that I worked with. I knew they didn't understand about my disease and I could sense a lot of anger."

Kelli and Jennifer echo sentiments of many of the women. The workplace is viewed as a highly competitive, individualistic, and isolating experience to the newly recovering woman. It may be that managers and staff members who themselves are children of alcoholics see inconsistency and chaos as family norms. As a result, such behavior in others may go unnoticed. When forced to recognize that an employee's problem is related to alcohol, old animosities can surface and the manager's reaction may then be one of anger. A solution is to punish rather than to intervene in a helpful fashion. Later, when the recovering person does return to work, hostility, anger, and distrust may be projected.

When I ask Doreene how others reacted to her when she went back to work, a big grin forms. Her roguish, baby-blue eyes lend prominence to her freckles. "I think I scared the hell out of them. The other managers couldn't control me like they used to. My buttons were in all different places. I still had them, I just moved them or made them a little thicker to push." Now, more pensive, she relates: "I forced my peers to change and I forced them to look at their own behaviors and that was frightening for them so I was still isolated in some respect. I was half way through my second year of sobriety before I really began to feel like everyone else. And then I just took off. It was like zoooom! I feel great. I'm comfortable in my

job. And I finally figured out that I'm an individual and I just do things differently from others. I'm a leader, not a follower among other leaders. So, in many respects I still don't fit, but now that doesn't bother me and I don't lament over it. I probably don't want to fit. I do not aspire to be one of the conforming mediocracy. But for so long that's what I strove to be. I wanted to be one of 'them.' Well, I was never one of 'them' and now that I'm sober it just made it worse in terms of not fitting in, but today, that's O.K. Oh, there are times when I wish I fit, part of me wants to fit, but I weep for a moment and then go charging on with my life. I've learned how to deal with people at their level and I can get my needs met in various places now instead of just from my peers at work. People don't intimidate me anymore.''

Acceptance is a process. Reaching complete acceptance implies that the woman is comfortable with the knowledge that she is alcoholic, an addict, or both. In an ideal recovery setting, a supportive environment leads to a perception of acceptance by others and provides fertile ground for self-acceptance. One's own strengths and limitations become better understood and provide the building blocks upon which self-confidence may be structured. An initial awareness that alcohol and other drugs have become a major component of one's disintegrating self does not happen spontaneously. It is a slow realization as one is forced by events to take stock of one's life. The realization that one is, indeed, an alcoholic usually occurs during the first 12 to 15 months of recovery. The process of self-realization develops in three stages. The first stage is a beginning awareness of one's inability to drink, which is followed by the secondstage—suppression of this awareness. The third stage occurs when the woman reflects on the events in her life and recognizes her own mortality. The recognition of mortality stimulates an honest self-appraisal of the true nature of the problem. For many, this happened between the sixth and 12th month of abstinence. For others, self-appraisal took up to 15 months. Each stage in reconstruction of oneself has an aspect of fear that must be overcome. This may range from simple trepidation to reducing the person to absolute terror. Once the woman's life-style has been reprogrammed

to support habits of sobriety, a sense of achievement is felt. Beginning acceptance of the reality of alcoholism dawns. This admission allows self-acceptance and liking oneself, despite imperfections. These steps on the road to personal fulfillment generally occur between the 25th and the 30th month.

Epilogue

I am proud of the progress made by each woman in her quest for self-fulfillment. I feel blessed to have been given the opportunity to share these moments for I have grown, too. Doreene has completed a master's degree and is now working with adolescents having problems making the transition to adulthood. She speaks the language of the streets and the language of troubled youth. She is able to earn their confidence and she meets this challenge with her vibrant energy. Mary Helen, too, works in a rehabilitation area with the older adult. Each, in her own way, is giving back what she has received.

Several attempts to reach Lynne had not been successful and she had left her place of employment without giving any notice. I could feel a knot beginning to form in my own gut. Contact with the ''bamboo telegraph'' was not encouraging. I decided to try and find her. She had moved several times, but I was able to follow her moves. This was the last known address. As I drive through the countryside on that beautiful fall day, I wonder if she has, after all, been unable to sever the ties with her mother and has returned to drugs as a way to cope with the growing misery in her life. As I turn into the wooded lane, I begin to wonder if I am in the right place. The underbrush is rampant and I decide to trudge the rest of the way on foot. It is another half mile or so through hardly a path when I come upon a small clearing in the center of which is a small cottage in need of much repair. Had it been any other occasion, I would marvel at this hide-a-way even with its limitations. I can see that the cottage has been used. A small amount of firewood haphazardly stacked along the side of the house

has been recently cut, and the grass near the steps to the small porch is trampled. I can see no signs of life and the chimney is cold to the touch. As I survey the sagging porch getting my courage up to approach the door, a man's voice spins me around. "Watcha want, Lady?" "I'm looking for Lynne," I try to reply calmly. "Is she here?" His steel blue eyes penetrate to my soul and I quiver. I have no doubt that he can deftly use the shotgun he holds loosely in one hand. "Nope," he replies, "she's gone." "Could you tell me where I might find her?" I ask. Again, he seems to stare through me. "You ain't never gonna find her," he replies after a few moments. "Is she using again?" I ask. His eyes cloud and I see his pain. "She's gone, she ain't here, she ain't never gonna be back." And with that he turns and goes into the house. And I, too, turn and leave.

Selected References

Bradshaw, John. *Healing The Shame That Binds You*. Deerfield Beech: Health Communications, Inc. 1988.

Brown, Stephanie. *Treating Adult Children Of Alcoholics*. New York: John Wiley & Sons, Inc., 1988.

Brown, Stephanie. *Treating The Alcoholic*, New York: John Wiley & Sons, Inc. 1985.

Daley, Dennis. *Surviving Addiction*. New York: Gardner Press 1988.

Duerk, Judith. *Circle of Stones*. San Diego: LuraMedia, 1989.

Fitzgerald, Kathleen Whalen. *Alcoholism. The Genetic Inheritance.* New York: Doubleday. 1988.

Gomberg, Edith S. "Risk Factors Related to Alcohol Problems Among Women: Proneness and Vulnerability." In *Alcoholism And Alcohol Abuse Among Women: Research Issues.* DHEW Pub. No. (ADM) 80-835. 1980.

Gomberg, Edith S. "Alcoholism In Women." In *Social Aspects Of Alcoholism.* pp: 117-161. Edited by Benjamin Kissin and Henri Begleiter. New York: Plenum Press, 1976.

Kleeman, Barbara E. "Women Alcoholics in Management: Identification and Intervention in the Workplace." Boston, Mass. *University Microfilm* Cat. No.: 8220942. 1982.

Knupfer, Geneive. "Female Drinking Patterns."In *Selected Papers Presented at the Fifteenth Annual Meeting of the North American Association of Alcoholism Programs* Washington, D.C. 1964: 140-160.

References

Leonard, Linda Schierse. *Witness To The Fire, Creativity and the Veil of Addiction.* Boston: Shambhala Publications. 1989.

Mello, Nancy K. "Some Behavioral and Biological Aspects of Alcohol Problems in Women." In *Alcohol and Drug Problems in Women*, pp. 263-293. Edited by Oriana Josseau Kalant. New York: Plenum Press, 1980.

Scales, Cynthia G. *Potato Chips For Breakfast.* Stroudsburg: Quotidian, 1986.

Schuckit, Marc A. and Duby, Jane. "Alcoholism in Women." In *The Pathogenesis of Alcoholism*, pp. 215-241. Edited by Benjamin Kissin and Henri Begleiter. New York: Plenum Press, 1983.

Stammer, M. Ellen. "An Ethnography of Women Nurse Alcoholics: The Cultural Path of Drinking and Recovery with Implications for Intervention in the Workplace." Washington, D.C. *University Microfilm* Cat. No.: 8800091. 1987.

Tamerin, John S. "The Psychotherapy of Alcoholic Women." In *Alcoholism Psychotherapy*, pp. 3-22. Edited by Sheldon Zimberg, John Wallace and Sheila B. Blume, New York: Plenum Press. 1985.

Tatelbaum, Judy. *The Courage To Grieve.* New York: Harper & Row, 1980.

Trice, Harrison M. and Beyer, Janice M. "Women Employees and Job-Based Alcoholism Programs. *Journal Of Drug Issues* (Summer 1979): 371-384.

U.S. Department Of Health And Human Services. National Institute On Alcohol Abuse and Alcoholism. *Advances In Alcoholism Treatment Services For Women.* Edited by Lois Chatham, Acting Director, Division of Extramural Research. Washington, D.C.: DHHS Publication No. (ADM) 83-1217. 1983.

U.S. Department Of Health And Human Services. National Institute on Alcohol Abuse and Alcoholism. Demonstration Project: Final Report. *Women's Occupational Alcoholism.* Edited by Susan Solomon, Project Officer. Washington, D.C.: U.S. Government Printing Office, 1982.

Volpe, Joan. "Research Observer's Report." In *Advances in Alcoholism Treatment Services for Women*. Edited by Lois Chatham, Acting Director, Division of Extramural Research, National Institute on Alcohol Abuse and Alcoholism. DHHS Publication No. (ADM) 83-1217. 1983.

Whitfield, Charles L. *Healing The Child Within*. Deerfield Beach: Health Communications, Inc., 1987.

Wilsnack, Sharon C. "Current Status And Research Needs." In *Alcoholism And Alcohol Abuse Among Women: Research Issues* DHEW Pub. No. (ADM) 79-835. 1980.